D0811395

INTO THE FRAME

INTO THE FRAME

The Four Loves of Ford Madox Brown

Angela Thirlwell

Chatto & Windus
LONDON

Published by Chatto & Windus 2010

2 4 6 8 10 9 7 5 3 1

Copyright © Angela Thirlwell 2010

Angela Thirlwell has asserted her right under the Copyright, Designs
and Patents Act 1988 to be identified as the author of this work

First published in Great Britain in 2010 by
Chatto & Windus
Random House, 20 Vauxhall Bridge Road,
London SW1V 2SA
www.rbooks.co.uk

Addresses for companies within The Random House Group Limited
can be found at: www.randomhouse.co.uk/offices.htm

The Random House Group Limited Reg. No. 954009

A CIP catalogue record for this book
is available from the British Library

ISBN 9780701179021

The Random House Group Limited supports The Forest Stewardship Council
(FSC), the leading international forest certification organisation. All our titles
that are printed on Greenpeace approved FSC certified paper carry the FSC
logo. Our paper procurement policy can be found at
www.rbooks.co.uk/environment

Typeset by SX Composing DTP, Rayleigh, Essex
Printed and bound in Great Britain by
CPI Mackays, Chatham, ME5 8TD

For John, Zoë and Adam
and
Tosh, my constant writing companion and oldest friend

CONTENTS

INTRODUCTION

FOUR WOMEN, WHOSE LIVES SPANNED most of the nineteenth century and a quarter of the twentieth, were related by blood, marriage, love or friendship to one man – the great Victorian artist, Ford Madox Brown. Two wives: his first cousin Elisabeth Bromley and, after her death, Emma Hill; and two secret loves: the Greek artist Marie Spartali and, following her marriage, the German-born writer, Mathilde Blind.

Madox Brown's relationships with Marie and Mathilde were almost entirely contemporaneous with his marriage to Emma, who provided the one continuous, unbroken thread. All four were remarkable women, striving for self-expression in an age that sought to suppress them. They struggled and thrived, failed and succeeded. Elisabeth, Emma, Marie and Mathilde burst out of received stereotypes of Victorian women. Their combined and contrasting stories tell us something about the journey women made from dependency to autonomy, towards more modern roles and choices for women. Elisabeth Bromley was born in 1818, the year Mary Shelley published, anonymously, her landmark novel of the supernatural, *Frankenstein*. Marie Spartali died in 1927, just a year before women gained full emancipation in Britain, on equal terms with men.

Ford Madox Brown came from a Scottish medical and naval family. His parents were middle class but less financially solid than cousin Elisabeth's. They and their son lived almost continually in Continental Europe for the first twenty-five years of the artist's life. He was always an outsider and refused to join any group – even the Pre-Raphaelites with whom he was so closely associated.

Elisabeth Bromley was Madox Brown's first love and his intellectual partner. Cultured and educated, she came from solid, English, middle-class stock. She was well read and religious, wrote poetry and voiced romantic responses to landscape. Undoubtedly Elisabeth would have been a virgin on marriage but from the evidence of her two pregnancies and the free remarks on nude models in letters between her and Madox Brown, it would seem that in spite of her piety she had a healthy approach to their sexual life, more an eighteenth-century outlook than the one generally supposed to have been held by Victorian women. In her twenties, Elisabeth had to battle with a terminal illness, tuberculosis, for which there was no cure until the 1950s.

Madox Brown's second wife, Emma Hill, came from the English agrarian working classes who migrated in large numbers to the cities during the 1840s. Without formal education, she was intelligent and enjoyed reading George Eliot and Tolstoy. Emma battled with a class system she climbed out of by marriage to Madox Brown. But she also battled with an escalating drink problem. Her looks were her passport to a better life. She was the artist's wife and model – if not a model wife. Madox Brown certainly drew and painted from nude models but there's no evidence that he asked Emma to pose nude, although she may have done. As she gained in respectability, moved into the bohemian middle class, and married, she lost patience with modelling. And as a wife, she wasn't paid – except in bonnets and rings and dresses, and perhaps in drink money. It's impossible to know whether Emma was a virgin when she met Madox Brown, but she was ready to try free love, and happily gave birth to their daughter outside marriage. She has a lot in common with modern young women, almost nothing with the accepted figure of modest Victorian womanhood.

The two women Madox Brown secretly loved came from completely different roots from his two English wives. Like Madox Brown himself, they were both outsiders – as Emma had been in another way, outside his middle-class milieu. Accomplished and well educated, Marie Spartali was the daughter of wealthy Anglo-Greek parents. She applied to Madox Brown's teaching studio for art lessons. Her first struggle was with her parents, to be allowed to marry a man outside their circle. In spite of her legendary beauty, there was a steely quality about Marie. She got on with her work; she resisted Madox Brown; she was determined to marry the man of her choice, even though he may have seemed a hollow choice to observers. Her second, lifelong battle was to combine a professional career as an artist with the responsibilities of children and stepchildren. As she said after the birth of her third child, the longer she

lived the greater she found 'the difficulties in a woman's way to doing anything *well*.'

After Marie Spartali left his studio, Mathilde Blind, née Cohen, took the place Marie had previously occupied in Madox Brown's heart. Mathilde was a German-Jewish outsider who became a secular agnostic – a religious position entirely shared by Madox Brown. She was highly educated, a real scholar, a feminist and political radical. Her life choice was literature. Poet, critic, translator, novelist and biographer, her battle was an intellectual woman's battle against cultural norms. Ultimately, she always chose her career above marriage. Mathilde believed that woman is 'a being whose sympathies are too vast – whose thoughts too multiform to converge to the one focus of personal love . . . it is at once her right and her duty to take an active share in the general concerns of humanity, and to influence them . . . directly by her own thoughts and actions.' In temperament and ideals she was the woman in his life who was most like Madox Brown, a European, her own worst enemy, and a prey to unrequited loves.

Both Marie Spartali and Mathilde Blind were fundamentally different from the two wives of Madox Brown's youth. Although their lives were entangled at significant points with Madox Brown, they pursued careers and relationships of their own that moved across and outside his orbit. From the same generation as his daughter Lucy, they could take more opportunities than were open to either Elisabeth or Emma. Mathilde and Marie were both consciously and unconsciously striving to become productive artists in their own right, independent of men. They were 'new women', although the term itself did not become current until the 1890s. As they gradually challenged the accepted notions of suitable womanly behaviour, they became more self-assured, and more self-driven. Perhaps for reasons connected with their professional output, they left a deeper footprint in the surviving archives than either Elisabeth or Emma. Although Marie assiduously burnt her incoming correspondence, and Mathilde and Madox Brown suppressed any interchange that might have made their story public, other people preserved many letters from Marie and Mathilde. So there is more documentary 'evidence' with which to reconstruct their stories than remains to tell either Elisabeth's or Emma's.

Intimate relationships in the Victorian era had infinite gradations of subtlety. The relationships explored in this book can't be reduced to the simple question of whether or not the protagonists had sex. What we can retrieve from the past about intense or painful emotions is as relevant today as it ever was. Victorians suffered and wept and raged and laughed for many of the same reasons that we do. Social conventions may have

changed for ever; human feelings, obsessions and individual consciousness endure.

Also unchanged is the importance of creative work. All four women, as well as Madox Brown himself, were involved in work that was important to them, whether entrusted to a private notebook like Elisabeth's, or part of a creative partnership like Emma's modelling, or undertaken for public scrutiny and sale like Marie's exquisite paintings and Mathilde's ambitious writing. Conversations between Madox Brown and the four women in his life are lost. But the emotional ties between them fed into the various forms of art that all five made, or featured in. And much of that art is still available to be examined and interpreted. It is a crucial resource, a supplement and support to the written archives and can suggest a flavour of the inner conversations behind their human dramas.

Putting the lives of these four women 'into the frame', enables us to look at the private life of a major public artist and some of his key works from a fresh perspective. But Ford's quartet, composed of the most significant women in Madox Brown's life, are not silent muses hidden in the shadow of the 'Master'. Here, for the first time, they step out of the shadows and into the picture, speaking with voices we can hear and understand.

I. ELISABETH

ELISABETH BROMLEY
10 September 1818–5 June 1846

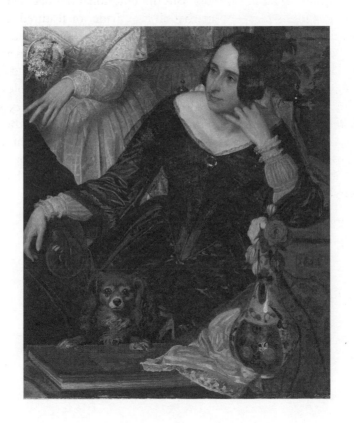

Elisabeth Bromley, aged 26, detail from *The Bromley Family*, 1844.

CHAPTER 1

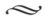

YOUR HUSBAND
LOVES YOU AS
THE FIRST DAY

ORD MADOX BROWN, BACHELOR ESQUIRE, married Elisabeth
Bromley, Spinster Commoner, on 3 April 1841 at the ancient
parish church of Meopham in Kent. There has been a church on
this spot since Saxon times. In spite of an earthquake in 1382, its dignified
stone structure survives to this day. Elisabeth walked up one of its pillared
aisles through the fine nave with its richly carved pulpit, decorated with
swags of fruit and exuberant cherubs. At twenty-two, Elisabeth was
slightly the elder. Ford Madox Brown was not yet twenty. The young art
student looked so baby-faced that the vicar, Mr Thompson, asked the
congregation in genuine disbelief, 'Where is the bridegroom?'

The entry in the parish register still exists; the clerk spelled the bride's
name 'Elizabeth', she signed herself 'Elisabeth Bromley' and the spelling
seemed fluid throughout her life. When Madox Brown designed her

tombstone five brief years later, he chose the spelling Elisabeth herself seems to have preferred. The marriage was celebrated according to the rites and ceremonies of the Church of England. Witnesses included Elisabeth's mother, Mary Bromley, and Augustus and Helen Bromley, her brother and sister-in-law. Their first daughter, another Helen, aged about three, was indulgently allowed to make her mark as a witness. The elder Helen Bromley eventually played a crucial role in parenting and educating the only surviving child of the marriage, Lucy Madox Brown, born in 1843.

At nineteen, Madox Brown had fallen in love with his first cousin, Elisabeth Bromley. It was hardly surprising that he made an impulsive decision to marry before he was twenty. By April 1841, he had lost literally half his family. His affectionate mother, Caroline Madox Brown, who had always encouraged his talent, died in Calais in September 1839. He never forgot her, nor how his temperament had struggled to express grief adequately. 'How bewildered I felt & what a relief it was to me, on the way home from the funeral to find tangible proof of my not being quite deficient in feeling – those tears were perhaps the greatest relief I had ever experienced.' Madox Brown showed this same initial numbness, or rejection of sentimentality, to repeated bereavements throughout his life. He even tried to impose his own unyielding response to death on others – with near disastrous results. Forty years after Caroline's death, he recalled, 'twice I have been to Calais since, & had her grave seen to, & these visits are what is now least like a dream to me in the whole remembrance.'

The death of his mother was followed less than a year later by the death of Eliza, known as Lyly, his elder and only sibling. Both mother and daughter had suffered from consumption. Many years later, already a grandfather and on a journey to Belgium, Madox Brown sought out his sister's grave in the country where he had left her thirty-five years before. 'I found that the stone over my sister's grave had fallen down & been casted away – 35 years is a long time – I am having another put to her memory – she was only 22 & I was very much attached to her.'

After these two early bereavements, Madox Brown was especially susceptible to a new feminine sympathy. On her way back from finishing school in Germany, Elisabeth Bromley broke her journey to stay with the Browns, then living in Antwerp. The Bromleys and the Browns were related through two Madox sisters. Mary Madox, born in 1780, married Samuel Bromley in 1809 and gave birth to her last child Elisabeth in 1818.

Mary's younger sister, Caroline Madox, born in 1792, married Ford Brown on 18 April 1815. By the time their second child and only son was born in Calais on 16 April 1821, the Browns had already left England to live mostly in northern France. His parents added Caroline's maiden name to plain Brown, and called their son, more distinctively, Ford Madox Brown.

The career of Ford Brown Snr, the artist's father, as a purser in the Royal Navy, had been disappointing. Perhaps he was more interested in the life of the mind. His son remembered him as a 'cultivated Scotchman', fond of the fine arts, science and music, with a wide knowledge of French, Spanish, Italian and classical literature. 'His last appointment was to a seventy-four [gun ship], a post of considerable emolument. But after the peace of 1815, [when many officers were decommissioned] he never got another ship'. This sudden change from a life on the high seas made him restless on dry land, his son later recalled. 'He could not stay long in one place but kept on one pretence or another, shifting his family from France to England, & from town to town.' Ford Brown had never been an easy man. Even his sweet-tempered wife Caroline described him as 'figity', always wanting 'someone to grumble at'.

Still resentful of the early retirement forced upon him twenty-five years earlier, by 1840 Ford Brown Snr seemed much older than his sixty years. Although family relationships had once been affectionate, they were tested to the limit by his querulous state of constant ill health, exacerbated by gout and a stroke. Elisabeth's arrival in Antwerp at this moment had seemed fortuitous. Madox Brown could talk to Elisabeth. They shared the same family references. They understood each other's histories. Her appealing oval face, within its sleek wings of dark hair, had been familiar to Madox Brown since childhood. Now she had poise and natural serenity. Within weeks they acknowledged 'an ensnaring of hearts'. Choosing the two-years-older Elisabeth replicated the familial link with his dead sister, and represented perhaps an unconscious imitation of that relationship. Elisabeth and Lyly had been almost exact contemporaries. For the bereaved young man Elisabeth embodied sister, mother, sweetheart and wife in one.

Elisabeth also represented a breath of English air. Although a 'finished' young lady from a European school, she was from solid English stock. The Bromley family could trace its origins back to a distinguished legal family which produced the scholarly MP, Sir Thomas Bromley, who became Lord Chancellor of England (1579–83) during the reign of Elizabeth I. He himself claimed descent back to Geoffrey de Bromley who died in 1272. The family tradition for eminent public service was maintained by one of

Elisabeth's elder brothers, Richard Madox Bromley, whose middle name came from his mother, Mary Madox, the sister of Caroline, young Ford's mother. Sir Richard was knighted for his high-flying Civil Service career in the departments of the Admiralty and the Exchequer. He lived expansively and generously. When his youngest sister Elisabeth married Ford Madox Brown, he settled a liberal £900 on her. The young couple's annual private income amounted to about £250, as Madox Brown had a legacy from his mother Caroline's small estate (doubled after the death of his sister), which mainly consisted of shares in the Ravensbourne Wharf at Greenwich.

Tenderness between Madox Brown and his dead mother always underlay his fondness for Kent, the county where he married. Caroline Madox came from an 'old Kentish family – among whose ancestors were Crusaders, one of whom, Sir Richard Manning, was knighted by Coeur-de-Lion on the field in Palestine'. Although Madox Brown's early years were spent mostly in France and Belgium, he retained affection, even an idealised loyalty for Kent, his mother's and his wife's English county of origin. However, he had spent his formative years on the northern coast of France. These years were vivid to him, even as an old man. He never lost his command of the French language and could speak and write it with ease. In fact, a certain deliberation when speaking English, as well as eccentric notions about English spelling, may be traceable to his early fluency in French.

As the Brown family had to subsist on a half-pay naval pension, their reduced finances made them choose economic exile in France. Here the genteel but impoverished middle classes could live altogether more cheaply than in England. Although the Browns maintained ties with England by regular visits, their children's upbringing was French. As the Browns moved successively from Calais and Dunkirk, to Bruges, Ghent and Antwerp, the picturesque towns and forests of northern France and Belgium left an enduring impression on young Ford. Sixty years later, he remembered being dangled out of a parlour window to watch the carnival parade in Dunkirk, while a wild fish girl 'danced about like a maenad or demented creature, beating on a tin mug with a wooden spoon.' From their home near the French coast, he remembered crossing the Channel on rolling packet boats, dressed in the outfit that four-year-old boys of his time and class wore for such occasions. 'I was dressed in what was then called a blouse – jacket & trousers all in one, buttoned up behind & a little of the shirt frequently, on that side, remained out. Precisely, so I have painted the little boy in the fresco of John Dalton of Manchester: only that

mine was of blue cloth & in spite of the fine day it got marked with my [sea]sickness & so remained an . . . eye-sore to me long after'.

Detail from *Dalton collecting Marsh Fire Gas*, 1886–1887,
one of the twelve murals FMB painted for Manchester Town Hall,
showing a version of his boyhood self on the right.

★

It had all begun in 1825 with a horse's hoof. When he was only four, young Ford had impulsively corrected an equine sketch his father was drawing. Immediately his parents recognised their son's flair for art. To promote his obvious natural talent, Caroline herself joined a local drawing class with young 'Fordy' – his family pet name. Later his parents 'engaged the best drawing masters' in the Pas-de-Calais for their precocious young son and his sister Lyly.

Two key elements in his future career were already apparent in the child. From an early age he had an almost painful instinct about what was beautiful and what was ugly. One day when his spelling book got torn in a quarrel, his mother ingeniously repaired it with needle and thread.

'Because my mother had sewn it I thought it all right, but it was nevertheless [yet another] eye-sore to me.' Like his clothes soiled with seasickness from the Channel crossing, the ripped spelling book offended young Madox Brown's aesthetic sensibility.

The second artistic trait rooted in childhood was an acute sense of the expressiveness, even the grotesquerie of the human face. At a family picnic in the forest of Guînes, outside Calais, he meandered away and 'lost himself'. Conjuring up bears or wolves behind every tree, he 'began to howl but no one heard me'. At last he was rescued by 'a sand-boy and a sand girl with a donkey' who laughed as he howled, '*je veux Maman*'. They propped him on their donkey and returned him to his parents. But their menacing faces seared his imagination. 'Not Gargantua and his sister could have seemed more terrible to my frightened senses than this ferocious looking couple.' Contorted or grimacing human faces would feature throughout Madox Brown's work. One of the two prizes he won as a student at the Royal Academy of Fine Arts in Antwerp in 1839 was for '*Têtes d'expression*'. His commitment to expressiveness made it hard for an audience accustomed to the anodyne prettiness of much Victorian art to accept his principles of dramatic truth-telling. In 1871 Dante Gabriel Rossetti acclaimed Madox Brown as 'one of the greatest painters living anywhere, though the intensity of expression in his works places them beyond the appreciation of commonplace people.'

Once the Browns had decided their son was to be a great artist, their removals were driven by finding the best academies of art in their corner of Europe. Ironically, a training which was first French, and then more widely European, underlay Madox Brown's later reputation as a quintessentially English artist. When he died in 1893, newspaper reports from France stressed his French roots.

At the age of fourteen, in November 1835, Madox Brown travelled to Belgium in order to become a private pupil of Albert Gregorius, director of the Bruges Academy of Painting. Gregorius had spent many years in the atelier of the French neoclassical painter, Jacques-Louis David. The Bruges Academy was established in 1717 and until 1890 was housed in a striking Gothic structure called the Poortersloge, at the junction of 14–18 Academiestraat and Jan van Eyck Plein. Outside the academy a statue to Jan van Eyck daily inspired students as they gazed down the canal named after Bruges' famous artist. In the following autumn of 1836, Madox Brown moved to the Ghent Academy to be taught by another of David's pupils, Pieter van Hanselaer, although as he was still only fifteen he was debarred from the life-drawing classes. He graduated to the Antwerp Academy in 1838, taking tuition from its newly appointed director, and

arguably his most distinguished teacher, Gustave, later Baron Wappers, noted for crowd scenes of heroic revolutions in Europe.

It wasn't only the practical, formal sessions in the studio which nourished young Madox Brown. In Bruges, he had seen brilliantly luminous pictures by the Flemish masters, Hans Memling and Roger van der Wiedermeyer. St Bavo's Cathedral in Ghent held the great altarpiece by the brothers Hubert and Jan van Eyck, *The Adoration of the Mystic Lamb*, completed in 1432. This Belgian training resonated throughout Madox Brown's career and determined a major direction in his art. Although a modern artist who chose subjects with contemporary significance – such as economic emigration to Australia in *The Last of England*, or the impact of the Crimean War in *Waiting: An English fireside in the winter of 1854–1855* – Madox Brown was equally committed to painting scenes from British history. Choosing historical subjects gave him scope to advance political principles. His heroes were either democrats who changed political history, such as Oliver Cromwell, depicted in contemplation in *Cromwell on his Farm*, or working people who rebelled against tyranny, as shown in *The Expulsion of the Danes from Manchester*. But some of the technical lessons he learned in the Belgian academies, particularly about painting on a dense bituminous ground, he had to unlearn later when he met the English apostles of Pre-Raphaelitism with their new joy in prismatic colour.

As an art student in Antwerp in 1838, Madox Brown lodged at the Hôtel du Pot d'Etain, also known as the Hotel de Tinnen Pot (the Copper Kettle), then 2780 rue des Peignes, now 66 Oude Koornmarkt, within sight and sound of the carillon chimes of the cathedral. He and his fellow student, the 'slightly hot-headed' Irish artist, Daniel Casey, were enchanted by a blonde girl next door with 'very pretty small feet' whom they wooed, unsuccessfully, with bunches of violets. Casey called his friend *'mon vieux* Fordy' and they remained lifelong friends, although Casey later lived mostly in Paris, while from 1846 Madox Brown settled permanently in England. The lasting sympathy between the two artists is apparent in a sensitive, clear-eyed portrait Madox Brown drew of Casey in 1848, ten years after they had trained together as art students.

The Antwerp Academy where Madox Brown went to classes with Casey had once been a medieval monastery. Students walked and chatted beneath its original arched roof beams and in the airy cloisters of its Winter Garden.

When Madox Brown first enrolled here as a *schilder* (painter) aged seventeen, to draw 'from the Antique' during the 1838 winter session, he

was one of the youngest in his class of thirty-one students, mainly in their
early twenties. His fellow students were mostly Belgian or Dutch, with a
few French and German students on the roll. Only three or four were
British although within the next few years the student body became more
widely international. The language in Antwerp was and is Dutch, but
reflecting Napoleonic influence, the street names at that time were
French, as was the language of the academy's Prize List. The second award
Madox Brown won was for the class '*Dessin d'après l'antique*'. On the face
of it, neither prize appears to have been particularly notable, fourth in a
prizewinners' list of six for the Antique, and sixth in a list of six for Facial
Expressions.

 He might have done himself greater justice in the Prize Lists if he hadn't
absconded from classes in order to fulfil an unexpected commission,
painting portraits in Luxembourg. His director of studies, Gustave
Wappers, was clearly annoyed – as Lyly reported to her runaway brother:
'he said he did not care about your going to Paint portraits but he did not
like a good scholar to absent himself for any other reason when he had so
much likelihood of gaining the prize.' Although forced to play truant
from his studies to earn a little money, the city and the art of Antwerp
seeped into his consciousness for life. In the cathedral, he saw Rubens'
overwhelming altarpieces, *The Raising of the Cross*, 1609–10, and *The
Descent from the Cross*, 1611–14, in high baroque style, a flamboyant
contrast with the cool, medieval naves in which they hung. When he
returned to the city in 1875 he found the Rubens paintings as 'fresh & fine
as ever' and even mapped out a picture inspired by the master which he
planned to call *Rubens' Ride*.

Madox Brown's earliest surviving image of his alluring cousin Elisabeth
was probably painted in Antwerp in 1840. Under the tuition of Gustave
Wappers, who placed supreme value on the painting of historical scenes,
he chose to reimagine the execution of Mary, Queen of Scots, one of the
most sensational monarchs in popular memory. Madox Brown asked
Elisabeth to model for Mary Stuart's young attendant who, overcome
by terror immediately before the execution, faints backwards into the
arms of a senior waiting woman. During his preparation for the complex
final painting, Madox Brown made a dramatic, foreshortened study of
Elisabeth's head thrown backwards on to a pillow at an awkward angle. It
was a challenging pose and brilliantly observed. The position is a
particularly vulnerable one and suggests the intimacy that existed between
the couple.

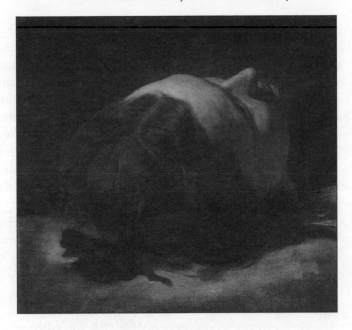

Elisabeth models for the swooning attendant.

In the study, Elisabeth's eyes are open. She is fully aware of the difficulties faced by the artist. It is tempting to imagine the sittings for this oil sketch: absorbed hours of total concentration, alternating with thoughtful discussions. Not only did she consent to the pose but she actively participated in the picture's earliest conception. Elisabeth's head would eventually be placed in the foreground of Madox Brown's theatrical and moving composition.

In the powerful oil painting, eventually completed in Paris in 1841 soon after they married, and exhibited there in 1842, Elisabeth's eyes have been appropriately closed as her imagined character drops into unconsciousness. But in the study her face is alert, her features strongly composed, her dark hair parted at the centre and caught back into a knot at the nape. When Madox Brown incorporated his preliminary study into the main composition, he covered Elisabeth's head with a peaked wimple low over her forehead, faded her rich, dark hair, tightly braided round her ears, to blonde, and tilted her straight nose to a retroussé version. These changes, although small, leached the expression from Elisabeth's resolute face, and more closely fitted the passive role Madox Brown imagined for the fainting gentlewoman.

He dressed the figure inhabited by Elisabeth in sombre brown velvet,

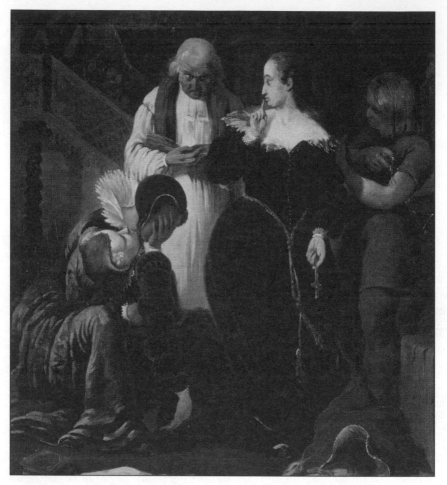

The Execution of Mary Queen of Scots, 1840–42.

almost blending with Mary's suggestive dark gown. For Mary, Queen of Scots, Madox Brown devised a sumptuous, low-cut gown, its blackness offsetting the startling fleshy whiteness of her exposed neck and shoulders, about to meet the axe. Beneath the towering figure of the queen, Elisabeth's maidservant droops in her attendant role. Her right arm, in its gorgeously hooped sleeve – implying rope, imprisonment and restraint – is thrust down to occupy a significant area of the lower foreground. One despairing hand almost sweeps the scaffold's floor while her limp body is supported by another of Mary's last attendants.

It seems oddly prophetic that even in their early days together, Elisabeth was seen by Madox Brown in a moment of collapse. He had lived with tubercular debility in his mother and sister that had ended only in their

deaths. Were ominous signs already apparent in Elisabeth's youthful physique? Was that why her husband chose to cast her as a supporting actress in a minor role in the most ambitious composition of his life so far?

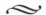

ELISABETH'S NOTEBOOK AND *KING LEAR*

LISABETH'S CONSTITUTION WAS DELICATE, her face refined and spiritual. She poured her secret thoughts into a black leather–bound journal with a gold tooled design on its front and back covers. This notebook, carefully preserved, with its difficult spidery script on inviting unlined pages, is the only surviving, tangible link with the real Elisabeth. She had begun to keep it before her marriage, composing tentative, experimental poetry in both English and French. She tried her hand at translations from Schiller and copied out pious mottoes, spurring herself to perfect moral behaviour. Many years later her daughter Lucy used it as a commonplace book, making the object a physical connection with the mother she could barely remember.

Inside this fragile notebook Elisabeth's emotional, literary and religious preoccupations are laid before us. Soon after their wedding, she and Madox Brown left England in summer 1841 to live in Paris for a double reason: so that he could pursue his art studies, and to improve Elisabeth's uncertain health. Her command of French was assured enough for her to seek out contemporary poetry in the language. From Théophile Gautier's 1838 collection, mordantly titled *La Comédie de la Mort*, she copied 'Après le Bal' into her notebook:

> *Maintenant c'est le jour. La veille après le rêve;*
> *Le prose après le vers: c'est le vide et l'ennui;*
> *C'est une bulle encor qui dans les mains nous crève*
> *C'est le plus triste jour de tous; c'est aujourd'hui.*

Like Gautier, Elisabeth dreaded 'the wakening after the dream, the prose after the poetry', yet another bubble that bursts in our hands. The humdrum rhythm of domestic life inevitably contained an element of 'the emptiness and the boredom'. Gautier's volume, with titles such as 'Melancholia', 'Romance' and 'Pensée de Minuit', spoke to her cast of mind, attuned as she was to reading Burns, Byron and other European Romantics. Through poetry, Elisabeth faced up to the paradoxes of romantic love.

Four months after her wedding, in 'Love's excuses for sadness', she was bold enough to examine her private response to her new situation – and her new husband. She forced herself to examine the duality in her own nature:

> Chide not belov'd, if oft with thee,
> I feel not rapture wholly:
> For aye, the heart that's fill'd with love
> Runs o'er in melancholy.
>
> Paris. August 16th 1841

A few weeks after writing 'Love's excuses', Elisabeth knew she was pregnant. We know nothing of the pregnancy but some foreboding lines, entered in her notebook towards the end of September 1841, display one of Elisabeth's recurring themes – the proximity of death to life:

> Death claims us all – then grief away
> We'll own no meaner Master.
> The clouds that darken round the day
> But bring the night the faster.
> Love, feast, be merry while on earth.
> Such Grace should be thy moral
> E'en death himself is friends with mirth
> And veils the tomb with Laurel,
> While gazing on the eyes I love
> New life to mine is given
> If joy's the lot of Saints above
> Joy fits us best for heaven.

In spite of her intimations of mortality, she gave birth safely to a son on 29 June 1842, when she was still only twenty-three. For a few days everything seemed to progress normally. Then the child suffered convulsions and on the fifth day, he died. Elisabeth rushed to her private companion, her little black book. As an outlet for her grief she copied out some lines by Burns:

> Oh sweet be thy sleep in the land of the grave
> My dear little angel for ever.

At the end of the poem, she added 'and thou art gone too, my baby'. On the same day, perhaps the day of her son's funeral, she composed some lines of her own, recording what had happened:

> Convulsions shook his infant frame;
> The mother's only babe was dead.

Elisabeth had a resource at this dark moment. She applied her faith in God, to confirm in her own mind the enduring life of the child she had lost. Emphatically, she underlined the present tense in the last line:

> But still her faith in Him she kept
> In Him who turned to grief her joy
> And still she murmur'd as she wept,
> Oh blessed <u>is</u> my baby boy!

In faint pencil beneath these lines, she noted the bare facts of her son's life. 'Born June 29th 1842 died July 4th aged 5 days – Paris July 5th 1842.' At this moment of crisis Elisabeth's trust in a beneficent Christian God was under severe trial. Although she was aware that infant mortality rates in France and England were high in the 1840s, her loss felt irreparable, perhaps intensified because the child was a firstborn and a son. The death of her longed-for child was hard to bear.

Slowly, Elisabeth rallied and wrote verse about some of the cities, resorts and landscapes she had seen during her European travels – such as 'my dear, my lovely Rhine'. But her mind kept recurring to her lost child. She fused her longing for the waters of the Rhine with her submerged longing for her dead child:

> Let me again behold thee
> Ere the grace for ever holds me,
> And I will ne'er repine.
> Let me again behold him
> In my arms once more enfold him,
> My dear my lovely Rhine.
>
> Paris, Sept 23rd 1842

In severer moods, she scourged herself with impossible ideals of behaviour, copying into her notebook standard religious exhortations to imitate Jesus Christ in Temperance, Silence, Order, Resolution, Frugality, Industry, Sincerity, Justice, Moderation, Cleanliness, Tranquillity and Humility. The entries she chose for Sincerity – 'Use no hurtful deceit, think innocently & justly, & if you speak, speak accordingly' – and Resolution – 'Resolve to perform what you ought; perform without fail what you resolve' – are keynotes of Elisabeth's personality and indicate the impossibly high standards she set herself.

However, she was soon pregnant again, and their fresh hope inspired Madox Brown, too, with new optimism. Although anxious about money (he was selling very few pictures) their spirits were lifted by the birth of Lucy, their only child to survive, on 19 July 1843, in Paris.

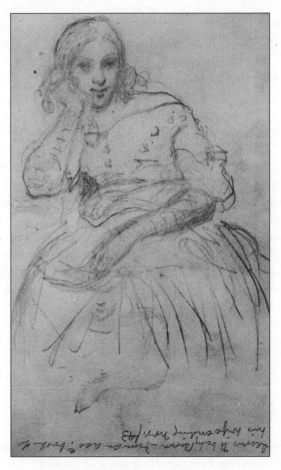

Sketch of Elisabeth in FMB's account book, November 1843

*

One of the things Madox Brown loved most about Elisabeth in the early months of their marriage was the sense of shared living with someone who was his true contemporary. In stylish Paris, where they both spoke the language with ease, he felt proud of Elisabeth who was 'sufficiently handsome and accomplished to move with some distinction in the society of the better class of English in that city', recorded his grandson and first biographer, Ford Madox Hueffer, who later became the modernist writer, Ford Madox Ford.

The young artist could discuss current pictures on the easel with his new wife. Elisabeth kept an account book itemising their domestic expenses and inside its back cover Madox Brown drew an intimate portrait sketch of Elisabeth, in characteristic pose, one cheek resting on her upturned hand. Half amused, half quizzical, she returns her husband's frank, enquiring gaze. Entries in the account book finish at November 1843. By this time, Elisabeth had a healthy baby girl of four months. A new sense of fulfilment and peace is apparent in the delicate drawing. There is relaxed amplitude in Elisabeth's attitude, a hint of tension dissolved in her subtle Mona Lisa smile.

But married love could not fully sustain Elisabeth. Even with her thriving new daughter, regret for her dead son was reignited daily by images she saw around her in the museums and galleries of Paris. In her poetry, she tried to imagine a family scene in which Lucy's elder brother featured, to force the dream into reality, but she had to confess that she failed. Her sensitive intelligence had always understood the paradox of human happiness, that its underside is grief. She had a painful capacity for being in the sunshine and yet 'feeling alone the shade'. When she secreted images of widowhood deep within this poem, images that Madox Brown might have found ominous had she shared these ideas with him, she acknowledged how the loss of her first child had effectively broken her.

'Lines suggested by the sight of a beautiful Statue of a dead Child'

I saw thee in thy beauty! bright phantom of the past,
I saw thee for a moment. – 'twas the first time, & the last,
And tho' years since then have glided by of mingled bliss & care,
I never have forgotten thee, thou fairest of the fair!

. . . I saw thee in thy beauty! with thy sister by thy side
She a lily of the valley, thou a rose in all its pride.
I looked upon thy mother – there was triumph in her eyes.
And I trembled for her happiness – for grief had made her wise.

. . . I see thee in thy beauty! with thy waving hair at rest:
And thy busy little fingers, folded lightly on thy breast;
But thy merry dance is over, & thy little race is run.
And the mirror that reflected two can now give back but one.

I see thee in thy beauty! with thy mother by thy side –
But her loveliness is faded, & quell'd her glance of pride
The smile is absent from her lip – & absent are the pearls
And a cap almost of widowhood, conceals her envied curls.

She felt that the birth of her first baby had filled their home with joy, only for it to be dashed away a few days later by death. 'But mine heart hath blinded both mine eyes – and I can see no more'. The natural tears after childbirth flowed more bitterly because of the outcome of her first pregnancy – which Elisabeth never ceased to mourn. Her serenity deepened into gravity. Even the playfulness of baby Lucy failed to change her habitual mood.

In Paris during 1844, with Elisabeth and their daughter, Lucy, Madox Brown made a series of powerful drawings based on *King Lear*. Both he and Elisabeth were sophisticated readers who shared enthusiasm and discussion about books and plays. However, at the age of only twenty-three, Madox Brown chose Shakespeare's bleakest tragedy, his unremitting study of old age, a subject that he would return to over and over again throughout his artistic career. Their own domestic tyrant, the ailing Ford Brown Snr, had lived with them in Paris from the early days of their marriage. When he died in November 1842, Madox Brown and Elisabeth had arranged his burial at Montmartre Cemetery.

Until the beginning of Victoria's reign *King Lear* had not been popular on the stage, as both producers and actors deemed its stark exposé of family politics to be commercial suicide. To previous generations, the play's setting in pre-Christian England had seemed primitive, even barbaric. But this view changed in 1838, with a landmark production of *King Lear* in London, starring William Charles Macready. The crass omissions and notorious happy ending of Nahum Tate's sanitised version

which had held the stage since 1681 were removed at last. Macready more or less restored Shakespeare's original text; although he did not play it in its entirety, he reinstated the character of the Fool, and gave the audience 'the only perfect picture we have had of Lear since the age of Betterton'. With 'moral, grave, sublime' Macready in the title role, the production was an instant hit with Victorian audiences. Young Queen Victoria came to see it, apparently the 'only person present to whom the play was entirely new.' While Macready was 'fixing all other hearts and eyes' during the first three acts, she turned her shoulder to the stage and merrily chatted to the Lord Chamberlain. But by the fourth act, the intensity of Lear's tragedy and Macready's performance captured the queen and she 'laughed no more'. When Macready's company toured abroad, the success of the production was repeated in Europe and America.

Modern European artists, too, were increasingly attracted to Shakespeare's plays. The German artist Moritz Retzsch had produced a set of sixteen engravings, *Umrisse zu Hamlet* (Outline Sketches for *Hamlet*), in 1828, in his characteristic 'outline style' which later influenced Pre-Raphaelite painters such as Dante Gabriel Rossetti, Elizabeth Siddal and Ford Madox Brown. Indeed, Madox Brown drew on and elaborated Retzsch's linear German style for his own bold new series of *Lear* drawings.

Living and working in Paris, Madox Brown almost certainly knew another dramatic Shakespeare series, also illustrating *Hamlet*. Eugène Delacroix published a group of thirteen dashingly romantic lithographs in 1843, just a year before Madox Brown turned to *King Lear*. Madox Brown loved Shakespeare. His drawings for the play functioned both on an epic and a personal level; in a sense, they were a visual counterpart to Elisabeth's private notebook. He made an artistic decision to concentrate almost entirely on the main plot, King Lear and his daughters, and to leave out the subplot about the parallel family, the Earl of Gloucester and his sons. He bared the play to its essentials but never stripped it of its emotional complexity. In wiry pen and ink illustrations Madox Brown focused on clashes between individuals: Lear against Cordelia, Goneril and Regan against Cordelia, Lear against Goneril and Regan. His prime interest was in character and psychological interaction, which he showed in vivid shorthand through exaggerated facial expressions or contorted body language. The characters in his *King Lear* drawings mime and gesture like archetypal characters in *commedia dell'arte*.

When viewed in sequence like a strip cartoon, the sketches build up to a powerful narrative drama. Madox Brown's energetic pen-strokes also pointed up profound thematic contrasts – youth against age, parent against

child, insubordination against authority, female against male, weakness against strength, man against the elements, loving kindness against ruthlessness.

But he also wanted to convey a sense of historical realism; so he set out to show how people lived in sixth-century Britain, immediately after the departure of the Romans. And, more universally, he examined the way families live in every time and place. Deceptive in their apparent simplicity, his drawings accessed both the elemental and archetypal, the modern and individual. Twenty years later Madox Brown underestimated these *King Lear* drawings as 'ill-finished' but friends persuaded him to include them in his landmark one-man show, *The Exhibition of WORK*, in 1865. In the catalogue he listed his *Lear* subjects in prose equivalent to the bare style of the drawings themselves. 'In this first one Cordelia is asked to state the measure of her love, in order to deserve a larger share of the kingdom. She answers, "Nothing, my lord . . ." Lear says, "Nothing! speak again, for out of nothing nothing comes."'

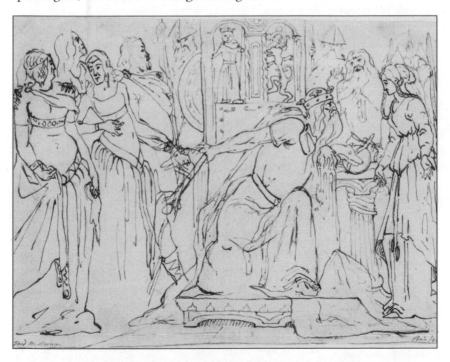

Lear questions Cordelia, drawn in Paris, 1844.

To emphasise the tension of this moment, Madox Brown thrusts Lear into the face of earnest, young Cordelia. The king's beard may be long

and white, his kingdom's map crumpled at his feet, but the sinews in his right forearm still bulge with aggression. Cordelia half-tenderly inclines towards him, though she refuses to humour her father's insatiable need for honeyed words. In the composed features of his wife Elisabeth, Madox Brown found an implicit parallel with the resolute dignity of Cordelia who, in response, measures words so precisely:

> Unhappy that I am, I cannot heave
> My heart into my mouth: I love your Majesty
> According to my bond; no more nor less.

Placed on the right of the picture, Cordelia is quite literally in the right, his youngest and best-loved daughter. Consternation is marked on the faces behind the candid princess, contrasting with the riotous delirium of the body language and head movements of Lear's two elder daughters, Goneril and Regan, on the left of the picture. Madox Brown blocked his pictures with the instincts of a theatre director.

In the second drawing, Lear finds his angry bluff called, as the king of France, head held high, takes Cordelia as his bride, even without her

France claims the dispossessed Cordelia, drawn in Paris, 1844.

'portion' or share of the kingdom's inheritance. Lear slumps on his throne; he is already reduced. Madox Brown commented in his 1865 catalogue that the Duke of Burgundy, who would not take Cordelia dowerless, 'is biting his nails in displeasure. Regan and Goneril sneeringly watch her.'

Later, Madox Brown used this drawing as the basis for the full-scale painting, *Cordelia's Portion* (see Plates). Here, the raw power of his original conception of the play, worked out in the early days in Paris, is translated into a more 'aesthetic' style, but the drama of conflicting emotions is still foremost. In the conflicts of the play Madox Brown found echoes of his own conflicted temperament: the struggle between pride and humility, between self-belief and inadequacy, between the need for public recognition and the refusal to toady in order to achieve it.

In his pictures based on *King Lear* twenty years later, the uncompromising Cordelia became the richest source of interest to Madox Brown. He recognised that, although truth-telling and virtuous, she was as stubborn as her father. Like Cordelia, Madox Brown was truth-telling and stubborn throughout his life. His refusal to kowtow to the art moguls of the day, such as dealer Ernest Gambart, or art critic John Ruskin, effectively ruined his career in a worldly sense. He knew how self-

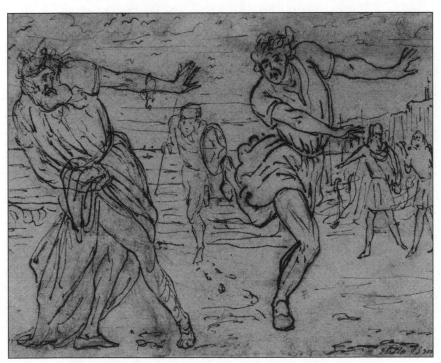

Lear mad on the beach at Dover, drawn in Paris, 1844.

defeating this policy was, but he did nothing to change it. He simply could not ingratiate. Nevertheless, he berated Cordelia who in a sense had been the cause of Lear's decline, madness and tragedy, for the moment 'when honesty, stiffened in pride, glued to her lips the soft words of flattery expected by the old man . . . So virtue, too, has its shadowed side, pride – ruining itself and others.' Although Madox Brown projected the character of Elisabeth, and later the features of his second wife, Emma Hill, into Cordelia, he knew that he himself contained aspects of both parent and child, both Lear and Cordelia.

Now queen of France, Cordelia returns to rescue Lear, driven mad and driven out of his home by her vengeful sisters. 'Found wildly running about the beach at Dover, he is secured, put to sleep with opiates, and the physician, who is about to wake him by means of music, has predicted that his reason will return with consciousness. Cordelia at the foot of the bed, awaits anxiously the effect of her presence on him.' Madox Brown always considered *Cordelia at the bedside of Lear* one of his most important paintings, and felt particularly proprietorial towards this picture of recon-ciliation (see Plates). Again like Cordelia, he combined intransigence with compassion.

Madox Brown not only identified with the truth-telling of Cordelia. In the rejection of Lear, he expressed the pain of his own artistic career. In 1844, the year he was obsessed with *Lear*, he submitted several designs in the fresco competition for the new Palace of Westminster, rebuilt after fire ten years earlier. He won no prize or any recognition. The *Lear* sequence, in which he could explore extremes of rejection, proved consoling on many levels.

The characters of Lear and Cordelia also suited Madox Brown's artistic principles. He would never bow to conventional notions of the beautiful, or to the commercial demands of the marketplace. Henry James identified his shining sincerity but also his uncompromising personality, his almost self-destructive perversity. 'He would make no concessions and play no tricks, he was obstinate and rancorous.'

There is a literal directness and sheer theatricality in Madox Brown's early vision that James later identified as a 'childlike *gaucherie*'. What James said, unfairly, about the body of Madox Brown's work is true of the *Lear* drawings with their accentuated angles and posturing. 'Everything in Madox Brown is almost geographically side by side – his method is as lateral as the chalk on the blackboard. This gives him, with all his abundance, an air of extraordinary, of *invraisemblable* innocence.' This 'innocence', or sense of the elemental story, drove Madox Brown throughout his life. He loved theatre and his unerring instinct for dramatic

truth energised his pictures. "Throughout all its phases, his art was absolutely dramatic – he was – in fact, a dramatist, expressing himself plastically,' as his grandson said. The drama Madox Brown mined in *King Lear*, and animated in these early drawings, would culminate towards the end of his life in the set designs he made for Henry Irving's production of the play in 1892.

When Macready controversially cast Priscilla Horton, rather than a male actor, as the Fool in his radical production of *King Lear* in 1838, reviewer John Forster noticed how inextricably the Fool was 'interwoven with Lear'. A similar integration of both male and female sympathies underpinned Madox Brown's long identification with the play. Continually revisualising and revisiting its drama provided a lifetime's catharsis.

OUT OF TOWN

FOLLOWING THE DEATH OF THEIR SON in 1842, Madox Brown felt a sense of paternity restored when their daughter was born a year later. Emma Lucy Madox Brown, always known as Lucy, held a special significance for both parents, a child who brought with her a sense of rebirth and innocence, like Perdita, the symbolic heroine of Shakespeare's *Winter's Tale*, who was born to replace a dead son, Mamillius. That which had been lost was now found.

Shakespeare's theme of fathers and daughters, especially in *King Lear*, had already engaged Madox Brown. Now the young father, still only twenty-two, found a different artistic way to celebrate Elisabeth's sense of maternity restored. He began painting a tender little picture in 1843 in Paris, which he worked at over many years and later called *Out of Town* (see Plates). With Elisabeth and Lucy as his original models, it shows a mother holding a baby, with a toddler at her skirts, tacitly honouring the memory of their dead eldest child. Elisabeth's poem, 'Lines suggested by the sight of a beautiful Statue of a dead Child', about a son and a daughter, was a direct parallel with her husband's picture. Perhaps Madox Brown began this picture as an outlet for his feelings, just as Elisabeth used her private notebook as a repository for hers.

Out of Town showed a modern Madonna and Child, prefiguring a later picture Madox Brown would begin in 1851, of another place, another time, another wife, another child – *The Pretty Baa-Lambs* – which featured Emma Hill with her daughter Cathy, a picture filled with light. Madox Brown left the much darker *Out of Town* unfinished for many years. He simply didn't have the will to go back to it after Elisabeth's death. But he did complete it, from other models fifteen years later, in 1858. He may

have been cast back to the subject, the loss of his first son and later
Elisabeth, by the death of his and Emma's infant son, Arthur, in 1857. In
spite of the time lapse, and the necessary use of other models, a powerful
sense of Elisabeth remains in *Out of Town*. Strong maternal arms clasp this
second baby as if tethering her to life itself. Under the shadow of her chic
Parisian hat, the mother has Elisabeth's meditative expression, her straight
nose and pointed chin. But here her smooth, dark hair falls in blonde
curls. It was the second time Madox Brown had substituted blonde for
Elisabeth's brunette. Was it artist's licence – or did Elisabeth experiment
with a new French hairstyle to celebrate Lucy's birth? Perhaps a reference
to 'envied curls' in her private notebook reflects an actual flirtation with
fashion and a lighter side of Elisabeth's earnest personality.

But soon after giving birth to her second child, the refinement in
Elisabeth's face took on a gaunt aspect and doctors began to discuss
whether she was suffering from consumption. For Madox Brown this was
a cruel reminder of the terminal illnesses of his mother and sister in 1839
and 1840. Unlike Caroline and Lyly who died abroad, Elisabeth always
expressed a longing to be in her own country. Although she had agreed
to live in Europe so that Madox Brown could continue his art education
and further his career, she could not deny how deeply she felt the pull
back to her English roots.

When they reached England in the summer of 1844, Elisabeth's
increasingly ragged health forced the couple to live apart. In order to
support his wife and their child, Madox Brown rented space in a working
studio in Camden Town, London, while Elizabeth and one-year-old
Lucy were sent to Hastings, a south-coast resort that was considered one
of the healthiest options for patients with weak chests. The eventual title
Madox Brown gave his picture, *Out of Town*, may reflect this time of
temporary separation. He was in London, painting. She was quite literally
'Out of Town' trying to breathe sea breezes into her tubercular lungs. It
was a test to see whether her constitution could withstand the English
climate on a long-term basis.

Back in England, after he and Elisabeth had been married for three years,
Madox Brown painted a group portrait of the Bromleys, his wife's family,
and his own relations (see Plates). Perhaps he worked on it when he was
able to escape from his London studio at intervals during 1844 to meet
Elisabeth and the family in Kent. He chose a garden setting, posing his
relations within a proscenium arch of an artfully cultivated trellis frame.
He enjoyed the whole idea of his wife's extended family – solid,

comfortable, rootedly English – at a time when after nearly two and a half decades spent mostly in Europe, he had lost his mother and sister, his peppery old father, and even his firstborn son.

A pastoral, almost romanticised quality pervades this group portrait with its high-skied, tender blue background and its foreground packed with domestic symbols (trug, dog, book, vase, flowers). The whole composition recalls Continental conversation-piece pictures that Madox Brown had seen during his art training. He devised a cunning semaphore of hands to interlink each family member and fix them in their natural setting. Clever Sir Richard indicates towards his younger brother Augustus, whose hand climbs the trellised tree, shielding his wife Helen, interestingly more than twelve years his senior. Both she and Clara hold decorative posies, emphasising the unifying motif of flowers. Clara's hand gently touches Mary's shoulder, while Elisabeth's languid arm reaches naturally across to her mother's armchair. This symphony of hands emphasises the artist's idealised theme, the harmonious interplay of individuals. He doesn't seem to have found it at all incongruous to place a heavy armchair out of doors in this summery bucolic setting. In the left foreground there's a garden trug balanced by a rose vase on the right. A small dog just off lower centre, directly beneath Elisabeth's forearm, is another motif for family loyalty and fidelity, like a little dog at the foot of a tomb.

The dark suits of the two men match the dark dresses of Elisabeth and her mother in the foreground. Although Madox Brown could not have known it at the time of painting, the two survivors, Clara and Helen, are both dressed in white with warm peach accents, occupying the more central space. The whole picture is composed like the posy that Clara holds towards us. The artist seems to be saying – this family is like a bouquet of flowers. The two men talk, Helen listens attentively but the other three women are still and relaxed, composed like a photograph. Everyone is at ease with each other. Everyone is at ease with young Madox Brown who values his place in the family. He stands with his brushes where we do – or rather, we as viewers stand at the same place as he stood.

Elisabeth his wife is elegant, controlled in an early Victorian tight waisted crinoline. Her low décolletage is edged with white lace and her white frilled undersleeves end neatly at her wrist. She leans her head pensively on her graceful hand. Her thoughts are her own; this time she does not return her husband's gaze.

★

Even at a distance, when Elisabeth and Madox Brown were forced to live apart by the insidious progress of her relentless disease, he confided every detail of his creative life to his 'dearest Lizz', his 'blessed Wife'. He longed to re-establish, if only on paper, the mutual intimacy and intelligent commentary that had so sustained him in Paris. Nor did he conceal his frustrations from her. Theirs was a marriage of true partners and contemporaries. Although at times Elisabeth could be introspective and retreat into her notebook, she also had a talent for sympathy and humour. He did not patronise or talk down to her. As the slightly younger partner in their marriage, he leaned on her and listened to her views. He confessed to her how bothered and anxious he felt in the competitive atmosphere of the shared London studio. The other side of the joshing male competitiveness were moods of pure indolence which infected the young artists – Charles Lucy, Frank Howard (an infernal pest, thought Madox Brown affectionately), John Martin and William Etty.

Madox Brown had plenty of work in hand, but fretted constantly that he could not meet all his deadlines. He told his wife Elisabeth in December 1844, 'I have showed my coloured sketch [*The Spirit of Justice*, entered unsuccessfully in the second cartoon competition to decorate the Houses of Parliament] to Etty and Martin; they were both pleased with it, which is a rare feeling for Etty to express. God bless you. I have no time or humour to write more, but believe me, your husband loves you as the first day. God bless you.'

Madox Brown was not a believer, though Elisabeth was a practising Christian and genuinely devout. He respected her belief and automatically invoked God's blessing (as people do) as a safeguard, almost as a mantra, to protect his ever more delicate wife from the assault that consumption was making on her depleted immune system.

Above all, he confided in her all the details of his day to day artistic projects because he knew she would be interested and would respond constructively. The logbook of his activities helped to shrink the physical space between them. 'My dearest Lizz, I write you from the Studio again.' A Scottish artist called MacIan was excited by Madox Brown's picture *Parisina*, and 'said the price I asked was perfectly preposterous, fifty guineas. He said it was worth six times as much. You will be surprised but not displeased to hear that I have almost begun a picture for the Royal Academy – *The Banks and Braes of Bonny Doune* [illustrating a traditional air by Robert Burns] – one full-length figure the size of life . . . I have made an outline from nature for it. She is barefoot, seated on the bank and with the water at her feet, looking round at the birds at play, which awakens a pang', he told her in February 1845. Was the young artist

longing for a simpler time in his life, unfettered by responsibilities of wife and child? Or did the pang caused by the life model reawaken a vision of Elisabeth, healthy, vigorous and sexually desirable, as she had been in the first days of their courtship and marriage?

Technical details about work in hand were constant nourishment for Elisabeth. 'My blessed Wife', he wrote excitedly on 6 May 1845, 'I have got my fresco-ground prepared at last . . . My sand and lime is all mixed, and I am only waiting for tracing paper to begin my fresco . . . I am getting on, and *so is the time*, – I hardly know which is the faster.' He was confident and confiding enough to tell 'blessed Lizz' about the pretty models who were prepared to take off all their clothes in front of male artists. And they laughed at the reaction of conventional wives who primly declared of life-modelling that it's 'nasty undelicant [*sic*]' and 'a filthy disgusting thing to do'. Elisabeth may have been religious but she wasn't prim. She kept cool when he regaled her with stories of laddish behaviour in the studio.

However, Elisabeth did worry about her husband when she heard how hard he was working, often making do with just five and a half hours in bed. He fell asleep at 11 p.m. and hired someone to wake him promptly at 4.30 in the morning. In his turn, he was uneasy about the way she concealed the true state of her lungs. 'God bless you over and over again. How cruel of you never to say a word about your health!' Whenever he could award himself a peaceful moment, he stole away to write to 'My own dear Lizzy, I am now in peace and quiet by mine own fireside, and have time to say all I wish to you, my dear wife. I must, as you wish, give you all the news, such as it is: but first and foremost make yourself happy and quiet.' If only they weren't apart, he would confess himself never in better spirits. 'Our prospects seem brighter to me than ever', he encouraged her in May 1845. He was filled with new buoyancy, based on months of hard work and intuition about his true artistic potential. He was designing *The Ascension* to enter for an altarpiece competition in Bermondsey, as well as *Adam and Eve* and *The Body of Harold brought before William the Conqueror*, both displayed in Westminster Hall during the Parliament fresco-painting competition. 'It may be a kind of excitement, but I feel sure that in a few years I shall be known, and begin to be valued . . . God bless you, my dear Wife, and bless our child', before signing off with a bit of a swagger, 'Your affectionate hubby'.

After enduring separation in England for most of 1844–5, the prospect of Elisabeth struggling through another English winter made the Madox

Browns decide to try another country that would enable them to live together again. The climate of Rome was said to be more beneficial for Elisabeth's illness than Paris. In addition, the Eternal City would provide artistic inspiration for her husband. They left England in their own carriage on 27 August 1845, in order to reach Rome by the end of September. On their way south, in the art museum at Basle, Madox Brown gazed for the first time at the hyper-realistic pictures of Holbein. It was a defining moment. From then on he saw himself as a modern Holbein and set himself to transcribe directly from the visible world. In the opinion of Ford Madox Ford, his grandfather 'really did initiate modern art. He seems to have been the first man in modern days . . . who began trying to paint what he saw.' During that journey to Rome, Madox Brown also fell under the spell of the early Italian masters, Giotto, Masaccio, Ghirlandaio, Leonardo and Luini. Later he was influenced by the great works of Fra Angelico, Michelangelo and Titian. Their inspiration gave him the impetus to dare. He was never interested in following artistic fashion. He used to say that he found the beaten track barren, as well as beaten. Once in Rome, he met the German Nazarene artists, Overbeck and Cornelius, Continental precursors to the English Pre-Raphaelites, and his eyes were opened to the ways that modern art could make the medieval new again.

He always remembered the joy of artistic creation in Rome with Elisabeth, and the sensitive reciprocity which urged him on to achieve great results. Looking back a year after her death, to a time when Elisabeth had been in the later stages of tuberculosis, her intellectual presence was still alive to him. 'Never can I forget the pleasure with which I could muse over my work in Rome, at a time when visited by the most bitter afflictions & apprehensions for the future, at a time when all other satisfaction was impossible.' After the understandable melancholy connected with the death of her first child, it is possible that Elisabeth had also suffered post-natal depression following the birth of Lucy in 1843. By early 1846 her consumptive illness was already acknowledged to be terminal, and her fragility could have made 'all other satisfaction' – or sexual relations – impossible. Dr Richard Deakins, who attended Elisabeth during her final months in Rome, may have advised the couple to refrain from sex. In spite of the unbearable strain of this final time together, the artist remembered, indeed 'never can I forget' that Elisabeth encouraged him to begin the painting which later became *Chaucer at the Court of Edward III*. Full of praise for the composition, she prophesied 'that it would ensure me ultimate success, regretted that she would never live to see it, and *ordered* me to complete it after her death.'

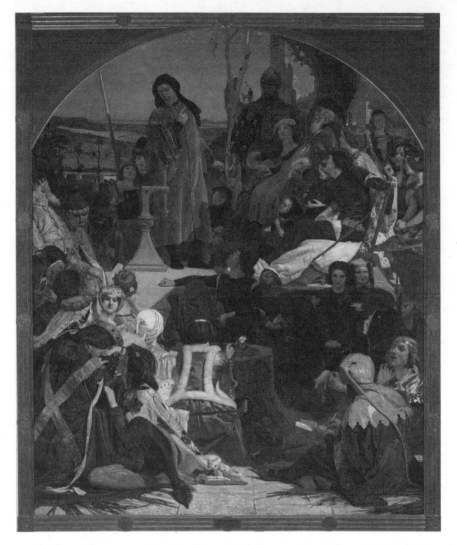

*Geoffrey Chaucer reading the 'Legend of Custance' to Edward III and his
court, at the Palace of Sheen, on the anniversary of the Black Prince's
forty-fifth birthday.*

Elisabeth's belief in this magnificent picture had a curious link forward
to Emma Hill who would eventually become Madox Brown's second
wife. He associated its inception and its subject with Chaucer's poetry
which he and 'blessed Lizz' read together. But it was Emma's profile
beneath a royal crown that featured as the Princess of Wales, so avidly
listening.

CHAPTER 4

ALAS! MY POOR WIFE

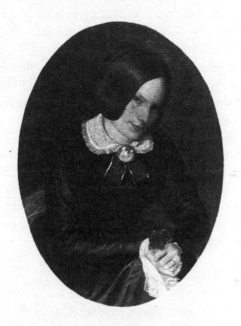

THERE IS ONE LAST SURVIVING IMAGE of Elisabeth. Though tinged with mortality, perhaps it is the most beautiful. It was one of a pair of matching oval portraits that Madox Brown painted on the same canvas, in Rome early in 1846, of his wife and daughter Lucy. Elisabeth's head is tilted, half-questioningly at her husband. The picture is sombre but skilfully lit as he picks out the pallor of her skin, the simple lace collar at her throat, the prominent cameo at its centre. Perhaps Madox Brown bought Elisabeth this unusual brooch in Rome. It shows a mother and child, like a miniature Della Robbia, and signals the importance of motherhood to Elisabeth. The curious monumentality of the brooch at Elisabeth's throat makes a poignant contrast with the wearer's tenuous grasp on life. Elisabeth died before her daughter was three years old, and Lucy always lamented the rupture of the early mothering she had received. 'My Mother['s] loss was often felt by me with bitter tears; tho never could a father have been kinder'.

Elisabeth's hands are clasped in prayer, or in determination, holding a little bunch of violets like a cloud, and the tell-tale handkerchief of the consumptive. In the Victorian 'language of flowers', violets symbolised faithfulness and modesty, two of Elisabeth's most outstanding qualities. In the countryside near Rome, violets bloom and are gathered in February, suggesting a spring date in 1846 for this portrait, just before all hope was lost. On her left hand her wedding ring is clearly visible. There is a gleam in her still-glossy hair and the same gleam is echoed in the soft folds of her dark silk dress. It was the colour of mourning. Elisabeth was still alive but the portrait is already a memorial.

In the end, after less than nine months in Rome, their English physician in the city pronounced her case hopeless. At that time, doctors could only base their diagnosis on symptoms and signs. They listened to the 'whispering pectoriloquy' – or the sound of sheep bleating in a cave – that they were supposed to hear from tubercular cavities in their patients' lungs. In the 1840s, prognosis for consumptives was bleak. Tuberculosis accounted for about twelve per cent of all deaths, and only twenty to twenty-five per cent of diagnosed tubercular patients would survive for five years. By May 1846, Elisabeth had one wish and that was to get home to England to die. Willing herself onwards, she visualised her return to English soil before it was too late.

> My heart for English faces sigh'd,
> For English accents pined in vain:
> Till when I press'd thy strand & cried
> Dear England, thou art mine again!

They made a last desperate journey 'by sea to Marseilles, & by river steamer to Chalons, posting thence to Paris.' In spite of her burning desire, she never reached England alive. Aged just twenty-seven, Elisabeth died on 5 June 1846 in the post-chaise in Madox Brown's arms, as they crossed the boulevard des Italiens in Paris, still pointing onwards, so weak that she had lost any power to speak.

Elisabeth's death was a trauma for Madox Brown. Piercingly aware that it had been her final wish to get home to die, now he honoured that wish by arranging to bring her body back to England for burial. Grief was compounded by the expensive outlay of transporting the coffin across the Channel. In desperation he rushed off with some of the family silver to Mont-de-Piété, the famous Parisian pawnshop, in the rue des Blancs-

Manteaux. He left the chit with Daniel Casey, his old friend from art-school days in Antwerp, now living in Paris, and Casey redeemed it for him at the time of the 1848 Revolution. The plate remained in the Caseys' possession. Nearly ten years later it seemed unlikely that he would ever return to reclaim his property so 'good Madame Casey' sent payment for the plate to Madox Brown's London bank. It came to £15. 10s. 10d.

Madox Brown brought Elisabeth's coffin by sea and land back to London where he lodged temporarily at 30 Clements Lane. Wretchedly, he arranged with the London Cemetery Company for her burial to take place in the afternoon of Thursday 11 June 1846 at the new Highgate Cemetery of St James, Swain's Lane, Highgate, in north London. He bought the rights in perpetuity to a private grave there, numbered 1865, square 43, as well as permission to put up an ornamental headstone 'subject to the approval of the Company'. Burial costs came to £5. 13s. 6d. including an extra six shillings for the grave to be deepened a further three feet, from seven feet to ten feet. Elisabeth's coffin was transported from 25 Arundel Street, off the Strand.

Later Madox Brown designed a Gothic cross for Elisabeth's grave, carved with ears of wheat and grapes to suggest the symbolic bread and wine of her devout Christianity. He had lost the perfect companion of his youth whose poised, reflective face looked out from his earliest pictures.

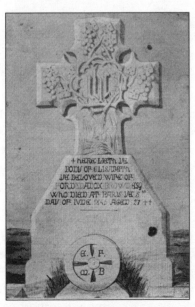

The Gothic cross FMB designed for Elisabeth's
grave in Highgate. The lettering is no longer visible.

Obsessively on the fifth day of every month – as she had died on 5 June 1846 – he visited Elisabeth's tomb to check on its upkeep. His three-year-old daughter was inextricably linked in his mind with his lost wife. They had the same Madonna-shaped faces, although little Lucy's was more mobile, less grave than Elisabeth's. Lucy now lodged with one of Elisabeth's elder brothers, Augustus Bromley, his wife Helen and their small children at Milliker Farm, near Gravesend in Kent. Madox Brown often followed his cemetery appointment by jumping on the packet boat downriver to see his 'beautiful babe'. He drew an exquisite little portrait head of his child.

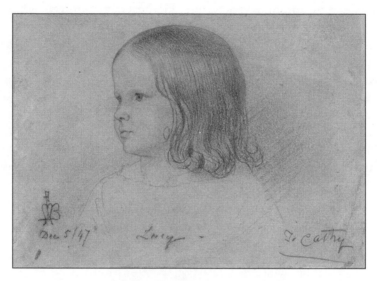

Lucy at four years, four months, 5 December 1847,
later inscribed to Lucy's younger half-sister, Cathy.

'It is today 18 months since the death of my poor dear wife', he computed sadly on 5 December 1847. Then he berated himself. 'These are thoughts that I must banish it unnerves me.' He rescued the fuchsia from Elisabeth's grave to nurture it indoors over the winter months. When standard roses on her grave grew too tall and straggly, he arranged for shorter ones to be planted. On wet days in his rented studio at Clipstone Street he thought of her in the cold ground and remembered the warm home they had once had together on the Continent. Chance enquiries from old acquaintances who hadn't heard of Elisabeth's death, asking for her address, made the physical reality of her whereabouts as cutting as a grave-digger's spade. 'O! dear, her [address] has been for upwards of 19 months the Cemetary [*sic*] of Highgate, mine this rascally

barn of a studio, to think that We once had a home together! in Paris how different & even in Rome how different, bless you my poor child.' He knew he had to take a grip on himself and looked for a solution in work, although he assessed his progress as 'muddled and worked and muddled'. He always castigated himself for not doing enough work.

Finally back in London from the Continent, bereaved and frantic about money, Madox Brown was trying to make an artistic career support both himself and his child Lucy, whose face was a constant reminder of Elisabeth. He continually berated himself as 'a swine, a brute and a beast'. He suffered a range of physical and psychosomatic disorders, toothache, facial swellings, insomnia, and low-grade infections. He was sliding into clinical depression – or melancholia, as he called it.

By September 1847 he had hit on the therapeutic idea of keeping a diary. But this would be a diary with an added purpose, the diary of a working painter. The entries log Madox Brown's life, day to day, sometimes hour by hour. They are irregular, intermittent and unexpected, always an accurate and colourful record of his personality. He headed the first page 'Diary of my Painting 4th September 1847', as he felt sure his paintings would make the diary significant. He would keep notes of his pictures in progress, compositional ideas, studio models, preparatory sketches, and research visits to the British Museum Reading Room. The diary was an outlet for his conflict between the drive to work and the torment of artist's block. He records endless repainting, scratching out, starting over, scraping, spoiling, retouching. His quest for perfection was almost pathological, not enough hours committed, not enough drafting and redrafting. He whipped himself on, compulsively recording the hours and minutes he worked each day: six and a half hours; ten hours; or guilt-inducing 'ooo' hours as he put it. At the end of one section of the diary, he totted up with schoolboy precision a grand total of 2,659 hours making art. However impressive the total, he still considered himself a lazy beast. He laboured such long hours that his eyes couldn't judge the colours on his palette. He had no commercial success and was desperate about money. Low and dejected, he never felt happy – and the studio swarmed with rats.

Nevertheless he did feel moments of elation. These were all connected with his art. Losing himself in a study, a drawing, or a sketch for a painting, he found total absorption and a pleasure 'after mine own heart'. He revelled in the delirium of colour, yellow lake, madder, carmine sienna, verdigris, umber, vermilion. He painted, he erased, he reworked every line of a drapery, every sinew of a limb. In the reading room at the British Museum, he researched the most esoteric details of medieval dress

to work into his latest historical picture, *Wycliffe reading his translation of the Bible to John of Gaunt* of 1847–8, scholarly habits he never abandoned. He went to lectures at the Royal Academy which he scathingly dismissed as 'twaddle'. In his Diary, he expressed his views and artistic ambitions in the characteristic tones of his speaking voice, exclamatory, self-flagellating and opinionated.

Just occasionally the young widower allowed himself a ticket to a play or an opera, although he always felt guilty afterwards about the expense. He saw *King John*, *Twelfth Night* and *Lucia di Lammermoor*. He read Keats, Shelley and Byron, Macaulay's *History of England*, George Henry Lewes' *Life of Goethe*, Tennyson's 'Morte d'Arthur', and *The Newcomes* by Thackeray whom he thought the 'great word artist of now'. But he found Coventry Patmore's popular idealisation of married love, *The Angel in the House*, 'deplorably tame and tiring'. Madox Brown knew about the reality of his own recent marriage, and the way it had ended in the grip of Elisabeth's consuming illness. In Paris and Rome he had discussed making pictures with Elisabeth. Now he had no Elisabeth. He could discuss works in progress with his fellow artists and male friends. But none of them could offer Madox Brown the love and intellectual companionship of his lost wife.

Whenever he could get away from London, and especially at birthdays and Christmases, in memory of Elisabeth, Madox Brown spent time in Kent with their daughter, Lucy, now four years old. At New Year's Eve 1847 he even allowed himself 'music and young ladies'. It was a breakthrough.

II. EMMA

EMMA HILL
16 May 1829–11 October 1890

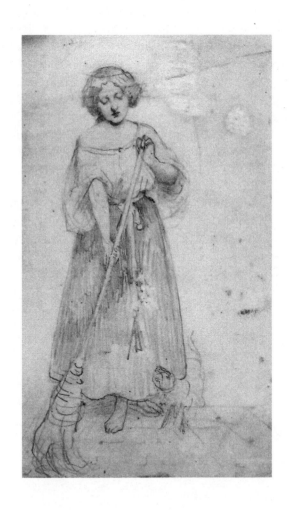

Emma sweeping as Cinderella.

A GIRL AS LOVES ME

MADOX BROWN WAS TWENTY-SEVEN WHEN Emma walked into his pictures and his life. At Christmas 1848 he made the first surviving portrait of his new model. Six weeks later, as he jotted cryptically in his diary, 'a girl as loves me came in and disturbed me'. Was he embarrassed or privately thrilled that this young woman expressed her feelings so directly? Emma may have been unusually outspoken in the studio but other things she preferred unsaid. She was less candid about her family background, although her grandson, Ford Madox Ford, believed she was the daughter of a Herefordshire farmer who became impoverished during the years leading up to the repeal of the Corn Laws in 1846. As early as 1841 the family had left the land to seek a better living in London, where they rented rooms in Essex Street, in the parish of St Pancras. In the 1841 census Emma's father, Thomas Hill, now a bricklayer, was aged sixty, her mother Catherine was forty-nine and Emma Matilda Hill was twelve.

Emma was still in her teens − her grandson says only fifteen − when she first came to pose for the artist. If she told Madox Brown that she was fifteen at Christmas 1848 that date would suggest she told him she was born in 1833. When she died in 1890, her death certificate and her gravestone gave her age as fifty-five, perpetuating the myth of Emma's eternal youth and pushing her birth year even further forward, to 1835. But if her age of twelve in the 1841 census is correct, she was born in 1829. Her exact birthday was 16 May, as Madox Brown's future son-in-law, William Michael Rossetti, once noted in his diary. So she was probably about nineteen, not fifteen, when she modelled for Madox Brown for the first time.

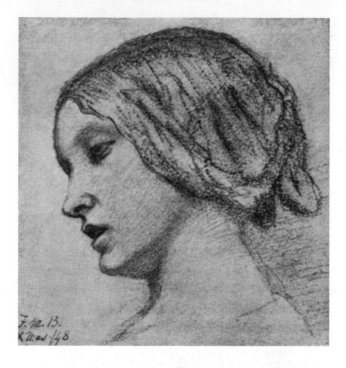

FMB's earliest surviving image of Emma Hill, inscribed
'F.M.B.Xmas/48'.

Madox Brown's earliest sketch of Emma is a suggestive study and
conveys a double message about the sitter. Her lips are parted as if she's
about to speak, perhaps to say she loves him, and yet her head droops like
a snowdrop. She seems both assertive and vulnerable, active and passive at
the same time. The intimacy of the sketch with its caressing black chalks
may even hint that he made it when Emma's head was lying on a pillow.
He later used this expression as the basis for Cordelia, who is both tender
and strong, in *Cordelia at the bedside of Lear*, 1849–54, now in Tate Britain
(see Plates). Emma's unspoilt beauty personified his ideal of female
integrity. The face of the girl who had once lived on a farm could convey
the innate nobility of Shakespeare's ancient British princess.

Emma's mother, Catherine Hill, now a widow in relatively humble
circumstances, opposed her daughter's liaison with Madox Brown, for
reasons unstated. Perhaps she felt a personal antipathy towards her
daughter's suitor, or distrusted the intentions of artists, or felt awkwardly
conscious of their class differences. Ironically, she would be a financial
burden and a regular irritant in their relationship until her death many
years later on 7 March 1877, at the age of eighty-four. But Emma ran to

her in times of stress and loved her enough to name her first child Catherine when she was born in 1850, outside marriage.

Emma was the total opposite of Elisabeth Bromley. Emma was working class not middle class; uneducated rather than cultured; refreshingly robust instead of delicate; blonde instead of sleekly dark. William Michael Rossetti, her future stepson-in-law, who was the same age as Emma, recognised the feminine allure in her 'pink complexion, regular features, and fine abundance of beautiful yellow hair, the tint of harvest corn.'

With a new woman in his life, Madox Brown no longer visited Elisabeth's grave quite so regularly, but he did not forget her. She had lain there for over two years. Death was a natural component of Victorian lives but with Emma trudging beside him up to the plot in Highgate Cemetery, Elisabeth's impact gradually receded. He turned back to life. His painting became more ambitious and confident. For his part, he allayed Emma's sense of social ambiguity – 'without educational advantages' – by asking her to model for the most patrician, romantic and glamorous women in his pictures.

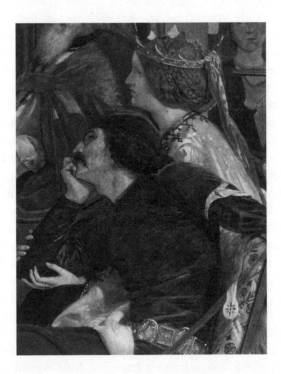

Detail from *Chaucer at the court of Edward III*, showing Emma as Joan, the Fair Maid of Kent, consort to the Black Prince.

One of Emma's first transformations into art occurred when Madox
Brown asked her to model as the coroneted Princess of Wales, in the
imposing arch-shaped composition of *Chaucer at the court of Edward III*.
This Princess of Wales had been popularly known as Joan the 'Fair Maid
of Kent', or more sarcastically as the 'Virgin of Kent', because she had
been married twice and had five children before her wedding to the Black
Prince. In spite of her history, Joan's love affair with the prince was for
life. The portrait of Emma's head for the Fair Maid, with its looped,
braided hair and streaming red headdress, was completed remarkably
swiftly for this most painstaking and conscientious of artists, in just two
two-hour sittings. Madox Brown liked this profile view of Emma. It was
how he had seen her in his first portrait sketch. Now Emma was translated
from her obscure beginnings to the aristocracy, not through birth or
status, but through the art of the man who loved her. She was able to
inhabit the role instinctively. Her freshness and naturalness made her
different from his usual, paid, professional models.

However, an early temperamental disparity between artist and model,
not simply attributable to their different social backgrounds, was soon
apparent. Although Madox Brown berated himself for not putting in
longer hours at his easel, when once he got down to work, his
concentration was absolute. On the other hand, Emma's concentration
was fleeting and skittish. Persuading her to model for him often led to
trials of strength and became a bartering tool that Emma used to get her
own way. So the dynamics between model and artist were based on
sparring and manoeuvring, rooted in the archetypal scenario of the battle
of the sexes. It was the opposite of his first marriage to Elisabeth Bromley
which had been built on an unusual bond of sympathy, almost a modern
sense of intellectual parity.

Madox Brown continued to woo Emma with a strategy of social
compliment throughout her life, as she posed successively for Cordelia,
Juliet and Mary Chaworth, Lord Byron's first love. With its perfect
regularity and breathing sexuality, Emma's face conveyed an almost
universal appeal. She could morph into a princess but also embody
Everywoman. From now on she would be his finest and most symbolic
model.

Choosing Emma was a quiet exclusion of all that Elisabeth had
represented. In his desire for Emma, Madox Brown deliberately rejected
chronic illness and delicacy, either of physique or of sensibility. On their
rambles in the fields around north London during 1849, he embraced
vigour and Emma with scant regard for Victorian convention. Emma's
frank desire restored the young widower to life, to a physical life of the

senses. Emma was liberating, she was instinctive, and she was fun. At the
end of the summer they ran off to spend a week together at the seaside
resort of Ramsgate, from where he could almost see France, the land of
his birth. The jaunt was spontaneous and illicit, the total reverse of his
constrained, bourgeois marriage to serious-minded Elisabeth. In extreme
youth, he had conformed and complied; now, in his late twenties, with
Lucy, his daughter by Elisabeth, to support, he was ready to fulfil the role
of the bohemian artist. Perhaps he slipped into this new persona by
association with the charismatic, bohemian figure of Dante Gabriel
Rossetti who had approached him out of the blue in March 1848 to ask
for art lessons.

Suspicious that he might be the object of a student prank, Madox
Brown, armed with a 'stout stick', knocked at Rossetti's door. But
Rossetti assured him he was entirely genuine. Madox Brown was so
charmed that he accepted Rossetti as his student, waiving any fees, and
made Rossetti 'his friend on the spot – a friend for that day . . . and a friend
for life.' This marked the beginning of Madox Brown's association with
the Rossetti family, and with the Pre-Raphaelites.

Madox Brown's huge picture, *Wycliffe reading his translation of the Bible
to John of Gaunt*, anticipated one key aspect of Pre-Raphaelite art. It was
a contemporary take on medievalism, it made the medieval modern. The
picture was shown at the Free Exhibition in London in 1848, the same
year that three young artists, John Everett Millais, Holman Hunt and
Dante Gabriel Rossetti, discovered they shared a passion for early Italian
artists, such as Giotto. Inspired by the freshness and special transparency in
pictures before Raphael, they were the original three Pre-Raphaelite
Brothers, soon expanded to seven. His new friendship with Rossetti
projected Madox Brown into this circle of iconoclastic young artists who
founded a revolutionary new art movement, known intriguingly as the
Pre-Raphaelite Brotherhood.

Unlike other art movements that evolve almost by osmosis, and are
often named only later and by outsiders, in autumn 1848 the Pre-
Raphaelite Brotherhood convened itself and chose its own name.
Holman Hunt recalled that while studying at the Royal Academy
Schools, he and Millais were criticising Raphael's *Transfiguration* when
another student interrupted: 'Then you are Pre-Raphaelites.' Millais and
Hunt 'laughingly agreed that the designation must be accepted'. 'Pre-
Raphael' was not a term of abuse but a reference to the decadence into
which they, and Ruskin, considered art to have sunk since Raphael's
time. 'Brotherhood' was chosen by Dante Gabriel Rossetti for its exotic
connections with Italian revolutionaries or brigands. Its secretive,

exclusive nature was deepened by the adoption of the initials 'PRB' signed on their paintings, a calculated provocation to those who tried to crack the code.

It was a protest movement. They were in protest against conventional Victorian art, epitomised by the Royal Academy establishment and artists like Sir Charles Eastlake, who became RA president in 1850. His figures emerged from dark, murky backdrops. The Pre-Raphaelites loathed the sombre tones of such painting, which they famously derided as 'slosh', with Sir 'Sloshua' Reynolds as their chief hate-figure. They wanted to open the eyes of their audience on to a pristine day with a precise and heightened attention to detail. Pre-Raphaelite foregrounds were to be rendered with a brilliant clarity, so that the wet woodland enfolding Millais' drowned Ophelia would 'dazzle the spectator stamen by stamen'.

They achieved this by a painstakingly slow technique invented and perfected by Hunt and Millais. Painting a tiny section at a time, on a wet white ground, they sought to imitate the luminosity of Italian Primitives. 'What they saw, that they would paint – all of it, and all fully.' Their aim was 'truth' through 'exactitude of study from nature'. Rejecting the sentimentality of much Victorian art at the time, the Pre-Raphaelites painted real people with dirty toenails. In style and technique their movement marked a return to the early Italian Renaissance but their subject matter was radical and innovative. Contemporary issues such as fallen women, adultery and illegitimacy were treated with their neo-medieval techniques and the results shocked the art establishment and complacent gallery-goers.

Although Madox Brown championed radical ideas in art and politics, his dread of cliques, which in his view, had 'no proper function in modern art' meant that he never formally joined the Brotherhood. Dante Gabriel Rossetti was in favour of electing Madox Brown to its closed circle but Holman Hunt vetoed the idea. However, he contributed to the *Germ*, the avant-garde arts magazine and showcase for the Pre-Raphaelite Brotherhood's new ideas, which survived for just four issues in 1850. Apart from an etching, *Cordelia parting from her sisters*, based on his earlier *Lear* drawings, Madox Brown supplied a theoretical essay, 'On the Mechanism of a Historical Picture', and a sonnet, 'The Love of Beauty', about the 'passion-worn' author of *The Decameron*, Giovanni Boccaccio. Only artists who had known love and seen 'the face of girlhood in/Line-blending twilight, with sick hope' could truly understand the Italian poet, he wrote.

Madox Brown remained an unofficial Pre-Raphaelite, enjoying an isolated position that suited his sense of personal geography. Seven years

older than most of the Pre-Raphaelites, he felt 'rather old to play the fool'. A maverick, outside the group, he was, nevertheless, often referred to as 'Father of the Pre-Raphaelites' – or even, 'King of the Pre-Raphaelites', long after the 'whole Round Table' of the PRB had been dissolved. In Rossetti's view, its end was marked five years later, by Millais' acceptance of his election to the Royal Academy in November 1853.

FMB as King of the Pre-Raphaelites, caricature by John Hipkins.

Of the original Pre-Raphaelites, Madox Brown was the only one who had actually seen art in Italy pre-dating Raphael, and met the German Nazarene artists, whose linear, neo-medieval art prefigured the English Pre-Raphaelites. His connection with Rossetti and the Pre-Raphaelites, their devotion to labour-intensive pictures, made on new principles of eye-watering attention to natural detail, coupled with modern significance, spurred some of Madox Brown's most memorable pictures.

Did Madox Brown intend to marry Emma at this time soon after he met her, or did he simply want to use her as a 'stunner' to model in pictures

fired by his new association with the Pre-Raphaelites? His feelings about women had been conditioned by his love and admiration for his mother, Caroline, his sister Lyly, and his wife Elisabeth. But he also dealt with women in the studio who were prepared to model in the nude by day and were probably prostitutes by night. Did he feel any confusion about which 'type' of womanhood fitted Emma best? And did Emma wonder or even care at this stage whether he would legitimise their love affair?

It is problematical to reconstruct Emma's inner feelings. As the artist's model she was continually seen from the outside, the object of male scrutiny. She left no diaries, very few letters. Emma's character is skewed for us through references Madox Brown made to her in his own diaries and letters, and through the lens of his startling and indelible images. Even when we look at her appealing, fresh face staring out from Madox Brown's most famous canvases, it is a face composed in the role of a princess, or a legendary lover, a mid-nineteenth-century social type or a modern Madonna. It is not the real Emma.

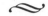

EMMA IN THE
FOREGROUND

I F ELISABETH HAD REPRESENTED THE LIFE of the mind, the life of
sensibility, Emma opened Madox Brown's eyes to the life of the
body. So having launched into a love affair, he decided to live on and
off with Emma, unwed, in relative obscurity in what was then almost the
countryside of north-west London. He spent most of his working hours
at a studio in Clipstone Street. Artist friends accepted these domestic
arrangements between 1849 and 1853, and Emma had little social status to
lose or compromise. On the other hand, she was confident enough to
hold her own with them, and with her lover. When necessary, she had
the spirit 'to bring him to his knees'. She was not intimidated by the new,
bohemian, intellectual world she was entering.

In the early years of his attachment to Emma, Madox Brown suffered
severe mood swings and angst which he attributed to his lack of
recognition in the art world. But his depression may have been, in part,
connected with Emma. Sexual relations at first were happy and, like
making some of his pictures, conducted *en plein air*. Emma had freshness
and generosity. She asked few questions, at least in the beginning. In the
countryside where she claimed to have her roots, and in the working class
that she came from, it was not unusual for courting couples to anticipate
the wedding ceremony. In fact, it was almost a requirement. Bed before
wed – check whether the bride is fertile before taking her to church.
Emma seemed to have little problem with that scenario. But Madox
Brown was brought up in an altogether more aspiring, bourgeois, if not
very affluent family. During his courtship and first marriage to Elisabeth

Bromley he had been a very young man, not quite twenty years old. Then he had played by the book – the Victorian book of sexual behaviour and social etiquette. The influence of Elisabeth, dead just over two years before the advent of Emma, was still potent in his mind. Elisabeth's code of behaviour had been rigorous, her religion a powerful force in both their lives. Although Madox Brown was to abandon conventional Christianity in his more mature years, he still went to church and took his child Lucy to church during the 1850s. Did the thought of loving Emma out of wedlock prey on his mind, upset his fractious equilibrium? If so, why did he not marry her straightaway?

He had not married her even when she conceived their first child in February 1850, shortly after their 'elopement' in September 1849 which their grandson later euphemised as a 'honeymoon'. Emma had been six weeks' pregnant with her first child, Catherine, in March 1850 when Madox Brown's diary entries abruptly ceased. Within his twenty-year span of diary writing from 1847–67, there is this black hole, a gap of four years. Because of this we have lost his commentary on his early years with Emma, his near breakdown, and the Hampstead years when he made some of his greatest paintings. He was in hiding even from himself and did not resume his private journal until 16 August 1854.

He delayed any decision to marry, was ill and fretful, and pursued by money worries. With his personal history of female losses, especially the all too recent death of Elisabeth, perhaps he was reluctant to marry again. But was there another reason that prevented an early resolution between the lovers? Did class-consciousness unsettle Madox Brown – murmuring she's not your type, not your class? Could an uneducated girl be a fitting wife for an ambitious man? Could he be proud of her in public, as he had been proud of Elisabeth? In spite of Emma's obvious physical attractions which he relished as a man and an artist, he was reluctant to parade her social origins. People would notice the clear differences between Emma and Elisabeth. On the other hand, perhaps he was genuinely fearful that Emma might wreck his life, or at least could disgrace him in public. It is possible that she already had a drink problem at this early stage in their relationship. As it progressed into the mid-1850s, he gradually began to admit the scale of the problem to himself, both in his coded diary entries and in his decision never to let Lucy live with them *en famille* until she became an adult. Instead, she was a boarder at aunt Helen Bromley's school in Gravesend and only visited her new family during the school holidays.

By 1851, the lovers had moved to a rented cottage at Stockwell, just south of the Thames in the parish of Lambeth. They now had a baby

daughter, Catherine Madox Brown, born a few months earlier on 11
November 1850. Her father was under increasing pressure. Not only was
he conducting an irregular relationship with Emma but his work was
demanding and unremitting, and his income uncertain. Nevertheless, his
intimacy with Emma inspired him to take artistic risks. He decided to
make her the central figure in a crystalline picture with a deliberately
teasing title, *The Pretty Baa-Lambs*, which he began in 1851 (see Plates).
Although it seemed to allude to a sentimental nursery-rhyme vision of
idyllic childhood, beloved by the Victorian middle class, neither the title
nor the picture fitted expectations. Instead it showed a modern young
mother with a baby, disconcertingly dressed in eighteenth-century
costume. It refused to tell any conventional narrative. The mischievous
title mocked the art establishment. He chose the playful reference to
nursery rhyme in order to prick the bubble of pomposity in the art world.

During that summer of shimmering warmth in 1851, Madox Brown
was laid up with sunstroke, twice, while Emma's fair skin burnt for art's
sake. No wonder he initially thought of the picture as 'Summer Heat'. His
'painting room being on a level with the garden, Emma sat for the lady &
Kate for the child.' Because of his insistence on high realism, 'the Lambs
& sheep used to be brought every morning from Clappam [*sic*] common
in a truck.' And he noted a detail which would have delighted little Cathy:
'One of them eat up all the flowers one morning in the garden where they
used to behave very ill'. He completed the picture 'in five months of Hard
Labour during which time I was very hard up', mainly because an Irish
patron, Francis McCracken, had failed to pay up the fifty guineas agreed
for Madox Brown's neo-medieval picture, *Wycliffe reading his translation of
the Bible to John of Gaunt*.

In his exhibition catalogue entry written later in 1865 about *The Pretty
Baa-Lambs*, Madox Brown said the picture had been misread when it was
first exhibited back in 1852. At that time 'discussion was very rife on
certain ideas and principles in art, very much in harmony with my own,
but more sedulously promulgated by friends of mine. Hung in a false light,
and viewed through the medium of extraneous ideas, the painting was, I
think, much misunderstood. I was told that it was impossible to make out
what *meaning* I had in the picture.'

In fact, Madox Brown explicitly rejected the notion that he had
intended the picture to have any symbolic, moral or even literal *meaning*.
Instead, the commanding figure of Emma propping up baby Cathy,
presented the viewer with a provocative image, a witty combustion of
high realism and extreme artificiality. On the one hand, it was the first of
his pictures made according to his new friends' Pre-Raphaelite principles

of realism, painted 'almost entirely in sunlight', from life, *en plein air*. To achieve its special brilliancy, Madox Brown exploited the radical Pre-Raphaelite technique of painting on a wet white ground – he used Robertson's undrying copal, Flake White – divulged to him by Millais. On the other hand, *The Pretty Baa-Lambs* showed an apparently modern mother in fancy dress, exhibiting the extreme affectedness of wearing eighteenth-century dress in the nineteenth. It seemed to be a contemporary take on old religious pictures of the Virgin and Child, and yet it implicitly recalled Marie-Antoinette playing at shepherdesses at Le Petit Trianon. It was a topsy-turvy world. This modern virgin was no virgin but a young woman who dared to 'live in sin' with the father of her child. Even the child was not a Christ-child male but a mid-century girl-child. Madox Brown had subversively displaced the traditional Virgin and Child from their usual thrones.

If *meaning* is irrelevant, as Madox Brown explained, the painting can be seen as a modern experiment. The interrelationship of shapes and colours almost approaches an abstract, although the picture's inception was from the real. Madox Brown naturalistically depicted every droplet of sweat on the sunburnt faces of his modern Madonna and Child as he forced them to pose during the long, hot summer of 1851. 'This picture was painted out in the sunlight,' he explained, 'the only intention being to render that effect as well as my powers in a first attempt of this kind would allow.' Meticulously he described the matted curls of wool on the sheep, the scumbled grass, the individual gravel stones, and the infinite gradations of a high English summer sky. The picture's dazzling summer colours were an affront to Victorian eyes, used to dark muddied tones, or at least to a symphonic harmony of tones within a composition. In spite of, or perhaps because of the artist's truthful rendering of the hot sweaty colour in Emma's cheeks, the quilting and lace on her elaborate gown, and the glistening forearms of the maidservant, the picture's bold greens, blues and pinks assaulted the viewer with a neon, almost a pop-art shock and immediacy.

Innovatory and challenging, *Baa-Lambs* was a landmark not only in English but also in European painting. Madox Brown was the first artist to paint figures in a landscape, totally *en plein air*. In doing this, he was not only ahead of, or contemporary with, some members of the Barbizon school in France, but he also anticipated Monet who brought his ladies out into the garden at Ville d'Avray in 1869. 'Few people I trust', wrote Madox Brown, 'will seek for any meaning beyond the obvious one, that is – a lady, a baby, two lambs, a servant maid, and some grass.' He was exploding the idea of a literal narrative that art lovers could read into mid-

century pictures. 'In all cases pictures must be judged first as pictures – a deep philosophical intention will not make a faire [*sic*] picture, such being rather given in excess of the bargain; and though all epic works of art have this excess, yet I should be much inclined to doubt the genuineness of that artist's ideas, who never painted from love of the mere look of things, whose mind was always on the stretch for a moral.' Story or moral need no longer drive a picture. Madox Brown was ahead of his times, pointing the way forward to suggestive and non-narrative pictures such as Millais' *Autumn Leaves* of 1855–6, and later to the aesthetic movement and 'art for art's sake only' epitomised by Whistler. And the form of Emma, transcending narrative *meaning*, dominated Madox Brown's new conception. But he would use her face in quite another way when he cast her as Everywoman in *The Last of England*.

In July 1852 the sculptor Thomas Woolner (one of the seven Pre-Raphaelite Brothers), with two friends and many other hopefuls of all classes, set sail from Gravesend on board the *Windsor* bound for Port Phillip in Victoria, 'well equipped for digging' in the exciting Australian gold rush. Transportation of British convicts to Australia had officially ended in 1840 but a few convict ships continued to dock until 1868. The discovery of gold in 1851 changed the popular conception of Australia from a place of social sewage to a land of untold opportunity. Woolner was cheered on from the quayside by his fellow artists Madox Brown, Rossetti and Holman Hunt. Emigration was in the air and in the press. Carlyle had encouraged it in his *Latter-Day Pamphlets* the previous year. Woolner's departure crystallised a brilliant idea in Madox Brown's mind. He would dramatise the emigration theme in a picture – and call it *The Last of England* (see Plates).

The idea for the picture came to Madox Brown when he was deep in depression, so short of money or any recognition in the art world that he was seriously considering desperate measures – emigration to India. His state of mind had deteriorated so alarmingly, that on medical advice he and Emma settled on a planned disengagement. After the lease of their Stockwell cottage expired in summer 1852, Emma lodged at Hardiman's Farm off Parson Street in Hendon. Madox Brown stayed overnight in his London studio at Newman Street, visiting Emma and Cathy at the farm. Emma and Cathy were then banished to Dover, while he went alone to Mrs Coates' lodgings at 33 High Street, Hampstead, where he 'remained one year & nine months most of the time intensely miserable very hard up & a little mad.' But he was not so mad that he couldn't conceive one

of his most iconic paintings, an anatomy of English life at the midpoint of the nineteenth century. Emma returned from Dover to live just over Hampstead Heath, in Highgate. From here she could come to model for Madox Brown's first studies for the emblematic wife in *The Last of England*.

The full-face study of Emma in her bonnet shows a very composed young woman. Beneath the rather undefined eyebrows, the lightness of her eyes is startling. Maybe Emma outlined her upper and lower lids with a kohl crayon and enhanced her very distinct eyelashes. Her clear-eyed gaze transferred into the finished painting. In the portrait study her upper lips are open showing her front teeth, just as they were in Madox Brown's first sketch of her at Christmas 1848, although in the finished painting her lips would be determined and shut. Here her bonnet ribbons are neatly tied, her hair swept back in two tidy sections framing her face. Madox Brown was intent on achieving a portrait as exactly like Emma as possible and his intense soft study in black chalks seems to have a breathing accuracy.

Coventry Patmore, poet of 'The Angel in the House', saw angelic intimations in Emma's face. He found it 'the chief charm' of *The Last of England*. When Madox Brown began his first studies for the emigrating

Study of Emma, December 1852, as the emigrating wife for
The Last of England.

wife in December 1852, Emma was still Miss Hill, although their daughter Cathy was already two years old. It's a paradox that outside the frame of the painting of a married couple is the turbulence of an unresolved relationship. 'At the beginning of /53 I worked for about 6 weeks at the picture of "Last of England"'. Omitting any direct reference to a spring wedding, on 5 April 1853, he laconically remarked to his diary that 'about this time I lost many days through interruptions of a domestic nature.'

In complete contrast with her sunburnt role in *The Pretty Baa-Lambs*, now Emma had to pose on the most inhuman, sunless days for this entirely wintry picture. Madox Brown worked intensely during the early weeks of 1853 while Emma froze 'chiefly out of doors when the snow was lieing [*sic*] on the ground.' 'To insure the peculiar look of *light all round*, which objects have on a dull day at sea, it was painted for the most part in the open air on dull days, and when the flesh was being painted, on cold days.' He was 'the first painter in England, if not in the world,' said his biographer Ford Madox Ford, 'to attempt to render light exactly as it appeared to him'.

Madox Brown would take the theme further than an examination of a single life-changing moment in the story of a young couple. It was not just a tragedy from modern everyday life. 'This picture is in the strictest sense historical,' wrote Madox Brown in his later catalogue entry of 1865. 'It treats of the great emigration movement which attained its culminating point in 1852. The educated are bound to their country by quite other ties than the illiterate man, whose chief consideration is food and physical comfort. I have, therefore, in order to present the parting scene in its fullest tragic development, singled out a couple from the middle classes, high enough, through education and refinement, to appreciate all they are now giving up, and yet depressed enough in means, to have put up with the discomforts and humiliations incident to a vessel "all one class".' He indicated their refinement by the sensitive individuality in their faces, in contrast with the caricatures of riotous 'illiterate' men in the background.

Emma was the perfect choice for the emigrating wife – and she would have appreciated her elevation to the bookish middle classes. Probably 'working from self in the looking glass', Madox Brown copied his own face for the husband who 'broods bitterly over blighted hopes and severance from all he has been striving for. The young wife's grief is of a less cantankerous sort . . . The circle of her love moves with her.' The circle of that love is personal as well as universal for the infant hand clasped beneath Emma's shawl belongs to their second child, Oliver.

The circle is also literal and suggestive, the porthole of a ship, the shape of Michelangelo's *Doni Tondo*, which Madox Brown may have seen when

he visited Florence in September 1845 on his way south to Rome with Elisabeth. The near-circular form of *The Last of England* intensifies its charge and concentration. Within it, the two equal partners of the couple dominate the composition, but other passengers press against the circle, both contained by it and threatening to burst out of it. The circularity of the whole picture is subtly reinforced by the cunning triple framing device of Emma's bonnet. Within the bonnet, the roundness of her head is emphasised by the halo of her familiar plaited coil of hair, and between her head and the bonnet, pink ribbons double-frame her head. Like half-rhyme in poetry, or variations on a musical theme, other more angular shapes reiterate the circular structure – the octagonal contours of the umbrella which the husband protectively curves round his wife are repeated in the deck ropes round the ship's stern. Smaller near-spheres or discs are present throughout the picture; Emma's adult face, Cathy's childish one, accentuated by the apple stuffed to her open mouth like a dummy, even the round buttons on Madox Brown's greatcoat that reflect a momentary gleam of grey from sea and sky.

Another circle is indicated by the play of hands. Madox Brown had semaphored a family circle with an elaborate play of hands before, in his *Portrait of the Bromley Family* in 1844. In the earlier picture the con-figuration of hands had a slightly archaic, mannered artificiality about it. In *The Last of England* the hands are natural and realistic. They movingly endorse the reciprocity between the two protagonists, between man and wife, and hint at the love that encircles their children. Madox Brown's artist's hand 'blue with the cold' in the prominent centre foreground is drawn with acute sensitivity, every detail of chapped knuckle, nail and pinched skin clinically observed. Emma's smaller black-gloved hand grips her husband's, just puckering the skin where her thumb holds him tight. In the adult embrace of hands is their whole love story, as well as the benumbing fear of leaving their native land. Equally strong, equally tender, and, as Madox Brown recorded in his diary, painted on exactly the same day, 2 September 1855, is the ungloved hand of his wife, holding the hand of her otherwise invisible infant son, sheltered beneath Emma's grey tweed 'shepherd plaid' shawl.

Parity between the two protagonists is signalled at the centre of the porthole composition where his greatcoated arm leans into her more fluid soft grey form, and her wild, rose-madder bonnet ribbons flutter across his chest, connecting husband and wife. Their eyes are held on the same horizontal line – although their gazes are directed obliquely away from each other, across the horizon of their lost world. The emigrant wife is taking a part in her own life story and providing a source of strength for

her man. Emma is not just a passive pawn or a flattened symbol. She is a real young woman, whose strands of hair escape across her forehead, suggestive of the anxiety that lies behind it.

Madox Brown's concentration on details like the escaping strands of hair was remorseless. The flying ribbons of Emma's bonnet alone took him four weeks to paint. By insisting on painting out of doors he examined every detail of expression, eyes, skin, textiles and elements, with absolute clarity. His first principles of truth to nature and reality in every detail were entirely Pre-Raphaelite. 'Absolutely without regard to the art of any period or country, I have tried to render this scene as it would appear. The minuteness of detail which would be visible under such conditions of broad day-light, I have thought necessary to imitate, as bringing the pathos of the subject more home to the beholder.' Detail by detail, like the skin of an onion, Madox Brown peeled back the truth about the social and economic state of mid-Victorian England. His rigorous examination of reality ensured pathos without sentimentality. But he achieved more than a topical exposé of his own time and place. The picture merged social history at the mid-century with personal and universal narratives, even perhaps remaking the archetypal Christian myth of the flight of Mary and Joseph. The artist encapsulated universal themes of tragedy and endurance, as his grandson, Ford Madox Ford, pointed out: '*The Last of England*, as far as its rendering of the dramatic motive that the painter desired to express is concerned, is surely unsurpassable. It pays its tribute to the stern force of irresistible, slow-brooding Destiny quite as unmistakably as any of the great tragedies have done. It is as remorseless in its own way as either *Lear* or the *Bacchæ* of Euripides.'

On final completion of the picture in September 1855, Madox Brown sold it immediately to dealer David White for £150. 'Old' White assured the artist that in future he would 'command the highest prices in the art market'. 'Amen' to that, said Madox Brown. For by now he was a married man again.

Emma and Madox Brown's courtship had been bohemian and unconventional by Victorian standards, although almost common custom today. By 1852, when he began painting *The Last of England*, they had been living together for three years. On 18 April 1852, he and Emma took their first child, Catherine Emily Brown, to be baptised at Old St Pancras Church. She may not have been legitimate but at least she was official – an interesting decision for parents who had so far bucked social conventions and appeared to care little for religion.

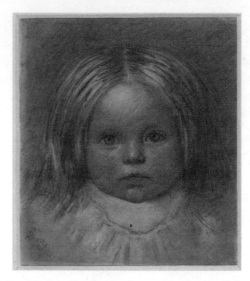

Catherine Madox Brown aged 20 months, 14 July 1852.

Perhaps because Madox Brown looked so young and had first become a father at twenty-one, he never forgot how it felt to be a child. His many sensitive portraits of babies and children made throughout his life testify to his special bond with the young.

Emma at twenty-four was still beguiling – 'the most beautiful duck in existence'. A versatile and natural model, she would, almost always, be available to pose for pictures. As he habitually needed months or even years to paint a picture, his demands on Emma's time and patience were insistent and time-consuming. He would not compromise and make easy, commercial pictures and had no major patron at this stage. During the early years of his relationship with Emma, he constantly worried about money. But the first thing he did whenever he sold a picture was to buy her a dress, a parasol, new shoes or some rings.

Legitimising Catherine's birth may have been one factor in her parents' eventual decision to go to the altar a year later. But why did they apparently sneak off outside their own parish in Kentish Town, to marry at St Dunstan-in-the-West on London's busy Fleet Street? Did Madox Brown know the rector? Was it more difficult to get a local church wedding if you were a widower, living 'in sin' with the mother of your illegitimate child? And why now, when Cathy was already a spirited child of two and a half, did it become necessary to formalise his relationship with Emma?

In the months leading up to her wedding in spring 1853, Emma lodged in North Hill, Highgate, where she may have attended an academy to

Miss Goody Two Shoes: Valentine for his first grand-daughter
Olivia Rossetti, showing FMB's perpetual sympathy with the young.

bring her up to marriageable standard. Nearly four years had passed since
she and Madox Brown had become lovers in 1849, and before any
decision was made to marry. There seems to have been no precipitating
event for this delayed wedding. Emma was not pregnant. But Madox
Brown's year in Hampstead had proved so excitingly productive and this,
together with his appointment as head of the North London School of
Drawing in 1852 (although in the event he never saw any salary) raised his
sense of optimism – and solvency.

For his second wedding, twelve years almost to the day after his first,
Madox Brown chose a modern, metropolitan setting. It was in total
contrast with his first traditional, country wedding in Meopham Parish
Church in Kent. The once medieval church of St Dunstan-in-the-West
(rebuilt 1830–3 by John Shaw Snr, completed by his son John Jnr) is on
Fleet Street at the western entrance to the City of London. Because of
choking traffic, a Victorian road-widening scheme pulled the new church
back to the north of its original medieval structure. Madox Brown may

have taken temporary lodgings nearby to qualify for marriage at St Dunstan's, as he gave his parish or residence as 'Fleet Street' in the church register. Emma gave her place of residence as Highgate. But in fact the lovers were probably living together in Hendon. Perhaps they felt it necessary or more genteel to conceal their cohabitation for the benefit of the rector.

Did they also conceal the existence of their daughter Cathy? It would have been surprising if she had attended her parents' wedding, a quiet Tuesday morning affair on 5 April 1853, a week after Easter. Madox Brown was eleven days short of his thirty-second birthday; Emma would be twenty-four in May. Her husband-to-be was a widower so Emma did not wear a romantic confection of a white dress, still relatively unusual, but instead her sober best outfit.

Two years before Emma officially became Mrs Brown, Dante Gabriel Rossetti had asked her to model for one of his *Studies for Delia*. These studies formed the basis for his eventual watercolour, *The Return of Tibullus to Delia*, based on the Roman poet's love for flighty Delia. Rossetti made at least five other studies for the same subject using his

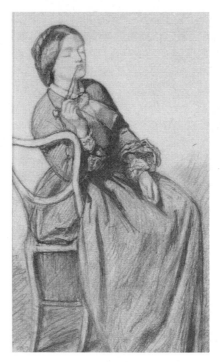

Dante Gabriel Rossetti's *Study for Delia*, probably modelled by
Emma Madox Brown, November 1851.

girlfriend Lizzie Siddal as the model. The study of Emma is different: moody, but more prosaic than the sulky, sexier Delias based on Lizzie, who was Rossetti's on-off obsession throughout the 1850s. Emma's hair is braided as it would be in Madox Brown's wedding-morning sketch and there is a similar flat-tied bow at her throat. If a mid-Victorian bride married simply in her best dress, rather than in the worn-once extravaganzas of today, it is possible that we are looking at Emma's wedding gown. She is in an interior, seated sideways on a chair, eyes closed as she gnaws on a necklace dangling a heart-shaped locket, role playing classical Delia who, like Penelope, though perhaps not as chaste, awaited the return of her hero. Here Emma looks disengaged, playing the part rather than inhabiting it as Lizzie could in the eyes of Rossetti her lover.

Two drawings by Madox Brown survive of Emma on her wedding day. Strangely, they are very different. The first is initialled 'FMB' and inscribed '5 April 53'. It shows Emma youthfully coiffed with her long hair plaited round her head, a schoolgirlish image that implies a virginal, religious halo. Characteristically, a few strands of hair escape from her centre parting, showing that Emma has not tried too hard with her appearance. Her gaze is confident and direct, with the beginning of a smile, as if she's about to speak, just like his first sketch of her in 1848. Her features are sweetly regular. She has dressed formally rather than

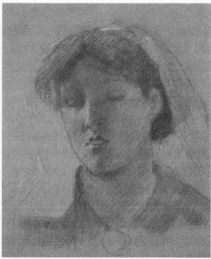

Emma on her wedding day – two versions.

glamorously, with a flat bow at the throat of her bodice or blouse and a soft shawl thrown round her shoulder against the early April morning's chill.

By contrast, the other drawing is undated, but the artist's family has always known it as an image of 'Emma on her wedding day'. The airily coloured chalks, unlike the monochrome pencil of the other study, give this drawing a more mysterious, languorous air. Here Emma has fixed a veil of light cotton or cambric to the back of her head. By the middle of the nineteenth century brides were beginning to wear a veil, and it is possible Emma chose one for the ceremony. In this drawing her eyes are closed, perhaps in a bedroom moment, or against the early spring sunlight, but her mouth is still parted in that typically Emma expression, as if she is on the cusp of speaking or gasping or giggling. How long can she be trusted to hold the pose?

It's an intimate snapshot; she's not quite dressed, not quite ready for the ceremony. There's an ambiguity, an allure, a sexual charge to this drawing, quite different from the clear-eyed, modern young woman in the pencil sketch. Approximately one third of young women from Emma's working-class social origins were pregnant at the time of their weddings. But Emma was not pregnant, her baby was already a toddler. She was slim and assured and she was marrying up.

Interestingly for the times, Emma and Madox Brown appeared to have been in control of their fertility. Even the illegitimate birth of their first child, Cathy, may not have been a 'mistake' but a calculated choice by at least one of her parents. Emma did not go on to become a Victorian slave to maternity. She did not have the ten children of middle-class Mrs Dickens. After Cathy's birth in 1850, Emma had no more babies for four years and only two more pregnancies that went to term: Oliver in 1855, Arthur in 1856, and at least one miscarriage. Commentators have scorned Emma as an uneducated girl, unworthy to be the partner of Ford Madox

Brown. But she had more savvy than many middle-class wives of the period, and whether by using a vaginal sponge or persuading Madox Brown to practise coitus interruptus, Emma knew how to control the size of her family. Sex was not a taboo for her. Her frank knowledge of sexual reproduction from her upbringing on the farm ensured that she was far less ignorant than her middle-class, urban sisters.

The year of Emma's and Madox Brown's wedding, 1853, was the year of Holman Hunt's much debated picture *The Awakening Conscience* which showed a young courtesan leaping off the knees of her protector as if she'd just seen the light about her immoral and exploited lifestyle. But Emma was no kept mistress in a claustrophobic, St John's Wood interior. She was a girl who smelt 'not like scent bought at shops, but like that of herbs and flowers growing in the country.' She met her husband on equal physical terms and the wedding was an endorsement of their parity, even if this was not and could not have been in 1853, also financial.

Like many middle-class weddings at that time, the bride and groom went to church simply with a couple of close friends and possibly a parent. The close friends both came from the groom's side. They were Madox Brown's fellow artists, glamorous Dante Gabriel Rossetti, and landscape artist Thomas Seddon, who both signed the register as witnesses. Emma had been a witness at the marriage of her elder sister, Eliza Hill, to architect John Gandy on 4 January 1846 but there is no clue as to whether Eliza, in her turn, attended Emma's wedding. The only parent left alive on either side was Emma's mother, Catherine Hill, and in spite of her disgruntlement, perhaps she made an effort to be at St Dunstan's for the brief ceremony performed by the rector, Edward Auriol. The rector may have been a sympathetic, liberal man. He and his wife Georgiana were inconsolable when their 'tenderly beloved and only child', Edward James Auriol, a seventeen-year-old student at King's College, London, drowned in the Rhône at Geneva one bright morning in August 1847. This personal tragedy may have encouraged Edward Auriol to rejoice rather than to blame Emma Matilda Hill and Ford Madox Brown for the existence of Cathy, their love child.

Less than a month after the wedding, on the evening of May Day 1853, Dante Gabriel Rossetti drew a pen and brown ink portrait of Emma by candlelight, throwing a rich dark shadow behind her head, showing the same candid gaze as in the first of her husband's wedding drawings above.

Although her hair lacks the wedding braid, Rossetti's attention to the details of an escaping strand of hair across her temple, as well as her parted lips, is strikingly similar to Madox Brown's daylight portrait on the wedding morning. Is there a suggestion in both portraits of Emma that she

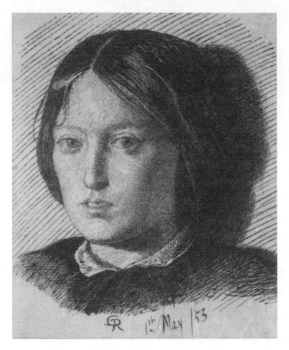

Mrs. Ford Madox Brown by Dante Gabriel Rossetti, 1 May 1853.

has the merest gap between her two front teeth? This small, intimate image of Emma, an alternative study of his young wife by Rossetti, remained in Madox Brown's possession all his life.

SPECIAL RELATIONSHIPS: EMMA, MADOX BROWN, ROSSETTI AND LIZZIE

A LTHOUGH THE MADOX BROWN WEDDING day seems to have passed by as mere ratification, Rossetti's letter four days later on 9 April 1853, in response to one from Emma, opened with courteous formality to the ex-Miss Hill, using her new title, 'My dear Mrs Brown', which he knew would please her. Amongst news for his friend Madox Brown, Rossetti thanked Emma for her kind mention of Miss Siddal. Just a few weeks separated Emma and Elizabeth Siddal. However, the bond between the two young women would soon infuriate him. They may have been friends before Rossetti ever glimpsed Lizzie, the milliner's girl from a bonnet shop in Cranborne Alley, near Leicester Square. She was discovered by his artist friend Walter Deverell in 1849 or 1850 but soon appropriated by Rossetti as the ideal model. Her tall, elegant figure, her unusual 'greenish-blue unsparkling eyes' beneath 'large perfect eyelids', set in a 'brilliant complexion' and framed by a 'lavish heavy wealth of coppery-golden hair' inspired many of Rossetti's most intimate pictures.

Rossetti had felt a special sympathy for Madox Brown's dilemma during the years 1849–53 when he and Emma had been living together, before they finally married. For Rossetti himself soon became enmeshed in an ambiguous ten-year relationship outside marriage with Lizzie Siddal. This was the classic scenario for most of the Pre-Raphaelite artists. They chose women from a lower social class, often a model in the first instance, sometimes a prostitute, to be elevated to muse, mistress and even wife.

They waged a war of education upon these girls, so that in a Pygmalion effect, they could become worthy of their intellectual lovers. Holman Hunt rushed away to the Holy Land to sublimate his passion for Annie Miller, a golden-haired prostitute. He left instructions for her to be educated up to standard during his absence. Naturally she preferred boating trips with both Rossetti brothers. Throughout the 1850s, Rossetti was involved in a semi-official, allegedly celibate engagement with his 'stunner' Lizzie Siddal, who developed into an artist and poet of real talent. During that decade, perhaps because Lizzie denied him a full sexual relationship, Rossetti established Fanny Cornforth, probably a prostitute, as his live-in mistress. Meanwhile, in 1859, William Morris married Janey Burden, from a rural, working-class background similar to Emma's, who became Rossetti's lifelong obsession.

After marrying Emma in 1853, Madox Brown's state of mind continued to veer dangerously. His brilliant pupil, Rossetti, had become his greatest friend, but kept nocturnal hours which aggravated Madox Brown's volatility. Yet, in spite of, or perhaps because of, his unpredictable mental state, he was extraordinarily creative during the early 1850s, working punishing hours, sometimes night and day alongside his

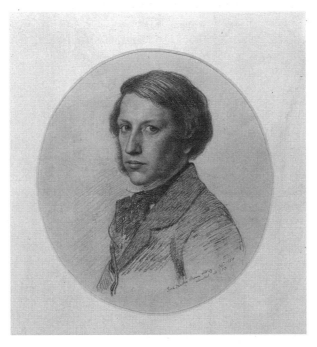

FMB's *Self-portrait*, aged 29-32, begun September 1850, re-touched October 1853.

pupil. 'All this while Rossetti was staying at [the studio at] Newman St with me – keeping me up talking till 4 A.M., painting sometimes all night making the whole place miserable and filthy, translating sonnets at breakfast working very hard & doing nothing.' Emma felt sidelined by Rossetti whose brilliant talk captivated Madox Brown.

As well as new pictures featuring Emma, such as *Take Your Son, Sir!*, her husband was constantly retouching other Emma pictures including *Lear and Cordelia* and *The Pretty Baa-Lambs*. After living at Hendon the family moved on 1 September 1853 to rented accommodation at 1 Grove Villas, Church End, Finchley, where the rates were fifteen shillings a quarter. In spite of continued self-loathing, depression, hopelessness, nervousness and self-flagellation for his perceived laziness, these extremes of mood stabilised over the next eighteen months. He calculated that during this period he 'wasted 2 weeks through Nervous dissorder [*sic*] of the Brain'. Although he often worked out of doors, and sometimes in a rented studio, he still needed workspace at home. Because Emma was unused to managing their household at Finchley, he found himself jarred by every domestic detail. They hired a girl from the local Barnet Union – the workhouse – as a maid-of-all-work but she was so cheeky that in August 1854 he sacked her with a month's wages – then castigated himself: 'was I right? Custom says yes – Conssience [*sic*] says no . . . I feel like a scoundrel . . . I have just killed a wasp.' In penance, he forced himself to lay a stair carpet in unbearable heat after an eight-hour painting session. 'After about 5 P.M. had a shower bath & dressed & so spent the afternoon & eve loving Emma, the poor dear tired with no servant & char-woman not to be had in the neighburhood [*sic*] – getting very stout in the waist also now.' She was five months into her second pregnancy.

In some sort of tacit recompense to Emma, during autumn 1854 he decided to put her into a poetic new picture, *The Brent at Hendon*, 'a mere brooklet running in most dainty sinuosity under overshadowing oaks and all manner of leafgrass,' (see Plates). The setting was only three quarters of a mile from home. He could walk there and back to plan his composition before breakfast, taking the road from Hendon to Finchley and hopping down to the brook at Hendon Lane Bridge. The scent of cow parsley and sounds of birdsong filled the air; sunlight darted in the shadowy pools. There was a tangle of ash, silver birch, sycamore and willows shading the meandering river Brent. The sheer complexity of the vegetation made the task daunting but exciting. So many beauties in the scene made it hard to decide what to include in the composition. 'However nature that at first sight appears so lovely is on consideration almost always incomplete', so he decided to 'complete' nature by including Emma, lushly pregnant as

the hot autumn scene, reading diligently in the shade of a gnarled oak tree. For a girl he had once considered uneducated, it was an enormous compliment. Although he later brushed aside the importance of the reading figure as a piece of sentimentality, the truth was that at last he had seen her as a glorious amalgam of mind and body. The old rift between seeing Elisabeth as intellect and Emma as sensuality had been healed. At the same time he was still refining his portrait of Emma for *The Last of England* which he continued to work on until 1855. They were not merely husband and wife but partners in a unique creative enterprise that would fix itself in the visual memory for centuries.

During 1854 and 1855 Madox Brown was working concurrently on several landscapes, *Carrying Corn* and *The Hayfield* as well as *The Brent at Hendon*. But lack of ready money continued to distress him. He spent two hours trying to account for a lost sixpence in his accounts, noted that funds were reduced to £1 9s. 6d., and fumed that he had nothing to put in the church collection plate for the orphans of the recent cholera epidemic. Money worries preyed on his mind and escalated with Emma's waistline, especially in the final trimester of her pregnancy during autumn 1854. He bought 'Emma the duck' two dresses for £1, then grumbled at her for such an outlay when they only had £8 left. He worried about getting her a new servant, she had a sick fit, he had to pay for medicine, and more cholera cases were diagnosed in the neighbourhood. 'I ought to go & take Lucy a pounds worth of things & can't – I ought to buy shoes & can't – We ought to send monney [*sic*] to Emma's Mother –', he wrote in September 1854. In spite of this they managed modest weekend diversions, Sunday visits to church followed by walks from Hendon, as far afield as Mill Hill, to take tea in some gardens, 'not an aristocratic proceeding but pleasant & healthful.' The prospect inspired discussion. 'The scenery is very beautiful & paintable about this part & I suppose the finest round London. One bit in particular pleased us, it was looking down from a hill in a deep hollow surrounded on all sides by beautiful trees lay part of a road already small by the perspective; through the foliage at the top in the extreme distance was Hendon church with large foreground figures on the hill in front. It would have made a most admirable picture for perspective depth, everything alas! can not be painted however.'

In October 1854 there were not even candles in the house. 'Emma strongly advised lazyness [*sic*] so I cuddled the children & her on the sofa till tea time it being very cold, after tea I made Lucy play her pieces over.' He felt completely undervalued. There had been no visit from picture dealer David White. 'What chance is there for me out of all the Bodies, Institutions, Art unions & accademies [*sic*] & Commissions of this country,

Classes, sects or cotteries [*sic*], Nobles dealers patrons rich men or friends. Which one takes an interest in me or my works. Is it encouraging to go on? Is it not rather a clear affirmation of my not being required by the British Public and yet – patience is the only motto – we shall see what we shall see. I only wish to be allowed to go on to be permitted to work – Ill sensation – by the next generation. Emma brought me home 8/6 of her money, unspent funds at present 10 shillings.' It was the contrast in scale that grated. He was doing work that deserved the admiration of posterity, yet with no more than ten shillings ready cash he was forced to beg for credit from Smart the Hendon grocer. On the one hand he could be lost in wonder at the jewel-like berries that studded the autumn hedgerows, on the other hand he felt paralysed by 'fearful Idleness self abasement & disgust'. No wonder Emma was confused, poorly and nervous, as he confided to his diary. Even new dresses failed to inject their usual boost of confidence. She began to refuse invitations, 'not finding herself small enough to go'.

And to add to all this, the Madox Browns found themselves the victims of their own hospitality. Dante Gabriel Rossetti arrived to stay on 1 November 1854, fretfully working on his picture *Found*. With one toddler, Cathy, as well as her eleven-year-old stepdaughter Lucy temporarily staying in the house, the heavily pregnant Emma struggled to cope with yet another house guest. After six weeks, 'not seeming to notice any hints', Rossetti was still *in situ*, camping on a bed on the parlour floor, 'not getting up till eleven, & moreover making himself infernally disagreeable besides my finances being reduced to £2 12s. which must last till 20th January, I told him delicately he must go.'

Perhaps something was askew in their calculations but from about mid-December they daily expected Emma to go into labour. This only increased Madox Brown's sense of imminent dread. On Christmas Eve they were cheered by a chance discovery. 'Emma found in her drawer 2 shillings & 3 farthings all in fourpenny pieces, pennys, halfpence, farthings etc left there at different times & forgotten, what a boon. Katty appropriated the 3 farthings.' But these small pickings did little to assuage Madox Brown's anxiety. 'Have been casting up my accounts find that in 20 weeks we have spent 66.18/ & owe about £35 besides, the excess is chiefly in the House money, about £15 or 15/ per week.' He had no doubt that this was Emma's bad management. He ascribed overspending on entertaining to Emma – which was grossly unfair as the guests were mostly his. Recent visitors included his elder daughter Lucy and her cousin Lizzie Bromley, both the Rossetti brothers, and sculptor Thomas Woolner, just back in London after his adventures in Australia. Madox

Brown even grumbled about bed and board for Emma's monthly nurse (midwife) who had been awaiting the birth for at least two weeks. Early in January Emma started to have weak contractions which persisted on and off for over a fortnight until she finally gave birth to Oliver half an hour after midnight on the morning of 20 January 1855.

In the early days of her love affair with Madox Brown, Emma had resented the crowding presence of Rossetti, who monopolised her lover, sometimes throughout the night. After marriage, and the birth of her son, positions were reversed. Rossetti's irritation with Emma grew in exact proportion to Emma's intimacy with his girlfriend Lizzie Siddal. (Rossetti persuaded Lizzie to drop the final 'l' from her surname, as he considered it more refined.) Their friendship may have gone back to childhood, to an acquaintanceship between their two mothers, Mrs Siddall and Mrs Hill. Rossetti's niece, Helen Rossetti Angeli, thought her friendship with Emma 'was certainly the closest of Lizzie's intimacies'. In a parallel arc, Rossetti's greatest mutual male friendship of his life was with 'dear Bruno'. These inter-quartet alliances only intensified the strain between the two couples. The Madox Browns continued to entertain Rossetti and Lizzie but when they came to dine with the poet-painter William Bell Scott, it was Bell Scott whom Emma singled out for her special attention. Sensing Rossetti's antipathy, she would sideline him. Heightening tensions with Rossetti made Emma fractious with Madox Brown – 'she is a silly pus [sic] & I am very wretched tonight' – but two days later husband and wife forgot their frustrations in the moonlight together: 'took a walk with Emma. Saw in twilight what appeared a very lovely bit of scenery with the full moon behind it just risen. Determined to paint it.'

Throughout the summer of 1855 Rossetti continued to be spiky with Emma. He was convinced she had an evil effect on Lizzie Siddal, jittery model and muse, his beloved 'Guggums' or 'The Sid'. 'Lizzie and Emma Brown were both drunkards', Lucy later told her daughter, Helen. 'Lizzie somewhat disguised the fact by taking drugs [laudanum].' They used to 'carouse' in the house together. The girlhood friends were both addicts. Emma's taste was for beer, wine and spirits. It's not clear exactly when Emma's drinking began or intensified but by May 1855 the couple were quarrelling 'all day about her extravagance'. At first Madox Brown tried to disguise the extent of Emma's problem, even from himself. She was stormy, sulky, 'unwell', had a 'fainting fit', was 'raving & did not know me', or went out and 'lost all her money'. Her escapades affected not only their personal equilibrium but also Madox Brown's work schedule and meant he lost valuable time rescuing her from scrapes. His diary entries euphemistically veiled his suspicions, until eventually he resorted to two

transparent letters, 'E.D.' – Emma drunk. Her lack of control increasingly infuriated her husband who thought nothing of drinking till the small hours himself. If he hid the bottle, she withheld sex in a constant battle of domestic comedy. She fell off a stile. He spent the night on the sofa in the parlour.

Emma and Lizzie ganged up on Rossetti – or that was how he saw it. He couldn't accept that they had female secrets that excluded him. On 16 August 1855 'Emma went into town with Miss Siddal before Rossetti was come in from his rooms at the Queens Head [where he was lodging] so that when he did come his rage knew no bounds at being done out of the society of Guggam & vented itself in abuse on Emma who "was always trying to persuade Miss Sid that he was plaguing her etc etc, whereas that of course Miss Sid liked it as much as he did etc etc"'. In Emma's absence from the scene, Rossetti swore at four-year-old Cathy in tones of 'most impassioned despair' – 'O! go and be damned.' Convulsed between mirth and anger, Madox Brown laughed and swore at his enraged friend. But inwardly Madox Brown was close to despair and still fantasising about emigration to India. Bathetically his next move would take him only as far as 13 Fortess Terrace, Kentish Town, which he rented in September 1855 for £52 10s. per annum.

In his increasingly depressive mood Madox Brown recurred to an old internal debate about suicide. Craving affirmation, he reread Shakespeare's *Antony and Cleopatra* several times, finding 'that there is in shame and degradation a pitch than which self inflicted death is more to be tolerated.' As diary writers often do, he took stock of his life at the turn of the year and on birthdays. 'How little done Oh Lord, & how much gone through? How many changes, how many failures? Is it fate, is it fault? Will it end or must it end me?' he relentlessly questioned himself on his thirty-fourth birthday, 16 April 1855. Soon he had coined his private codeword for suicide, '*I* feel Haydonish & old & down in the mouth.' Benjamin Haydon, also a diarist and history painter, had sensationally committed suicide less than a decade before in 1846. Haydon's case seemed a dangerously appealing model.

This state of mind infected domestic relations. One morning, as he bickered with Emma, he 'determined to give her a dose of it as otherwise she becomes unbearable', so they pitched into a self-righteous silence. He felt almost asphyxiated by tension, finally writing Emma a letter 'the answer to which our fate seems now to hinge on'. Waiting for her reply, he was 'heavy with dread thoughts'. He remembered 'when I was young a disappointment in painting used to give me a dreadful pain in my throat, now other miseries take the place of these & the nervous system feels most

acutely about the heart & chest – no pain is like this.' In his diary he returned to suicide as an option. 'What would become of my children if I were to finish my wretched Existance [sic] & what is to become of me if I do not. O God! have mercy on me & save me.' But he carefully recorded '6 hours' work tally for the same day, 5 July 1855. His Hamlet mood and vocabulary persisted that summer. 'Had a mushroom for tea & thought about death – which after all seems to me a very natural consummation.' He came out in boils, felt a tightness in his chest, had dizzy spells and blinding headaches, perhaps migraines, but recognised that these symptoms, though physical, originated in his mind.

Money worries continued to torment him, and so the next debacle involving the four friends was doubly maddening because it incurred needless expense. Rossetti ordered Madox Brown and Emma to meet him and Lizzie at Drury Lane opera house. 'When we got there he had forgotten that after a certain hour we could not get in, so Emma & I paid 5/ & he & Guggum went home.' Madox Brown loathed the programme, the intolerable acting and the English operatics: Bellini's *La Sonnambula* followed by *Rob Roy*, an operatic drama. Before the curtain came down in the stifling auditorium, he felt ill. Staying overnight at Rossetti's at Chatham Place, he spent all the next day 'in a raging fever in the midst of all manners of squalls & discomfort, Emma having to nurse Nolly who did not seem to relish the change . . . Rather better towards night. Dear Emma doing all she could for me.' Scenes of total confusion involving Rossetti, Lizzie and their friends floated across his consciousness. Infuriated by such needless extravagance, he calculated that the whole expedition, including 'going to the play, *by orders*', cost him £2 10s. He finally rose from his sickbed two days later at 3 p.m. to drag Emma round house-hunting. She 'was done up having walked full five miles' so he put her in a cab and sent her off to play Lady Bountiful to a family even poorer than their own. One wonders how Emma managed to switch from overheated opera-goer, to breastfeeding young mother, to bohemian intriguer, to genteel house-hunter, to Victorian charity lady – all within the space of forty-eight hours.

In these early months of motherhood, a great deal was expected of Emma. Her drink problems may have stemmed from trying to fulfil all these roles at once, as well as posing at all hours and in all weathers for Madox Brown's pictures. Living so closely with the unfolding drama between Rossetti and 'Miss Sid' partly excited her but also partly distorted her sense of reality. By the beginning of 1856, her behaviour had become so unpredictable that Madox Brown arranged for his observant elder daughter, Lucy, to continue her education with Rossetti's mother,

Frances, and sister, Maria. She would not only go to them for lessons, she would also board in the Rossetti home. It would cost him £40 a year but for once he felt relieved by spending money. He was anxious to keep Lucy out of the house where Emma's drinking was becoming more and more difficult to conceal. But perhaps equally Emma couldn't face the added pressure of Lucy's resentful adolescent presence.

Emma was still nursing Nolly by his first birthday in January 1856. She had relied on breastfeeding as a contraceptive. As soon as he was weaned, she became pregnant again. Vulnerable and sensitive in the early months, Emma was in no mood to tolerate Rossetti's abrasiveness. By May Madox Brown could no longer ignore the tension between Emma and Rossetti. Lizzie frequently stayed at Fortess Terrace in order to confide in Emma, and Rossetti was now convinced 'that Emma sets Miss S. against him. He did not speak one word to Emma either how d'y do or good bye.' Naturally Emma complained to Madox Brown who promptly wrote to Rossetti asking for an explanation of his rudeness. 'The dislike he has taken to Emma is most absurd,' thought Madox Brown, and all because Rossetti suspected Emma of inciting Lizzie against him 'which she does not, for poor Miss Sid complains enough of his absurd goings on.' In Madox Brown's rather too sanguine opinion, 'Emma was [Rossetti's] very good friend till this sort of brutish conduct the other night which is difficult to overlook'.

As the tête-à-têtes between Emma and Lizzie intensified, Madox Brown considered it high time Rossetti and Miss Sid got married. He placated Emma for Rossetti's mistreatment by taking her out shopping for an angelic new bonnet and spending lots of 'tin' – slang for money. Suffering his usual after-effects of spending money, he then felt ill, irritable, worried about work, and ended up 'in a terrible rage with Emma after which I took a short walk & better again'.

Rossetti's relationship with Lizzie heightened into its see-saw pattern of mutual frustrations, with Emma becoming Lizzie's ever closer confidante. In the women's view, Rossetti had been unfaithful twice over, not only to Lizzie but also to his friend Holman Hunt. While Hunt was away in the Holy Land, Rossetti wooed Annie Miller, Hunt's model for *The Awakening Conscience*. Lizzie felt her marriage prospects daily receding. In June she persuaded Emma to join her in a restorative visit to the seaside at Ramsgate. Rossetti immediately turned guilt into attack and became 'bearish', jealous of Emma's intimacy with Lizzie. In the end Emma set off alone but the whole expedition turned into disaster. She had a sickening passage, was drenched on arrival, and to make matters worse, 'lost all her tin out of her pocket'. Did she literally 'lose' it, or spend it on

drink, or was she pickpocketed? Madox Brown was forced to rescue her
by train, his patience with Rossetti now almost completely exhausted. It
was an angry scene in Ramsgate, quite different from their idyllic
elopement in the resort seven years before.

On their return to Kentish Town, Rossetti and Lizzie continued to
impose on the Madox Browns' hospitality. 'On coming home whom
should we find but Rossetti & Miss Sid up stairs. I was very cool to them
for I am sick of them coming here & his rudeness to Emma'. The
intolerable strain told on both Emma and Madox Brown who found
themselves trapped in a relentless cycle of quarrelling and making up. He
offended her. Emma locked herself in the parlour at bedtime. Madox
Brown lost precious work time restoring peace. The situation between
the two couples continued to grate and Madox Brown noted that Rossetti
had transferred his affections to Annie Miller. Tactlessly, he kept talking
about Annie to 'Miss Sid'. 'He is mad past care.' Lizzie dosed herself with
laudanum to blot out the pain of Rossetti's fickleness, and Emma, heavy
in the seventh month of a hot summer pregnancy, was agitated in direct
proportion to her friend's distress. A few days before she gave birth,

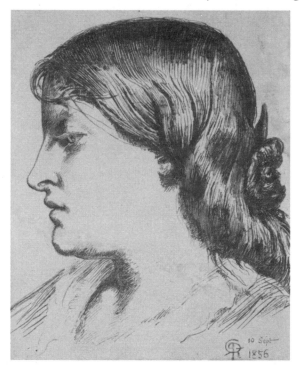

Mrs Ford Madox Brown, by Dante Gabriel Rossetti,
10 September 1856.

Rossetti made a pen and ink portrait head of Emma. In resentment or anger she averts her face. She looks heavy-jowled, with the almost goitrous neck and sultry, inward looks that Rossetti repeated in many of his female portraits.

Even when Emma was clearly in the early stages of labour, Rossetti called at Fortess Terrace and took Madox Brown off to burden his friend with his own concerns. It was another of Emma's long, slow labours, this time over three full days 13–16 September 1856. 'Emma dear still in pain . . . Emma still suffering . . . Emma worse & gradually more till near one when, thank God, she was releaved [sic] & we have a boy. I to bed in my clothes.' Emma could not even get rid of Rossetti in the naming of her new boy, who was to be called Arthur Gabriel Madox Brown, with Rossetti and Lizzie as godparents. In spite of Rossetti's demanding behaviour, Madox Brown never veered from his commitment to his fellow artist. He loved him for his genius, his air of Continental excitement, his sheer charm and, at his best, his generosity of spirit. Despite the irritations, it was a mutual friendship which sustained both men over many years.

Everyone in the family served as Madox Brown's models and Emma's new baby was no exception. Madox Brown began to draw Arthur Gabriel in the first days of his life. At the end of September he sold his 'little picture of Emma & boy for 84£' to John Miller, a Liverpool art patron. It was probably a smaller copy of *Waiting: An English Fireside in the Winter of 1854–1855*, (see Plates). Madox Brown had been at work on this subject featuring Emma since autumn 1852. He now gave it a topical twist by relating it to the Crimean War of winter 1854–5. The young mother, a modern-day Penelope, sews and waits for her soldier-hero, her child's father, to return from the war. Each of Emma's babies modelled in turn for the sleeping child so s/he is a sort of composite Madox Brown child: Cathy, Nolly and Arthur. On the side table next to the baby's head is a portrait miniature of its father, resting on a pile of 'letters home'. A ghostly, looming shadow is dramatically thrown up in the cross light, between the fireside on the right, and the lamp to the left of the central figures. The child's nightgown is washed with firelight, the colour of dried blood, another reference to the war from which its father may never return.

Emma suspends the moment's tension on the skein of her thread. She is Everywoman and she is Emma, archetype and individual. 'Waiting', she represents the essence of English womanhood, while the unseen husband fights Russia in the Crimea. Madox Brown exhibited the picture at home and abroad, at the Exposition Universelle in Paris in 1855 and in Liverpool in 1856.

In a rush of gratitude to Emma for the £84 realised for the picture, and

in relief that she'd safely come through her third labour, in September 1856 Madox Brown 'went & laid out a lot of money for Emma & chicks', splashing out £4 on a new dress for her. Emma generally had £2 per month dress allowance from her husband but now he was able to award her a lump sum for the remainder of the year. He calculated carefully that she was due exactly £5 12s. 1d. But his exuberance didn't last long. As he suffered a new excruciating pain, symbolically enough in his painting wrist, he castigated himself for fearful idleness, while 1856 slipped away.

During spring 1857 he reworked another Mother and Child subject – always one of his favourite themes – drawing the naked baby from Arthur, now six months old, and the head of the mother from Emma for the equivocal picture *Take Your Son, Sir!* which he never satisfactorily finished. (See Plates). Set in a domestic interior, Emma symbolises a type of motherhood, although whether a Madonna or a Magdalen is debatable. Is it an image of completed mutuality and fulfilled parenthood? Or does an abandoned mistress offer her infant to a retreating father, clearly to be seen in the convex mirror which forms a halo behind her head? Madox Brown would have been aware of Jan van Eyck's famous picture *The Arnolfini Marriage* of 1434, which was acquired by London's newly formed National Gallery for 600 guineas in 1842, and put on display from March 1843. As the National Gallery's first example of Flemish Primitive art, it may have stirred Madox Brown's buried memory of his years in Flanders, where he had fallen in love with Elisabeth Bromley. In van Eyck's double portrait an elaborate convex mirror is placed prominently between the wedding couple. Madox Brown transferred the device of van Eyck's mirror into his own portrait of modern times.

The ambiguity of *Take Your Son, Sir!* may reflect the duality in Madox Brown's feelings about Emma, and about Lizzie and Rossetti who were such an inseparable part of their lives. Would the Madox Browns have discussed together the possibility that Lizzie, like one interpretation of the mother in the picture, might find herself trapped into single parenthood, while Rossetti took Annie Miller boating on the Thames? Madox Brown admired Lizzie, her ethereal looks and her offbeat talents for painting and poetry. 'She is a stunner & no mistake. Rossetti once told me that when he first saw her he felt his destiny was defined; why does he not marry her?' Like Emma, he deplored Rossetti's caprice as he strung Lizzie along throughout the whole of the 1850s. 'Miss Siddall has been here for 3 days & is I fear dying. She seems now to hate Gabriel in toto. Gabriel had settled to marry . . . & she says told her he was only waiting for the money of a picture to do so, when, lo the money being paid, Gabriel brought it

& told her all he was going to pay with it & do with it, but never a word more about marriage. After that she determined to have no more to do with him. However, he followed her to Bath & again some little while ago promised [sic] marriage immediately, when since he had again postponed all thoughts of it.'

This prevarication drove Lizzie to further drug-taking and distraction. Rossetti came for a serious talk with Madox Brown. The only thing preventing an immediate wedding, he assured his incredulous friend, was 'want of tin' to buy the marriage licence. Excited by this claim, Madox Brown lent him an immediate £10 but Rossetti 'spent it all somehow' and licenceless even came back for more. Although in later years Rossetti lent generously to his friend, at this stage when he had most need of funds, Madox Brown totted up that Rossetti and Miss Sid together owed him £42 10s. He and Emma could only look on in horror as Rossetti's intentions veered alarmingly. 'He has quite lost her affection through his extraordinary proceedings.'

Emma was physically exhausted in the months following Arthur's birth, and had to spend five weeks recuperating in Hastings. On her return, the whole cycle of Emma hearing Lizzie's story and Madox Brown listening to Rossetti's, spun into orbit again. As Emma went to and fro with notes, recriminations and apologies between the maddened lovers, their scenes were played out in front of the Madox Brown audience with ever more wounding self-hurt and loathing.

During this summer of 1857 Madox Brown risked precious funds to finance the first exhibition devoted entirely to Pre-Raphaelite art, held at Russell Place, Fitzroy Square, for which, among others, Rossetti and Miss Sid 'never paid their shares'. Apart from Madox Brown, Rossetti and Lizzie, exhibitors included Millais and Holman Hunt, as well as later Pre-Raphaelite associates John Brett, Charles Collins, William Davis, Arthur Hughes, John Inchbold, Thomas Seddon and William Lindsay Windus. Reviewing the show, the *Athenæum* compared *The Last of England* with Hogarth. This compliment had special meaning for Madox Brown who had always revered Hogarth's 'modern moral subjects' and a year later became chairman of the Hogarth Club which until 1861 provided an alternative salon to the Royal Academy. Madox Brown 'read' Hogarth's paintings and engravings for their social topicality, embraced their humanity, and absorbed their pore-by-pore authenticity. When he visited Hogarth's house he was so moved and inspired that he wrote two sonnets promising himself 'I also would excel!' The 1857 exhibition attracted attention and confirmed the view amongst the public and critics that the Pre-Raphaelites had done something 'very different from what could be

seen in the ordinary picture-shows.'

The energy required all took its toll on Madox Brown and Emma. But that summer, private grief relegated anxiety about art shows and Lizzie and Rossetti to second place. Their youngest child, 'poor little Arthur', who looked out of his father's ongoing canvas of *Work*, contracted tubercular meningitis and died aged ten months on 21 July, after 'one painful week'.

Madox Brown was so hard up that he was 'obliged to ask [his patron]

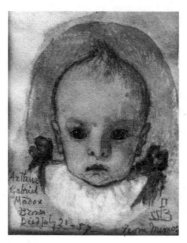

Arthur Gabriel Madox Brown, 1857, inscribed 'From memory'.

Plint for money to bury him'. Following Arthur's death 'till nearly the End of August Emma was ill & in bed with a bad miscarriage'. Within less than two months she had lost two children, Arthur Gabriel and her unborn baby. Thomas Plint, the Leeds stockbroker, liberal reformer and art collector, who had recently agreed to pay 400 guineas in instalments for *Work*, sent an unexpected gift of £38, which Madox Brown accepted and 'started off to Manchester as a great relief with Emma & Lucy & staid there a week for we had all of us been getting terribly hipped.'

In September 1857, Madox Brown visited the landmark Manchester Art Treasures Exhibition, billed as 'The Greatest Show on Earth'. It attracted 1.3 million people, many of whom had never looked at art before. Madox Brown exhibited *Christ Washing Peter's Feet*, a noble picture of consummate realism, animated by telling details: the furrows and broken veins on Peter's face, the veins in his forearm, the sheen of water on his left leg, his worn-through sandals, and Judas idly scratching his foot at the outside

edge of the table. Frederic Shields, whose artistic career was just beginning in Manchester and who would later become a close friend, was riveted by the picture which he compared with Giotto. In a lecture to the Manchester Literary Club, Shields said he found the picture 'brilliant and forcible . . . true and refined in its colour and lighting, and wonderful for its grasp of human character and passion'. But Madox Brown thought poorly of the whole magnificent show, mainly because he was badly treated by the hanging committee, who consigned his great painting to 'the very roof'. Madox Brown was not to know that Manchester would later become the backdrop for a major element in his career, and a great part of his private life.

In the private lives of the Pre-Raphaelites, in October 1857, Dante Gabriel Rossetti spotted a new stunner, Janey Burden, daughter of an Oxford stableman. Ten years younger than Emma, Janey came from a similar social background, agricultural labourers who had migrated to town. Perhaps Rossetti should have taken his chance with Janey from the beginning, even though he was involved with Lizzie Siddal. But Janey took her chance with William Morris, whom she married on 26 April 1859. A year later, Lizzie was sicker than ever from drug addiction, so Rossetti finally proposed marriage and meant it. Emma offered to go down to Hastings to nurse her friend but Lizzie was too ill to get to church on the day Rossetti hoped to marry, his birthday. The impossible couple eventually married two weeks later on 23 May 1860.

Emma's nursing services were called upon when Janey Morris gave birth on 17 January 1861 to Jenny, her first child. 'Kid having appeared, Mrs Brown kindly says she will stay till Monday,' reported Morris laconically to Madox Brown. As Emma was the only one of the Pre-Raphaelite wives or lovers to have gone through childbirth by this time, her experience was appreciated. Then, on 2 May 1861, Lizzie gave birth to a stillborn daughter. In mourning, she suffered post-natal depression, first taking refuge with Emma and then rushing away, distraught. Her fragile temperament never recovered and on 11 February 1862 she died of an overdose of laudanum. In 1949, Helen Rossetti Angeli described how Lizzie left a suicide note pinned to her nightgown which Madox Brown snatched from Rossetti and burnt. She heard and believed this story from her mother, Lucy Madox Brown, who had been eighteen at the time of Lizzie's death.

Thus the Browns' lives were entwined with their friends' at the most poignant moments of birth and death. Ford was beside Lizzie's deathbed with Rossetti. Emma, who shared with Lizzie a pernicious addiction, was nevertheless the Pre-Raphaelites' expert in childbirth, nursing and nurturing.

DEAREST EMMA
AS A MOTHER

EMMA'S CAPACITY FOR NURTURING HAD been awakened from the moment her first child was born almost a dozen years earlier, on 11 November 1850. Catherine Emily (Katty) had been given the name 'Brown' when her parents presented her for baptism at St Pancras Church on 18 April 1852, at the rather advanced aged of seventeen months, although they fudged their own names as 'Ford and Matilda Hill'. Cathy often disguised the exact year of her birth, pretending she had been born two years later, in the year of her baptism, perhaps out of vanity, trying to appear younger than she was, or out of awkwardness that her parents' wedding followed rather than preceded her birth.

Cathy's parents were progressive enough not to let their daughter's illegitimacy cloud their delight in the new baby. Born in time for breakfast, she was so plump and blonde that they referred to her as their 'hot roll as she arrived with the hot rolls brought round in the morning by the baker.' Cathy grew into 'a laughing mischievous little maid of two', living with her parents in a small house with a long narrow front garden at Church End, Finchley, in what was then the countryside of north-west London. In the garden Emma's childhood knowledge of plants and the soil could be put to good use. It was full of the pinks, mauves and whites of candytuft and convolvulus, flowers that Cathy associated with her pretty young mother who was 'always so gentle and sweet'. Later Madox Brown told his daughter that in those days Emma's 'skin resembled a peach and she had chestnut hair which she could sit upon.'

Cathy was an outgoing child who swung on the garden gate, watching

gentlemen walk by on their way to work in the city. She would ask them the time and they would stop, chat and reward her with goodies. 'But when my Father found out what was going on, he put a stop to it and I remember he called me "damned cheeky"' – an expression Cathy stored up and never forgot. Nor did she ever forget the subsequent row. In her childish register of fear and understatement, she noted 'a great deal was said at the time by my parents to each other at which I was rather frightened as their voices were rather loud.'

Although Cathy was ticked off for talking to passing gentlemen, she was allowed plenty of freedom, the same sort of freedom in newly suburban London that her mother had enjoyed on the farm between Herefordshire and Gloucestershire. One washing day while Emma was busy, the child wandered nearly four miles away, dragging a dolly as big as herself. Realising she was lost, she sat down determinedly to cry. An elderly woman from nearby labourers' cottages rescued her, gave her bread and treacle, dressed her in a rough nightgown and, to Cathy's great indignation, crimped her hair up in papers. Emma allowed her daughter's abundant hair to fly free. However, Cathy slept peacefully in a drawer next to the old woman, who dreamt of adopting this changeling child. It was only the bellman or town crier who located her the next day. Cathy often wondered what her life might have been like if the adoption had actually taken place. 'The poor woman wept bitterly my mother said, & refused any compensation; so that for some time afterwards I used to go with my mother or a maid we had to see the cottager and have bread & treacle. Of course I only recollect the fact of losing myself & finding my dolly very heavy. Also of sitting at the door and seeing my father appear. Also I remember that I had a <u>Whipping</u> for running away which I thought very strange as my mother had kissed me and seemed so happy to get me back.' Cathy was mystified by the conflicting reactions of her parents: her mother's anxiety for a missing child, apparently contradicted by her father's standard Victorian punishment.

In spite of this one instance of corporal punishment that Cathy recalled, Emma's principles of child-rearing were liberating. Although people, including her stepdaughter Lucy, scorned Emma for being brought up in the countryside, this early closeness to nature fed into an immediate, instinctive maternity. Lucy was less than a generation younger than stepmother Emma; only fourteen years divided them. She resented the new family who displaced her. But as an adult, particularly when she had children of her own, Lucy valued Emma's support. Emma happily breastfed her children and always considered their rights; both principles strongly influenced Lucy's philosophy of childcare. Emma allowed no

nurse to come between her and her baby daughter. Cathy was a valued family member. From the outset she was 'treated as a small friend and felt in consequence a very important person.' Emma had a beguiling line in fairy tales and magical stories that she told round the fireside to her children. She sent shivers down their spines when she recounted 'that when she was a baby lying in her cradle the ghost of a huntsman came into the room and picked her up and looked at her sadly and sighed and put her down again.' Sometimes Emma and Madox Brown sang duets and filled the house with harmony. When her husband played the popular Victorian game of 'Favourite Things' he gave 'Blow, blow thou winter wind' as his favourite air. Perhaps this was one of Emma's most often performed songs.

When Cathy was four, her first brother, Oliver Madox Brown, always known as Nolly, was born on 20 January 1855. Looking back, Cathy felt her brother's birth consigned her 'to the background of things in general. My father was delighted to have a son. He did not care for girls he always said.' It had been over twelve years since Madox Brown's first son by Elisabeth Bromley had died in Paris. The name he chose for this new son, Oliver, was a link with his republican hero, Oliver Cromwell, whom Madox Brown featured in two pictures. He was working on a contemplative picture, reimagining *Cromwell on his Farm* (1853–74) from before Nolly's birth, and later he would choose another more public aspect of his hero in *Cromwell, Protector of the Vaudois* (1877–8). By calling his son Oliver, he invested the highest hopes in this male child from the moment of his birth. Some special providence, he felt, had restored him as the father of a son, after two girls, Lucy, Elisabeth's daughter, and Cathy, Emma's daughter. His thoughtlessness made Cathy sad, hearing her gender so dismissed. Emma, who had no brothers, found a way to make Cathy and Nolly close friends, and even endeared Nolly to Lucy, his elder half-sister. From his earliest days, Cathy warmed to Nolly, a laughing, independent child whom Emma brought up with the same careless, confident disregard for constraint that she had shown with Cathy.

After Nolly came one more brother, Arthur, born on 16 September 1856, who died on 21 July 1857, before Cathy was seven. This was her first experience of death. She always remembered her mother crying and her father drawing the dead baby. 'I went into the Studio and saw my Father crying most bitterly and my mother trying to comfort him while on an easel in front of them was the drawing of the poor baby which I have now; it was left to me by my Mother at her death.' No one noticed as Cathy tiptoed into Emma's bedroom and saw Arthur laid out on a tiny bed, 'as I thought asleep and surrounded with flowers. I remember my

astonishment even now; he looked so sweet, just like a pretty doll & I tried to kiss him. His hands were so cold that I was frightened and I ran and told my mother how cold little Arthur was & that the fire was out; & I remember the shock I felt when my Father said – "Who unlocked the door."' Cathy finally cried herself to sleep in Emma's arms.

'Afterwards for some time my poor mother was ill . . . while I used to wander about the house in a desolate state.' Emma's grief for baby Arthur redoubled during a difficult miscarriage that followed almost immediately. It was not surprising that she relied on alcohol even more, either as an analgesic for the after-effects of labour, or to numb her mental pain.

During Emma's protracted illness following the miscarriage, Nolly, already a true Madox Brown eccentric at two and a half, was sent to stay with Georgiana Macdonald and her parents. Seventeen-year-old Georgie had become officially engaged two years earlier to Edward Burne-Jones who encouraged her to explore her artistic talent in Madox Brown's teaching studio. Georgie remembered the thrill of painting from a model under the great artist's direction, and also 'how proud and pleased I was at the confidence Madox Brown placed in me' when he entrusted Nolly to her care during Emma's illness. Nolly's originality reflected his parents' advanced principles of relaxed childcare and made a lasting impression on the Macdonalds. 'Nolly was an enchanting child, and in his own home so bold and manly as he roved about in a rough pinafore, that I was unprepared for the infantine vision in white embroidered cambric which he presented when dressed for our journey: his manliness had been doffed with his Holland overall, and as I lifted him in and out of the omnibus by which we travelled I felt an alarming sense of responsibility', confessed Georgie.

Nolly was quite unperturbed by banishment from his family home. As soon as he arrived at the Macdonalds' home at 17 Beaumont Street, Marylebone, and shed his embroidered coat, 'he became again the Nolly of Fortess Terrace'. Georgie found a cut on one of his grubby fingers which 'though reckoned by himself as unworthy of notice, he courteously allowed us for our own satisfaction to have dressed and bound up at the chemist's, where his courage during the operation moved the chemist to fill a virgin pill-box with acid drops and present to him afterwards. The acid drops were all given to dogs on his way home.'

Georgie's younger sisters kept a bad-tempered guinea pig in their dark backyard. 'Nolly feared neither tooth nor claw of any animal yet known to him, and had put his hand into the cage and been sharply bitten before there was time to say Don't. "O Nolly, has it hurt you?" someone cried. "No, dear," he answered gently, and a moment afterwards, with a

benevolence that set all parties at their ease, he added thoughtfully, "It's a very nice little pig."'

When Madox Brown visited Nolly, he amazed the Macdonalds 'for he did not kiss or caress the little fellow, but only perched him solemnly upon his knee and conversed with him for a minute or two before bidding him good-bye again.' It was clear his parents treated him as a small adult, and yet encouraged the free play of a post-Rousseau child. It was an unusual combination of childcare approaches for the times. The Madox Browns were child-centred before the concept had been thought of. 'It was not possible to be angry with Nolly. He might plant his boot in the middle of a pie that was set in the window to cool, yet the cook bore him no grudge.' If he bounced into a newly made feather bed, and sat grinning from its downy pillows, everyone burst out laughing. 'He tried to strike matches on the granulated tip of a dog's nose, and the dog itself did not mind, and he filled up the eyes of a water-colour portrait of himself with drops of water, because "they were his own eyes, so he might do what he liked with them."'

From her adolescent vantage point, Georgie had noted the interplay at Fortess Terrace between Nolly and Cathy, his 'flaxen-polled sister next above him in age' with whom he played or tussled. Georgie observed that Emma was 'too amiable and indulgent to be any sort of terror to them, and Madox Brown's forehead would pucker helplessly at them all while he went on talking in his measured, serious way with friend or visitor. I have seen him carry on conversation for some time whilst one of the children wriggled backwards and forwards underneath the bars of the chair on which he sat.' It was clearly a method of child-rearing quite outside Georgie's own recent childhood experience. One major factor was that Madox Brown effectively worked from his studio at home. Children and their demands were part of his daily routine and he worked around them. Emma, too, seemed completely at ease with this natural, daily intermeshing of work and home.

Madox Brown sometimes gave a rumbustious tone to family life. During the years at Fortess Terrace from 1855 to 1862, he and Emma entertained young, hard-up friends from the artistic world. One night Cathy was awoken by terrifying sounds emanating from her father's studio windows, 'as if wild beasts were in the house'. Creeping downstairs, she found an extraordinary scene. All the male adults she knew, brothers Dante Gabriel and William Michael Rossetti, William Bell Scott, Edward Burne-Jones, William Morris and Peter Paul Marshall, were imitating animals at the tops of their voices: 'the lion, hyena and donkey were the most energetic. In the midst of the uproar there came a very loud

knocking at the street door from a policeman who had been sent for by the neighbours.' Tucking Cathy back in bed, Emma reassured her that the men had been playing childish games to her father's uncontrollable guffaws, while she and Lizzie Siddal chatted and sewed together in the firelight.

Madox Brown's vigour was infectious. People often said that Cathy's escapades were tomboyish and that she should have been a lad. She did prefer playing with boys, though she firmly rejected any suggestion that she should have been a boy. She simply roamed free and climbed trees. One day, aged about eight, she took her brother Nolly, aged nearly four, into a neighbour's garden filled with inviting apple trees. She was already high up in one of the trees when suddenly the owner pounced. He managed to smack little Nolly – who wasn't even up the tree – three times and the two children ran home, screaming. 'In the evening when my Father returned he saw the weals on my brother's arms and forthwith rushed to his neighbour's house, dragging me with him, rushed at the man who had <u>dared</u> to touch my brother and <u>thrashed</u> him with his cane, and then went home cursing aloud. Of course he was summonsed, and I remember his asking me if I knew what an oath meant, and I said of course Papa, I hear you swear so often.' The affair ended with Madox Brown having to pay a fine of £5, 'in those days a very difficult amount to get together', which he had to borrow from William Michael Rossetti.

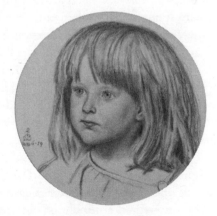

Oliver Madox Brown aged 4, inscribed 'FMB May 16–59'.

Money was often in short supply, so although Emma and Cathy loved pretty clothes, new bonnets and boots, they often had to do without. Sometimes during the 1850s, Cathy could not venture out of doors as she had no boots to wear – her feet were literally 'on the ground'. Then

Emma provided the children's imaginative focus. She sang and made up 'all sorts of wonderful stories to amuse us and keep us quiet because we were restless at being kept in.' Cathy was used to regarding her father as a man of genius, and imbibed the family lesson that money came second. Madox Brown was always a scrupulous returner of borrowed cash and a most generous lender. Cathy valued his generosity as well as his genius. 'I used to think my father the one important personage in the world, and that it was an honour to go without shoes and other things in order that my Father could lend money to different artists (when he sold his pictures) which he often did while others were starving from want of money or extravagance. My poor father being absurdly proud always refused to accept the return of a loan but always told people to pass the money on to the next man (or woman) who needed help.' Yet Madox Brown, although a larger-than-life figure, was an inconsistent father to Cathy, sending out contradictory moral messages. By refusing to accept repaid loans, he did not allow others to behave as scrupulously as he did himself. When it came to particular friends, such as Dante Gabriel Rossetti, Madox Brown lent not only money, but bed, board and even his trousers.

Emma too was always generous. Although she had little spare cash, she was invariably touched by tragic stories, usually of female mistreatment by men, which came to her notice. If she had no money, she offered food or clothing, but most of all she offered a sympathetic hearing. Crazy Jane was one of Emma's saddest cases. 'She had been a beautiful girl who married some ne'er-do-well who spent all her money and then left her. Her little boy was killed in some accident and shortly afterwards her husband was hanged for killing somebody.' Hardly surprisingly the balance of her mind was overturned. Emma did what she could for her, fed her often and allowed little Cathy to befriend her. Crazy Jane cuddled a rag doll and would only sleep outdoors under a hedge. One cold morning she was found dead 'with her doll against her'. Cathy was very sad and discussed with Emma how alone in the world Crazy Jane had been, with 'no one belonging to her'.

When Cathy was nine, in 1859, her father and Dante Gabriel Rossetti came home together in the early hours after a good night out. In a shadowy doorway they discovered a bundle of old clothes unfurling to reveal an undersized seventeen-year-old, clutching a three-week-old baby. Madox Brown with his usual open-handedness immediately arranged a week's lodgings for the girl and her infant. But more importantly, he told the girl to come and see his wife the next morning. On a pouring autumn day, Emma listened to her classic upstairs-downstairs story. A gatekeeper's daughter, she had been a parlour-maid in

a large country house where one of the 'gentlemen' house guests seduced her, took her to town and 'made much of her till a month or two before the baby came', whereupon he disappeared. The girl had no recourse but the workhouse, where her baby was born. Emma heard this common but pitiable story with so much sympathy that the girl, although illiterate, managed to stay in touch with Emma for years, sending messages about her later life. She married the gardener at the great house, who had always been fond of her, and he adopted her little girl. But then the baby died. Emma involved Cathy in these sad cases, setting an example of empathetic listening and action. Emma's response to each individual was different from sentimental charity. She was determined to make a small difference to society, and to pass on this lesson to her daughter.

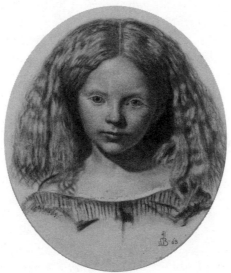

Catherine Madox Brown aged 13 inscribd 'FMB-63'.

Cathy absorbed many values and qualities from her assertive, compassionate and feminine young mother. One of her happiest childhood experiences, when she was about eleven, was accompanying Emma to see William and Janey Morris at Red House at Upton. 'First there was to me the excitement of a real new frock, & hat; in those days, a thing difficult of achievement for my mother, the frock of grey linen and the hat of white straw "mushroom shape", with a blue ruchery round it.' Emma knew how important it was for her growing daughter to feel happy about her appearance. As an artist's model Emma had a sense of her own beauty which she passed on to Cathy. The outfit was simple but stylish and Cathy knew it. The visit was a great success. Cathy spent hours engrossed in

Wuthering Heights and a translation by Speranza, Oscar Wilde's mother, of
the German horror story, *Sidonia the Sorceress*. The garden at Upton was
filled with the most wonderful roses. Cathy fantasised that William Morris
was the Beast and Janey Morris the Beauty, as she slid slowly and
gracefully about the garden, smiling mysteriously. Emma had fed not only
the child's love of fairy tales but also her sense of mythic beauty.

CHAPTER 9

HEYDAYS

Aᴌᴛʜᴏᴜɢʜ ᴇᴍᴍᴀ'ѕ ᴅʀɪɴᴋɪɴɢ ᴅɪᴅ ɴᴏᴛ ʟᴇѕѕᴇɴ during the 1850s, the couple evolved a way of living that was often mutually happy. Madox Brown continued to put Emma into his pictures. One of his most beautiful landscapes, *Walton-on-the-Naze* (1859–60), was a vivid memory of a summer holiday spent together on the Essex coast. (See Plates). The artist, Emma and daughter Cathy are an organic part of the composition, positioned on the right within the embracing arc of the rainbow, and part of nature itself, earth, sea and sky. At the opening of the decade, Emma and Madox Brown had clasped hands for *The Last of England*; now as it drew to its close, the intimate hand-holding behind Emma's back spoke of intimacy and trials surmounted, in spite of everything. Painted in super-naturalistic detail, with Emma's hair streaming down after swimming, the painting celebrated both the reality and the romance of an enduring marriage.

In spite of years of hardship and lack of public recognition, *Walton-on-the-Naze* heralded one almost golden period in the lives of the Madox Browns. As he entered his forties, Madox Brown's energy reached fresh levels. In 1862 the family moved up the road from Fortess Terrace to the handsomest and largest house at the centre of eighteenth-century Grove Terrace, on the borders of Highgate. Here he paid rent for number 14 in sporadic instalments which came to approximately £60 per annum. The house had a sweeping stone staircase, high ceilings with elegant mouldings, tall windows where the light flooded in, a balcony with a wrought-iron balustrade, and a long garden. It gave a sense of peace and space; it was like being in the countryside.

From here, Madox Brown, who had always been a 'fighting man'

and 'a kind of pioneer', began to plot a daring piece of entrepreneurship. From 10 March until 10 June 1865, he would stage an exhibition at Hamerton's Gallery at 191 Piccadilly, devoted entirely to his own works, a highly original venture. One-man shows on this scale by living artists were almost unheard of. The personal retrospective was arranged like an autobiography, to illustrate Madox Brown's development as an artist and display his most important works. One hundred images, in cogent groupings, led the visitor inexorably forward to the heart of the show, his great canvas *Work* – the social mirror of Victorian England. In another 'first', a comprehensive, self-analytical catalogue written by the artist himself, guided the Victorian gallery-goer through the exhibition.

The painting of *Work* had filled his hours and his mind since 1852, at a time when he was living alone, without Emma. He had begun it on Pre-Raphaelite principles, out of doors and in all weathers, in Hampstead, where he blocked out the main action of his action-packed picture. To fulfil the requirements of painting on the spot, from life, he constructed an elaborate painting-wagon, rather like a naturalist's hide. Local children

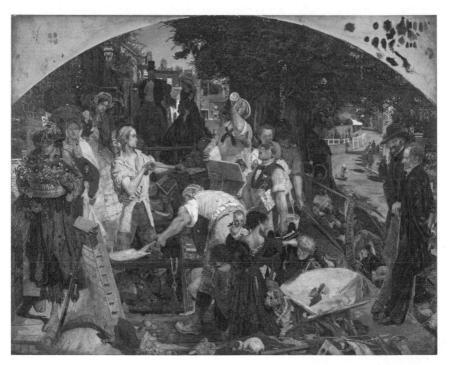

Work, 1852–65: Emma is the figure on the left, behind the barefoot chickweed seller, in the original Manchester version of the picture.

FMB's painting wagon in Hampstead. Spellbound children and dogs in
foreground, artist in check trousers struggling 'with chaos and the devil',
police or 'Peelers' in tall hats, keeping an eye on law and order.

thought it promised a Punch and Judy show, as he wheeled it daily
through the Hampstead streets.

Madox Brown described his state of mind at the time, and sketched his
painting contraption in a letter to portrait painter, Lowes Dickinson, then
living in Italy:

> I now reside [in Hampstead] . . . in a state of seclusion . . . and loneliness
> only to be equalled by that of a captain of a man of war . . . I sent two
> pictures to the Academy with perfect unsuccess unless of abuse . . . I have
> worked about two months . . . at a picture put by for next year, a 20 figure
> affair. This I painted in Heath Street here it being 6½ feet long on a truck
> fitted up by myself for the occasion to the astonishment of all well regulated
> people . . . The Hampstead police I can affirm to be not altogether wanting
> in <u>veneration</u>. While on the other hand <u>wonder</u> developed in the little boys
> to the extent of 'wondering if he stopped there all night' and '<u>how he got
> his vitals</u>?' Enough now of my struggles with chaos and the devil.

He was still retouching the picture in the months leading up to his 1865
exhibition. It was Madox Brown's most controversial painting, a shocking

analysis of contemporary life. It was his most ambitious picture, perhaps the most ambitious English picture of the nineteenth century, a literal parable of social conditions in mid-Victorian times, debating the values of different types of work. In the foreground, heroic navvies labour to lay modern clean-water or sewer pipes. In complete contrast, lolling against a fence on the right, apparently 'doing' nothing, are the intellectuals or 'brain-workers', Reverend F. D. Maurice, founder of the Working Men's College, and Thomas Carlyle, philosopher and historian. It was a novel to be read, a modern morality play to be decoded.

Although he had begun *Work* in 1852, it was a huge subject which occupied him over many years. Whenever he added to the complex picture, it sent him into 'the most ethereal and extatic [*sic*] state possible. I do not hurry with it because it is such enjoyment.' So although he confessed himself 'in a state of great despondency & nervousness' and berated himself as a man of genius who still managed, somehow, to remain unsuccessful, his most demanding picture usually lifted his spirits. 'All day at the design of "Work". This is now to me a species of intoxication. When I drew in the poor little vixen girl pulling her brother's hair, I quite growled with delight.' Growling was becoming characteristic of the Madox Brown register.

Emma played a part in his intricate composition. This time, shading her face beneath an elegant parasol, she posed as a rich married lady, 'whose only business in life as yet is to dress and look beautiful for our benefit. She probably possesses everything that can give enjoyment to life; how then can she but enjoy the passing moment, and like a flower feed on the light of the sun? Would any one wish it otherwise? Certainly, not I, dear lady.' When she first modelled for this figure, it was with an element of wish-fulfilment, for Emma was not prosperous in the mid-1850s. In his commentary on the picture, Madox Brown directed the wealthy lady to raise her gaze from an 'exceedingly beautiful tiny greyhound' to look instead at a group of motherless, ragged, dirty children in the foreground. His purpose in *Work* was moral and political. Emma was a component of his message. Nevertheless, with her love of new clothes, she would have enjoyed posing as a lady of means and fashion.

Ford Madox Brown's exhibition, with *Work* as its main talking point, at last consolidated his reputation with the press, the public and, perhaps most importantly, with art patrons. He took out advertisements in the newspapers and put them up at railway stations, and on 10 March he hosted a successfully crowded private view, in spite of torrential rain all day. Gladstone, Chancellor of the Exchequer, paid a surprise visit, delighted Madox Brown 'by his manners and modesty' and shook the

artist by the hand. The show and the gesture catapulted Madox Brown into the public arena. The exhibition was widely reviewed in papers and journals ranging from the *Saturday Review*, the *Daily Telegraph* and the *Pall Mall Gazette*, to the *Reader*, the *Athenæum* and *Fraser's Magazine*. The critics found it almost unprecedented to see a hundred pictures all by one artist and to absorb a sense of a whole artistic career at a glance, like an anthology or a 'volume of varied contents'. He was an intellectual painter who could examine the emotions of human character in dramatic or symbolic circumstances. For the first time he was acknowledged in public as 'indisputably a true and a great artist'. He could 'do' religion, history, drama, society, landscape, and decoration, and all in his 'own, suggestive, exceptional' style. At last the press recognised his artistic importance, his versatility and real originality. The novel added dimension to this exhibition was Madox Brown's own lively explanatory catalogue. The only artist before him to provide such a catalogue was thought to have been Blake.

On 5 July 1865, Madox Brown calculated that the exhibition had brought in £126 9s. 0d. He had sold over 2,000 exhibition catalogues at sixpence each, and more than 3,000 people had paid a shilling for entrance. However, his financial position remained tight. Entries in a housekeeping ledger book show that his annual income during the 1860s averaged about £800, but so did his outgoings. Like most people he spent what he had, only having cash in hand of a few pounds to carry forward at the beginning of each year. Although he had a small, regular private income from his mother's legacy, and from Elisabeth Bromley's share in Ravensbourne Wharf, he depended mainly on the whims of art buyers and patrons. These included theatrical scene painter Hawes Craven, lead manufacturer James Leathart of Newcastle, banker George Rae of Birkenhead, and perhaps most important of all, stockbroker Thomas Plint of Leeds, whose estate after 1861 continued to pay Madox Brown for the major picture of *Work*, first commissioned five years earlier. Other income came occasionally from private windfalls, sporadically from art dealer Ernest Gambart, from teaching students at a guinea a lesson, and from designing furniture and stained glass for William Morris' Firm of Morris, Marshall, Faulkner & Co. founded in 1861. Madox Brown was one of the original seven partners.

It was an unpredictable but now more substantial income than any he had previously enjoyed. By October 1866, he and the family moved to the more central, and at £96 per annum, the more expensive address of 37 Fitzroy Square, which would become a focus for London's intelligentsia over the next ten years. As soon as he arrived he felt exuberant

enough to play the parlour game of 'Favourite Things'. Many of his answers to the standard questions were mischievous and light-hearted. Who is your favourite queen (Jezebel), artist (afraid to say), author (Anon.), costume (bathing dress), dislike (onions)? His favourite dish was Thunder and Lightning, a Cornish recipe of pilchards, mutton, treacle and garlic, which guests at his table may have dreaded. But a note of absolute seriousness or self-mockery was apparent in his favourite virtue, 'Discretion' (hardly his chief merit), and his favourite occupation, 'Selling Pictures', a wry reference to his hitherto notorious unsuccess in this area. No surprise to Emma perhaps, his favourite amusement was 'Flirting' and his favourite ambition 'To be mistaken for a swell'. Some of his replies signalled a kind of inner truth.

With its elegant Grecian urn above the front door, 37 Fitzroy Square was once well known to Thackeray who used it as the fictional home for Colonel Newcome in *The Newcomes*. From basement to attic there were twenty rooms on six floors, accessed by two stone staircases, serviced by Charlotte Kirby the cook, a housemaid, and a very pretty lady's maid who spent most of her time posing for pictures. With its shabby chic, the imposing house, 'big enough for a castle', was an aesthetic paradise. However, the non-artistic set found it distinctly peculiar. The drawing room was carpeted with coconut matting, which professional and middle-class families usually confined to the kitchens they rarely entered. There were 'common gas burners, & the most extraordinary pictures on the walls; cane-bottomed chairs' and a suspiciously oriental divan in the centre of the room.

Here Madox Brown and Emma, with Lucy, Cathy and Oliver, constantly entertained. 'He had a burst of prosperity; he sold his pictures for some years; his studio became a centre for a whole intellectual life in London; every foreign visitor of distinction came there', Cathy later told her grandchildren. All the Madox Brown women dressed aesthetically and wore daring touches of make-up. There were brilliant parties, animated debates and even fashionable séances. Here James McNeill Whistler met 'the most wonderful people – the Blinds, Swinburne, anarchists, poets, musicians, all kinds and sorts, and in an inner room Rossetti and Mrs Morris sitting side by side, in state, being worshipped'. This relationship with Janey Morris was one of the factors which drove Rossetti past the borders of sanity in 1872. As ever, Madox Brown was Rossetti's true friend. He involved himself to the point of self-abnegation as one of a team of helpers who eventually promoted Rossetti's recovery.

In spite of anguish over Rossetti, the Madox Browns' social life had undergone a transformation. From the day-to-day hardship of their

FMB's List of Favourite Things, 2 October 1866.

previous life in the suburbs, they were now at the centre of bohemian London. Admirers thought the painter the handsomest man in London and the best conversationalist. Once called King of the Pre-Raphaelites, during his party days he was known as a King of Hearts. He kept his beard and hair long, and Emma cut it blunt and square so that he looked like the playing-card king.

Celebrities from the worlds of art, literature and politics congregated at the new Bohemia. It was an eclectic mix of personalities who 'were in the

playbill': Sir Charles Dilke, Lord O'Hagan, several *Times* leader writers, Edmund Gosse, Professor Minto, William Allingham, poet Arthur O'Shaughnessy, Henry Kingsley, Kegan Paul the publisher, and actor Forbes-Robertson who later triumphed as Hamlet. Swinburne got drunk and women spoke up. 'Those were bright gatherings; and those were genial times', where 'amiable' Emma presided as the female focus. The Madox Brown home was 'open house for all who had any interest in art or, indeed, in anything that concerned the welfare of humanity.' One guest, Irish politician and writer Justin McCarthy, never forgot the brilliant things that were said, 'odd paradoxes that were started, and sparkling sarcasms that were tossed about in those nights of extemporaneous discussion.'

English was not the only language to be heard, as glamorous foreign personalities attended, 'numerous Communard exiles & French citizens, Ralston the early translator of Turgenev, with the great Turgenev himself.' Nolly's tutor, Jules Andrieu, an exile after the fall of the Paris Commune in 1871, probably introduced poets Rimbaud and Verlaine to the Fitzroy Square parties in 1872. Among the leading artists invited, the only ban was on Royal Academicians, Madox Brown's bête noire. His loathing of factions and cliques hardened over his lifetime, although he allowed a humorous note to creep into his protestations. 'He hated all Academicians, all Cabinet Ministers, all Officials, all Tories, all Whigs and the *Times* newspaper . . . All Academies – except the *Académie Française* – were anathema.' Madox Brown's and Emma's famous evenings were 'much sought-after among the élite of the pen and brush . . . before misfortunes – and in some cases perhaps too much good fortune – had scattered and shattered the symposium.'

And among the most prominent party visitors noticed by Whistler were two striking and vividly contrasted young women, poet Mathilde Blind, and artist Marie Spartali.

Emma's natural beauty had inspired some of Madox Brown's most indelible images when she had modelled during the 1850s for *The Pretty Baa-Lambs* and *The Last of England*. He would continue to make portraits of Emma such as the nostalgically named *May Memories* (1869) and the more intimately truthful *Mrs Ford Madox Brown* (1869). (See Plates). She would continue to feature in his most erotic pictures, *Romeo and Juliet* (1867–70), *Byron's Dream* (1869) and *Down Stream* (1871).

Emma's physical appeal was undiminished but so was her dependence on drink. His marriage to Emma, who retained her beauty until death, pitched Madox Brown alternately from pleasure to despair, by way of many degrees of irritation. He craved domestic peace and a companionship

Byron's Dream designed and engraved for the title page
of the Moxon *Byron*, 1870.

of the mind. Long ago he had known an intellectual and emotional rapport
with Elisabeth. In the reality of family life with Emma, her sometimes
needy and unpredictable behaviour, with the added pressure of painting
and earning, he had suppressed any hope of recapturing, even partially or
fleetingly, such an ideal. Until one day in 1864 when a talented and very
beautiful new student enrolled in his teaching studio.

III. MARIE

MARIE SPARTALI
10 March 1844–6 March 1927

Marie Stillman by Maria T. Zambaco, 1886, cast bronze portrait medal. The recto is inscribed, dated and signed 'MARIE STILLMAN MDCCCLXXXVI M.T. Zambaco'. The verso, showing madonna lilies, is inscribed 'SINE MACULA' – without a stain, faultless.

GREEK GODDESS

ROM OUR STANDPOINT IN THE twenty-first century, accustomed to bland celebrity looks and digitally manipulated images, it is very difficult to recapture exactly what the Victorians and Edwardians found so captivating in their ideals of feminine beauty. Both men and women agreed that Marie Spartali's beauty was breathtaking, although she herself seemed unconscious of the delirious admiration she aroused. Art was what was important to her, and if she gowned and composed herself like Isabella d'Este in a Renaissance painting, it was in the same spirit as planning one of her own Rossetti-style pictures. Marie was not content to feature in works of art; she wanted to make her own. So although she inspired some feted images of languorous Pre-Raphaelite beauties – Dante Gabriel Rossetti's *Fiammetta*, Madox Brown's *Haidée*, Julia Margaret Cameron's *Mnemosyne* and Burne-Jones' *Danaë* – she determined to take the brush in her own hand to create images of equal mythic beauty. Few other artists understood the collusive alchemy between painter and model as instinctively as Marie Spartali, with her experience from both sides of the easel. But one person who shared this insight was her Anglo-Greek compatriot and almost exact contemporary, the painter and sculptor Maria Zambaco.

Marie Spartali and Maria Zambaco, together with Maria's cousin, Aglaia Coronio, were known in London as the Three Graces. Painters were avid to secure all three as models, either separately, or even better, as a triumvirate. Marie and Maria shared ambitions to create art, as well as to feature in other artists' pictures. Therefore, both went to famous painters for tuition; Marie Spartali to Ford Madox Brown, and Maria Zambaco, first as provocative model, then as student to Edward Burne-

Jones. Unlike Marie, who never posed other than in aesthetic, becoming dresses, Maria Zambaco was daring enough to pose unclothed for Burne-Jones. Life modelling seemed so natural that Aglaia's mother gave a Burne-Jones nude picture of her daughter to Marie as a wedding present. Within both artists' studios during the 1860s, two of these luminous Greek women aroused disturbing passions in their teachers. Madox Brown's obsession with Marie Spartali remained in the mind. But the Zambaco–Burne-Jones affair became the talk of bohemian London and nearly unhinged the lovers, as well as cruelly affecting the artist's wife, Georgie Burne-Jones. Many years later, Maria Zambaco made a portrait of Marie Spartali whose experience had so closely paralleled her own. By choosing to make a portrait bronze, in lineage from classical antiquity, Maria Zambaco emphasised the Greek inheritance of both women, and implied that her subject's personal beauty had an epic dimension.

In 1886, when Zambaco executed her bronze, Marie Spartali was forty-two. She had been married to William Stillman for fifteen years, was stepmother to his two surviving daughters, had given birth to three children of her own, and lost one of them. Yet the profile she presents on this medal, completely innocent of jewellery, is that of a young girl in a high-shouldered Renaissance dress, her dark chestnut hair simply coiled, with the merest hint of a classical laurel wreath crowning her head. Her features are delineated with clarity, her eye unwavering, her nose long and straight, her mouth and chin firmly cut. In spite of the apparent youthfulness of the face, like any immortal Greek goddess unmarked by wrinkle or imperfection, there is an apparently contradictory maturity in her far-sighted gaze. And perhaps it is her central core of stillness that made Marie so compelling to admirers. The reverse of the medal reiterates Zambaco's focus on Marie's calm perfection. A banner flutters with its motto, *SINE MACULA* (without a stain), beneath a three-bloomed spray of madonna lilies, traditionally associated with the immaculate Virgin Mary. Even Marie's name links her to Mary, the apogee of Christian feminine virtue. The three-bloomed lily spray suggests the Trinity of Christian doctrine. Thus the medallion portrait connects Marie with two great mythologies, classical Greek antiquity, and nearly 2,000 years of Christianity. It confers immortality by association and conflates physical beauty with spiritual perfection.

It was a lot to measure up to. But Marie Spartali Stillman had a legendary aura even in her own lifetime. And expectations about her beauty spread across continents. In 1886, the same year that Maria Zambaco immortalised her in bronze, Emma Lazarus from New York visited Marie in London. Emma Lazarus' sonnet, 'The New Colossus',

was the only poem read in October that year at the gala opening of the Statue of Liberty: 'Give me your tired, your poor/Your huddled masses yearning to breathe free'. Although Emma noticed that Henry James was 'over-worked, & over-dined and over-bored & over-everything', he nevertheless told his sister Alice that he'd fallen in love with Emma Lazarus, who said his 'works had converted her from pessimism to optimism'. Emma Lazarus herself was equally bowled over when she lunched with Marie, 'that exquisite creature' who, like a human *objet d'art* trapped in a desiccated marriage, could have been Isabel Archer stepping out of the pages of James's *Portrait of a Lady*, which had been published in 1881. 'I quite agree with you,' Emma reported to her friend Helena deKay Gilder, 'that Mrs S. is the most beautiful woman I have ever seen. I could not take my eyes off the magnificence of her hair & her eyes – & the perfection of the whole woman, head, face & figure . . . She was dressed in black which was very becoming to her – but I suppose anything would be.' Throughout her life, Marie's transatlantic reputation as a stunner fulfilled report and exceeded expectation.

Excitement about Marie and her younger sister Christina began in the early 1860s when they were 'discovered'. A four-wheeled carriage miraculously wafted a flock of painters – Dante Gabriel Rossetti, James McNeill Whistler, Thomas Armstrong, Alphonse Legros, George du Maurier and Edward Poynter – to a garden party at Alexander Ionides' home in Tulse Hill, 'depositing them at the feet of the Misses Spartali. Whistler seized upon Christina, the younger, for his *Princesse du Pays de la Porcelaine*, Rossetti secured the elder, Marie, as a model for . . . *Dante's Dream*, and *A Vision of Fiammetta*.' Armstrong reported 'how he hurried Algernon Swinburne down to inspect the new-found treasures and of how, when Marie Spartali came towards them across the lawn in a white dress trimmed with little bunches of coloured ribbon (afterwards reproduced by Rossetti in his *Borgia* watercolour), the young poet could only murmur feebly, "She is so beautiful that I want to sit down and cry." Theirs was a lofty beauty, gracious and noble; the beauty worshipped in Greece of old, yet with a wistful tenderness of poise, a mystery of shadowed eyes that gave life to what might have been a marble goddess; a beauty which would seem to possess much of that marble's eternity.'

Many worshippers noticed that Marie's beauty was a palimpsest of Janey Morris's more sultry looks, except that, in spite of her Greek forebears, cool and willowy Marie was not as Mediterranean-looking as Janey. When Janey wasn't available to pose, Rossetti turned to Marie for

her lovely face, elegant figure and long tapering hands. 'The two marvels had many points in common; the same lofty stature, the same long sweep of limb, the "neck like a tower", the night-dark tresses and the eyes of mystery.' To say that Marie Spartali was 'Mrs Morris for Beginners' as the theatrical painter Graham Robertson quipped, was an oversimplification. Unlike Mrs Morris, whose saturnine glare repelled as many people as it attracted, observers never differed on the beneficent impact of Marie's beauty. Nor did time seem to take its usual human toll on her face. Instead 'the years crowned it with an added perfection.'

Unlike Elisabeth Bromley and Emma Hill, the first two, English, loves of Madox Brown's life, Marie Spartali's ancestry was exotic. Her parents were Euphrosyne Valsami and Michael Spartali, prominent shipping magnate in the Victorian business world and Consul General for Greece in London. Although her family was well established and assimilated, and Marie had been born in London on 10 March 1844, she was only first-generation Anglo-Greek. Both her parents were refugees from racial persecution in Turkey: Euphrosyne Valsami's family first moved to Genoa, and the Spartalis came from the expatriate Greek community in the ancient city of Bursa, on the Sea of Marmora in Turkish Asia Minor. Michael Spartali left by way of Smyrna, Trieste and Switzerland, to seek eventual asylum in London where, in partnership with another branch of the family, he founded the international shipping firm Spartali & Laskarides.

Marie and her equally lovely sister Christina received an unusually scholarly education at home from tutors in ancient and modern Greek, Latin, French and German, as well as music and art. Christina played the piano to near concert standard, while Marie took professional singing lessons with Manuel Garcia who taught Jenny Lind, the Swedish Nightingale. Marie's voice had an exceptionally beautiful timbre. Her intellectual qualities combined with her physical allure so that she seemed to embody the wisdom of a modern Athene with the loveliness of Aphrodite. She moved through artistic and bohemian social circles with the unconscious grace of a latter-day Greek goddess. Of all the beauties who aroused Rossetti's admiration, Marie 'was probably the most gifted intellectually. Of an ancient and noble race, austere, virtuous, and fearless, she was not lacking in caustic wit and a sharp tongue', observed William Michael Rossetti's daughter Helen – who valued wit. 'One felt it a great privilege to be *persona grata* with her – not to be found utterly wanting by those clear, rather mocking grey eyes.' She was liberal, too. While other

women – and men – listened in decorous and reverent contemplation to Dante Gabriel Rossetti reading his sexually explicit poem, 'Jenny', Marie was quick to voice her glowing admiration.

Marie was not only transcendentally beautiful in the eyes of many mid-century artists, she was also a captivating personality, emotionally sensitive, and a staunch friend. She maintained a life-long friendship with fellow artist, Lucy Madox Brown, becoming the 'most intimate and the most beloved of all Lucy's female friends'. Marie's tact ensured that their friendship survived in the studio, in spite of the embarrassment of Lucy's father's infatuation. In the years after both women married, Lucy's husband, William Michael Rossetti, considered Marie one of his 'most cherished friends'. A serene and generous temperament ensured that Marie retained the equal love of both William and Lucy without making them rivals, an unusual skill. Marie understood all kinds of love which included a long, platonic friendship with Vernon Lee (Violet Paget), the forceful lesbian celebrity who offended everyone else.

Marie's beauty remained legendary into old age – 'like entering a vault and discovering Queen Nefertiti' – as Mario Praz said. It was the perfect dramatic frisson for the distinguished Italian scholar of English literature. As a very young man, yet to write his pioneering study *The Romantic Agony*, he came to London. Here he visited Marie, now nearing eighty, on 23 March 1923, still trailing clouds of Pre-Raphaelite glory. Mario Praz never forgot the romantic atmosphere of mystery and solitude that Marie spun around herself, even though in widowhood she lived with many members of her extended family. He noticed how her profile 'stood out, clear-cut and still pure, against the grey sky of London'. It was the same profile Maria Zambaco had cut and the same purity she had underlined – *sine macula* – nearly forty years earlier on her bronze portrait medallion.

As Mario Praz recognised, Marie's beauty, like Nefertiti's, had a remote, mythical quality. None of the artists who adulated Marie found it easy to capture her essence in their pictures. She eluded them. They discussed placing her this way and that way against the light but were forced to confess that her lustrous head was the most difficult they had ever attempted. Her appeal depended on a 'subtle charm of life' that they could never perfectly replicate. The charm was in the challenge.

What was the romantic history of this beautiful girl? Arousing so much admiration and desire, did she feel desire herself? Curiously, very little scandal attached itself to the name of Marie Spartali, until she fell in love, disastrously and irrevocably, in 1869, when she was twenty-five.

Marie felt no urgency to surrender her single status, although Michael Spartali would have welcomed either of the Rossetti brothers, Dante Gabriel or William Michael, as her suitor. Only one sensational rumour survives. Apparently her beauty had attracted a dissipated aristocrat, Lord Ranelagh, who 'was madly in love with her and had actually proposed. It would seem that at least for a time she was equally attracted', reported Diana, Holman Hunt's granddaughter, a century later. Hunt himself wrote to Frederic Stephens (like Hunt, one of the seven co-founders of the Pre-Raphaelite Brotherhood) confirming there had been an aborted but once 'intended marriage with Lord Ranelagh which the beauty had set her heart upon and which his Lordship too had condecended [sic] to agree to . . . I only wonder that all the young men with roman noses did not fight about her that is before the Ranelagh infatuation wich wld naturally take the presumption out of any fellow of ordinary degree.'

Thomas Heron Jones, 7th Viscount Ranelagh (1812–85) was thirty-two years older than Marie, an army officer and estate owner, once a notorious rake and still a man about town. He was a natural target for Carlo Pellegrini, portrait caricaturist of *Vanity Fair*, in whose pages Lord Ranelagh featured, top-hatted, cigar-smoking, thickly bearded, his now stooping, tightly buttoned figure leaning heavily on a cane. It's hard to imagine what Marie saw in him apart from raddled glamour. She didn't need the lord's money as, at this stage, her father was wealthy. The Ranelagh story seems out of character with Marie's inclinations. She much preferred romantically impecunious heroes she could 'rescue' – and indeed the report is only attested by the Holman Hunts. However, Marie had an impetuous streak and the rumour may have some basis in fact. The strange thing is that Holman Hunt's own bungled, early love life was once entwined with Lord Ranelagh too. Hunt had adored the voluptuous prostitute, Annie Miller, but declined to marry her without an education. Naturally Annie preferred dancing at Cremorne Gardens by night to studying schoolbooks by day and her crowd of admirers cheered her on. While she modelled for or frolicked with Pre-Raphaelite associates like Frederic Stephens, George Price Boyce and William Michael Rossetti, her worst crimes, in Hunt's view when he returned from the Holy Land, were to consort with Dante Gabriel Rossetti and to become Lord Ranelagh's mistress. It was no surprise that Marie's father, Michael Spartali, considered the ageing, slippery lord an unsuitable match for his peerless daughter.

CHAPTER 11

ART STUDENT

MARIE DECIDED TO BE MORE THAN THE PREY of fortune hunters, or an idolised muse. From her lessons in the schoolroom, a love of drawing developed into serious ambition. But amateur tutors at home had their limitations, so in spring 1864, at the age of twenty, she resolved to take her talent to new, professional levels. Marie asked Papa to approach Dante Gabriel Rossetti for lessons but Rossetti was still recovering from Lizzie's suicide in 1862. Nor was his heart in teaching. He passed the request on to 'old Bruno', knowing the commission might boost Madox Brown's always uncertain income. Almost too late, Rossetti realised the identity of Madox Brown's prospective student. 'My dear Brown,' he wrote, 'I just hear that Miss Spartali is to be your pupil, of which I am glad. I hear now too (which I did not know before) that she is one and the same with a marvellous beauty of whom I have heard much talk. So just box her up, and don't let fellows see her, as I mean to have first shy at her in the way of sitting,' he added proprietorially.

Marie enrolled in 1864 at Ford Madox Brown's teaching studio, first in Kentish Town, then in Fitzrovia, where he trained his daughters Lucy and Cathy, and son Oliver. Other students attended, including Theresa Thorneycroft and Nellie Epps – who later married Edmund Gosse. They were all precociously talented. Madox Brown ran his art classes like the ateliers of the early Florentine masters, in a working artist's studio with all the associated buzz – competitive, striving and animated.

Unlike many professional artists, Madox Brown was impassioned about teaching. He believed the power of making things clear should be one of art's highest priorities as well as the chief function of an art teacher. Ever

since his year as head teacher of the North London School of Drawing during 1852–3, Madox Brown had evolved his own aims and objectives. Energising his students, who were mainly working men of humble backgrounds, hungry for instruction, had been equally rewarding for their tutor. He was proud that 'the numbers for several years were kept up to near a 100' at the school. 'The thing was a great success; about 180, I think, male & female pupils', Madox Brown recalled, perhaps inflating the numbers in retrospect. Marie was not the first intellectual young woman he had taught. 'I had the honour of teaching the poet Christina Rossetti there for a few nights. She bid fair [to] draw as well as her brother had she continued.' Later in the 1850s he took over from Dante Gabriel Rossetti, teaching evening classes at the Working Men's College in Camden Town.

Madox Brown had methods. He based them partly on his own art training as a boy in the academies of Bruges, Ghent and Antwerp, but more significantly on his special philosophy of teaching. Indeed he laid out a very clear programme of art for mixed-ability groups which he sent to the principal of the Working Men's College where Ruskin taught. Explaining that art formed 'one of two grand subdivisions of mental culture (science the other)', Madox Brown set out a humane teaching manifesto – to foster the individual talent of each and every student. 'I teach with the object of developing by the readiest means the Art faculties of the students – but in special instances I modify the course to suit their peculiar case.' He balanced practice with theory, advocating not only life classes but also history of art – especially the study of pictures by Hogarth. His classes encouraged 'drawing in french chalk & pen & ink & painting in oil & water-color from life – still-life & casts from nature. Students are advised to inspect all Public galleries, rejecting pictures painted during the 18th & latter half of the 17th centuries (excepting Hogarth & his English contemporaries).' Rejecting the grandiose or the artificial, he always stressed realism, a doctrine dear to the eyes, hearts and hands of his evening-class students. Although his programme of 'Art Education for Working Men' was rigorous, it was enlightened – and his students knew it. He was such a committed teacher that a group of twenty-one students from his evening class at the North London School, working men – Thomas, Harwood, Cooper, Mills, Inman, Short, Medcalfe, Boulson, Burge et al. – wrote to him in careful copperplate, to express their thanks for his methods and encouragement:

We consider it is owing to you that we have succeeded so well as we have done, some of us having begun with the greatest diffidence have succeeded

in making a tolerably good drawing, and we all hope by strict attention and perseverance to show that your kindness is not thrown away on us, & everybody must acknowledge that the greatest encouragement to a beginner is a Kind Master.

Students had to draw exactly what their Kind Master put in front of them, whether it was an antique plaster cast or his own handsome face. If he didn't like their first efforts he would make them start all over again, until they got it right. It was part of Madox Brown's creed of realism and attention to detail. Students couldn't attempt avant-garde subjects without discipline and traditional draughtsmanship. When Rossetti came to Madox Brown for tuition in 1848, his first assignment was to copy some pickle jars. The dreary still life was far from the imaginative project he had expected. 'His aspiring soul chafed sorely against the pickle-jars'. Nevertheless Rossetti set to and painted the pickle jars well enough for Madox Brown to keep the study all his life.

By 1864, when Marie joined Madox Brown's private classes, the major academies of the time still excluded female students from life drawing. However, within the privacy of his studio, Madox Brown's students were

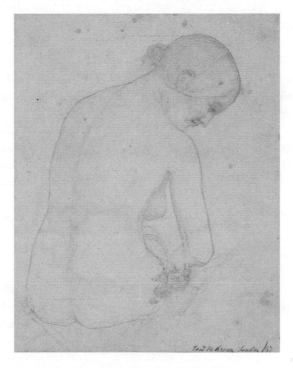

Female nude, approx 1847.

probably encouraged to draw from the nude model – a crucial element, he believed, in any artist's training. Since his early art training in Belgium, Madox Brown had made studies from the nude, preparatory to final compositions. He had openly discussed them with his first wife, Elisabeth. One of his daughter Lucy's drawings, listed in William Michael Rossetti's picture collection at his death, was a nude female study dated 1860, and in 1869 she made a fine drawing of a male nude from classical antiquity, *The Dancing Faun*. As he told Marion H. Spielmann, editor of the *Magazine of Art*, 'any attempt to discard the living model would amount to doing away with art itself', and he advocated 'alternately, the study of the nude & the study of the antique statues.'

Madox Brown generated enthusiasm and application in his students by force of personality and by varying his teaching methods. Studio lessons were augmented with field trips to museums and galleries. Unconstrained by narrow social conventions, he proved a natural educator. When Marie joined Madox Brown's studio in 1864, Cathy had already been training there for nearly four years, since she was ten:

> At eight every morning she was in her father's studio preparing his painting things for him. After that she would draw whatever he placed before her, sometimes plaster casts, sometimes his own head. If he did not approve what she had drawn, he would scratch a line right through it and make her begin again and again until she had got it right. The aim was to draw exactly what she saw. Thus she was disciplined. 'Drawing', she said, 'can be taught, but colour comes naturally to an artist.' There was no theory about the mixing of colours, no rule as to how they should be put on [. . .] In the studio from early morning she painted until midday. After lunch they would rest for half an hour and then work again until 4.30, the tea-hour. Then, whether she liked it or not, she went for a walk with her mother [Emma]. At 5.30 they would return and help Madox Brown to receive his friends; and at 6.30 the first bell would go and they would dress for dinner, at which William Rossetti, Swinburne, Edmund Gosse, and Peter Paul Marshall would often be present, Dante Gabriel Rossetti coming in afterwards, when they would all return to the studio for the evening.

This extract from one of Cathy's obituaries in 1927 evokes the routine and excitement, the day-long devotion to studio activities under Madox Brown, the dynamic and inspiring teacher whom Marie Spartali encountered at her first lesson.

EROS IN THE STUDIO

L ITTLE MORE THAN A YEAR AFTER MARIE FIRST joined the studio, Madox Brown's diary entries were laconic but informative: 'Miss Spartali. Painted at Cathy in the "nosegay". Had to leave off to go after Emma (5 hours).' In eighteen brief words he gives us the essentials of his life on one typical day – Friday 15 September 1865. We know that Marie came for her lesson, that he had to interrupt his work on *The Nosegay* – a picture of an airy blonde girl gathering flowers or hearts, for which his daughter Cathy was modelling – to go in search of Emma, perhaps out shopping or drinking. Yet in spite of disruptions he managed a tally of five hours' work that day. In 1866 his diary entries became even terser. From July that year until January 1868 when the diary terminates, entries are either left blank, or simply record the dates of Marie's lessons, with a sole word repeated – 'Spartali', 'Spartali', 'Spartali'.

It was a classic scenario in reverse, an erotic transfer of power in which the teacher became enthralled with his student, unattainable as a Greek goddess. Apart from her beauty, there was another motivating factor. Marie was the first woman Madox Brown had loved who was determined to pursue a professional career. And a career in art was one in which he could actively participate and promote. Not for twenty years had he been able to enjoy intellectual parity with the woman he loved, not since the death of Elisabeth in 1846. Marie's intelligence, refinement and, above all, her innate virtue recalled the ghost of Elisabeth Bromley. And every mental, physical and social attribute made Marie the polar opposite of his present wife, Emma Hill.

Without uttering a word that could be construed as encouragement, from the moment she first entered Madox Brown's studio at the age of

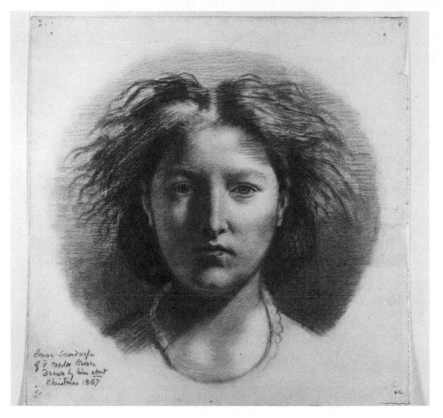

Emma stares back at FMB, Christmas 1867.

twenty, Marie inspired 'Love's Problem' in the tormented heart of her teacher, who was now in his late forties, only a year younger than her own father. Exerting restraint in her presence only intensified his longing. Because it was an impossible love, it had to remain unspoken. But that didn't silence his persistent, internal monologue of longing and questioning. The proximity of the studio lessons, the allure of a beautiful young woman eager for instruction, the sexual subtext of many of the subjects on the easel, *The Nosegay*, *Romeo and Juliet*, the book illustrations for Byron's erotic poems, the power of desire in the head, drove him to silently compose love letters he could never send.

Instead of love letters, however, he chose another outlet for his passion, writing sonnets. Since Petrarch loved Laura in the fourteenth century, the sonnet became the convention for unrequited love. Its various rhyme schemes are prescribed; its fourteen-line structure tight and compact. When sheer emotion is pitched against the sonnet's technical form, the result can be personal, anonymous and universal, all at the same time.

Lovers who are not writers are often driven to write poetry, perhaps for the only time in their lives, by an unlooked-for emotional experience. Rossetti had translated Dante's autobiographical sonnet sequence, *La Vita Nuova*, in 1850. His soon-to-be notorious *Poems* of 1870 would contain *The House of Life*, another sonnet sequence, analysing more dangerous, erotic aspects of love. 'A Sonnet is a coin: its face reveals/The soul.' Was there a sense in which Madox Brown turned lover and sonneteer in order to keep up with his old friend? His obsession with Marie drove him to poetry, endlessly drafting and redrafting.

Madox Brown had written sonnets before, notably about Hogarth in 1853, and again in 1865 to accompany his pictures of *Work* and *The Last of England* when he showed them in his London Exhibition. Now *in extremis*, he turned to words, not images, as his most immediate means of self-expression. The swift way he could compose a sonnet was quite different from his meticulous, slow painting methods. He felt freer in poetry, an art not his own. For once, he could suspend his unremitting perfectionism.

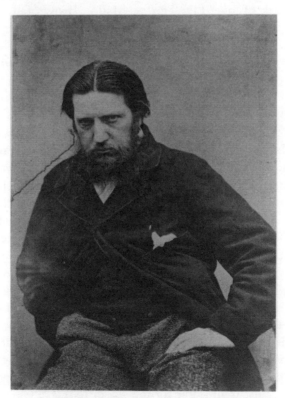

FMB moody in the mid-1860s.

As soon as he started writing, the sonnets became an integral component of his secret love. He threw himself into writing them with an abandon he could not demonstrate in the studio. Although he always found handwriting hard graft, now he incessantly recopied his poems into an exercise book specially bought for the purpose. He headed the whole sequence 'Hopeless Love – Sonnets by Ford Madox Brown', ensuring his love might be left to posterity, his pain recorded as a testament to individual human experience. Did he ever imagine they would be published? As he intended, perhaps, they were preserved. Whether by oversight or by intention, his daughter Cathy did not destroy them at his death. Writing poetry was a safe outlet in an unsafe situation, a step away from naked autobiography or diary-keeping.

It was a predicament of inappropriate emotions, a midlife crisis, similar to Hazlitt's 'fatal passion' in his forties for Sarah Walker, also twenty years his junior. The urbane essayist had found the only outlet for his craziness in writing a secret confessional memoir, *Liber Amoris* (1823), his book of love. Like Hazlitt, Madox Brown felt he had been attacked by love itself, poisoned and maddened by its force, which like a 'Fake Cupid' swept uninvited into his life. His 'heart's magazine' was stacked with incendiary devices likely to explode from within at any moment – almost physically an 'Amor Incendiaris', an incendiary love. But whereas Hazlitt was conscious of a huge cultural and social gulf between himself and his serving-girl, and despised her as much as he desired her, Madox Brown had every reason to idolise his mortal goddess. Although of foreign extraction, Marie was the most 'upper class' woman of all the women Madox Brown loved. And in spite of the authority vested in teachers, their social status in the nineteenth century, from governesses to dancing masters, was only on the cusp of acceptability. Madox Brown's position as Marie's teacher, at a guinea a lesson, could have made him feel as socially anomalous as Herr Klesmer, the piano tutor who fell in love with Miss Arrowpoint in George Eliot's *Daniel Deronda*.

Reflecting the torment of unrequited love, the painter-turned-poet chose oxymoronic titles to express the agony of his inner conflict: 'Cruelly Kind', 'Absent Presence', 'Mute Worship', 'Change in Constancy', 'Angela Damnifera' and 'Pleading Contraries'. Others he frankly titled 'Hopeless Love', 'Late Love', and 'Voiceless Love'. The first sonnet, the 'Enigma' of 'two blind loves' – with its insistent play on oppositions and paradox, set a transparent riddle for the reader to guess:

Blind Love! My slave in youth, and lord in age
>> Because in pride I scorned a friend brought low
>> As falsely true to Love, hath aiming through
An old wound, struck again in his blind rage.
Now two blind loves have made my heart their cage
>> One mine, & one not mine whom I forego,
>> Yet mine the more, as longed after as so
And still to <u>mine</u> no slight doth this presage.

For her I long for, I would not possess,
>> And most desired, her coming I debar;
I speak her fair but in my loneliness,
>> And grief & pain my joy & pleasure are;
Come read my riddle all ye who do confess,
>> A treasonous faith to Love, at Love's own bar!

Who are the two blind loves in his heart? 'One mine' is of course his love for Emma, his legal wife. And 'one not mine whom I forego' is his love for Marie, his 'most desired'. While admitting 'a treasonous faith to Love,' he claims there is no real threat to Emma because 'her I long for, I would not possess'. To read his riddle is easy enough.

Again and again he lingers on the sorrow that this love has come too late, 'like Autumn primroses', to emphasise his 'shortening days'. Again and again he protests that his love is platonic:

Be mine no doubtful theme. I sing her praise
Who taught my senses first unsensual love.

He had to resort to the exchange of ambiguous glances. Recognising that his love was probably hopeless, he knew he must not voice it to Marie. He dared not 'for my honour say I love,' though 'that it were best concealed I do agree'.

The strain made him listless and absent-minded. His thoughts became a tangle of contradictions. He was an 'Absent Presence'. 'Men call me absent, that when spoken to/They see my thoughts are centred far away.' Caught in the agonising stasis between telling his love and suppressing it, he never by word revealed his love to Marie. And because of Emma, the mother of his children, he knew his obsession must remain secret forever. However in the third sonnet of the sequence, he abandoned all caution, to make play with other muses who shared Marie's name:

'Her Name!'

Mary! saddest of all sweet names that are,
 How more than sweet or saddest unto me,
 O name of her that mine can never be!
Art thou become, that so surpassess far
Each namesake. Mary of the 'lingering star'[A]
 And Shelley's Mary[B] waiting by the sea,
 And Byron's frenzied first-love,[C] – lastly she[D]
Scorching to lust her poet worshiper,

These shall be famous for their lover's fame
 Or hapless lives – but thou more graced shalt pass
 To future ages (with my name alas!
Untwined) a peerless heroine without blame;
And caught from child-learned litanies I exclaim
 '*Je te salue Marie pleine de grâces*'.[E]

Madox Brown's claims for his beloved are expressed in hyperbole. Indeed, in the final line, by reference to Christian ritual, his Greek Orthodox model of grace is no less exalted than the Virgin Mary. 'A peerless heroine', his Marie far excels all these other Marys adored by literary lovers. It is her name that will surpass all theirs in posterity, although he laments she can never be 'Marie Madox Brown'.

'I must again behold her or go mad!' he scribbled on one empty sheet. But 'sense and honour both bid me reflect', he conceded. Prevented from confessing his love, he played on imagery of eyes and seeing, persuading himself 'that she my loved one sees my love I see'. He could hardly wait for her next scheduled lesson. When they met at last, he convinced himself that 'An Understanding' existed between them:

 We met! no word disclosed what either thought,
 I touched her hand – we proffered greetings staid
 And interchange of friendship soft – such aid
 To bridle passion's eloquence I sought.

[A] Burns' 'Highland Mary'.
[B] Mary Shelley, née Godwin, daughter of Mary Wollstonecraft.
[C] Mary Chaworth.
[D] Mary Gordon, Swinburne's cousin.
[E] Hail Mary, full of grace.

Only my faltering voice's tones in ought,
 Belied the calm of sentences well weighed
 As I, with quivering lip the mentor played,
With moistened eyes – unteaching as I taught!'

While she, with those mute-speaking orbs but gazed,
 For pity on me, showing no surprise,
 And now O Love! past skill of calumnies
We are agreed: through the long years, amazed
I clasp my prize! on giddy height upraised,
 For Oh! a tear-drop glistened in her eyes!

In spite of admitting that 'no word disclosed what either thought,' a single, imagined teardrop was sufficient to feed his fantasy. Studio sessions brought them together but still obliged him to play the mentor, increasingly straitjacketed in that role. His student's speaking eyes recurred in the sonnets, but they told him nothing. Wilfully, he misinterpreted their messages. Restrained from voicing his inmost desires, he was reduced to the unrequited lover's stock fantasy – the delusion of exchanged looks. On the one hand, he recognised that Marie was an innocent, but an innocent whose soft glances spelled out his ruin. 'Of all the torments known beneath the sun,/O! loved one, surely you impose the chief,/In that your eyes provoke love past belief.' On the other hand, could she be intentionally refusing to read his 'passionate glare', he wondered?

 The truth was that Marie honoured him simply as her art master. Her capacity for love was unawakened. She was, at this time, virginal to the core of her being. He tried to transfer the burden of her non-response on to her, to find fault with the sovereign beloved whose glance may not be benign – for where her 'glances fall 'tis ill for some!'

Marie could not return Madox Brown's passion although, at some buried level, her empathetic nature may have been aware of his anguish. Outside her art classes, Marie moved in charmed circles; by birth, in the diplomatic, cultured, Anglo-Greek sphere, and by choice, within the bohemian and artistic orbit. Everyone admired her as she moved regally through her social calendar of parties, dinners and receptions. She had the leisure and the inclination for romance, and she was stirred by political, even lost causes that linked her to Greece, the exotic homeland she had never seen.

The Cretan uprising against the Turks of 1866–8 had been the talk of the Anglo-Greek community and of the newspapers. Marie's father, Michael Spartali, found his work quadrupled by the political situation. One of his more impulsive tactics was to try to involve the world of artists and poets which his daughter knew. 'Dear Swinburne,' wrote Madox Brown in January 1867, 'Mr Spartali the Greek Consul . . . thinks a poem by you on the unhappy Cretans might have the effect of rousing the public attention as perhaps nothing else would. If you could only get the steam well up at once you would be doing a good action & oblige a whole nation including <u>Miss</u> S.' If Miss S's father had been able to read the future he might not have been quite so keen to support the Cretan champion, the American William James Stillman. And equally, if Madox Brown had been able to foresee the outlook for his lovely protégée, would he have been quite so eager to urge Swinburne's stanzas to soar like 'tongues of flame'? 'I know you will & can do it & we are all in excited expectation of the event! You will understand that the Consul himself writes to me to ask this of you & it will be the richest gift you can make to the cause of these real heroes.' Anything that linked Madox Brown to his Greek goddess, or could render service to her, excited him. Sympathy for the Cretan cause in London was fired by Swinburne's response in his impassioned 'Ode on the Insurrection in Candia [Crete]':

> It is not a land new-born
> That is scourged of a stranger's hand,
> That is rent and consumed with flame.

★

William Stillman, a widower, arrived in London with his three children in September 1869, after acting heroically as American Consular Officer during the Cretan rebellion. People were divided about William Stillman. Born on 1 June 1828, he was the last of nine children in a New England family of Seventh Day Baptists, brought up in Schenectady, upper New York State. 'Hell and its terrors' were constantly invoked. In childhood, he was sent away to school, and this early separation from his family may have contributed to his emotional immaturity as an adult. He was always a loner with a deep sense of hurt and alienation. After graduating in 1848 from Union College, Schenectady, he aimed to become an artist of distinction, and indeed trained with a series of painters, including the landscapist Frederick Church. In the studio he met other artists of the Hudson River school and was influenced by Ruskin's *Modern Painters*. However, he slowly realised that his talents would be more realistically

channelled into art journalism and his excellent photography. But his sense of artistic disappointment set the tone for his later harsh criticism of Marie's pictures.

A failed artist with a hunger to make his mark in the world, Stillman turned to diplomacy, serving first in the American Consulate to the Vatican. Then in 1865, Abraham Lincoln appointed him Consular Officer in Crete. Here he became a pivotal figure during the violent uprising. Both the Greek government in Athens, as well as the islanders who suffered under the Turkish regime, trusted his judgement. In one daring incident, he arranged for the besieged community to escape by sea. Stillman supported the Cretans' underground resistance and campaigned to raise money and arms for them through his contacts in London.

When he reached London, he was feted at a series of rapturous receptions hosted by the Greek community, and at one of these, on 7 September 1869, he met Marie at her parents' luxurious home, The Shrubbery, on Clapham Common. However, Michael Spartali's enthusiasm quickly dissolved when he realised that his daughter Marie was fascinated by more than Stillman's politics. The American was clearly penniless. Even worse, Marie's parents learned that Stillman's first wife, Laura Mack, who had remained firm during the siege on Crete, had collapsed with post-natal depression after the birth of her third child, Bella, and recently committed suicide in Athens. Stillman maintained that Laura had been mad and suffered religious delusions. He was keen to distance himself from Laura's condition in case it reflected on himself or their marriage. He always found the business of childbirth particularly distasteful and contrived to be as far away as possible when his children were born.

But Marie knew nothing of Laura. Stillman arrived in prosaic London trailing an aura of heroism – in complete contrast with the diplomats, businessmen or even the artists that Marie knew. She, who appeared to have everything, made the American, who appeared to have nothing, her personal cause. He was an older man, sixteen years senior to Marie, only eight years younger than her father. Stillman's experience in diplomacy and the field of war was completely foreign to her own life in drawing rooms, concert halls, garden parties and studios. He was as exotic to her as Othello was to Desdemona, and the tales Stillman told Marie of daring exploits just as thrilling as the stories with which Othello wooed his love. As Othello was physically impressive, so was Stillman. He was quite different from the (mostly) short Greeks Marie met in London, and equally unlike the pallid bohemians. Stillman was tall, at least six feet three inches, but as delicate as a larch. Marie too was unusually slender,

unusually tall, close to six feet, and in spite of her beauty, may have been awkward about her height. Even Madox Brown her teacher, a man to whom in every other sense she looked up, was just over five feet seven inches. When she met Stillman she found a man to whom she did not need to stoop. This physical matching was a significant factor in her instant attraction, her sense of being at ease with a man. In another way they were a match for each other – both were outsiders in London. Marie's exotic background was paralleled to some extent by Stillman's American roots. His foreignness excited her compassion and empathy.

In an emotional sense, however, Marie was not looking for her 'match' but her complement. Secure in her wealth and her looks, she allowed courtship roles to be subtly reversed. It was as if Marie assumed the role of the knight and Stillman the damsel in distress. His neediness aroused her instinct to rescue. Her hero from the Cretan campaign, with three motherless children, one of whom was an invalid, was openly prepared to trumpet his poverty. These were the losses that spoke to her. Although she was now twenty-five, and despite her expensive education, Marie was naïve when she met Stillman. Her heart had never been touched. She had the outlook and inexperience of a Victorian seventeen-year-old. In her circles, even the most intelligent women would have been inexperienced emotionally, and sexually. Stillman completed a lack in herself. He supplied the older man, a father figure to replace her dominant Greek father. Unlike Madox Brown, the father figure in the studio, Stillman was available, and actively seeking as swift a remarriage as possible. Only marriage could supply him with instant childcare, unpaid housekeeping, freedom to resume his political career, and perhaps cash in the form of a dowry. Her parents viewed his blatant material needs from quite another perspective.

For him, the personal made the political possible. Unknown to Marie, but glaringly obvious to her parents, the political would make the personal impossible.

Meanwhile in Madox Brown's studio, the heady proximity of work and love, Marie's beauty combined with her artistic ambition, continued to exert its potent charm. The romantic subjects she worked up on the easel, such as two 'heart-sisters' discussing the object of their love, provoked a responsive sonnet from her teacher who called it 'On a picture by Marie Spartali showing two maidens clasping each other over a low wall by the sea'. He described Marie's favourite visual motifs, magic groves and peacocks, her aptitude as a colourist for the 'slanting rays of sun-set skies',

but as always reverted to his most dreaded theme, the chill of 'death's foot-fall' on his 'hopeless love!' One sonnet in November 1869, he inscribed:

'On a painting by Marie Spartali representing herself amid fields, sitting
 with a treatise of mathematics in her lap, & a laurel-crown on it.'

> This is that sov'reign lady of all bliss,
> The baffling aim of every man's desire
> With snow-like purity to feed his fire
> With tantalizing lips that none may kiss;
> And should one rashly think to make her his
> Enslaved he shall remain who did aspire
> To own those matchless eyes, yet shall not tire,
> While from their depths some song is heard like this;
> I am love's problem! Ye who thread his maze,
> Be warned! My crown proclaims your martyrdom!

In his rational moments Madox Brown knew that it was he, not she, who was 'Love's Problem'. His mute worship of 'Mistress never to be mine!' continued into December 1869. The intimacy of the studio was both agony and opportunity, as he watched her 'grecian-like', beside the firelight hearth at the end of the short winter's day.

With the escalation of his yearning for Marie came its corollary: his sense of entrapment in marriage to Emma. United since 1849, together they had brought up their children, faced financial worries, the death of infant Arthur in 1857, Emma's miscarriage and subsequent illnesses, as well as her alcohol addiction. A month after exchanging, as he thought, 'passionate glares' with Marie, he addressed a revisionist sonnet to his wife in December 1869 – 'Sweet love of twenty years, still young and fair/Impassioned mistress, friend and wife in one', trying to convince himself, and reassure Emma that 'You still shall be my heart's best care.' Unlike his adulation for Marie, which he knew was a 'card-like castle – built of air', love with Emma was solid reality. He never forgot the passion of their early prenuptial days, the outdoor sexual adventuring that she so frankly relished:

> Nor can I yet forget our April sun,
> Of raptures, beggaring comparison!
> The hazards we did wanton in & dare!

He acknowledged that Emma's allure was still 'Venus-like', and that

Emma, like Marie, possessed an innate 'nobility which neither smart,/Nor lassitude can weary out'. His wife of sixteen years should rest secure that her 'best features will endure'. Emma triumphed, not merely as the famous face in his most celebrated paintings, but also in his affections, 'because your failings grow not from the heart', he added in a final, throwaway line. What recipient of a love poem or a love letter likes to be reminded of her failings? Whether or not Madox Brown showed this sonnet to Emma, her reactions to it are unrecorded, though she may have sensed that the denouement was imminent.

At New Year 1870, Madox Brown was still wallowing in 'Idle Groans', complaining he was in hell, that Marie remained 'unfathomable', and indulging his desperate speculation that 'You either have no love for me at all/Or you do hide your love for me too well'. In darkest January, Dante Gabriel Rossetti came round at midnight to break the dread news to Madox Brown of Marie's decision to marry Stillman. Eight years after Lizzie's death, Rossetti was the perfect confidant: his own adulterous love for Janey Morris, trapped in her unhappy marriage to William Morris, was at its height. Janey was to model as Proserpine for Rossetti's portrait of infernal love. Sonnet writing had become the outlet for both men. Madox Brown wept on his friend's shoulder until dawn broke and brought final confirmation of his loss from Marie herself. His next sonnet, addressed to Rossetti, told of an end to all his unspoken hopes of Marie. On 16 January 1870, he knew he was a wrecked man:

> My friend at midnight brought me word how she
> My unwooed love would wed another man.

Madox Brown remembered that bitterest of days but kept silent and forced himself to promise the lovers his help and support. It was one way he could stay close to Marie, 'who only sees in me her truest friend', he told himself.

THE ENGAGEMENT

ON 15 JANUARY 1870, JUST FOUR MONTHS after their first meeting, Marie Spartali announced her engagement to William James Stillman. 'An heiress with all London at her feet', Marie was in love with a man her parents considered spectacularly unsuitable.

The Spartalis met all appeals from the couple with threats of disinheritance and their own imminent suicide. But Stillman's warnings of illness escalated into suicide threats more portentous than any issued by Marie's mother. 'Dear soul,' he wrote to his fiancée, 'how is it that this poor life and nature, so unfruitful of happiness even to myself can promise you so much – how can I bring you life who am at times almost likely to abandon life myself!' Now in the face of her parents' opposition, he urged her to prove she was 'worthy' of marriage to a poor man. He was indignant that the Anglo-Greek community, and indeed bohemian circles, expected him to supply her with a certain standard of living. 'In fact all the set seem to regard it as inevitable that I must provide you with a certain amount of luxury before marrying because the style in which you have been brought up is one of luxury and you are "a great lady".' He asserted, self-righteously, 'art & philosophy compensate me for a great house & many servants.' He didn't need £1,000 a year when 'four or five hundred would perfectly suffice.' (Michael Spartali would later recall Stillman's precise arithmetic with ironic effect – £400 being the allowance that he eventually settled on Marie.)

Stillman related the question of money to religious teachings inculcated by his mother. He did not understand Marie's freethinking, secular version of metropolitan Greek Orthodoxy. He urged her to lead an almost Christ-like existence of martyrdom and self-abnegation:

I think that if you were to begin at once and show them that you can live simply while you have luxury at command, they would be convinced and your father seeing that you refused useless indulgencies and were fitting yourself by the denial of these, to be 'a poor man's wife' would be more convinced of your love and your strength than by anything else. Refuse to have any expensive dresses or to go to society that makes them necessary, to spend money for anything you do not actually need – be not only a beautiful, and artistic and well educated woman, but a Christlike soul and a philosophic one and then they will understand not only how much you love me but how much you are capable of for that love.

Filled with doubt as to the eventual outcome of the courtship, he believed faith and prayers would bring him his just rewards. But it wasn't only a spiritual satisfaction he craved. 'My darling love – I kiss you in spirit & hope for the body'.

Stillman was an unconventional suitor, wooing Marie with his exegesis of Emerson's philosophy. 'You are sure to be an "intelligent" pupil', he told her, and oddly, she didn't seem to resent his superior tone. He savoured the fact that Marie was eminently teachable in his own areas of expertise, especially the philosophical and the political. Not only could he play professor to Marie's student, he also tried to usurp Madox Brown's role as her art teacher. Stillman still cherished a notion that he could succeed in the art world. After becoming founder-editor of the *Crayon*, the New York art magazine, in 1855, and meeting Ruskin and Turner in England the same year, he fancied himself as a perceptive critic of modern art. His love letters to Marie often contained patronising advice on her current work:

Your drawings do not seem to me to have been sufficiently studied in their accuracy & details, before hand – you are too fond of taking the subject *in medias res* and making your picture before you thoroughly feel all its parts. It seems to me that the true way of making a good picture is this. Conceive your subject (if anything more than a study of color or form) fully, before you begin it; think out all your accessories in a general way, make a sketch in black & white without reference to detail of the whole simply to get the thing well in your mind, & if you have patience, a subsequent study of general effect in color. Thus beginning your drawing you will find things fall into shape naturally because you know clearly what you are going to do.

But somehow he could never offer Marie his total support. Her picture
'*The Romaunt* [*of the Rose*, exhibited at the Dudley Gallery, 1870] is in
general color & effect almost faultless, surprizingly harmonious,' he told
her, 'but slightly lacking in intensity of ensemble – too much like the
work of a refined & melodious nonchalance,' conceding, as an
afterthought, 'no piece of fresh work in the exhibition compares with it
in that way or in general way.' As a critic, Stillman's assessment of Marie's
work was lukewarm. She did not challenge his judgement but seemed to
accept it as what she deserved. In spite of adulation of her beauty by all
the male artists in London, and by general consent, Marie was deprecating
about her own artistic ability. By contrast, the art critic William Michael
Rossetti recognised deep subtlety and more than just a colourist's talent in
Marie's work:

> Miss Spartali has a fine power of fusing the emotion of her subject into its
> colour, and of giving aspiration to both; beyond what is actually achieved,
> one sees a reaching towards something ulterior. As one pauses before her
> work, a film in that or in the mind lifts, or seems to lift, and a subtler essence
> from within the picture quickens the sense.

Henry James, too, observed 'something very exquisite' in Marie's
pictures, not only her ability as 'a really profound colourist'. More
importantly, for him 'the principal charm of her work is the intellectual
charm'. Stillman, however, maintained his attack on Marie's technique for
which he explicitly blamed Madox Brown. 'You want severe schooling
in drawing & a more precise & deliberate manner of education. The latter
will come sooner or later and always of itself – for the former you must
see the work & if possible work under the direction of a draughtsman of
more comprehensive power than Mr. Brown who is rather a draughtsman
of detail than of the subject as a whole as in fact most English artists are.'
He warmed to the subject of her teacher's deficiencies, as he saw them:
'In general effect, in distribution of masses, points in which my own
feeling is very strong and which are exceedingly important in the effect of
pictures on the exhibition goer or picture seer of any kind, you have a
great deal to learn which you will never get of Brown for he has no feeling
for it if I may judge by his pictures.' Stillman's feelings for Marie were
goaded by professional and sexual envy of Madox Brown.
 Stillman's love letters became an extension of the convoluted art-
history lectures he delivered to Marie on their secret visits to the National
Gallery. Private rancour underlay his warnings about living artists she most
admired. 'I feel more & more continually that you will never acquire in

the British School those large & telling qualities of art . . . Nobody has it here now, not even Rossetti & perhaps, even, he is further from it than almost any other great painter.' Greatness was a quality Stillman guessed would always elude him so he disparaged it in others, especially his contemporaries.

His barely subdued envy of Marie's talent made him habitually undermine her art. Now he issued a special restriction: she was not to aspire to any public recognition for her work. On this single, small-minded point, he could agree with her parents. They felt, as he did, that it was not appropriate, not 'ladylike' for Marie to pursue fame for her art. 'And then dear,' wrote her suitor, 'you are a woman, one whose inner life shall, please God, so satisfy her for what the world cannot give, supreme self continence & fidelity to the ideal, that she will never be lured from her truest self by the thirst for shallow applauses & the admiration of the ignorant.' It was a contradictory message. He urged her to aim at impossible ideals in art, but she must not seek public appreciation for her work. His love, he implied, not her ambition, should be enough to satisfy her. After all, even art and music were reduced to nothingness in the equation of his love: 'I would rather see you one moment than all the pictures in the world and touch your hand than hear all earthly music.'

Resentment of Marie's ability spilled into neurotic jealousy of her friends. He could not bear to share one instant of her time. 'I remember very well leaving you for a moment at the national gallery seeing you in conversation with a friend whom I did not know & I felt a little as if you might care to see him more than me for the moment and I turned aside not to seem uncomfortable or curious. I am not given to little jealousies.' He protested his was a more noble sort of jealousy, 'which consists in wishing to protect her I love from all unworthy contact . . . to keep her from all things that are not in keeping with the shrine I have built for her.' He resorted to what was to become his favoured method of manipulation in their relationship. If she didn't concur with his sentimental, unrealistic standards, she would be held responsible for making him ill: 'This is my jealousy dearest − to know that you are approached by no unworthy friend, no base admirer − no occupier of your time & thought is good for me − the contrary makes me ill. So don't let me be made ill dearest.'

Now that Marie considered herself engaged to Stillman, though without parental endorsement, Madox Brown could see that his suppressed, internalised love was more hopeless than ever. His only option was to make himself useful to Marie by offering to intervene with her father. The

lovers were allowed to meet only once a week, at the Spartali family home, which her parents considered the only safe venue. Michael Spartali was desperate enough to make overtures to Madox Brown, the teacher he suspected of guiding Marie's artistic studies 'with a more than parental interest & zeal'. Now in his exaggerated, elaborate script, heavily sealed and marked 'Private', Spartali wrote to Madox Brown from his desk at 25 Old Broad Street. Enclosing a generous cheque for a year's 'disbursements' on Marie's behalf, he apologised for not delivering it personally as 'I am so broken hearted that I am not fit to be seen by any one & I avoid the world.' Madox Brown returned the cheque.

Spartali retaliated in pique. 'I regret the unwholesome adulation my daughter & her painting receives from a narrow circle of friends', he sniped, 'you . . . ought to discourage it.' Suspicious that the painter allowed Marie and Stillman to be together at 37 Fitzroy Square, he underlined his decree. Marie was only allowed to meet 'a certain party' within the Spartali home. 'As my daughter asked permission to occasionally see the party & as our house is <u>Her</u> house it was agreed that <u>instead of meeting</u> at friends' houses & causing remarks & scandal <u>She</u> was to receive him <u>at her own house</u> once a week & it was her own proposal & wish to avoid meeting elsewhere.'

If Spartali had been under any illusions that Madox Brown would take the same view as he did of the proposed match, he soon knew he was a beaten man. What he failed to grasp was that Madox Brown did not empathise with the parents in the case. 'I was in hopes that my daughter might have heard really parental advice from your lips.' But Madox Brown rejected the role of substitute father in which Spartali wished to cast him. As a transgressive lover of the mind, he identified with the lovers in their battle against authority. His granddaughter, Helen Rossetti Angeli, later recalled that her grandfather was an incurable romantic. 'As to the Consolation you tender', replied Spartali to Madox Brown, 'I receive it in all kindness but from a father of family – with much regret. I have yet to learn that because you hold a man in honor & regard – it follows that he is the most fitted in the world fiscally, for the hand of your daughter.'

Spartali, who had once admired Stillman for his heroism in the Cretan theatre of war, now had only the greatest contempt for him, as 'a Consummate Actor on the World's Stage', exerting a kind of magic on Marie whom her father considered 'a novice in such matters' of the heart. But it seemed that Spartali was equally inexperienced in matters of the heart. He was incredulous that the love of 'a Stranger . . . should prevail over that of 26 years of parental love & Sacrifice or of filial duty'. His letter

rumbled on with increasingly dramatic threats. 'Marriages under such conditions & celebrated over the corpses or graves of parents I apprehend forebode no happiness here or elsewhere – May you good Mr Brown, never as a father, have to regret your no doubt well intentioned remarks'. Spartali tried one last throw of the dice with Madox Brown, offering a late dinner, man to man, either at Fitzroy Square or at 'an hotel near you'. But instinctively Spartali knew that Madox Brown would never be his ally. 'I know the interest you take in her & the great influence you have over her,' he conceded. And Marie herself was anxious to prevent any tête-à-tête between the two bear-like characters.

For her own part, Euphrosyne Spartali, Marie's mother, also approached Madox Brown but after he visited her at The Shrubbery she withdrew, recognising that her daughter's teacher would not prevail with her daughter, and could not prevail with her husband. 'After you left I again thought the matter over & I find it useless for you to write to my husband as I had proposed. He does not agree with you in any point therefore the less he hears on this subject the better it will be.'

In the fallout after his engagement to Marie in 1870, Stillman offered to join Dante Gabriel Rossetti as his companion at Barbara Bodichon's country home in Kent. Rossetti appreciated the American's presence at a time when he was in a heightened state of mind, dreading the publication of his soon-to-be notorious *Poems*. They included those recently exhumed from his wife Lizzie Siddal's grave where he had impulsively buried them, with her, in 1862. They would appear, shockingly, in the same collection as his adulterous love lyrics to Janey Morris. Stillman was equally agitated, awaiting results of the stand-off by Marie's parents. In mutual need, each man was tending to the other's emotional fragility. Unfortunately, in their Kentish retreat, Stillman introduced Rossetti to chloral, the drug which would wreck his nervous system. But temporarily, Rossetti was soothed by Stillman who 'walks with me, talks with me, and avoids me with the truest tact in the world.'

Rossetti told his friend, the erudite art historian, Professor Charles Eliot Norton of Harvard, that Stillman

has actually come in for *the* Slice of luck still attainable in our circle – i.e. for Marie Spartali to whom he has got himself engaged by a national rapid act of annexation which has astonished all beholders . . . She is a noble girl – in beauty, in sweetness, and in artistic gifts; and the sky should seem very warm and Calm above, and the road in front bright & clear, and all ill things

left behind for ever, to him who starts anew on his life-journey, foot to foot
& hand in hand with her.

 However, there is a good deal of opposition at present on the part of her
parents, who are rich people and had projected quite a different kind of
match for their daughter.

While Madox Brown was besieged by Marie's parents in London and
Stillman was sharing his woes with Rossetti, the American also sought,
incongruously, to confide in Marie's teacher. 'I cannot refrain from
thanking you from the bottom of my heart for the kind & earnest interest
you have taken in her happiness in this matter & my consolation that she
has in you so kind & good a friend & one so full of common sense &
earnest love of truth & freedom', he wrote to Madox Brown. 'I hope she
will never be separated from your advice & direction & that the ties which
bind her to your family may never be weakened.' Stillman then made a
calculated declaration. 'I shall, for myself, not change or give her any
reason to doubt that my love is as completely hers as ever,' he informed
Madox Brown, adding, with a hint of menace, 'I hope & believe that you
will always be most true to what you believe to be her true interest which
will always be my own aim.' Stillman was gathering his strength to stand
up to all comers.

 Marie was in a painful dilemma. Stillman told her to defy her father and
to insist on her rights to see her fiancé. But she was genuinely devoted to
both her parents. She wrote sorrowfully to Stillman, regretting he had
advised her 'to violate her duty and saying that she should "never forgive
herself any want of deference to her parents and I could never persuade
her that she had acted rightly."' It was a complicated power struggle
between the main protagonists, all of whom had adopted the language of
melodrama. 'She thinks that her father will yield when he sees that her
happiness depends on it but I am morally certain that he will never yield
till he sees her at the point of death.' Disingenuously, Stillman protested
to Madox Brown that he would 'not attempt to influence her in any way.'

 Rossetti, increasingly fearful about his forthcoming *Poems*, tried to
detach himself from the lovers' drama. He advised Stillman 'to leave her
to herself & go to America for the Summer with a proviso that at a certain
date the affair shall be decided in one way or the other.' Stillman com-
plained that Rossetti neither sympathised with his pain, nor understood
Marie's determination. So he turned to Madox Brown, telling him, 'I shall
advise with you before forming any plan or conclusion.' Then he
protested in his usual brittle tones: 'I am not at all happy about it as you
can imagine and dread going to London but I must come to a clearer

understanding than letters can effect, nor can I decide anything without your opinion.' In London, Madox Brown steeled himself to read Stillman's repetitive declarations. 'She can be assured that my love for her is unchanged & that I will not withdraw from her whatever may be her decision until she wishes me to do so'.

This middle-aged lover of his perfect Marie continued to torment Madox Brown with reports of every twist in events. Stillman planned a lightning visit to Clapham to see Marie. Her mother Euphrosyne instantly threatened a fit of hysterics. The visit had to be abandoned. Madox Brown was treated to a querulous account of Stillman's disappointed hopes. The artist's psychological anguish continued, spiced with mischievous enjoyment of the lovers' predicament. When Stillman appealed to him to intervene with Marie (and not her father), it roused a curious excitement in Madox Brown. After all he had a notorious reputation for playing Cupid.

The whole affair 'is very wearing on me,' wrote Stillman plaintively, 'and I am only able to keep my spirits good by working continually & more than my health permits – safely.' He threatened Madox Brown, and by extension, Marie, that the struggle with her parents might bring on his 'old brain trouble . . . again', and then, with a dramatic flourish, it will be 'all over.' Was Stillman threatening Marie that too much prevaricating might result in his breakdown, or even suicide? His 'old brain trouble' seemed to be a tendency throughout his life to extreme hypochondria, bouts of being unable to work, and chronic dissatisfaction because his ambitions in art and journalism brought him little acclaim. 'Human nature will wear in time,' he warned Madox Brown. 'I am a human being . . . My brain will not endure indefinitely this pressure but will have a convulsion of some kind some day.' Stillman could be sure that through the conduit of Madox Brown, his manipulative, self-regarding words would reach and wound Marie who could only prevent her lover's nervous collapse 'by insisting on some progress being made – something to keep life in the affair.'

Stillman feared that Michael Spartali would gradually erode Marie's resistance. He continually harped on his own state of mind, his own suffering, while almost ignoring or trivialising Marie's. He was as dominating as any Greek paterfamilias, even laying down rules for Marie to adopt in dealing with her father. And he continued to bleat to Madox Brown, about the Spartalis. 'Now that they have contrived to keep me from the house they are discontented with the correspondence and when they have got that stopped I imagine the next step will be to get her provided with a suitor to clinch the matter if it be possible and same tactics

will follow each step – sour faces, threats of insanity & suicide'.
Humourless Stillman failed to see the irony that the strategy of Marie's
parents was exactly the same as his own.

Either intentionally or subconsciously he aimed his next salvo direct at
Madox Brown. 'I fear [her father] will try next to prevent her going to
your house & painting if possible which would be a veritable catastrophe
for her – the worst of all misfortunes.' Spartali had a double purpose: to
minimise the lovers' trysts, and to check further mischief-making by
Marie's influential teacher. Though swaggering that he was far more of a
'man of the world' than Spartali, Stillman's old claim to heroism was
becoming laughably hollow.

Marie remained in direct communication with her teacher, but was
uneasy lest any intercession by Madox Brown with her father might lead
to instant cancellation of her painting lessons. In spite of domestic
torment, she persevered with her work, arranging to paint with her
teacher on a Saturday during March 1870, and sending him the balm of
'infinite thanks for your sympathy & help & love to all yours'. A week
later, Marie booked another lesson, although she feared her work didn't
amount to much. She had props and a model, Mrs Keene, set up for her
latest picture (possibly *St Barbara*). The strain was seriously undermining
not only her sense of herself as a professional artist, but also her emotional
equilibrium. Afternoon art lessons seamlessly flowed into dinner at the
Madox Browns, where Marie and Stillman arranged to meet, against the
express 'rules' set by her parents.

However, by summer 1870, Michael Spartali had won a small victory.
He manoeuvred the lovers into agreeing to a trial separation. Marie was
anxious to prevent any potential confrontation between Madox Brown
and her father. 'I feel there is absolutely nothing to be done at present to
help us & my Father will <u>not</u> take a better, but rather a worse view of the
case – I suppose he cannot change his nature any more than I can mine &
I feel that if he insists on the sacrifice I must make it at any cost . . . I shall
come on Monday & will tell you more please don't see Papa before then,'
she begged Madox Brown. Stillman had agreed to an extended visit home
to America, with any final decision about marriage deferred until his
return. Michael and Euphrosyne Spartali prayed that geographical
separation would lead to emotional disentanglement.

On the eve of departure, a fatalistic desperation invaded Stillman. He
knew hostility to the match would be mobilised the moment he left
British shores. He resorted to his usual tactics with Marie, a mixture of
bullying and self-pity: 'If I don't come at 6 tomorrow you may know that
I am too ill to come.' It was the antidote to romance but Marie found it

romantic. He begged for rescue on all levels, material and emotional. He was her cause. She was specially moved when, just before embarking, Stillman told her that he repented the battle he had waged with her father. 'If I die without coming to an understanding with him tell him this', he wrote. It was one of his most calculated offensives, an ostensible conciliation between the two men she loved most. Even Stillman must have felt he'd pressed an unfair psychological advantage, as he added his normal rider about feeling too unwell to finish the letter. 'I am not fit to write tonight – my head wants a resting place and to rest on it from all thinking and anxiety.' And from feelings of illness he proceeded to issue his usual death threat. 'When our day comes can we be ill again? or shall I one day quietly flicker out, when life can keep in no longer?' It is hard to understand what Marie could possibly have found attractive in his melodramatic self-posturing. Perhaps her parents' opposition was the critical factor that intensified her love.

By the time the lovers made their final farewells in June 1870, Stillman had ascended to a state of calm exaltation. His language assumed that there were no further decisions to be made, that she was in some pre-sexual sense already his wife. 'What a darling you were today – so loving and warm – and I felt you so utterly mine in every fibre and feeling – my lily, my wife.' He invoked religion to bind her ever more tightly to him, 'may God give us eternal trust in each other and the world may think and do what it will of our folly and improvidence.' Stillman was close to ecstatic. 'I left you in a glow and from which [I] have not yet departed – love's aureole – when shall we live in it and feel in glory the live-long day?'

His overt sexual needs combined disconcertingly with his intimations of divinity. 'I feel you so strongly and so near me, so large sound & warm that it seems as if I had never quite known you before – it fills me so full to know that you are mine to me only in the wide world . . . to me only is all its beauty and fragrance known – mine, mine utterly, my wife my darling. Going away & time & trouble seem incompatible with this love – it is as if it pervaded all things – divine in all.' He had achieved a rarefied state, 'God bless you my own love – I am very happy.' He couldn't resist one last allusion to his own 'troubles and pains', although he did not refer to hers, and told her he could 'forget a life of them in an hour of your arms.'

Stillman and his three young children sailed from Liverpool to America in June 1870, and were not to return until eight months later, in February 1871.

<div align="center">★</div>

After Stillman's departure, when he realised Marie's affections were immovable whatever her parents might threaten, something froze inside Madox Brown. The sunshine of her love for Stillman (only seven years Madox Brown's junior) made him feel older than ever. During the drama of Marie's struggle with her parents, played out over a year and a half, Madox Brown tried to face reality. But in another tortured, paradoxical sonnet, 'Change in Constancy', dated 4 July 1870, six months and a day after Marie's engagement, he avowed that, like Shakespeare's, his love was 'not Time's fool'. It was unalterable, it would never die:

> To feel good cause to shun you – yet no will,
> To feel undone yet wish you good for ill –
> To feel how rashly I have deified you,
> To feel myself degraded – yet beside you,
> To feel this all – is Oh! to love you still!

Writing poetry brought him no release. By August 1870, Marie was still his 'Angela Damnifera' or harm-loaded messenger. He was dangerously near collapse, reduced to asking himself a barrage of rhetorical questions:

> Could I have known, that day I saw you first,
> How much my fate lay coiled within your eyes!
> How Nemesis spoke in your soft replies!
> Could I have known? – and so have fled the worst?
> Could I have known how for my bitter thirst
> Your coming brought but saltest tears & sighs,
> How going, life seems fled with you likewise
> Could I have known – Oh Angel love-accurs'd!

Marie would be forever a 'blessed & damned flame-hallowed Beatrice' to his yearning Dante. Madox Brown later contributed an almost identical version of this sonnet to William Sharp's 1890 anthology, *Painter-Poets*. Curiously, he backdated it, incorrectly, by over thirty years to 'Finchley 1858' – by which date he had already been living in Kentish Town for three years. Was this an attempt to conceal the real circumstances of its composition from Emma? By 1890, when she was dying, and he close to seventy, but Marie very much alive, was it still important to cover up his old love?

Throughout her unofficial engagement to Stillman and the many months

of his absence in America, Marie continued to rely on Madox Brown's lessons. She worked diligently but castigated herself for not achieving more while she was under severe and conflicting pressures. 'You must not expect to see much,' she warned Madox Brown, 'for all the studies I have made are too slight & imperfect to be of any use. It is impossible for a model to keep the position long enough & I get so nervous & distressed that I lose the little power I have & spoil everything.' A note of hysteria was now apparent in Marie's letters to Madox Brown. With him at least, she let down her guard. Confessions of her erratic work schedule revealed her true state of mind. She made and remade appointments to draw with him at his studio and at the British Museum. Her tone became confused and apologetic.

Nevertheless, Marie's catharsis lay in work. One of her paintings was *St Barbara*, also known as *The Girl with the Peacock Feather*. Artists such as van Eyck, Veronese and Rubens had described St Barbara's violent story. Marie's teacher, Madox Brown, had clear memories of pictures by van Eyck and Rubens from his student days in Flanders. In 1870, his students were in the ascendant, exhibiting and making pictures on the theme of love in its various guises. Oliver Madox Brown helped his father illustrate the Moxon edition of Byron's poetry. Lucy Madox Brown was planning

St Barbara by Marie Spartali, 1870.

her *Romeo and Juliet*, and her picture of courtship across a pianoforte, *The Duet*, was hung, like Marie's *St Barbara*, at the Royal Academy.

The picture had a special encoded significance for Marie. St Barbara probably never lived but her legend was potent, and icons depicting her were current in the Greek Orthodox Church. There are various versions of St Barbara's story dating from about AD 300 in Nicomedia, modern Izmit in Turkey, not far from Bursa where the Spartali family had once lived. This geography may have given the legend an extra frisson for Marie. All versions of Barbara's story feature a brutal father, Dioscorus, who imprisons his daughter in a high tower, either to punish her for converting to Christianity, or to prevent her beauty from attracting suitors. St Barbara is tortured and killed (usually beheaded) by her father for her disobedience, but in some accounts he is struck by lightning for his unnatural act. Michael Spartali was far removed from the heathen Dioscorus, but Marie certainly felt she was being emotionally abused by his intransigence. Locked up in her high tower, St Barbara found solace in philosophy and poetry. In pictures, St Barbara is often shown with her tower, sometimes with a palm of martyrdom or with a feather.

St Barbara's strategy of internal escape was a direct parallel with Marie's liberation in the studio. Marie's choice of subject at this crucial time, while she was separated from her fiancé, was not accidental. She identified with beleaguered St Barbara. In Marie's romantic, late Pre-Raphaelite picture, her medievalised heroine occupies the central foreground, reading contemplatively on a chair designed obviously, if anachronistically, by the Firm of Morris, Marshall, Faulkner & Co. Her palm of martyrdom has been replaced, however, with a less violent symbol, the aesthetic feathers of a peacock. In the background rises St Barbara's tall, forbidding, phallic tower, heavily walled and moated. In a happier story, it might recall the castles of medieval French romances. The figure of St Barbara owes something to Rossetti's languid beauties but Marie's warm tones are much more like Madox Brown's autumnal palette at this time. And unlike Rossetti's women who exude sexuality, this pale St Barbara is an eloquent representation of Marie's innocence.

Once the picture had been shown at the Royal Academy, Marie felt empty. The continued absence of her lover far across the Atlantic bit more deeply. 'I too felt more sad than glad that the pictures were finishing tho' I was very anxious about their getting in [to the Royal Academy],' she told Lucy. 'Now that is at an end & I feel quite lost again. I remained in bed till midday yesterday not because I was tired but from want of a sufficiently strong interest in any occupation – then I went to see some French refugees [from the Franco-Prussian War] I had neglected & so the

day ended & I was just as weary at the beginning as at the end of it.' She had received two letters from Stillman, and was longing for, and half dreading his return to England. He had enclosed photographs of himself, looking dramatically 'even more thin & suffering than when he left.' She knew she would have to warn the Spartalis when his return was imminent which would mean the 'end of the calm state of things here – & perhaps I shall lose the affection of my parents altogether.' This time, however, she steeled herself to resist. She told Lucy that 'those very painful scenes have lost their terror now. There is nothing I would not bear for him.'

Marie escaped by painting in Madox Brown's studio, or simply by being accepted into his bustling, industrious, intellectual household. 'It was so delightful being at your house. Why do you say it was dull?' she asked Lucy for whom life at Fitzroy Square was no novelty. 'It never is under your roof & you know that I am happier with you all than anywhere; I don't mean because of the work but in idleness also.' She felt nervy and unsettled, knowing Lucy was already at work on her next subject, the scene from Shakespeare's *Tempest*, in which the two lovers, Ferdinand and Miranda, are opposed by Prospero, the heroine's implacable parent. Marie could not fail to notice the parallel with her own real-life situation. Jumpily she tried to put Madox Brown's ideals into practice, 'for I have not attained that philosophic & artistic calm which a distinguished artist considers indispensable to being a good painter – I wonder if I shall ever attain this quality?'

Although it's unlikely that Madox Brown ever achieved 'artistic calm' at this crisis in his emotional life, the idea of serenity was still more at odds with his rival's style. Even Stillman's knocking at doors was peremptory. 'You may be sure that a friend of mine will be heard thundering at the door before he has long been in England.' Marie was half enamoured, half fearful of Stillman's masculinity. 'I shall teach him to knock in a less characteristic manner some day,' she told Lucy. It was a style of dominating machismo to which she was accustomed, from her forceful teacher, and her governing father. Did she unconsciously seek these recognisable qualities in a lover? If so, her naïve claim that she would be able to change Stillman's character in the slightest detail was doomed to failure.

To while away the great gap of time that Stillman was abroad, Marie shuttled between the Spartali homes at The Shrubbery and on the Isle of Wight. Suddenly, in Paris, Christina, her younger, recently married sister, collapsed into mental breakdown. Christina's stability had always been in

doubt. Both Michael Spartali's daughters felt trapped by their parents or their lifestyle; both felt they had to escape. Christina had already defied them by marrying Comte Edmond Cahen d'Anvers, a Belgian Jewish banker who ran the Paris head office of his family firm. He was clearly in a better financial position than Stillman, but the Spartalis found him equally unsuitable.

Christina's condition had been exacerbated by habitual drug taking. Her drug of choice was pernicious chloral, the same destructive sleeping draught Stillman had recently recommended to Dante Gabriel Rossetti. Marie was deputed to go and 'amuse' Christina. Before she left for the Channel crossing, Marie wrote in haste to Madox Brown. 'We only heard last night that she was so much worse & to-morrow evening I hope to be with her.' Marie did not forget her artistic assignments, but her tone was subdued and self-deprecating: 'I have been working on several designs but they are still too childish to show you. When they get better I will write from Paris for I shall have time enough to think them over there.'

One of Madox Brown's sonnets may refer to his fears for Marie as she crossed the unpredictable English Channel, and the reference to drugs may date it to this visit to see her sister.

> My mistress this dark hour is on the sea
> (Oh may the gales deal gently with such freight)
> While on my sleeplessness strange visions wait . . .
>
> The half-lit chamber, faint with drugs I scanned,
> The blackened lips, the wan white brow, the trace
> Of pain on eyes fringed round with loveliness . . .

Once established at 12 avenue des Princes in the exclusive Boulogne-sur-Seine area of western Paris, Marie did indeed have time to think, when she was released from sister-watching. Madox Brown posted encouragement and a correspondence course in art, tailored to her individual requirements. As ever, the combination of teaching and suppressed emotion was potent. He even allowed himself to send her some poems, although it's not clear if they were from his own sonnet sequence. Marie responded warmly. 'Your remarks & letter were so very encouraging they made a delightful episode in my very monotonous life here. I can't make up my mind about the poems each has a distinct charm & I like them all so very much! The French one is so harmonious & quaint – I am glad you don't ask me to choose, but generously let me keep the three (for I suppose I may, since you don't tell me to return them).'

From poetry Marie turned to questions of art, deferring as always to her teacher's suggestions. 'I send a colored design of Antigone with the alterations you suggest. The reason the first was so very dirty, & indeed all I send, is that they look so badly drawn when they are clean I smear them over at the last, to try & improve the effect. I see you don't admire this plan & no wonder for I only succeed in making the paper look as if it had been kept in the cellar under the coals.' Marie's artistic 'plan', her smearing over, seems childlike, almost perverse, and reflects the safe relationship, of surrogate father, in which she contained her teacher. She outlined her current pictures, asking for approval and advice:

> I can't express what I mean in my designs, & it seems to me wonderful that you should find out. I wish one little page to be pointing Gunther out to Brunhild, & the other one underneath the window, to be throwing up his cap & shouting – The other design is only a remembrance of a part of the Bois I saw last week. I thought the birch trees looked so pretty in the evening light that I would try to remember the effect – but I could not do what I intended – so I only send it to show that I tried.

Marie's ambitions on the easel were constantly thwarted, she felt; resolution evaded her. Her unsatisfactory pictures were an outer expression of her inner personal life, frustrated, distanced and out of control.

When she wasn't trying to work, she found it equally hard to enjoy herself, even among the distractions of Paris. Her brother-in-law, Edmond Cahen d'Anvers, drove her out to a favourite Paris restaurant, Robinson's. 'I dare say you know the place well, where people dine up in the trees & draw things up in a basket', Marie wrote to Madox Brown. 'We climbed to the top of the highest tree & saw the view, & had the satisfaction of drawing up the refreshments & I quite understood that the place was delightful if one could be with congenial companions. But the fact of Mr Cahen's presence, always makes me feel as gay as if I were at a funeral & that he should take me out to amuse me, is very kind on <u>his</u> part, but quite impossible <u>now</u> – It was a different thing last year before we were related & I could laugh at him as much as I liked.' Christina's husband had a knack of making tourist pleasures seem ponderous, and Marie's sense of the ridiculous found him an easy target.

Nevertheless his treatment plan of applying sister to sister seemed to have worked, temporarily. Christina's mood had lifted. 'I shall leave at the end of this week, but I can scarcely believe the improvement will last, she has had so many relapses – I hope I shall soon be able to get to work again. I have had such a long compulsory holiday I am afraid

I have become idle.' Reasons, excuses, apologies, Marie's stamina was diminishing.

When Stillman returned from America in February 1871, poised to claim his bride-to-be, Michael Spartali and his wife Euphrosyne worked themselves into renewed hysteria at the likelihood of 'the dreaded event'. In his prospective son-in-law, Spartali saw 'a toothless commonplace everyday nonentity', a fortune-hunter on the lookout for a housekeeper to his three motherless children, one of whom was a chronic invalid. In scenes of high drama they threatened once again that the marriage would kill them both. Spartali threw himself on the mercy of Dante Gabriel Rossetti, begging him to intercede with Marie, to put the case against this 'worthless Sir Lancelot'.

In reality, of course, the person who saw Marie on a regular basis for lessons in the studio was not Rossetti but her teacher Madox Brown. Now Spartali was beginning to see plots everywhere. Suspicious about the exact nature of Madox Brown's proximity to Marie, her father continued to plead with Rossetti:

> I can only assure you that if the dreaded event takes place it will be her death and mine and perhaps my wife's and that you are the only person on earth that can save her and prevent it . . . I apologise for trespassing and abusing your kindness. But you alone can save this poor deluded girl. Do not think it is too late. There is still time . . . Pray keep this and the whole matter strictly *entre nous* and <u>above all do not take Mr Brown into your counsel</u>.

THE IMPENETRABLE MYSTERY

MARIE SPARTALI MARRIED WILLIAM JAMES STILLMAN on Monday 10 April 1871 at the Chelsea Register Office after a protracted engagement of fifteen months. Two witnesses signed the register at the civil ceremony: Marie's closest woman friend, Lucy Madox Brown, and Lucy's father, Ford Madox Brown. At the ceremony, Marie looked transparent but steadfast, her husband dominant. They made a striking pair, probably the tallest and slenderest couple in London, 'the Lankies', as William Michael Rossetti called them. Other people looked beyond the couple's physical glamour. 'The young bride went forth from the luxuries of plutocracy to share the fate of her brilliant and erratic spouse and mother his orphan children.' Although counting the American as a friend, William Michael Rossetti noted, 'he did not possess genius.'

The Spartalis refused to attend the marriage or the wedding breakfast which Madox Brown and Emma hosted, in a daze of conflicting emotions, at their home at 37 Fitzroy Square. Her parents disinherited and disowned Marie.

In Dante Gabriel Rossetti's opinion Madox Brown was at that time 'one of the greatest painters now living anywhere'. He hailed his *Romeo and Juliet* of 1870, which showed 'passionate rapture' and the anguish of lovers parting, as one of his supreme pictures. Madox Brown had been absorbed by the subject since 1867 when he first began making a water-colour version. In a paradoxical twist, it was Emma, then nearly forty, not Marie, who had modelled for Juliet, bidding farewell to Romeo after their single night together.

In the year of Marie's wedding, voluptuous Emma posed as the girl in a boat, apparently attempting to fend off a too-vigorous lover, in Madox Brown's erotic illustration to accompany Rossetti's tragic ballad, 'Down Stream'.

DESIGN FOR ROSSETTI'S "DOWN STREAM." 1871.

Emma models for *Downstream (Last Year's First of May)*.

Rossetti had first written the poem in a punt, perhaps with Janey Morris, the woman who obsessed him. He was delighted with Madox Brown's 'very excellent' drawing which he said was 'like a tenderer kind of Hogarth'. In the words of Rossetti's ballad, 'With parting tears caressed to smiles,/With meeting promised soon', the newly married Stillmans left Madox Brown's house for their honeymoon. Struggling to contain his feelings, he could not accept that on that day, of all days, she saw him as her substitute father, not as an abandoned lover. 'No word – no tear – no wild embrace/Gave hint of love as we did part.' With a single handshake and 'one look of pain', Marie left 37 Fitzroy Square for her honeymoon. But Madox Brown still believed that his soul's filaments would inexplicably extend towards Marie 'through eternities'. Emma wore an aesthetic gown and was glad to see them go.

After Marie's wedding, Madox Brown was still not free and he could not forget. He longed for the flutter of her dress, the touch of her glove.

Six days after the wedding, on 16 April, when in fact she was experiencing a not entirely comfortable honeymoon on a damp Isle of Wight, Marie returned to Madox Brown in a dream. Significantly it was the night of his fiftieth birthday.

> O only kind in dreams! O lost lost love!
> Why comest thou in sleep to tantalize
> And fan a smouldering passion with soft sighs?
> I would forget!
> . . . Come, cheat me once-more with that tender pressure,
> Scan me again with eyes aglow with pleasure,
> O lost lost love – so pitiful in dreams!

But it was all delusion. His only hope now was to remain in place as her artistic advisor.

Stillman and Marie left London by train for their honeymoon, staying first at Christchurch and Bournemouth, two leading tourist resorts on England's south coast, and then on the fashionable Isle of Wight. 'We got here all right some the worse for wear . . . but none the worse for tear,' wrote the bridegroom the very next day to Madox Brown. 'Marie was excessively fatigued & feverish but today she seems calm & stronger. The rain which so considerately kept away for the wedding follows us here & shuts us indoors which the landlord, having a previous order for our room insists on turning us out – in the dilemma we go to Bournemouth by the night train.' Having carried off the prize, Stillman's tone was as disgruntled as ever.

Marie's state of nervous exhaustion may have been caused by her wedding night which naturally Stillman did not report. It was her second life-change in twenty-four hours. The first was marrying the man of her choice in defiance of her parents' wishes. Whether or not Marie found her first sexual experience equally traumatic, it resulted in a honeymoon conception. Effie, her eldest child, was born almost nine months to the day later, on 8 January 1872.

That first morning of married life, feeling 'calm & stronger', Marie and Stillman went sightseeing, probably to Christchurch Priory Church with its tall Norman pillars and romantic marble statue of the drowned Shelley in the arms of his lamenting wife, Mary Wollstonecraft Shelley. It was hardly an auspicious image for a newly married couple to contemplate. Stillman instantly lost any capacity for tender lovers' talk. As usual he

addressed his wife like a public meeting. 'I gave Marie a lecture on the distinction of gothic architecture which if neither profound or technical was clear I think, & useful, though Marie says that she didn't take it in.' He even begrudged 'a ha'penny for M's lunch & a penny for caramels.' Everything grated on him: the English rain, the incivility of the landlord, even a beastly band that made 'music which is worse than drawing teeth' – a simile Marie particularly disliked. So peevish was his mood that she tore up his first attempt at a letter to Madox Brown. Even at this pinnacle of his desires, Stillman's capacity for happiness was at zero. And for obscure reasons Marie was magnetised by his depressive personality. Perhaps she believed she could cure him.

A week later, Demetrius Spartali, Marie's brother, reassured her that no one at home at The Shrubbery had committed suicide or fallen terminally ill as a result of her marriage. Stillman reported to Madox Brown that 'Marie improves astonishingly' but 'she has not begun drawing yet.' Marie took over their joint letter to say she had not lost her driving sense of industry, even on her honeymoon. 'The reason I have not been drawing yet is that I have been helping my husband by copying a M.S. for him so please don't imagine that I have become incorrigibly idle as his note leaves you to infer. I have been thinking over the subject you marked out for me it seems very difficult.'

Was it out of perversity or was it in complete innocence that Stillman and Marie continued to depend on long-distance support from Madox Brown who had campaigned for their match with such a tumultuous and divided heart?

If marriage to Stillman brought Marie manifest disappointments, all of these she concealed and denied, always maintaining perfect public devotion. Perhaps this was made easier by the fact that the couple lived apart for long periods. Stillman's roving commissions in diplomacy and journalism took him abroad and he rarely encouraged Marie to join him, although she begged to be allowed to do so. However, this arrangement of marital separateness cemented Marie's rapport with her stepdaughters, Lisa and Bella, who grew up to share her passion for art. Their eldest brother, John Ruskin Stillman, always called Russie, was a chronic invalid. Marie was as concerned about him as if he were her own child and suffered with his every crisis.

Separations from Stillman also deepened Marie's relationships with friends: long-standing ones like Lucy Madox Brown; new ones like the androgynous writer Vernon Lee; and Rossetti's disciple, Charles

Fairfax Murray. When Marie lived in Italy (in Florence 1878–83 and Rome 1889–96) she valued postal support and professional advice from senior artists and old friends such as Burne-Jones. 'I wish you were coming in now to chat and make me happy,' he wrote seductively to Marie, 'I LOVE HELPING YOU.' But most committed of all was the long-term friendship she maintained over the next two decades, until his death in 1893, with Ford Madox Brown. It was a measure of Marie's emotional intuition which served her well in all relations, except with her husband, that she was able to deflect Madox Brown's romantic obsession and transpose it into a mature friendship, nourishing for both of them.

After their damp beginning to marriage on the Isle of Wight, Stillman decided to take Marie to America to meet his relations. William Michael Rossetti spent Sunday evening, 4 June 1871, at the Madox Browns, 'to see the last (probably) of Stillman and his wife before they go to America . . . fixed for Tuesday next.' William noted, 'Brown has now a very good opinion of Stillman in his matrimonial relation.' Marie's teacher had no option but courtesy towards the husband if he wanted to retain contact with the wife.

Quelling his obsession, Madox Brown found release, as he had during previous life crises, in an unremitting work schedule. During that June Sunday evening, William saw Madox Brown's current pictures, *The*

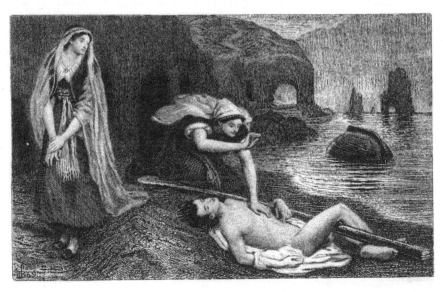

Marie models for FMB as Haidée, the figure on the left in *Don Juan and Haidée*, for the Moxon *Byron*, 1870.

Entombment of Christ, The Corsair and *Joseph's Coat*. The artist had also begun a large-scale oil painting called *Don Juan found by Haidée*, inspired by Lord Byron's picaresque love saga, *Don Juan*. Working on this erotic subject was a way to keep Marie close to him. In the month before her wedding he had asked her to pose for Haidée, the lovely pirate's daughter who found Byron's hero half drowned on a Cycladic beach. No matter that Marie was ten years older than dazzling seventeen-year-old Haideé. She shared with Byron's romantic heroine not only physical height and streaming chestnut hair – but also natural imperiousness and magnetic charm.

> Her clustering hair, whose longer locks were roll'd
> In braids behind; and though her stature were
> Even of the highest for a female mould,
> They nearly reach'd her heel; and in her air
> There was a something which bespoke command,
> As one who was a lady in the land.
>
> Her hair, I said, was auburn; but her eyes
> Were black as death, their lashes the same hue,
> Of downcast length, in whose silk shadow lies
> Deepest attraction . . .

Painting Haidée, and by implication the doomed love that blossomed between her and the revived Don Juan, Madox Brown could fix Marie for ever in his heart. In her exquisite curving pose, Marie embodied Byron's Haidée, but she was also the artist's Eurydice, now at the edges of the composition of his life. He imagined her 'tall, but faint and pale, sinking back into the shades.' The picture provided a last, safe, sublimated opportunity to express his adoration. But he knew it would be fatal to look back.

On that same summer evening, William Michael Rossetti admired Marie's picture, *Antigone and her sister Ismene on the Battlefield burying Polynices*, which she was painting under Madox Brown's instruction. Marie showed it in 1871 at the avant-garde Dudley Gallery, which Madox Brown's students preferred to the stuffy Royal Academy. These artistic projects ensured that Madox Brown could sustain a legitimate working relationship with Marie beyond her wedding day. Marie's picture also featured a supine young man, thrown across the lower half of the composition. Madox Brown's Don Juan and Marie's Polynices were subtly complementary – and contrasted. Her tutor's Byronic vision was of

amorous life reawakened, whereas Marie's study focused on Antigone in an archetypal pose of lamentation and death. Were these subjects prophetic allusions to the separate marriages in which teacher and student were now confined? The union Marie had fought so hard to achieve became in many ways an empty husk. Ironically, it was her tutor, the older man, who may have enjoyed the more sensuous life – with Emma his still desirable wife.

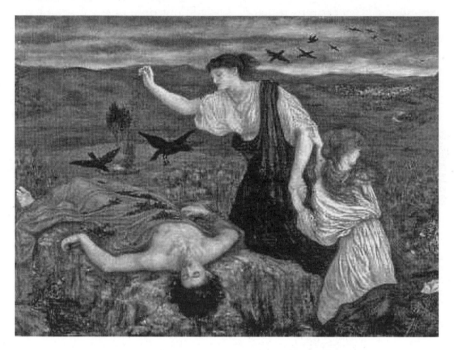

Antigone and her sister Ismene on the battlefield burying Polynices by Marie Spartali Stillman, 1871.

Stillman found time to scribble reports to Madox Brown about their honeymoon progress in New England during summer 1871, while simultaneously writing his account of *The Cretan Insurrection*. His son Russie had been close to death but rallied. With little surviving medical evidence, a modern diagnosis can only speculate that Russie's condition may have been caused by rheumatic heart disease, following acute rheumatic fever. William Michael Rossetti assessed the boy's condition might 'prove curable as far as the affection of the hip-joint is concerned: but of late a serious enlargement of the liver has come on,' continuing to cause anxiety. In spite of the boy's crisis and the early months of her first pregnancy, Marie greatly enjoyed America. If her husband noticed her

pregnancy, he certainly didn't mention it to Madox Brown. Stillman confessed, unusually, to feeling well but, as always, found something to be querulous about. 'The life here is not what it used to be.' By early August they were planning to sail home to England where they arrived with Stillman's children, Russie now nine, Lisa five, and Bella three, at the end of the month.

As soon as her marriage was an established fact, Marie longed to restore relations with her parents. On her return from America she rushed across the Solent to see them at their country home, Rylstone. Her mother showed hints of melting but her father ignored her. Even when he caught sight of her at the railway station, he 'gave no sign of recognition'. Michael Spartali brought his wife into line and the early thaw soon froze over. More than six months' pregnant, Marie visited her mother in London in October 1871 but Euphrosyne was 'painfully cold and unsympathetic'. This had such a distressing effect on 'poor Marie' that 'she cried incessantly till past midnight, and almost fell into convulsions.' Stillman feared 'total alienation' between parents and daughter, and William Michael Rossetti also forecast a complete rift.

A few days later, the Spartalis' other erring daughter, Christina, was

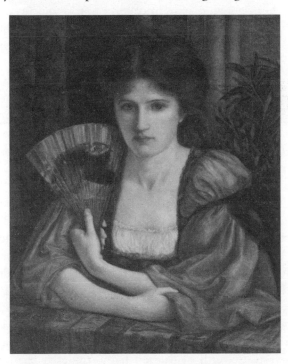

Self-portrait by Marie Spartali Stillman, 1871.

taken dangerously ill in Naples. This time Euphrosyne rejected her husband's hard line with their daughters and set off immediately with her son, Demetrius, for Christina's bedside. Awaiting the birth of her baby, Marie stayed in England, delicate and anxious under the strain of her parents' treatment. By the last month of her pregnancy in December 1871 Marie was increasingly worried about Christina, submerged in chloral addiction, 'a cataleptic habit'. This all weighed heavily 'upon poor Marie, making her very miserable at times: her cough also persistent and severe', in the seeping fogs of a London Victorian winter. With both daughters at the brink of collapse, Michael Spartali finally yielded and wrote to Christina, so 'that quarrel may be considered in course of healing.' William Michael Rossetti, always the most pacific of men, added in his diary, 'I should hope that the quarrel with Marie, much less well grounded in its essence, may also be healed at no very distant date.'

The birth of her first child, a daughter, on 8 January 1872, and Marie's placating gesture in naming her Euphrosyne (Effie) after her mother, unfroze Michael Spartali's heart. Two weeks after the birth, he 'relented so far as to have two interviews with [Marie] which passed off satisfactorily.' Released from the double bind of loyalty to her husband and love for her daughter, grandmother Euphrosyne urged Marie and Stillman to come and live in 'a vacant house abutting upon the Shrubbery grounds.' In a rare instance of tact, Stillman brought himself to write 'a conciliatory letter' to his father-in-law who had already shown great kindness to his stepgrandchildren. Lisa and Bella, Stillman's two little girls, had 'been staying at the Shrubbery ever since the confinement began', and even Russie's health was improving in the new rapprochement between the Spartalis and Stillmans. Euphrosyne Spartali wanted to furnish the new home for her daughter's family, while for his part Stillman declared, whether disingenuously or not, that he neither expected nor would accept any 'dowry or other money provision for Marie'.

By Marie's twenty-eighth birthday on 10 March 1872, the Stillmans were installed in their new house, 8 Altenburg Gardens. The children could run across the gardens from parents to grandparents, although their home was obviously inferior to the grand Spartali establishment. Marie was 'now looking well again, and cheerful, though a little delicate' after the birth of Effie, 'a more than commonly well-looking and well-grown infant.' However, they were all anxious about ten-year-old Russie who had developed 'dropsy'. The uncompromising medical prognosis was lingering illness leading to certain death. Undoubtedly mortality of a child, as much as the birth of Marie's baby, underlay the family reconciliation. Petty differences were put in perspective.

With her mother Euphrosyne and the children, Marie retreated during summer 1872 to Rylstone on the Isle of Wight. Unlike The Shrubbery which Vernon Lee waspishly described as 'Jewy', Rylstone was a triumph of hyper-aesthetic style. It was hung with 'most exquisite artistic papers', designed by Walter Crane. The mantelpieces were 'most lovely marbles and the fireplaces enlaid [*sic*] with Minton's tiles. Windows over the fireplaces, and the bedroom furniture Japanese in black and gold.' Even in these tasteful, familiar surroundings, Marie could not escape her cares. She told Emma Madox Brown she was worried about weaning baby Effie, a feminine subject Marie knew would interest Emma. Unlike country-bred, instinctive Emma, Marie could not bring herself to breastfeed. But Effie's nurse 'became so intolerably insolent we had to accept her offer to leave on the spot so poor baby has to be weaned suddenly & Mama & I watch her night & day with intense anxiety altho' she is very well & happy & drinks her food out of a glass like a grown-up person . . . we haven't anyone to take care of her & she requires a great deal of amusing & is very heavy.' It was a relief for Marie to turn her attention back to London as she accepted Emma's invitation to Cathy Madox Brown's wedding with German musicologist, Frank Hueffer, on 3 September 1872. A little over a year after Marie's contentious marriage there would be another, also celebrated without religious ceremony, and hosted by the Madox Browns from 37 Fitzroy Square.

Russie Stillman was still alive at the beginning of the following year, 1873, 'very weak and ailing but has progressed to some noticeable extent, being able to go out of doors on crutches a goodish deal.' The one-year-old infant Euphrosyne was a marvel of precocity. She cleverly recognised 'Papa' and 'Mamma' from the crayon portraits Dante Gabriel Rossetti had made of her parents a few years before. Stillman as usual was mixed up in a convoluted row, this time with the Photographic Society. Best of all, Marie was working again. She had painted a 'very good portrait' of baby Effie.

Marie may have been back at her easel but it was in the face of opposition. Stillman had always resented Marie's artistic talent as well as her intimacy with Madox Brown. He constantly undermined Marie and found fault with her teacher. When Madox Brown challenged him to explain the derogatory remarks reported by mutual friends, Stillman tried to extricate himself. 'I have never in any way or to any person disparaged Marie's art', although he griped, 'I have spoken of her trivial choice of subject with regret.' The only comment he would make was that Madox Brown was 'not severe enough with her in criticism but allowed her to take the way of her own feeling more than was good for one who had so

little experience of drawing.' Even Stillman sometimes felt he went too far in talking about Madox Brown behind his back – to Rossetti and other friends. 'As to your teaching I have always spoken of you as the only painter I know in England who does know how to teach without destroying the individuality of the pupil.'

Stillman made his views public in 1872 with an article called 'An English Art Reformer: Ford Madox Brown', in which he praised Marie's mentor as a committed teacher, rather than as a major painter. With his own longings to have been a great artist, Stillman could barely suppress his envy of Madox Brown. On the one hand he acknowledged Madox Brown's role as a reformer of early nineteenth-century art who had profound influence amongst the Pre-Raphaelites, but on the other hand he compared him disparagingly with Rossetti, Millais and Holman Hunt. 'If Rossetti was the imagination of the Pre-Raphaelite movement, Brown was its logic and its common sense, and these are qualities which win confidence, not enthusiasm.' Madox Brown 'pushes towards universality' said Stillman, but insinuated that somehow he fell short. His article was a cunning demolition job. Moreover, concealing his identity within the press conventions of the day, he published it anonymously.

Once established as Marie's husband, Stillman's irritability with her professional career escalated. Now he tried to put a stop to it altogether. Madox Brown was outraged. 'I need scarcely tell you,' he wrote to Marie, 'I was rather taken aback by your informing me the other day that you were considered <u>too weak to paint now</u>.' He felt sure Stillman's intention was to crush Marie's artistic resolve and wreck what was left of her relationship with her tutor. Madox Brown continued:

> I need scarcely tell you either that I can hardly believe you are in earnest in any intention of leaving off painting. But my object in writing is not to urge you in opposition to the wishes of your husband . . . I think it right to make it clear that I have never considered attending to your painting as a trouble . . . and that therefore I shall continue to consider your work in my care (in the way best suited to our mutual convenience) whenever you may think fit to resume it.

So enraged was Madox Brown that he could not even sign off with the conventional form of good wishes to the man whom he now saw as a skunk – his usual term for enemies. 'I add no compliments wishing to be thought sincere – remember me to your husband.'

Strangely enough, even though he had concrete evidence of Marie's ability to get exactly what she wanted – after all she had married him in

Caricature of FMB (wearing his French revolutionary hat) by John
Hipkins, inscribed: *His pet name for adversaries, "Skunks"*.

spite of strenuous opposition – Stillman had not taken into account her
equal determination to continue painting. However much he might
bluster or wheedle her into abandoning art, he would prove no match for
the combined determination of his wife and her teacher. All he could do,
ironically, was to echo her father and warn her to 'be careful <u>not to get
excited</u> in your painting. When you feel the "fire frenzy" which young
painters mistake for inspiration and which is simply nervous delirium you
must stop working.'

Those two words, 'stop working', were enough to goad Marie into
action. In spite of feeling 'so anxious all the summer about Russie & then
about my sister,' Marie told Madox Brown, 'of course I have not the
slightest intention of giving up painting.' As if in a dance, she was
balancing the claims of two rival partners. 'What I meant was that for a
few weeks my husband wished me to rest because after working a very
short time my eyes see nothing distinctly & my head swims. The
consequence is that what I paint carefully one day I have to wash out the
next & this makes me quite dispirited & unhappy for the time & so
nervous that I am unable to do anything.' She had been trying to paint her
beautiful, neurotic sister Christina, although she confessed to Madox
Brown that 'the result is by no means satisfactory'. Marie felt only regular,
professional working hours could justify the luxury of lessons with Madox
Brown. If she could not meet her own high standards, it would be

'extremely indiscreet on my part not to remember how short the days are for painting & how many calls you have on your time, how important your work is & how far it is to Clapham.' She tried to shield her husband from Madox Brown's rage. 'If I, or William, or both have been awkward & stupid in saying this or have seemed ungrateful please forgive us.' She concluded by promising to call at Madox Brown's in a few days, and sent her love, tactfully, 'to all'.

In the most graceful way, Marie was now expert in getting what she wanted. She soon applied for more lessons. 'May I come on Thursday to work for a few hours at my new picture? Unless I hear from you I will suppose that I may,' she begged. 'I have not done a stroke of work for more than a month & I am very anxious to begin again.' With all her new domestic responsibilities, it was difficult to recapture her working rhythm. 'Dear Mr Brown,' she wrote, 'Painting has not been going at all I am sorry to say, but I hope to set to work again this week & in a few days I will bring you what I have done.'

When Marie congratulated Lucy on her engagement to William Michael Rossetti in summer 1873, her own concerns rippled between the lines. Weary from five weeks guarding her sister Christina who was in London trying to give up chloral, uneasy about Russie's frailty, and wary of Stillman's opposition to her sessions with Madox Brown, Marie wrote to Lucy, with feeling. 'I rejoice in your happiness with all my heart & hope that your life may be bright & unclouded by any care.' Meanwhile Marie continued to write to Lucy's father, not only about art but also about personal worries, her children, parents and sister. She was a warmly reciprocal correspondent, taking an equal interest in all Madox Brown's paintings, lecture tours and news. But she never revealed the true state of her marital life to him or to anyone. Similarly, Madox Brown was unlikely to have discussed his own marriage with Marie, although she observed it first-hand during her many visits to his studio and home. Emma's alcohol dependency was part of his daily life, a problem he tried to defuse with humour. He missed a dinner party in May 1873 'because Emma got in one of her tantrums the night before & scratched my face, I was very glad of this as I did not want to go & it was a good excuse.'

Madox Brown and Emma were both ill in the months leading up to Lucy's wedding on 31 March 1874. But they rallied in time for the occasion. Later, during autumn 1874, they were hit by the single most tragic event of their marriage. For two months their son Nolly had struggled with an insidious illness. 'I am a mere baby and might as well be

presented with a rattle at once . . . Anything more miserably depressing
than the hole I've just been taken down to is barely imaginable,' Nolly
told his friend, the blind poet Philip Bourke Marston. Madox Brown
called in the family doctor, John Marshall, and then as Nolly worsened,
consulted Sir William Jenner who gave them hope, although Sir William
privately told Christina Rossetti that Oliver's 'imaginative nature was
entirely against his recovery.' On 5 November 1874, Oliver Madox
Brown, the golden boy, already an accomplished artist, novelist and poet,
died aged nineteen, in delirium, of 'pyæmia (blood-poisoning with fever
and abscesses).'

Madox Brown applied strict discipline to his mourning and to Emma's.
'When they were going to bury his boy and all the carriages were waiting,
he called [Emma and Cathy] to him and forbade them to shed a single tear.
He said, "This is the funeral of my son and not a puppet-show." And he
walked downstairs to where all the people were waiting with his head
straight up as if he cared nothing. But it was really because, if he had heard
Oliver's mother crying at the grave it would have sent him mad.' The

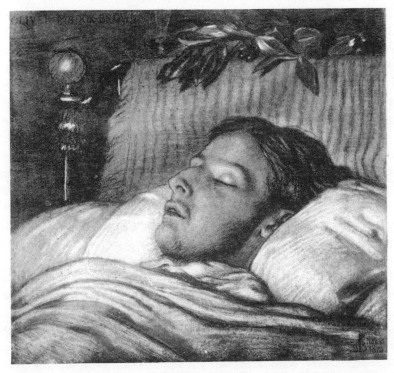

FMB's son, Oliver Madox Brown on the night after his death,
6 Nov 1874.

needs of Madox Brown's tightly controlled grief were paramount. Stoical restraint was his time-honoured method of coping with death, ever since his mother, Caroline, had died thirty-five years earlier.

Repressing his own despair, he neglected to empathise with his wife, who had borne and nursed Oliver. Emma collapsed a fortnight later as Madox Brown described ruefully to Dante Gabriel Rossetti. 'Yesterday we had an allarming [*sic*] day with Emma & nothing but misery for every one but she suddenly dropped off to sleep last night after 4 or 5 hours of intense pain just as the medicine intended to counteract the pain came in . . . to make matters more cheerful the nurse rushed into my room at 1.30 <u>a.m</u>. this morning & frightened Franz [Frank Hueffer, Cathy's husband] & myself excessively by requesting me to come instantly & look at Emma – She was sleeping so <u>very</u> calmly after the agony she had been in that she <u>did</u> look very much as if she were dead, but I saw in an instant that it was all right.' Emma had been told to keep quiet, her voice silenced or denied, so that her grief found its expression in physical illness. In the years to come, the anniversaries of Oliver's birthday and death date, each January and November, always made her 'very restless'.

In a life shaped and given meaning by women, Caroline his mother, Lyly his sister, Elisabeth the wife of his youth, Emma the wife and participant in his greatest pictures, Lucy and Cathy, his two professional, artistic daughters, and Marie the recipient of his most romantic unrequited love, his real hope for the cultural future of the Madox Brown name lay with the male line. He had had three sons – and had lost them all. He stared into desolation. 'What seemed likely to turn out the crowning reward of a life not overstocked with successes otherwise, is suddenly turned into a mockery and illusion.' There was no remedy in false gods, only in absolute fortitude and the salvation of work. 'We are strangely calm, after our wont, and indeed, <u>my</u> belief; it is of no use arguing with the whirlwind. There is nothing for it but to patch up what remains of hope in other directions and get to work again – but the savour is gone, unless in the work for itself,' he told his friend and patron, George Rae, the Birkenhead banker.

Four months later on 3 March 1875, Marie's grief echoed Madox Brown's when Russie, aged thirteen, died at the house on the Isle of Wight, specially lent by Michael Spartali to Stillman for his son's peaceful, final days. Russie had no chance to mature as an individual. The talents of Oliver Madox Brown were already apparent to the world, in pictures, stories and poetry. Madox Brown felt the loss of his son was the greatest tragedy of his life. He and Emma kept to their home, they saw few friends. The convivial days, the sparkling parties at 37 Fitzroy Square were over.

In spite of these events and the bloodless campaign between them, Madox Brown had no intention of allowing his resentment of Stillman to curtail his access to Marie. He found a new artistic project to connect him to the new Mrs Stillman and to underpin their platonic relationship. They would both paint portraits of Marie's daughter, Effie. These would serve a double purpose. They would allow Marie further tuition and give Madox Brown the chance to celebrate the mother in his picture of her child. 'I send you two photos which have just been taken of little Effie,' Marie wrote to Madox Brown from Ventnor. 'The one in the hat looks hard & uninteresting when one thinks of your lovely picture.' Marie made Effie look softly sentimental when she painted her in a hat, head tilted to one side, quite different from the steadfast gaze Madox Brown recorded. Whereas the background to Marie's picture was a Pre-Raphaelite garden, itemised flower by flower, if not 'stamen by stamen', Madox Brown's four-year-old Effie, dressed as a Spanish infanta, was strikingly more modern, as she emerged dramatically from darkness, clasping a single rose (see Plates).

Madox Brown remained Marie's guru and she constantly referred to him on everything to do with her painting career. In 1875, when Ellen Clayton was researching her book *English Female Artists*, Marie, who loathed any sort of personal publicity, asked Madox Brown how to deal with Miss Clayton. 'I see that perhaps she might be inclined to mention my work critically without touching on personal details. I can refer her to Mr W. Rossetti's article ['English Painters of the Present Day' in the *Portfolio*, August 1870] I suppose & give her facility of seeing anything of mine at Clapham. I think it very bad taste to write of living people <u>personally</u> even when remarkable people. The very little success I have would make it ridiculous in my case – I ask you to advise me because I generally do the wrong thing & I know I am rash.' During a renewed crisis over Christina's mental health, Marie added, 'Besides I really am just now worried out of the little common sense I have.' She prevailed upon Madox Brown to see the author on her behalf. 'I have written to Miss Clayton & asked her to call on you if she really wishes any information about my artistic training. I thought you would not mind seeing her for I do not know what to say.'

Five years after her controversial engagement to Stillman, Marie's real concern about Miss Clayton's enquiries surfaced. 'Of course I hope she will understand that I should feel very much hurt at any stories about my engagement appearing & if she enquires much about me, she cannot fail from many quarters to hear most extraordinary stories. I should be much obliged if you would impress her with this.' Following her teacher's

advice, Marie merely supplied Miss Clayton with a list of her pictures to date. When the book came out in 1876, Madox Brown's contribution to Marie's entry was apparent. There was little reference to Marie's personal background and none to her marriage. Instead Madox Brown had steered Ellen Clayton towards an account of Marie's artistic development and an assessment of her special strengths. Clayton praised the beautiful richness and subtlety of Marie's paintings and summarised her special qualities as 'an intense love of colour, and a deep poetic feeling.' Marie's tutor was also praised for encouraging Marie to pursue a professional art career. His exceptional flair for teaching, said Clayton, or Madox Brown through Clayton, or Marie through Madox Brown through Clayton, had been crucial to her ambition and achievements.

The pattern of Marie's marriage was set up from its earliest years. Five years after their marriage, Stillman was managing to miss both Marie's birthday and their wedding anniversary. He wrote to her from Ragusa, Sicily, 'I can never remember whether it is the 10th or 11th March or the 11th or 10th of April which are the anniversaries the most important to me of all.' (Her birthday was 10 March, their wedding anniversary 10 April.) The strong words of Marie's letter to him, now lost, were 'burning with a slow and inextinguishable fire'. He offered repentance for his 'offending words & deeds in these years past', but was quick to justify himself: 'I seem to be dreaming amongst a vast expanse of grave-stones – wandering in the lonely and devastated Herzegovina.' He was ill, he was in a war zone, reporting as a freelance correspondent for *The Times*. Serbia and Montenegro declared war against the Ottoman Empire in May 1876 but were heavily defeated, and a Bulgarian uprising was equally crushed. At a time when atrocities were flashed home by telegraph from correspondents near or in the field, *The Times* readers were becoming familiar with as yet little known Balkan provinces, through Stillman's war reports.

Whether far away or near at hand, Stillman had no emotional understanding of what a mutual marriage could be. He gambled it would be enough to petition once again for Marie's forgiveness, saying 'how sorry I am and how much I hope to shape myself to your heart in future'. When Marie's response finally arrived from Ventnor, she simply begged to be allowed to join him. However, he would not allow her to travel alone as 'we may have war in a month and all ports blockaded.'

Whenever she offered a practical solution to their semi-detached arrangements, he rebuffed her. She had chosen a man almost of the same generation as her father and her teacher. When Stillman heard about the

marriage of Anny Thackeray, elder daughter of the author of *Vanity Fair*, to her cousin Richmond Ritchie, twenty years her junior, he sneered, 'Time only will tell, but her chance, so plain, so much older, of retaining the interest of a young man is precarious.' It is baffling how Stillman, 'so much' older by sixteen years than Marie, managed to retain her interest throughout thirty years of marriage. As he himself said to Marie, 'there is an impenetrable mystery in all marriages'. Perhaps she was simply loyal to her first physical lover with a fidelity that was never in doubt.

When Marie's married life removed her from Madox Brown's studio, he devised practical ways of teaching her by correspondence. 'If at any time you should care to make a tracing of what you are beginning & post it to me, it might save you some trouble as the work progresses.' His ways of teaching her from a distance became her rock to lean upon. 'I should be glad to send you a tracing of my picture . . . as soon as I can finish the cartoon for it,' she wrote to him from Florence in 1878. 'It is a great encouragement to feel that you always take an interest in my work & care to see it in progress for when once it is done as well as I conscientiously can do it, I lose all interest in it & hope for a better result next effort.'

Harried by domestic problems, especially Christina's continuing drug habit which required her 'constant attendance', Marie was frustrated by many obstacles to committed, regular painting. She told Madox Brown she was inspired by the countryside around Florence, 'so full of beauty & light & so different to anything I have become accustomed to,' but she felt ashamed she had not 'been doing any earnest work. You will think that I have acquired the habit of gadding about.' She reported that her lofty stepdaughter Lisa had 'fortunately stopped growing' and, with characteristic wit, that 'Bella has caught all the Italian gesticulation without attaining any fluency in the language.' The girls, Lisa, Bella and Effie, were thrilled when Marie gave birth to a son, Michael (known as Mico), in Florence on 28 October 1878. Stillman was in Montenegro for the event. Late in her pregnancy, Marie was eager to hear Madox Brown's artistic news. 'I heard you speak of some plan last year of some frescoes for a public building which Mr Shields & you would perhaps paint but I never heard anything definite about it & I should much like to hear what you are working at,' she prompted him. And he sent her a chatty response, explaining his commission to paint the first six of a cycle of twelve murals to illustrate the city's history in the Great Hall of Manchester Town Hall.

Madox Brown had felt a connection with Manchester since he lectured there in December 1874, on modern European painting and 'Style in Art'.

FMB's ingenious invention, his lecturing machine or early autocue, 'for rolling the notes forward without the danger of mixing them together'.

This was a few weeks after his son Oliver's death. After that he had lost part of himself – his total absorption in work, the soirées at Fitzroy Square he had hosted with such zest. The colour leached out of his life. At a stroke his energy was cut off. To make matters worse, his personal finances once more were low. He desperately needed a major commission.

In September 1877, Manchester Town Hall, designed by Alfred Waterhouse, received its ceremonial opening. Rising to the challenge of its awkward triangular site, it was a Gothic masterpiece and won RIBA's gold medal the following year. At the heart of Manchester, it was a landmark, symbolic of the city's history, its future, and its present cultural and commercial dominance. Waterhouse had always envisaged a major decorative scheme for the interior. So he built in six blank panels on each of the two long sides of the Great Hall, awaiting the appointment of one or more artists with the skill to paint contemporary murals. The brief was to celebrate 'the entire history . . . real and legendary' of the mighty city of 'Cottonopolis', and to locate it at the centre of the modern, industrial world. Waterhouse and the commissioning committee flirted with Belgian, British and even local artists – witheringly dismissed by Madox Brown as 'Manchester beginners' and 'nobodies'. For their part, the councillors were nervous about Madox Brown's work. It was simply 'too outré' for them. City councillor Charles Rowley explained confidentially to art critic Frederic Stephens that Madox Brown's work was 'not pitched in a key popular enough for most of us but I think we could get him to compromise a little in that line'.

Reassured by Rowley's views, the councillors finally chose Madox Brown and his friend, the talented but neurasthenic artist Frederic Shields, to paint six panels each in the Great Hall. Madox Brown saw the project as the culmination of his career, a public validation of his life's work, and his permanent monument. He would undertake it in the spirit of a modern Veronese, the Renaissance painter who had celebrated civic Venice.

The initial brief in 1878 was to paint six separate murals, illustrating key events in Manchester's history from early to modern times. By 1880 Madox Brown realised it couldn't remain a long-distance assignment, for two major reasons. First and most obvious, the intention was that the murals should be painted direct on to the walls, like true frescoes. Secondly, the fee agreed, at £275 for each painting, was insufficient to maintain a London household, even when five years later in 1883, the Manchester committee grudgingly agreed to pay £100 extra for each of the five murals completed, and for the one in progress. They also agreed to raise the fee to £375 for each of the last six panels, finally confirmed in January 1884. Frederic Shields had been due to fill these but he withdrew, perhaps out of altruism, or lack of self-belief, or both, so that the whole project of twelve murals eventually became Madox Brown's.

He had set to on his first design during the summer of 1878 in his London studio. 'The one I have begun by is the baptism of Edwin in the seventh century', he told Marie. Over more than a decade the immense project would drive him to distraction but at the outset he was able to paint Marie the most harmonious description of his purposeful working days in Manchester:

> As I have gas of my own that I use when I like I work till quite late & sometimes the organist, a splendid musician, steals in unperceived, & the organ, one of the finest in the world, pours forth wonderful strains in the scarce-lit hall, to one all alone as it would seem. It is a great chance this utter quiet for work, from what I have been used to at home.

What he had been used to at home was what he called Emma's 'illness'. A housekeeping ledger book of the 1860s and 1870s shows Madox Brown's expenditure on wines and spirits was often three times greater than bills paid to the butcher and baker. In addition, there were regular daily or weekly sums for 'beer money', presumably for Emma. He did not elaborate to Marie about the problem of living with Emma's alcoholism which veered daily from farce to tragedy. While he was asleep one night in January 1878 she managed to steal the key to the cellar. In his party days

it had housed substantial racks of bottles. The morning after the night of the cellar key theft, she guiltily produced the empty bottles from under the bedclothes and managed to persuade their servant, 'Old Charlotte', a tiny woman with normally strong opinions, to dispose of them. Madox Brown confided this episode to Lucy in January 1878, but in his long-distance correspondence with Marie he did not unburden himself about Emma. He confined his anecdotes to self-mockery:

> I have now had two attacks of gout & two falls since I have been here; the two latter I have not written home to boast about – and none of the four have hurt me to speak of. The first fall was down a sort of trough in my [painting] platform that I was unused to: The second was in trying to alight from a bus in Lancashire fashion, while it was in motion. Since ladies here rush headlong from the busses, which have no doors, with their arms full of parcels & take no harm from the speed at which all is going. Emulous of their example I thought to do the same & found myself in soft mud – but with no bruises.
>
> This I remembered after was on my birth-day, but I shan't state my age [fifty-eight]. It is not quite so bright in Manchester, as with you in Florence but there is little time for reflection on it.

This mix of artistic news, musical appreciation, wry self-knowledge and underlay of domestic sadness is one of the letters that Marie did not destroy. Many years later, after Madox Brown's death, Marie explained her policy to his daughter Cathy. 'It has always been my custom to destroy all letters. I have seen so much mischief come from letters which are found after people are dead & I have always disliked the idea of my friends' letters being rummaged through after my death that since before I married I have always torn up every letter when answered.'

Marie's marriage was precarious financially throughout its thirty years. In 1884 it reached crisis point. There was no time to recover from Christina's shocking death by drug abuse in October, before Michael Spartali's shipping business went unexpectedly bankrupt on 15 November. Marie kept in regular touch with Madox Brown at this time, thankful for his sympathetic words on Christina's inevitable but tragic end. Stillman had long since lost patience, if he had ever shown any, with his sister-in-law. 'I am very sorry to have you a victim to Christine's folly & perversity,' he once told Marie, 'but I hope you will let her have her way & will not trouble yourself if she will kill herself let her do so.'

Numbed by Christina's death, Marie planned to go north to see Madox Brown's murals in Manchester Town Hall, and to be comforted by her old teacher. She would visit him en route to Liverpool, from where Stillman was due to sail to New York on 22 October. In the end, Stillman left from Southampton instead, so Marie's visit to Manchester was cancelled, and she was prostrate for three days with 'distracting neuralgia' induced by tension and frustration. She felt reduced 'to a miserable object . . . It would have been very cheering to have seen you all just now & your kind telegram making us welcome adds regret to the already disappointment.'

The prevailing view in the City was that Michael Spartali's business failed due to misfortune rather than misfeasance. The recent fall in the price of corn, in which the firm traded, was one factor. Another was an error of judgement by Spartali who had committed a large amount of money to an unreliable agent. But as *The Times* reported: 'The Official Receiver said "the books have been well kept" and the special manager appointed said that the business appears to have been conducted with the utmost regularity.' It was a disaster, but Spartali was in no way dishonest.

Nevertheless, the family would have to sell their beloved Shrubbery to help pay the creditors. However, there was one piece of good news. The lawyers unearthed a twelve-year-old deed conveying Rylstone to Euphrosyne. This Spartali property at least, was safe. But Marie told Madox Brown it hardly consoled her mother, 'so changed and so frail looking', continually brooding over her troubles and finding them ever more difficult to bear. In the midst of Spartali's failure, Marie confided her own sense of artistic failure to her old teacher. 'I do not think there is much chance of selling pictures in London for me . . . there are so many painters & I have so few of the qualities the buyers care for, besides I have always managed to be disagreeable to the Press. I cannot help it . . .'

The scandal of Michael Spartali's failure was widely discussed, not only in City circles but also far away in Manchester, and among the artistic set. 'Did you hear of the miserable failure of Mrs Stillman's father – for £600,000!' Madox Brown wrote to artist Frederic Shields. 'Heaven knows how Stillman will manage now without his wife's father's money – Rushing madly backwards & forwards from England to America will scarcely suffice to keep wife & children now.' The old abrasiveness he felt towards Marie's husband was clearly apparent. But he had only gentle and heartening words for Marie at this extra blow. She told him how deeply touched she was 'by your thinking so kindly of us when you heard of my Father's failure . . . of course it is a dreadful disappointment for him after fifty five years of such hard work; up to the present moment his courage

Photograph of Marie Spartali Stillman, n.d.

& cheerfulness have not failed him & he seems to have great hope of starting afresh when all this is cleared up.'

Marie's achievement had been to construct a mutually supportive friendship out of the debris of Madox Brown's earlier infatuation. The drama of her engagement and the tribulations of her marriage subsided in his mind. His vision long ago of a fulfilled love affair with Marie had always been unrealistic. But he was left with an abiding sense of her talent and beauty, and both had been fired by a devotion to making art, a resource which would sustain them throughout their lifetimes.

Meanwhile, as the most important commission of his life began to take shape, Madox Brown was juggling his concern for an erratic and often drunken Emma with his new interest in Mathilde Blind, an intellectual 'stunner' who had graced his London parties.

IV. MATHILDE

MATHILDE BLIND
21 March 1841–26 November 1896

Studio photograph, probably for Mathilde's carte-de-visite.

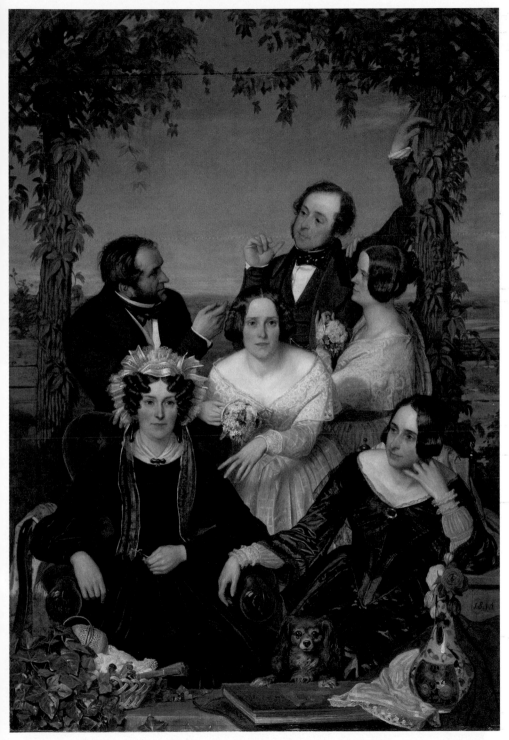

The Bromley Family, 1844. This family portrait shows Elisabeth's eldest brother, Richard Bromley, top left; his wife, Clara Moser, centre; his younger brother Augustus Bromley and his wife Helen (née Weir) Bromley, top right; Mary (née Madox) Bromley, Elisabeth's mother, lower left; and Elisabeth Bromley, Ford Madox Brown's first wife, lower right. We stand where the artist stood.

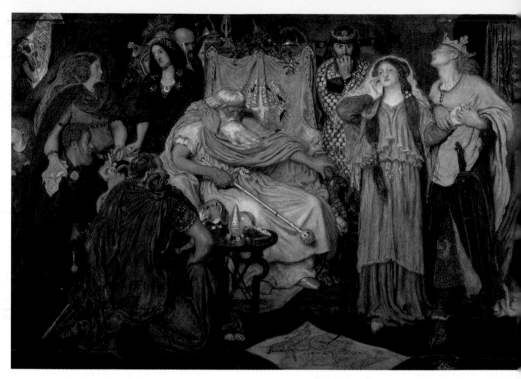

Cordelia's Portion, 1865–66.

Cordelia at the bedside of Lear, 1849–54.
Both Elisabeth and later Emma inspired FMB's vision of Cordelia.

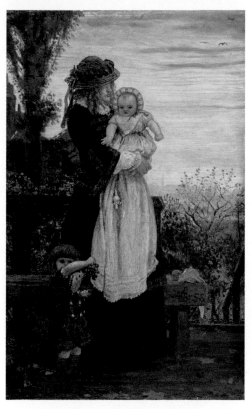

Out of Town, 1843–4, completed 1858. First modelled by Elisabeth and her daughter Lucy.

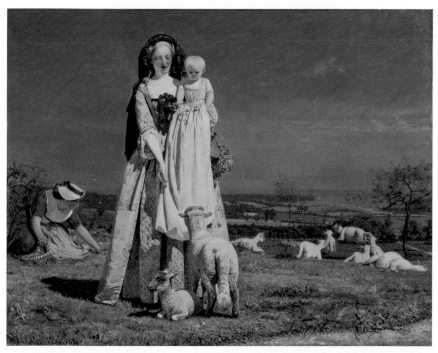

Emma and Cathy pose in burning sunlight for *The Pretty Baa-Lambs*, 1851.

Emma and FMB in *The Last of England*, 1852–55.

Emma pregnant, reading in the shade of *The Brent at Hendon*, 1854–55.

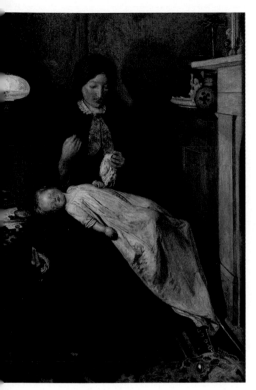

Emma models for
*Waiting: An English Fireside
in the Winter of 1854-55.*

Emma models for *Take Your Son, Sir!,*
1851–52 and afterwards.

On the right, under the rainbow, FMB
and Emma clasp hands behind their
backs in *Walton-on-the-Naze*, 1859-60.

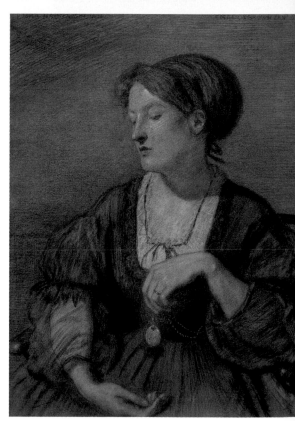

Emma in January 1869, at the height
of FMB's obsession with Marie

Teacher and student both paint Marie's little daughter Effie aged about 4.

La Rose de l'infante (Child with a Rose)
by FMB, 1876.

Consider the Lilies
by Marie Spartali Stillman, 1876.

The Establishment of the Flemish Weavers in Manchester, 1881-2,
which recalled FMB's early years in Antwerp.

FMB gazes at Marie
at her easel in 1869.

*Ford Madox Brown
at his easel* by Cathy
Madox Brown, 1870.

A RADICAL EDUCATION

URING THE EARLY PHASE OF MADOX BROWN'S hopeless love for Marie Spartali, another exotic young woman had entered his orbit, attended his parties, and attracted the attention of the Pre-Raphaelite set. This was Mathilde Blind, pronounced 'Blint' in Germany, but possibly 'Blinned' in Victorian London, as Dante Gabriel Rossetti riffed in his limerick on her name – 'I shouldn't choose her if I sinned!' Mathilde was to become a noted poet, critic, novelist, translator and biographer in her new language of English, in England, the country of her adoption. In addition, she was an ardent feminist and a committed rationalist-agnostic, although other people persisted in seeing her as a German Jew. She never denied her Jewish roots but, on the other hand, she did not feel they defined her.

Although Madox Brown and Mathilde came from very different family backgrounds and were separated by twenty years, both were brought up outside England. Each had important cultural roots in Europe. Madox Brown grew up in the French language and Mathilde in German, and in a sense, neither of these languages ever left them. Sharing an awareness of the wider continent was one of the bonds that underlay their long and complex liaison. But whereas Mathilde's childhood was wrenched apart by political revolution, Madox Brown's had been dictated by economic circumstances. It was only later that the two would be drawn together by political ideals of republicanism, democracy and the rights of the working class which had been nurtured in Mathilde from her earliest years. When Mathilde published her first book of poetry in 1867 at the age of twenty-six, under the androgynous, romantic pseudonym of 'Claude Lake', she dedicated it to Mazzini, the radical architect of Italian unity. Apart from

Marie Spartali's romantic interest in the Cretan uprising of 1866–8, Mathilde's political consciousness could not have been more different from the other three women who were so important in Madox Brown's life.

She was born Mathilda Cohen on 21 March 1841 in Mannheim, then in the Grand Duchy of Baden, south-western Germany. Her parents were Jacob Abraham Cohen and Friederike (née Ettlinger), both Jewish citizens of Mannheim, as recorded in the Cohen *Familienbogen* (family book). The child's name was inkily inscribed 'Mathilda', in its German form. At some point, either her dashing mother Friederike, or Mathilde herself adapted its final vowel to slip into its more fashionable French version. In spite of her later permanent emigration to England, she never adopted the Anglo-Saxon 'Matilda'. French names, especially for girls, were in vogue all over Europe.

Mathilde's mother, Friederike, had been born in Karlsruhe on 15 August 1819. Lively and intelligent, she 'possessed the beauty which, equally with many of her mental characteristics, became her daughter's heritage.' At nineteen, on 1 January 1839, Friederike had married Jacob Cohen, almost thirty years her senior. Significant age differentials were to characterise most of the central relationships in the life of Mathilde, their daughter. Jacob had been born in Hanover in 1790 where he lived with his first wife and their son, Meyer Jacob Cohen, always known as Max. This two-decades-older half-brother, born on 20 July 1820, would supply Mathilde's only financial security but not until the last four years of her life when Max died in 1892 making her the main beneficiary of his will.

After his first wife died, Jacob Cohen left Hanover and settled in Mannheim. The Cohen family book described his occupation as '*partikulier*', a merchant entrepreneur, possibly a ship-owner, although Richard Garnett, in his *Memoir* of Mathilde, called him 'a retired banker of independent means'. However, the proximity of important commercial shipping on Mannheim's two rivers, the Neckar and the Rhine, may suggest that the German description of Jacob's career was more accurate, or perhaps both were true at different times. Three weeks before marrying Friederike, Jacob signed a lease on N1, No. 9. (Unique in Germany, but similar to the layout of Manhattan, the streets of Mannheim were lettered and numbered on a grid system, still retained today.) It was a comfortable, bourgeois, second-floor apartment above Mannheim's Kaufhaus which he leased from a firm of bankers, H. L. Hohenemser & Son. The Kaufhaus was an imposing landmark at the centre of town; it incorporated a

department store, municipal offices, private apartments, and coffee houses beneath its arcades. When he was eighteen, Jacob's son Max moved out to live at B2, No. 11, about one block away, perhaps a tactical move when his father married Friederike who was less than a year older than her stepson.

Jacob Cohen died aged fifty-eight on 30 October 1848 when Mathilde was seven and a half and her brother Ferdinand was four. At twenty-nine, clever, attractive Friederike was a widow. Perhaps disheartened by a decade of marriage to a much older man, she now reversed the age differentials by committing herself to an already existing relationship with Karl Blind, a Protestant working-class radical, seven years her junior. In doing so she risked an alliance, initially without marriage, to a partner outside her own religious or social community.

Friederike and Karl shared advanced views, intellectual interests and a taste for revolution. In 1845, aged nineteen, Karl won a scholarship at Heidelberg University but he always made extracurricular activities his priority. At that time, Germany was still run on feudal lines, subdivided into nearly forty small sovereign states and principalities. There was no German right of citizenship, only a right of residence in an individual state. Consequently, freedom of movement was restricted and people had to apply for passports in order to travel from town to town. Karl Blind campaigned for a united Germany under a republican government with a socialist constitution. He promoted his radical ideals so vociferously at meetings and in journals that Heidelberg University withdrew his scholarship.

Blind committed himself and Friederike, whose husband was still alive, to a life of protest. And from 1847 it was probably Jacob Cohen's money which financed Blind's political activities. Together Friederike and Blind visited Bavaria during August 1847. 'A hot sun shone when we made a trip, with Friederike's children and their governess, to Neustadt – a little town known for the advanced views of its inhabitants.' Their purpose was to disseminate Blind's liberal pamphlets and incite workers to rise up in 'bread and potato riots'. But their activities led to their swift arrest in Neustadt, imprisonment and trial, while the Cohen children and their governess were dispatched home to Mannheim.

The prosecution managed to extract a 'confession' from Friederike which brought her release, and in November 1847, Blind's case too was dismissed, perhaps because 'a revolutionary spirit was already vaguely abroad'. By early 1848, the lobby for German unity, inspired by socialist revolutions throughout Europe, was gathering steam and Blind took part in civil disturbances all over Baden which led to his further arrest, and a

state trial at Freiburg. He described his four-hour defence speech as the most brilliant the judges had ever heard.

In 1849, Blind went to Paris on instructions to contact the social reformer Louis Blanc. Here he met Karl Marx who warned him not to go to a forthcoming demonstration. Blind ignored the advice and on 13 June 1849 he was arrested for conspiracy, together with Alexandre Ledru-Rollin, a fellow revolutionary. After two months in La Force gaol, France expelled Blind, and he joined Friederike and her two children in Belgium. The German revolution had been a failure. Karl Marx had already fled to London, and in 1852, the Blind family, too, finally sought political asylum in England. London beckoned as the only European centre that would admit Karl Blind and his socialist agenda. At some point, probably in Belgium, where the Blinds' two children had been born, Rudolf in Brussels c.1851, and Ottilie c.1852, Karl Blind had married 'the widow Cohen'. Friederike's previous children, Mathilde and Ferdinand Cohen, henceforth adopted the name 'Blind'.

While they prospected for a home in London, Friederike and Karl Blind visited the Great Exhibition at Crystal Palace on Monday 6 October 1851 just before it finished. The mammoth industrial and cultural show was a symbol of London itself, now centre stage in the modern world. Afterwards, the Blinds called on Karl and Jenny Marx at their home, 28 Dean Street, Soho. Marx came from a distinguished line of rabbinical teachers in Prussia but for pragmatic reasons his father, Heinrich Marx, had his children baptised into the evangelical faith. Marx himself was always ambiguous about his Jewish origins, exhibiting distinct anti-Semitism. Even after her marriage to Karl Blind, Marx persisted in calling Friederike 'Madame Cohen', describing her to Friedrich Engels as 'a vivacious Jewess', and mocked her for 'showing off' about atheism and her favourite philosopher, Ludwig Feuerbach. Marx reduced bright, resourceful Friederike to floods of tears and the couple left in a hurry.

At the time of the family exodus from Belgium in 1852, Mathilde was a precocious and literary child. One indelible memory of childhood in Belgium survived: 'I still remember sitting on the window-sill of a quaint Belgian town, the delicious savour of certain mellow pears and the relish of the walnuts after their melting softness.' On Friederike's thirty-third birthday, eleven-year-old Mathilde presented her with an ambitious four-page poem, inscribed and dated '15 August 1852, Ghistelles', a small village near Bruges and the Belgian coast. Mathilde's German ode, written in neat Gothic script, with its self-conscious diction, reflected her

education by governesses. Albion and London were not just geographical places, but ideal locations of the mind that Mathilde longed for in her imagination. She envisaged a magical journey to England's 'moonlit coast', arriving in London on a proud steamship along the banks of the mighty industrial Thames. For Mathilde, London was synonymous with glamour and modernity, 'celebrated all over the world/the wonder of the world.' But the Mannheim girl, whose father, Jacob Cohen, had probably run a shipping business, was also excited about the teeming reality of London's dockyards.

Thus political movements in Europe drove Mathilde to England at exactly the same time that Madox Brown was unpacking and probing society's inequalities in his two greatest subjects, *The Last of England* and *Work*. These interests would connect them intimately in the future.

After leaving the Brussels boarding school where she had been sent at the age of ten, Mathilde educated herself at her new home in St John's Wood, London, while her mother, Friederike, encouraged 'wide reading and deep thinking'. But from about 1855, when she was fourteen, Mathilde attended a day school round the corner in Adelaide Road, a 'so-called Educational Establishment for Young Ladies where, according to the printed circular at least, every branch of knowledge could be acquired from Greek to Callisthenics.' These other branches of knowledge intriguingly included 'Hebrew, harmony and the use of the Globes'.

To raise the tone of her school, the headmistress adapted her name from plain 'Smith' to Mrs 'Smythe'. A member of the Plymouth Brethren movement, she lived 'in daily expectation of the Millennium and went to bed every night in the hope of having the Light of the World knock at her chamber door'. Holman Hunt's picture, *The Light of the World*, showed Christ knocking at a door smothered in brambles, an emblem of human conscience. First exhibited at the Royal Academy in 1854, it was a constantly reproduced and quintessential Victorian image when Mathilde mischievously characterised Mrs Smythe as 'the prophetess of St John's Wood'. Mathilde had no intention of imbibing Mrs Smythe's holy curriculum. Instead, she and the other girls spent most of their time writing novels and poetry, editing a journal and acting scenes from Dickens. Together with five fellow students, whom she gave the fictional names of Amy, Veronica and Isabel Carlton, Lizzie Letchford and Blanche Hellifield, Mathilde was part of an inner circle. They 'shared the same tastes, read the same books, throbbed with the same enthusiasms.'

Mathilde described her sentimental as well as her academic education

in a typescript dating from a later period in her life, transcribed from an earlier document, a fictionalised, never published autobiography. The heroine of Mathilde's barely disguised autobiography was called 'Alma' which means 'soul', a name she would have thought entirely appropriate. The mask of 'Alma' gave Mathilde confessional freedom. Richard Garnett, who wrote a memoir of Mathilde, was sure that 'the persons introduced are undoubtedly real, but their names are, with few exceptions, fictitious.' He did not fudge or belittle the material he found. Without a doubt, he said, Mathilde 'fell violently in love' with 'Amy Carlton'. At nineteen, Amy was the eldest of the 'Carlton' sisters and four years older than Alma/Mathilde. The whole school agreed that Amy was a beautiful girl but to Mathilde 'she appeared a divinity. I felt for her one of those undefinable attractions which mark the dawn of the emotional life.' First love for Mathilde led to a spate of creativity. She poured out letters and poetry to Amy and kept a diary about her. Carelessly she left her poetic 'effusions' all over the house. Their discovery caused her 'unspeakable discomfort'.

During 1856 the Carltons invited Mathilde to their home, 'an ordinary, gimcrack, suburban villa' between Primrose Hill and the fields around Hampstead, though it seemed the 'temple of Aphrodite' to the young visitor. Amy's mother greeted Mathilde with uncompromising banter. 'So you are the girl who thinks such a lot of my Amy,' she said brusquely, 'what a pity you are not a young man, then you might take her off my hands perhaps!'

It was the first suggestion that other people, or Mathilde herself, might have discerned something unconventional about her sexuality. In spite of Mrs Carlton's teasing, Mathilde found the atmosphere of the household ineffably calming. In memory she idealised it to a dreamlike perfection. There was always a girl at a piano playing Mendelssohn's *Songs without Words*. Mr Carlton took to Mathilde and called her 'Sunbeam', not because she resembled his own blonde daughters but because of her vitality. Maybe it was the whole clan of English Carltons that the young alien idealised, for Amy herself soon fell from grace. While Mathilde quoted her favourite lines from 'divine Shelley', she caught Amy yawning 'furtively behind her white shapely hand'. It was enough to seize Mathilde with a 'strange inexplicable chill.' Clearly the soul-to-soul rapport she longed for was not to be found here.

Mrs Smythe's religious mania governed the school. She urged Mathilde to direct her thoughts towards Jesus, to replace her 'perishable' love objects with the love of Christ. Lizzie Letchford then gave Mathilde the first Bible she had ever possessed and encouraged her to subscribe to

Christ's 'religion of sorrow'. At this stage, unusually for her, Mathilde tried to conform, to bury the past. 'In a certain sense I had turned Christian for a time.' Although born Jewish, Mathilde's mixed upbringing with Friederike and Protestant stepfather Karl Blind had been entirely secular. She had left Judaism behind, even assimilated Judaism, long ago in Mannheim. Although she called herself a 'little heathen', she never once referred to her Jewish roots in these memoirs. The reason may have been that her attraction to Christianity was soon exploded by a new faith in rationality.

Mathilde's rejection of religion was driven by 'the last of my ardent school friendships', this time with the niece of a clergyman, Blanche Hellifield. Together they read Carlyle, Kingsley and Tennyson and found 'through most of these works there was pierced an accent of doubt.' Before long the two friends were investigating 'the strange discrepancies' between the creation story in Genesis and the evolutionary 'history of our globe as revealed to us by the rocks and stones.' In 1857, two years before Darwin published his theory of evolution in *Origin of Species*, sixteen-year-old Mathilde began to dig deeper into geology and theology. She stayed up into the small hours night after night, reading, comparing, annotating. She pored over Joseph Butler's *Analogy of Religion, Natural and Revealed* of 1736; she gutted William Paley's *Evidences of Christianity* of 1794, and Sanskritist Max Müller's recent essay of 1856, 'Comparative Mythology'. As a result, 'the veil of Christian sentiments in which I had tried to envelop myself dispersed like a vapour.' She reported her findings to Blanche, who accepted Mathilde's conclusions enthusiastically. 'When we read [Byron's drama] *Cain* together one evening the magnificent speech of Lucifer put us in such a transport that we fell into each other's arms with a sob of delight. It was the last time we were destined to see each other.'

For during Divine Service Blanche was discovered 'devouring Lucifer's indictment of Jehovah [from *Cain*] under cover of her prayer-book.' When interrogated, Blanche had proved no heroine but laid the blame squarely on Mathilde. The next day Blanche was packed off to relatives in the north of England to remove her from Mathilde's evil influence. Mrs Smythe first threatened Mathilde with eternal Hell, then implored her to 'go to Jesus' who was waiting to save her soul. 'Promise me to change your views.' 'Change my views,' responded Mathilde, 'you speak as if one's belief were like dresses that one can put on and off at will. If you can convince my reason I will change, but not before.' Mrs Smythe proclaimed immediate expulsion. Shelley, one of Mathilde's greatest heroes, had been expelled from Oxford in 1811 on charges of atheism, so with her head held high, she walked out of school for ever.

The Carltons, too, cut her off. 'Remember you will never see Amy, Veronica or Isabel again. I cannot invite you to the house as formerly. Edward is very much attracted to you, so is Fred. I cannot let them run the risk of marrying an infidel.' Perhaps Mrs Carlton's subtext was that a Jew was as much an 'infidel' as an unbeliever. And perhaps it was Mathilde's subtext that she felt dangerous and unconventional in more than one respect. Her sexuality, her attraction for the young men, as well as the young women of the Carlton family was as much of a threat to them as her freethinking. The front door of that once idyllic house 'closed sharply behind me on the death of my first friendship'. For the rest of her life, Mathilde would find the death of a friendship infinitely more bitter than the death of a friend.

The Blinds dealt with Mathilde's expulsion from school by turning back to the Continent where they still had family roots. Six months later in November 1857, they sent Mathilde to Zurich to stay with Friederike's brother-in-law and his two grown-up children, Albert and Frida. Uncle David enjoyed parading Mathilde about town during Zurich's winter season of concerts and plays. It was a totally new experience for the girl from England. At home the emphasis had been on radical politics, with an almost puritanical attitude to pleasures like theatre. Now on view in a theatre box with Uncle David, she found she had admirers. Delicious French bonbons arrived for her as well as mysterious verses 'in which I was addressed as a star of the first magnitude'. Although flattered, Mathilde was severe about the poetry, 'not up to the stamp of Shelley'. Her personal development was extraordinarily conflicted. Emotionally, she was susceptible to gifts like childish bonbons; intellectually, she scorned admirers who could not write poetry like Shelley. Her sexual response to young men was distinctly less natural and instinctive than her response to young women. She liked being with women because she felt free to be clever, to be her true self. In all Mathilde's adult relationships, it was always the mind that interested her first.

However, quite apart from the flattery and the bonbons, Mathilde's real interest in Zurich was to learn Latin and Old German. Uncle David said 'I should only get myself talked about as a bluestocking, a term of reproach, not yet out of date.' Undaunted, Mathilde found two remarkable academics to teach her privately: the Sanskrit specialist Professor Kuno Fischer, and his wife, Mrs Fischer, 'as deeply versed in Latin and Greek as a don'. A genuine scholar, 'with the profile of a crow and its sharp vigilant eye . . . Mrs Fischer told me one day that women made far

too much fuss about child-bearing. A mere bagatelle she informed me. She had been able to go on with a Greek grammar which she was compiling the day after the child's birth.'

These 'two epitomes of learning' were decidedly the oddest couple sixteen-year-old Mathilde had ever met. She loved going to their home on the outskirts of Zurich, 'idyllically situated amid rambling kitchen gardens and with a background of low wooded hills behind.' With Mrs Fischer's excellent tuition she threw herself into Roman biographies by Cornelius Nepos, Julius Caesar's account of the Gallic Wars and Ovid's *Metamorphoses*. Tutorials on comparative etymology with Professor Fischer were even more exciting. His teaching methods were 'to take words as if they were living beings and to carry me back to their birthplace, showing me their origin and growth, the organic changes they underwent, the groups and families to which they belonged, their eventual crystallisation.' They read early German poetry together: the Old High German alliterative ballad *Hildebrandslied*, the chivalric romance *Der arme Heinrich* by Hartmann von Aue, Wolfram von Eschenbach's Holy Grail epic *Parzival*, Walther von der Vogelweide's Middle High German lyrics, and the medieval courtly love poets, the Minnesingers.

However, Mathilde did not confine herself to the study of the past. Her radical credentials gave her an introduction to 'a group of brilliant Revolutionists' in Zurich. Georg Herwegh, poet and journalist of the failed 1848 German revolution, and his wife, were at the centre of a notable circle of 'many witty, original, fascinating, daredevil spirits'. The German political talk she heard at the Zurich salon would have been entirely familiar to Mathilde.

Mathilde's independent spirit gave her freedoms unheard of for other young women of her day. But the freedoms were not granted by others; they were claimed by Mathilde. In 1860 she made up her mind 'to carry out a long cherished plan to walk quite alone through the Bernese Oberland.' She set off one summer dawn with a knapsack and Alpine stick, to see J. M. W. Turner's blue Rigi mountain. Appropriating the masculine gender, she 'felt as happy as a schoolboy when he starts for his long vacation.' Crossing boundaries, stepping out in the sunshine, the girl who felt like a boy identified in her mind with 'gypsies, vagabonds and outcasts'. A sense of being an outcast stayed with her always and was one of the reasons that later she felt literally 'at home' – and made her home – with Madox Brown. He, too, was an outsider who had spent his formative years on the Continent and never felt totally at ease in England.

As Mathilde made her poetic way through the Alps, reciting Coleridge's ode to revolutionary France, she felt she had reclaimed her European birthright. She walked into liberty. 'Yes, for once I felt truly free!'

The natural world had always been a source of exaltation for Mathilde and now she felt a sensuous rapture, almost a sexual adumbration in the 'titanic sea-waves' of spectacular mountains which unfolded before her eyes. Mathilde considered that 'very few things in this life have exceeded my expectation' but her first vision of the Alps did exactly that. It induced a state bordering on ecstasy. The mountain ranges were 'like the last part of Beethoven's Ninth Symphony turned into visible form.' Music turned into mountains may have been a subconscious echo of Goethe calling architecture 'frozen music'.

Mathilde's rapturous love of nature was something she shared with Madox Brown who had been turning his impassioned observation of landscape into a series of glowing, gem-like paintings in the decade leading up to 1860. No vista was too intense or glorious but he longed to capture it in pictures ranging from *The Pretty Baa-Lambs* of 1851 (see Plates) to *Carrying Corn*, and *The Brent at Hendon* (both 1854), (see Plates)

Manfred on the Jungfrau first painted in 1840 and returned to in 1861.

The Hayfield (1855), *Hampstead from my Window* (1857), and *Walton-on-the-Naze* (1859–60), (see Plates). In his diary he word-painted the beauties of the natural world that set impossible challenges for the artist: 'exquisite day, hedges all gold rubies and emeralds defying all white grounds [i.e. canvases primed with wet white paint] to yield the like'. By a strange coincidence, at about the same time as Mathilde was walking through Switzerland, Madox Brown was retouching his Byronic mountaintop picture *Manfred on the Jungfrau*, first painted in 1840, which he said had been his earliest 'attempt at outdoor effect of light'.

Mathilde's spectacular walking route was not for the faint-hearted. She had enjoyed travelling alone, although she was not a loner. At a hotel in Andermatt she met a young woman called Constance, who was sightseeing with her mamma and some friends. Constance was amazed to learn that Mathilde was quite unchaperoned. 'But you are so very young to be travelling quite alone,' said she softly, 'are you not afraid?' It was the ideal opening for Mathilde to expound her theory of radical feminism. 'Why should we always be afraid?' she asked. 'It is fear that makes us slaves . . . I've made up my mind to be a free woman and this is a step in that direction.'

Constance enquired, 'is it possible for a woman ever to be free? Is she not predestined to be dependent? Do not nature and society play into each other's hands?' Mathilde replied that she could see very little difference between male and female in nature, between 'male and female eagles, seagulls and swallows, elephants or ants.' Constance was momentarily beguiled by this argument, but her mother and their friends couldn't accept Mathilde's feminism, nor believe that she was really travelling alone: 'what is your mother thinking of, I wonder to allow such a thing! In her place, I would send you to school, Miss.'

Most dangerous of all was the accusation 'you try to make yourself a man'. Constance's mother implied that Mathilde's independence would compromise her femininity and lose her value on the marriage market. 'Now don't try and damp her bright spirit, Mama,' cried Constance, suddenly taking Mathilde's hand. 'I admire her pluck; I wish we were all as plucky as she is.' Constance wore soft grey gowns with lace at her throat and wrists and 'reminded one of the smell of heliotrope'. When she looked at Mathilde, 'with her chocolate brown eyes it was like a caress'. Even allowing for the fact that a heightened language of affection was normal between women in the nineteenth century, it is clear that the attraction Mathilde felt for Constance was physical as well as emotional. She reminded Mathilde 'of a mountain tarn shut in by great rocks into which only certain chosen rays of sunlight and moonlight can penetrate.'

Constance found Mathilde 'too wild and untamed for her', but their intimacy deepened in those few days at the Swiss hotel. When Mathilde went on her way, both young women felt their parting 'very much'.

Mathilde's rhapsodic travels next took her through the Haslital valley, on to Meiringen and the Handegg Falls, the Great Scheidegg and the Rosenlaui glacier. Its extraordinary ice-scape was captured in paint by Pre-Raphaelite associate John Brett, in 1856, four years before Mathilde's expedition. Mathilde later visited Brett's studio and he painted a portrait of Ottilie Blind in 1869. It may bear some resemblance to what her half-sister Mathilde had looked like at the same age.

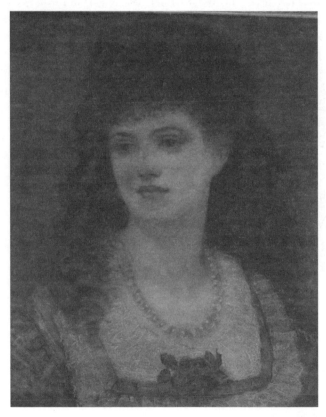

Mathilde's half-sister Ottilie Blind, aged 18, by John Brett, July 1869.

Mathilde's walking tour was not just through the physical geography of the Alps in all moods, through storms, rainbows and avalanches. It was a journey to her personal interior. Each feature of the natural scene and human encounter drove her deeper into self-examination and self-knowledge, while to the outside world she presented an eccentric

spectacle quite at odds with contemporary expectations of 'young ladies'. Arriving in Geneva, she met Lizzie Letchford, her old friend from Mrs Smythe's school, now distinctly a young lady. Lizzie was shocked by Mathilde's sunburnt, unkempt appearance and escorted her back to the Hotel Britannique to repair the damage. Mathilde had lost her mantle down a precipice on the Furka Pass; her umbrella had fallen into the River Reuss when she was almost blown off the Teufelsbruecke (Devil's Bridge); and she had been soaked to the skin in a 'most glorious thunderstorm' crossing the Great Scheidegg mountain, which quite took the shine off her 'nice Garibaldi'. But she had 'managed capitally' for she had seen everything, and even more than she intended, with the £8 of her original budget. Quite unperturbed, she had exactly four francs and thirty centimes left in her purse.

Lizzie brushed out Mathilde's mass of tangled hair. As she coiled it up into a luxuriant knot on the nape of Mathilde's neck, 'a slow and soft blush mantled on Lizzie's full cheeks, usually of an opaque whiteness.' Mathilde noticed the usual reaction she inspired in young women. However, Lizzie was practical as well as susceptible. She and her father bought Mathilde a new wrap and umbrella as well as her train ticket back to Uncle David in Zurich. 'For they declared, I could not be trusted out of their sight until settled in the train, otherwise I might perhaps turn up at the Caucasus.' It wasn't a joke. It really had been her next destination for she had heard that 'its mountain scenery far surpassed anything in the Alps'.

Meanwhile, in exile in England, Karl Blind was pursuing a consistent, international republican campaign. By associating himself with leading European figures of reform, including the Italians Mazzini and Garibaldi, Hungarian Kossuth, Russian Herzen, and Frenchmen Ledru-Rollin and Louis Blanc, he was making a career out of his revolutionary past. Blind styled himself grandly as a 'Political & Scientific Publisher' or 'Author General Literature'. In fact, he became a professional journalist, writing for dozens of English, European and American newspapers. His 'Letters from London' kept German readers in touch with the latest in British science and literature. He was a regular contributor to *The Times*, the *Globe*, *Daily News* and *Morning Star*, carefully avoiding discussion of British politics. Prolific even in a language not his own, he tirelessly promoted himself, with what Karl Marx ridiculed as an 'assiduous ant-like industriousness'.

Although there had been an uneasy friendship between the two men in Paris in 1849, and later during their early days in London, Marx soon

resented Blind's professional success. As a Prussian, Marx reviled his compatriot who had 'the hole-and-corner cunning of a man from Baden'. He pursued his quarry like a verbal terrier: Blind had 'as many little dodges up his sleeve as there are fleas on a dog.' In spring 1863, Blind compared himself with Mazzini and Kossuth in the *North British Mail*, telling the Scottish public he was a patriot exile who 'has hitherto stood in that middle way, where *he has the honour of being both beloved and hated.*' Blind's smug tone infuriated Marx who exclaimed to Engels, 'Isn't that "naice"?' He attacked Blind in the columns of the Stuttgart *Beobachter* for his pomposity and his dubious journalistic methods: 'fabricating letters, circulars, leaflets, protests, provisos, defences, proclamations, appeals, and other similar head-shakingly solemn Blindian political recipes, from which there is as little chance of escaping as from Mr Holloway's pills or Mr Hoff's malt extract' – two ubiquitous cure-all brand medicines of the period.

There were in London at least three distinct and opposing views of Karl Blind: his overblown view of himself as a German hero, the loathing of some of his fellow exiles, and the more sympathetic views of the wider Anglo-German society which he courted. The Blinds' home at 2, later 3 Winchester Road at Swiss Cottage in north-west London, soon evolved into a well-known salon where German exiles and political refugees met for revolutionary discussions, a generation after Italian refugees had similarly congregated at the London home of Dante Gabriel Rossetti's father. Although many of these European intellectuals had once distrusted commercial, perfidious Albion, now they expressed approval for their host nation where 'freedom of thought' was paramount. However, Karl Blind never took British nationality although he lived in Britain for the rest of his life.

His guests remarked upon the distinction of each member of the family. By her early twenties, 'Mathilde possessed beauty', and 'was distinguished for her literary culture'. Contemporaries found her poems full of stimulating ideas. They thought that if only she had been able to write in her first language – German – Mathilde might have achieved far wider recognition. The cultural, linguistic and emotional adjustments she had had to make from the age of eleven were huge. But although part of her secondary education had taken place in Britain, and she absorbed her new culture with enthusiasm, she never sounded like a native English speaker.

Rudolf and Ottilie, her younger half-siblings, added to the attractions of the Blind salon. Rudolf later became a painter, most notably of a decadent nude called *The World's Desire*. Ottilie, a close friend of the scientist Hertha Ayrton, grew into a graceful and intelligent woman, who

in 1876 married Charles Hancock, a rising young barrister. Friederike was
noted for her animated and entertaining conversation, her husband for his
erudition. Although steadfastly radical, he allied himself with both
German and British establishment figures, serving on the Schiller
centenary committee in 1859 and on the *Athenæum*'s Shakespeare com-
mittee in 1864. The striking family members combined to make the
Blinds' salon at Winchester Road a natural haven for poets, intellectuals
and left-wing Europeans passing through London.

During autumn 1860 one of their guests was fifteen-year-old Kate
Freiligrath. Daughter of the German poet and exile Ferdinand Freiligrath,
Kate was enthralled by nineteen-year-old Mathilde with her 'extreme
beauty and fire'. They shared long talks on literature. 'That is to say,
Mathilde as a rule talked and I listened', while the older girl discussed
Goethe and Schiller, or enthused about the wit and beauty of Heine. Her
assurance and fluency held Kate spellbound. But Mathilde didn't just
study literature. She wrote her own. Kate recalled one evening when 'the
fair young poetess' read aloud her new poem 'redolent of moorland and
heather'. Perhaps it was an early intimation of *The Heather on Fire*,
eventually published in 1886 when she was forty-five.

Mathilde's knowledge, both poetic and political, amazed Kate. But
there was another side to her personality that friends of later years might
never have believed. 'I mean her passion for dancing! Youth is the time
for dancing, and I was fond of it myself,' admitted Kate, 'but I think I
never saw anyone so absorbed by it' as Mathilde Blind. 'We sometimes
had small carpet dances to which Mathilde was asked as a bright and
particular star,' Kate remembered. 'Or she would give a similar enter-
tainment, or we met at some German public ball, which the German
Liederkranz [singing circle] was wont to give annually.' From the moment
Mathilde entered a ballroom to the moment she left, 'she would be
besieged by numberless applicants', observed Kate. 'But I firmly believe
that the homage and admiration of those days, were almost a matter of
indifference to the beautiful young girl, who simply danced for the
enjoyment of dancing per se.' Later in her novel *Tarantella* (1885),
Mathilde used Antonella's demonic dancing as the outward physical sign
of inner psychological crisis. Apparently Mathilde knew about the
delirium of dance from personal experience. And perhaps Mathilde left
her partners behind and danced in a free improvisation to music,
prefiguring the ecstasies of Isadora Duncan. 'This passionate throwing
herself into one thing with all her soul', commented Kate, 'was eminently
characteristic of her.'

Mathilde's physical spell was enhanced by a canny dress sense. William

Bell Scott, who met Mathilde at parties, noticed that she knew exactly
how to complement her dark good looks with exotic colours. He told his
mistress, Alice Boyd, that Mathilde was 'a jolly little red republican, with
an immense mop and spread of black hair and an Indian or Turkish (bright
yellow stripes you know) scarf tied across her.' Kate noted how Mathilde's
clothes always set off 'her burnished hair, that had a thread of gold hidden
somewhere in its dusky masses, and her glorious eyes that were so
eloquent of speech.'

Both Jacob Cohen's children, now with the name Blind, identified with
Karl and Friederike's political principles. At twenty-two, Ferdinand was
inspired to action. In 1866 he went to Germany, the land of his birth, to
study scientific agriculture. Here he became convinced that Bismarck, the
future Iron Chancellor, was accruing dangerous personal powers and
intended to take the country to war. As Ferdinand wandered through the
blooming fields of Germany, he decided that the only way to curb
Bismarck was to eliminate him. So in Unter den Linden on 7 May 1866
he shot but failed to kill Bismarck. Almost immediately after his arrest,
Ferdinand managed to blow out his own brains while in police custody.

At first the exiles could not believe the reports buzzing out of Germany.
Letters of confusion, affection and condolence poured into the Blinds'
home. But Ferdinand's assassination attempt had clumsily backfired.
Ultimately, it caused only a profound sense of embarrassment among
German exiles in England, for in the popular imagination, Bismarck was
regarded as a national hero building up his country. Even sympathetic
observers like American freethinker Moncure Conway (who later would
give the secular addresses at both Madox Brown's funeral and at
Mathilde's) estimated that Ferdinand's action had not only brought
sorrow to his family but had actually demolished the republican cause.
The perception was that 'young Blind had sacrificed himself to give
Bismarck the halo of a Man of Destiny.'

Mathilde went into deep mourning for her brother. The impression she
made of 'combined beauty, dignity, and sorrow will never be effaced.'
Such a 'grievous catastrophe' of 'misguided patriotism' sobered her natural
exuberance. In her view, Ferdinand died a martyr to a political cause,
inculcated by his stepfather. If Ferdinand was trying to win Karl Blind's
approval, his futile sacrifice only added to Mathilde's growing unease with
her stepfather. She had lost her brother, the companion of her exile. After
her son's death, Friederike grew even closer to her clever, firstborn
daughter. Nearly six months later in October 1866, people were still

making condolence visits to the Blinds. Friederike was grieving for Ferdinand but she was a modern parent who gave Mathilde her freedom. Perhaps she remembered the personal and political freedoms she had grasped for herself in her own twenties. That autumn Mathilde made a two-month visit to Stuttgart and Heidelberg. Friederike worried about her daughter in the cold German October. 'I love your letters and I think of you a lot – However far away I am, I am thinking of you – and I kiss you utterly – your faithfully loving mother.'

Mathilde thus came from an unconventional background of freethinkers and militant activists. In the year of Ferdinand's death, while preparing her first collection of poems for publication, she dedicated it to 'JOSEPH MAZZINI – The Prophet, Martyr, and Hero, In Undying Gratitude and Reverence.' Mazzini was a frequent visitor at the Blinds' salon at which he and Mathilde discovered a true meeting of minds. 'The delight of Mazzini in her society seemed to some of their political friends to be of importance to the affairs of Germany and France; for Mathilde was well acquainted with such matters and keenly interested in them.' In her eyes, Mazzini was an intellectual giant, her moral and political mentor, a modern Dante. The age difference between Mazzini and Mathilde was thirty-five years, more than a generation. But in London together, they shared more than exile, they shared a political outlook. Their cast of mind was international. He was an Italian who cared about German and Polish independence; she was an Anglo-German who cared about Italian independence.

Long conversations held in Mazzini's cluttered room at 2 Onslow Terrace were so vividly etched into Mathilde's memory that she never forgot them. Every surface, table, sofa, chairs, was submerged under books, newspapers and pamphlets. Perched on the edge of a seat, behind the swirls of his cigar smoke and dressed in black, he cut a romantic figure. Dark, luminous eyes gave a glow of 'eternal youth' to his ascetic, gentle, wasted face. Tame birds flew around and landed trustingly on the shoulders of the man who was 'an object of distrust and terror to most of the governments of Europe'.

From this room Mazzini kept 'the flame of revolutionary enterprise alive'. But he made time for Mathilde. He told her not to be too impatient, or expect that her life's aims, political and poetic, 'should grow up in one night like mushrooms'. An inspirational teacher, he mapped out a plan of structured study for her: six hours a day of astronomy, geology, ancient and modern history, and most important of all, the history of

philosophy. She was dazzled, she said, by 'the infinite distances that opened out before me as if by magic'. She hung on every word, drinking in his advice 'with the same greediness with which a flower drinks in the rain'. They became close friends. Indeed, in her twenties 'she was disposed to devote her life and her fine talents to his person' as well as to 'his great mission', to unite Italy and free her from Austrian domination. Although she did not ally her personal life with the great man's, his influence was a crucial factor in her lifelong republicanism and freethinking.

At the age of fifty, when Mazzini had been dead for almost twenty years, Mathilde looked back and asked herself, almost in unbelief: 'And did I once see Mazzini plain? Did I hear him talk? Did I touch his hand? Did I feel the unique magnetism of his personality?' For Mathilde, as for many political radicals in London, Mazzini had been 'the incarnation of an idea'. He talked brilliantly about the duty of the individual, and his belief in the evolution of society 'as an upward movement'. They discussed Dante, Shakespeare, Goethe and Carlyle, and the pursuit, not of happiness, but of Mathilde's life task. For 'if with steady aim you pursue an appointed task, just as unexpectedly as the sunshine falls on your path', he told her, 'happiness will surprise you unawares.' He warned her: 'Do not contemplate: work.' 'Worship duty: it is the only reality.' His social conscience drew her attention to the plight of the downtrodden, such as crofters who had been evicted from their homes in the Scottish Highlands. His ideas on religion, on the Christian story as something humanity deeply needed to invent, reinforced her own secular position.

Mazzini's talk was enlarging in every sense, empowering, and original. He was another of the significant older men in Mathilde's firmament. They were two of the most distinguished guests at Madox Brown's glittering parties in Fitzroy Square. Kate Freiligrath was struck by the similarity between Mathilde and Thackeray's heroine, Beatrix, in *The History of Henry Esmond*. 'When she came into a room, were it ever so large', Mathilde, like the fictional Beatrix, 'would draw all eyes to her.' It was an exact parallel with the effect Marie Spartali – a completely opposite physical type – had aroused in Madox Brown and countless admirers across London.

WE ARE NOT IN ARCADIA

BRILLIANT AND ATTRACTIVE, MATHILDE WAS SUSCEPTIBLE to love, as her friend Richard Garnett knew. He had a special interest in Mathilde's capacity for love. We know this because an extraordinarily long, frank and unpublished correspondence survives between Mathilde Blind and Dr Richard Garnett, polymath, autodidact and superintendent of the British Museum Reading Room. These letters tells us a great deal about the way Mathilde managed the most important emotional relationships of her life, alternately daring to go forward and then retreating. This amorous friendship with Garnett overlapped with and shifted into the most significant liaison of her life – with Madox Brown. The arc of the Mathilde-Garnett attraction in these letters suggests an eloquent template for the lost, suppressed or burnt correspondence Mathilde may have later exchanged with Madox Brown. The letters between Mathilde and Madox Brown have never been found. They, or Emma and Madox Brown's daughter Cathy, were assiduous in destroying any evidence. But the often daily proximity between painter and poet may have meant that few letters were necessary, just as there were few letters between Madox Brown and Emma.

Like Mathilde, and like the Rossetti siblings, Garnett did not go to university. But his appetite for scholarship and poetry was gargantuan. And the Library at the British Museum was the perfect place for him to cultivate his passion for European languages and politics, as well as classical literature. All these interests he shared with Mathilde. In the library, he was ideally placed to encourage the researches of studious young women. Garnett was thirty-four, a married man with three children (three more were to follow), when the surviving correspondence began in 1869. By

then Mathilde was twenty eight. She had been reading at the British Museum Reading Room since she was eighteen, when she had applied for a reader's ticket, on voguish pink paper, at the same time as her mother. 'Admit both ladies 18 May 1859', wrote the librarian across their application letters, just two years after the opening of Panizzi's great round Reading Room. Mathilde was then living on modest funds from Jacob Cohen's inheritance, and from Friederike, her mother. In her twenties she began to receive intermittent small payments for her literary work. The Reading Room was her university, her research centre. It also provided free heat and light, as well as a haven away from home which held her abrasive stepfather, Karl Blind.

From the beginning Mathilde and Garnett exchanged views on the finer points of Greek, German and Italian translation, as well as English poetry. As senior partner of the friendship, Garnett adopted a benevolent, mentoring tone. He enjoyed his role as teacher, offering advice or reproof on her poetry and translations. He ticked her off for her awkward inversions of natural word order, her use of archaisms and for imprecise translations of specific words. But like all good teachers he tempered criticism with encouragement. 'This is all I have to say in the capacity of Devil's Advocate and in the main I think the translation a very fine one,' he wrote of her English version of the *Lament for Euphorion* from Goethe's *Faust*. Initially, she enjoyed playing the ingénue, playfully signing herself with the romantic, Tennysonian diminutive 'Maud', not 'Mathilde Blind'. They discussed George Eliot whom they both admired, in Mathilde's words, for her 'marvellous psychological insight and power of delineating character, and the strength and sublimity of the moral and mental sides of her mind'.

The correspondence reflected a rapport that grew more and more intimate. In Garnett's mind Mathilde found an equal appetite for intellectual endeavour. Intimacy was only possible for her when someone understood the prime importance of her writing life. 'My only real intense life has been for a long time in writing', she told Garnett, 'and when I cannot swim and float about in the enchanted waters of poetry, I am like a fish out of water & I gasp & pant for want of the proper element to breathe in.' He sympathised when she felt 'horribly depressed', encountered writer's block or was dissatisfied with her efforts.

Their exchange of ideas ranged eclectically. They discussed De Quincey, Schopenhauer, Peacock, Plato, and Thoreau. Above all, Garnett shared Mathilde's enthusiasm for Shelley. When she gave a lecture on the poet on 9 January 1870, at St George's Hall, Langham Place in London, he was there to hear it. In spite of her 'beauty and earnestness',

she was not a natural public speaker, he felt. Her harsh, South German accent 'told heavily against her' but she fiercely posed Shelley's famous question, 'Can man be free if woman be a slave?' For Mathilde, Shelley was 'the standard-bearer . . . of justice, liberty, and truth. He is the lamp of vestal fire . . . the electric telegraph of thought.' Garnett provided her conduit to the Shelley descendants, Lady Jane and Sir Percy Shelley. They found Mathilde's ideas on the poet, and later her Tauchnitz edition of 1872, 'a thousand times better' than William Michael Rossetti's allusions to Shelley's sexual irregularities in his 1870 biography.

Constant postal discussions with Garnett, as well as face to face meetings in the British Museum and at dinners and lectures, 'acted like a tonic' on Mathilde's soul. Her nervous being, complicated by her awkward assertiveness, leaned on his more optimistic spirit. His knowledge of German literature reawakened an ancient ghost. When he discussed German poetry, it recalled her past, 'just as if somebody accosted me and spoke in some language I had known long ago.' Garnett soon dropped the formality of 'Dear Miss Blind' and wrote instead to 'My dear Mathilde'. 'Your genius and perseverance <u>shall</u> triumph over the perversity of editors.' He acted as her agent, networking with British and international journals and publishers. She became a regular reviewer for the *Athenæum* (1872–87) and the *Examiner* (1873–4). If her work was rejected, he told her to 'measure my disappointment by your own'; if accepted, he triumphed too.

The mentor was falling in love with his protégée. He longed to be in a non-Victorian Arcadia with her. She called him her 'dear friend' but he wanted to move the relationship on to a different plane, deeper than a literary camaraderie. He told her, 'my regard for you is not in the least dependent upon your fortunes as an author, neither are my opportunities of enjoying your society to depend upon them. That is fair, *n'est ce pas?*'

Mathilde was not sure it was 'fair'. While she benefited from his free advice and literary contacts, Garnett had a wife, Narney Singleton, and family waiting at home after his working day at the British Museum. He tempted Mathilde with fresh news of a 'Shelley harvest' or new cache of information. She was 'burning to hear all about it', and teased him, consciously or subconsciously, with invitations to come over to discuss it. He had heard some rumour of her *tendresse* for the unattainable and sexually ambiguous poet Swinburne, so he teased her in return – with Swinburne's initials. 'Adieu, dear Mathilde, *soyez heureuse*. I wish I could subscribe myself ACS for your sake; but, believe me at least your affectionate friend, R.G.' Continuing in playful, alphabetical code, he declared 'a steady resolution on A's part to do all he can for B[lind], to

whom he is indebted for so many happy hours.' B had done more to exercise and strengthen A's own nature 'than any one he has met in the whole course of his life.'

What did Mathilde feel for Garnett? Did she love him or did she use him to further her career? She led him on, sending poems and suggestive descriptions of landscape, her form of literary flirting. He provided a rock for the reliant aspect of her nature. He appealed to Mathilde by comparing her with Margaret Fuller (1810–50), the American women's rights campaigner. Fuller was famous for saying that women could do any jobs done by men – 'let them be sea captains if they will' – a point of view entirely endorsed by Mathilde. She enjoyed being compared with Fuller, who supported Mazzini, one of Mathilde's greatest political heroes. Garnett pressed his advantage. Mathilde was like Margaret Fuller especially in her power to arouse the sort of 'attachment when affectionate admiration combines with intellectual sympathy.' But noting that he and Mathilde were next due to meet at a party at the Madox Browns in June 1870, he wished her 'some better intellectual stimulant' than his own, and hinted darkly, 'I will try to rejoice if I hear that you have found one. Adieu.'

Had Garnett sensed an imminent danger, one that Mathilde herself had not perceived? The Franco-Prussian war began on 19 July, the same day that Garnett told Mathilde the war would 'weld Germany into a nation'. Many miles away from London on holiday with his family in Wales, he reminded her 'if there should be anything to call for my aid or sympathy, let me know.' He wrote to her mother, Friederike, offering to send lint to the front for German soldiers. Wooing the mother, he would woo the daughter too. He brought his big literary guns to bear on the courtship. 'I am also writing to my friends at Berlin to enquire if they can find anything for me to do in the English press or otherwise'. Garnett's infatuation with Mathilde led him to identify with German political causes and take action, in the same way that Madox Brown had done in 1867 on behalf of the Cretan revolutionists and his beloved Marie Spartali. Perhaps both men, safe from any real wars, recast themselves as heroes from Arthurian legend and romance, determined to take up the causes of their unattainable ladies.

Meanwhile Mathilde had found a new Shelley enthusiast, another older man, with whom to share poetic confidences. He was William Michael Rossetti, whose edition and *Memoir* of Shelley she had just criticised rather severely in the *Westminster Review*. She met him at a party in July 1870 and William's brother, Dante Gabriel, was soon teasing William about his new 'favourite Miss Blind'. Mathilde used the friendship to provoke Garnett. 'I had another delightful letter from Mr Rossetti . . . We met him at the

[Moncure] Conways last week and Mama asked him for last Sunday. I had <u>such</u> a conversation with him!' She found his integrated personality 'indescribably soothing'. At nearly thirty years of age, and unmarried, Mathilde still lived uneasily at home with her overbearing stepfather, Karl Blind, her vivacious mother Friederike, and Rudolf and Ottilie, her younger half-siblings. William Michael Rossetti calmed Mathilde's troubled spirit for, as she told Garnett, 'matters at home have again been in a most intolerable state'.

Karl Blind.

Relations between stepdaughter and stepfather were volatile and often unbearable. 'For what with the troubles here and the horrible heat and the War', Mathilde felt morally and physically upset. 'However abhorrent the idea of the War is to me,' she thought it might be concluded in the long term to Germany's advantage. In the same breath, she pointedly asked Garnett if his wife had accompanied him on his trip to the spectacular Swallow Falls at Betws-y-Coed in North Wales.

Garnett could no longer restrain himself. The sublime grandeur of the Welsh scenery inspired a declaration that boldly rejected codes of Victorian respectability. 'You may be sure, dear Mathilde, that I have thought much of you, and that the thought was seldom absent from my

mind . . . I thought how much more I should have enjoyed [the mountains] in your company . . . pleasing ourselves and hurting no body, but for conventionalities and the restraints which the worse half of the world imposes upon the better.' However, he remained a married man and could only resort to his usual mantra. 'We are not in Arcadia.' He tried to persuade both Mathilde and himself that his love was platonic. 'We have proved, I believe, what some doubt; that a pure and dis-interested friendship is possible between young people of different sexes.'

Once Garnett was re-established at his desk in the British Museum, the relationship resumed its natural, literary course. Mathilde applied to him for books and advice as usual. 'You shall want for nothing in my power to procure', he promised. Although a more peaceful rhythm had been temporarily restored in the Blinds' domestic life, Mathilde put him off from visiting the house.

She told Garnett she had found a new family. It was Madox Brown's, at 37 Fitzroy Square. She spent a boisterous evening there at the end of August 1870. '[William] Morris was there and quite *en famille* he imitated parrots, cats etc. to perfection, I liked him better than I did before. They said they hoped I would often come in to dinner *sans gêne* [with no fuss].' Although Mathilde had known Madox Brown as a genial host of parties for the intelligentsia during the 1860s, it was not until Marie Spartali was to marry and leave his orbit in 1871 that Mathilde would occupy the place in his heart where Marie had been. At the date of the 'boisterous evening', Marie was engaged to William Stillman, and Madox Brown was preparing for his loss.

By 1871, the flirtation between Mathilde and Garnett was at least two years old, and from Garnett's point of view, at its height. But at some deep level, he knew he was losing his intimate connection with Mathilde, which she was in the process of transferring to Madox Brown. Mathilde was not only one of the luminous young women who attended Madox Brown's parties, but through her evolving friendship with William Michael Rossetti, she naturally gravitated towards Madox Brown, who was one of William's closest friends (and later his father-in-law). Marie Spartali married in April 1871, and without her radiant presence in his studio that summer, Madox Brown felt lost, lamenting that everyone was somewhere else. There was an empty space in his interior life.

Burying his grief about Marie, Madox Brown took Emma and the family for a painting summer holiday to Lynmouth, a picturesque resort on Devon's north coast which Victorians called 'Little Switzerland'. Back in 1812, Shelley had spent an extended honeymoon there in a rose-covered cottage with his first wife, sixteen-year-old Harriet Westbrook.

He had let off fire balloons in the cool evening air, loaded with his thirty-one point *Declaration of Rights*. Lynmouth was rich in radical and romantic associations. Madox Brown's youngest daughter, Cathy, brought her German suitor, Frank Hueffer. Courtship was in the air. And with Frank's presence in the family party, Madox Brown was already attuned to one German romantic.

Perhaps recalling Mathilde's remarks about Shelley, 'whose radiant light beckons to those who are tossed this way and that on the agitated sea of fierce and conflicting passions', Madox Brown invited Mathilde to join the family holiday. Petite, dark and intense, in vivid striped silks, Mathilde, the Continental revolutionary, whirled in on them with a storm of talk and German argument. During the evenings at Lynn Cottage, everyone enjoyed themselves 'vastly', as Dante Gabriel Rossetti heard.

Mathilde was the piquant opposite of Madox Brown's lost, pale, willowy Marie, but she was just as passionate about a career. With the instincts of a true literary sleuth, she tracked down a picturesque old woman in Lynmouth who remembered Shelley. Mathilde wrote excitedly to Garnett: 'My dear friend, I hasten to let you know . . . that I have discovered an old woman who lived with Mrs Hooper at the time Shelley lodged with her in 1812.' She interviewed Mary Blackmore, now aged eighty-two, 'in her little low room for the best part of one morning'. Old Mary Blackmore scoured her memory for Mathilde. She described Shelley as almost childlike, although she recalled he was very clever, constantly writing anti-government material. What a chord this must have struck with Mathilde with her own radical credentials.

She immediately involved Madox Brown in her Shelley mania. 'I am going to draw [Mary Blackmore]', he wrote to his friend Frederic Shields, and 'Miss Blind is to make an article about her'. Mathilde thought he had 'half promised' to draw Shelley's Lynmouth lodging house as well. Neither the drawing of the house nor Mathilde's projected article seems to have been completed, although Madox Brown's delicate portrait of old Mary Blackmore survives.

Mathilde instantly got up a fund, to which both Madox Brown and Garnett subscribed, to repay Mary Blackmore for a bill Shelley had left unpaid nearly sixty years before. Like Mathilde's relationship with Garnett, she and Madox Brown were drawn together by joint interests and projects that fused Romantic longing and radical politics, embodied in the life and works of Shelley himself. But now, instead of two writers exchanging notes across the Reading Room, the complementary occupations of writer and artist dovetailed with a new frisson. She offered Madox Brown something different from Marie – literature not art,

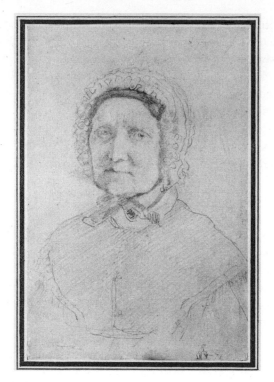

Old *Mary Blackmore* who had once known Shelley, sketched by FMB
in 1871.

Germany not Greece – so he could discover new worlds rather than fret
after lost ones.

At this stage in her life, just thirty, a dozen years younger than Emma
Madox Brown, and two decades younger than the artist himself, Mathilde
was fatally attractive. She not only looked desirable, she also responded
emotionally to other people, of both sexes. All her life, Mathilde had
many friends and admirers. For reasons perhaps connected with the
eruption of a new man, Karl Blind, in her mother's life before the death
of her father, Mathilde preferred paternal married men: Richard Garnett,
William Michael Rossetti, and most enduringly and passionately, Ford
Madox Brown. But the men she loved were required to be far more than
daddy figures. They all had to share her intellectual interests and concern
themselves in her literary career. They had to agree with her left-wing
politics, her fight against social and political injustice, and most notably
with her commitment to the rights of women, 'the most momentous of
all our modern ideas'.

While Mathilde was enjoying the stimulus of a Madox Brown seaside

holiday, Garnett knew his own connection with her was unravelling. 'Dear Mathilde, I have been dreaming about you half the night,' he wrote in July 1871. It was torment to imagine her in her new context with the great painter. 'Are the Madox Browns at work? I should think they must be the most delightful people possible to be with at the seaside, and I have a lively conception of Mr Madox Brown there in particular.' He almost felt the exertion of Madox Brown's personality on Mathilde. She simply ignored the dangerous direction of Garnett's letters and confined her responses to Shelley matters. Tacitly, Mathilde reminded Garnett that she could never be his lover in any meaning acceptable to either of them. But he still would not give up hope of a late spring in their quasi-romantic relationship. 'I have myself a little Spring song, which has for some years been waiting for the light, as I for Love.'

She continued to share with him her literary and political enthusiasms but they were safely impersonal, such as the speeches she had heard by Charles Bradlaugh and Sir Charles Dilke at a republican meeting in March 1872. Meanwhile she was spending more and more evenings round at Fitzroy Square with the Madox Browns. In 1872, Garnett could only counter those companionable evenings by discussing the last volume of George Eliot's *Middlemarch* and placing Mathilde's translation of Strauss' *Der Alte und der neue Glaube* (*The Old Faith and the New*) with a publisher, Asher and Co. He reminded her: 'You are doing what George Eliot commenced her literary career by doing and I trust you will be equally successful.' Mathilde deliberately moved her letters to Garnett down several levels from their former intensity. Scenery, literary endeavour and gossip fuelled the correspondence from now on. It was a mark of Mathilde's resolve, and Garnett's generosity, that they maintained a mutual support system she could count on for the rest of her life.

During one of the family evenings at Fitzroy Square in 1872, Lucy Madox Brown began a sympathetic portrait of Mathilde, showing her 'fine, animated, speaking countenance' framed by Pre-Raphaelite amounts of wavy, dark hair. Mathilde's gaze did not meet Lucy's but seemed engaged either in inner contemplation, or fixed on a distant object beyond the picture frame. Her face looked natural and de-glamorised. Seated in a carved Victorian chair, Mathilde filled the picture-space, a monumental figure, although she was, in fact, physically petite. Lucy used this solidity to suggest the grandeur of Mathilde's mind. In her hands were the symbols of a writer, pen and paper covered with flowing text. Lucy's understated pastels evoked a cerebral and emancipated presence.

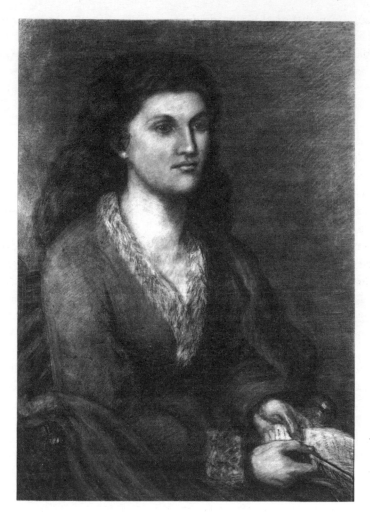

Mathilde Blind by Lucy Madox Brown, 1872.

Mathilde was just two years older than twenty-nine-year-old Lucy.
Neither sitter nor artist was married. Unlike many other Victorian
women, the topics uppermost in their minds were careers, radical
thinking, female rights and education, rather than the getting of husbands.
As a serious artist, Lucy enjoyed the parity of evoking Mathilde as a serious
writer. In 1872 the two women were culturally attuned, friendly and at
ease. Yet Madox Brown's growing intimacy with Mathilde would
become one of the foremost relationships of his life and the cause of future
dissension between father and daughter. Lucy's later resentment was not,
outwardly at least, triggered by Mathilde's connection with Madox

Brown for nearly another decade. Lucy knew intimately three of the four women who played such an important part in her father's emotional life: Emma, Marie and Mathilde. Ironically, the only one she did not know at all was her own mother, Madox Brown's first wife, Elisabeth Bromley, who had died before Lucy was three years old.

The correspondence between Mathilde and Garnett is rich and wide-ranging. It describes an arc of attraction that reached a high point and then subsided. But it never vanished entirely, even though the attraction was far more imperative and sexual on Garnett's side than on Mathilde's. She was aware of her effect on him, and her poetry and her novel, *Tarantella*, showed she understood the power of female desire. But at critical moments in her life, although not in her poetic fictions, she drew back, unable to risk a physical relationship. She preferred the intensity of unconsummated love, and the ambivalence and safety of rumour and teasing.

During the two decades of Mathilde's relationship with Madox Brown, she lived at intervals in his home for long periods, or outside his home but close at hand. Mathilde's extended visits to the Madox Brown family on grounds of her ill health, and their generosity, became the established norm, first in London during the 1870s, and then in Manchester during the 1880s. From 1877 onwards, William Michael Rossetti's diary constantly logged meeting Mathilde at the Madox Browns' home at 37 Fitzroy Square. William had married Madox Brown's eldest daughter in 1874. Whenever he and Lucy went round to dine or dropped in after supper, Mathilde was almost bound to be there, reciting her poetry or discussing her current literary work, drinking in Madox Brown's belief in her genius. It was a two-way process. He felt invigorated by her intellectual discussion of his pictures. When Mathilde threw literary parties, both Madox Brown and Emma were in close attendance. There was a designated 'Mathilde's room' in the Madox Brown London household where she spent most of her time in bed 'consuming hot meals and hot potions'. William often noted, without apparent surprise, that Mathilde had been living with the Madox Browns since his previous visit. A few days stretched out into a few weeks. Weeks became months. William put the extended stays down to Mathilde's ill health: sore throat, 'spasmodic bronchitis or incipient asthma', perhaps all euphemisms for the tubercular condition everyone feared.

On the edges of bohemianism, Victorian *ménages à trois* such as Madox Brown, Emma and Mathilde, or the triangle sustained by William Bell

Scott, his wife Letitia, and his mistress Alice Boyd, apparently aroused little censure. Their friends observed a conspiracy of tact. But although Madox Brown's extramarital and probably platonic relationship with Mathilde was presented to the world as purely of the mind, her ascendancy in his life caused bitter family rows and later incited both his daughters, Lucy and Cathy, to ostracise her. And on the outskirts of the immediate family, those with strong moral views certainly talked. A German brother of Madox Brown's son-in-law, Frank Hueffer, was shocked by 'the intimacy of Mathilde Blind in Brown's house, and denounced in the strongest terms her family, or some members of her family, and vowed that, if Mathilde Blind continued to go to the house', he would cut off his nephew, Madox Brown's grandson, young Ford Hueffer (who later took the name Ford Madox Ford). The Hueffers were German Catholics so they were bound to object to Mathilde Blind's place in Madox Brown's life, on suspicion of sexual irregularity. Fuelling their aversion may have been anti-Semitism towards Mathilde, or long-held dislike of Karl Blind's revolutionary politics, or a combination of factors.

There was a special factor which linked Mathilde with Madox Brown more closely than with any other man. It was acute imagination and a sensitivity of temperament. On 25 January 1880 they divulged similar childhood memories. Madox Brown revealed that when he was about eleven 'he passed a whole year in great mortal dismay, having somehow come to the conclusion that all he saw about him, including his parents, might be nothing but a vision.' Mathilde confessed that as a child, she too was subject to panics and superstitious terrors. One day in 1848, the year her father died, when she was about seven, she was lifting her infant brother out of his cradle when it suddenly struck her that he must be a changeling. She dropped him at once and scurried away. Within both adult carapaces of painter and poet remained the super-sensitivity of those fearful, Continental children. Perhaps they recognised each other.

THE LOST SOMNAMBULIST
OF LOVE

(Left) *Portrait of Mathilde Blind,* 1876, and (right) Emma Hill, detail from
The Last of England, 1852.

MADOX BROWN MADE AN INTIMATE PORTRAIT OF Mathilde in
December 1876 during a particularly tense time at 37 Fitzroy
Square, when he was daily hoping to secure the commission
to paint the murals in Manchester's new town hall. When William
Michael Rossetti saw Madox Brown's portrait in progress on 10
December 1876, he thought it very good, but 'the shoulders rather
narrow'. Charles Rowley, Manchester social reformer, city councillor and
frame maker, published the picture of Mathilde in his memoir, *Fifty Years
of Work without Wages.* This is the only image we have of the narrow-

shouldered portrait, now lost. Until 1970, the original was in the Royal
Shakespeare Theatre Collection at Stratford-upon-Avon. Since then it has
simply disappeared. But if we could only see it, titled, dated and initialled,
'MATHILDE BLIND. Dec. [18]76, FMB', it would glow with Madox
Brown's subtle pastels.

Madox Brown put Mathilde in a pose startlingly reminiscent of the one
in which he had painted Emma for *The Last of England* in 1852. Mathilde's
wrap enveloped her just as Emma had drawn her shawl about her almost
a quarter of a century before. But unlike Emma who gripped the hand of
her infant son beneath her shawl, Mathilde did not hold a child. Instead,
almost thrusting itself out of the picture frame into the viewer's space was
Mathilde's rolled-up sheaf of lecture notes on Shelley. By foregrounding
the Shelley connection, Madox Brown signalled the many principles he
and Mathilde passionately espoused.

Mathilde was Madox Brown's companion of the mind. Emma was his
wife of over twenty years. In the 1850s, she had worn the conventional
Victorian bonnet of a middle-class woman braving the elements for
emigration. But in this private, indoor portrait, Mathilde's hair is loose
and untamed, her enquiry of the artist both vulnerable and direct. Of all
the portraits of Mathilde, this ghostly image of a lost painting is by far the
most naked. By placing Mathilde in a severely uncluttered interior,
Madox Brown emphasised the intensity of her gaze on him, as well as the
scope of her inner life. Her quill pen, the tool of her literary career, on the
round table in the foreground, was placed in the same prominent spatial
position as in his daughter Lucy's earlier portrait of Mathilde.

Charles Rowley remembered Mathilde's constant presence in the
Madox Brown home. He called her a 'lambent spirit' but he also noticed
an inward, guarded, disappointed quality in Mathilde's portrait. He felt
she might always miss becoming a first-rate English poet because of her
German-language background, and in consequence, an 'inability naturally
to command our idiom'. When she read her poetry aloud, Mathilde's
voice had a throaty, exhaling character, ridiculed by Dante Gabriel
Rossetti:

> Do you know that sweet Willi, Miss Blind?
> I wouldn't choose her if I sinned.
> Such a storm of Sah-sah!
> Of Ho-ho! and Hurrah!
> Would be apt to endanger one's wind.

Rossetti, who was as directly descended from immigrants as Mathilde, was

mocking not only her guttural English but also her poem 'The Song of
the Willi'. Linked to vampire legends, these sprites or 'Willi' were
beautiful and destructive at the same time, like Antonella, the manic
dancer in Mathilde's novel *Tarantella*. Rossetti was also mocking Mathilde
for her unwitting use of the slang word 'Willi/willie', which as a woman
in polite Victorian society she would not have encountered.

But Rowley did not mock Mathilde. He simply considered her one of
the most lovable, enlightened and 'spiritual beings' in Victorian society.
'All her yearnings were for more light, more justice, truer happiness for
all', although he noticed that her own personality seemed 'blighted by a
Teutonic pessimism which saddened her life.' It was true that her private
life was marked by conflicted relationships with unattainable, older men
which were both profoundly unsatisfactory and absolutely ideal for her.
The more inaccessible they were, the safer she felt. By 1876, the date of
Madox Brown's portrait, her friends Richard Garnett and William
Michael Rossetti, with whom she had shared her love of Shelley's poetry
and politics, were both married with young families.

When Madox Brown made his portrait of Mathilde, he too was an
unattainable married man. In his mid-fifties Madox Brown combined the
attraction of a lover with the role of a home-providing father. Since losing
her natural father as a child, Mathilde had to make do with the
unsatisfactory and perhaps abusive Karl Blind. So paternal was Madox
Brown to the young poet that both his grandson, Ford Madox Ford, and
his granddaughter, Helen Rossetti Angeli, were under the impression he
had adopted Mathilde.

Mathilde wrote, provocatively perhaps, to Richard Garnett on 14
February 1877: 'You ought to come some day and have a look at the chalk
drawing Mr Madox Brown did of me; it is finished now and considered
very like by most people. Mr McCarthy saw it today and said it reminded
him of Mme Roland.' It was a fortuitous comparison by Justin McCarthy,
the Irish politician and writer. Madame Roland was later to be the subject
of a biography by Mathilde in the 'Eminent Women' series. An anti-
royalist heroine of the French Revolution, and leading figure in the
Girondist movement, she was sentenced to the guillotine during
Robespierre's purge of the Girondist opposition, a fate she met with grace
and courage. Tragic and romantic, Madame Roland was true to the end
to her political ideals, as well as to François Buzot her secret lover.
Mathilde could not fail to be thrilled and flattered by the association.

An undated studio shot probably taken for Mathilde's *carte de visite*
seems to date from about the same period as Madox Brown's lost portrait,
when Mathilde was in her mid-thirties. It is perhaps the most glamorous

of all Mathilde's surviving images but her gaze is averted self-consciously from the photographer, and the result is the most masked of all the portraits of Mathilde. (See p. 167).

From the 1870s onwards, Mathilde built up her richly varied literary career as a poet, critic, journalist, translator, biographer and novelist, almost exactly in tandem with her quarter-century relationship with Ford Madox Brown. While he was preparing to paint his great murals in Manchester Town Hall, she was writing her powerful *Dramas in Miniature*. In the intervals between her depression, his gout, her bronchitis and Emma's continued drinking, there was a current of creative energy flowing between poet and painter. Mathilde's poetry with its submerged sexuality can be read as a disguised autobiography of emotions. Her relationship with Ford Madox Brown had to be constantly concealed and equivocated. He had painted *Portrait of Miss Blind*. She wrote a sequence of poems called *Love in Exile* which mapped the journey of a love affair, alluding to her internal exile of forbidden love:

> I dare not call thee lover
> Nor any earthly name,
> Though love's full cup flows over
> As water quick with flame.

Mathilde called herself 'the lost somnambulist of love'. Only in dreams could she express physical love:

> Winding all my life about thee,
> Let me lay my lips on thine;
> What is all the world without thee?

It was part of Madox Brown's psychology that he considered himself a genius in internal exile. With their similar obsessive work schedules, he and Mathilde were temperamentally sympathetic and intellectual equals, a state he could never achieve with Emma.

By June 1877, William Michael Rossetti began to realise that he no longer heard important news about the progress of Madox Brown's Manchester commission direct from his father-in-law, but only filtered second-hand, via Mathilde. The whole family, apart from Madox Brown himself, began to find Mathilde 'self-assertive, high-minded, and alto-gether formidable'. Emma could not fail to resent her husband's feelings for Mathilde which were clearly 'more romantic than those of mere friendship'. She was outraged and secretly drank more as solace and

revenge. Her health suffered and she was often confined to the house in comic parallel with Mathilde's illnesses. Not to be outdone by the women, Madox Brown's gout flared up and he melodramatically threatened them all that he would be reduced to crutches.

For some time he had employed a 'friend-companion' or secret minder for Emma. She was Cicely Marston, daughter of Dr James Westland Marston the dramatist, and sister of poet Philip Marston. Madox Brown had chosen Cicely in order to keep an eye on Emma's drinking habits, or out of compassion for her straitened means or, in a blend of self-interest and altruism, for both reasons. When Emma was on holiday with Cathy at Great Yarmouth during July 1878, Cicely died unexpectedly 'of apoplexy' while calling on Mrs Moulton, an American poetess. As 37 Fitzroy Square 'was practically her home . . . poor Cicely must be brought here, but I am glad my wife is still at the seaside,' Madox Brown told his friend Frederic Stephens. Dr Marston and Philip were away in Europe so Madox Brown had no idea where to telegraph, but they were back in time for the funeral which took place from 37 Fitzroy Square. 'There was also an <u>inquest</u> here, but I was fortunately all alone,' Madox Brown told

FMB's letter about the sudden death of Emma's 'minder', Cicely Marston.

musicologist Alfred Hipkins, 'so there were the fewer to be shocked by the sad affair.'

He was anxious not to call Emma home for the funeral, remembering how she had relapsed after Oliver's death four years before. Instead, Mathilde rushed up from Eastbourne to attend Cicely's small funeral with Madox Brown, but as Emma was still away, she was careful to stay at a boarding house nearby in Upper Woburn Place. As soon as Emma returned, a couple of days after the funeral, Mathilde was re-established with the Madox Browns.

After the shock of Cicely's death, and on medical advice, Mathilde chose the inland resort of Matlock Bath in Derbyshire for a shared holiday with the Madox Browns. It seemed entirely accepted that Mathilde should make family decisions. Suffering her usual depression, an English spa appealed, 'as I can't summon up energy enough to go abroad by myself.' She thought the warm springs of Matlock Bath, newly popular with the Victorian middle classes, might also soothe Madox Brown's aching gout. They rented Belmont Cottage, a handsome four-square house built in 1847, high up in 'old' Matlock Bath. Although it rained, Madox Brown, Mathilde and Emma, Cathy and Frank all liked its secluded position 'exceedingly'. Long walks and the views over escarpments and lime cliffs across the Derwent Valley to the Pennines lifted Mathilde's spirits. However, Madox Brown was laid up in his bedroom with a painful attack of gout. His *tendresse* for Mathilde had begun in Shelley-mania on that summer holiday seven years before in Lynmouth. But it was altogether less romantic in Matlock.

The whole party was back in London by 11 September, 'Mathilde much improved in health', but Madox Brown 'still considerably disabled with gout'. He was eager to consult Oscar Clayton who was said to have cured the Prince of Wales' gout. Mathilde's depression recurred and she decided to try another spa, Tunbridge Wells, this time, alone. It's true that Victorians were often run down in the cold damp conditions, but there was almost a competitiveness in the ill health reported by Emma, Madox Brown and Mathilde. She continued to lean on Garnett who knew he had been displaced at her heart's core by Madox Brown. But he urged her to 'Reflect how very much better your situation is than at one time seemed probable (I am alluding particularly to Mr Madox Brown) and, after all, how much further advanced your book [probably *Tarantella*] is than at one time you thought it would be.'

Sharing ill health, as well as the ambition to make good work in painting and poetry, united Madox Brown and Mathilde in the head and the heart, if not in the body. Madox Brown had always been assertively

male in his tastes and frank about sexuality. In his *Diary* he recorded his personal loathing of Ruskin in entertainingly waspish tones, returning Ruskin's disparagement of his art by mocking the other man's apparent impotence. The critic's marriage to Effie Gray had been publicly and notoriously annulled in 1854 on grounds of 'non-consummation'. Madox Brown taunted the author of *The Stones of Venice* as 'the stoneless man', and 'Ruskinised' in Madox Brown's vocabulary meant castrated. After Lucy and William Michael Rossetti's honeymoon in Naples in April 1874, Madox Brown told Dante Gabriel that the couple had been 'lazy as to sightseeing, having much to occupy them in their own room – let us all say amen!' But although he would banter about sexual matters with his male friends he was careful to respect Mathilde's sense of propriety as a single woman. He told Lucy to make sure her husband William did not beg a bed for the night at Mathilde's when it suited him. Madox Brown knew William 'has such very unconventional notions that I fear he may be asking Mathilde to take him in there & she I know would scarcely like to refuse him & yet much fear what people might say: this is all.'

It would be anachronistic to describe this nineteenth-century love affair in terms that are recognisable to the twenty-first. The relationship between Madox Brown and Mathilde was probably not physical in the full sense. But repressed desire has a special erotic charge. Abstaining from sexual relations can engender a state of yearning close to rapture, almost a religious rapture, recalling the intense experiences of St Teresa of Avila. Mathilde was interested in a nun's yearning for union with God, and wrote about the resulting state of mind in one of her dramatic monologues, 'The Mystic's Vision':

> My heart is hushed, my tongue is mute,
> My life is centred in your will;
> You play upon me like a lute
> Which answers to its master's skill,
> Till passionately vibrating,
> Each nerve becomes a throbbing string.

Mathilde's images of possession, piercing and penetration, torture 'with a bliss so fierce', fused religious with sexual longings. It was an imaginative experience, a longing which she wrote about with daring authenticity. There were echoes in this poem of the ecstasy she had experienced in her youth as she walked alone through the mountains of Switzerland, declaiming Romantic poetry.

Far from being bitter about her nun-like single condition or her

necessary childlessness, Mathilde wrote tenderly about motherhood, reminiscent of the way Mary Cassatt, the American artist who was also single, painted childhood and maternity. Mathilde's lyric, 'A Child's Fancy', about a boy who reminds his mother that the stars might hear their conversation, recalls Blake in its nursery-rhyme simplicity. Some of her *Dramas in Miniature*, such as 'The Message' and 'A Mother's Dream' explored themes of motherhood. After all, her own mother, Friederike, presented a loving model, apart from her one major error in choosing Karl Blind.

Mathilde's other significant 'dramas in miniature', such as 'The Russian Student's Tale', exposed double standards about virginity for men and women current at the time, and the role of society and poverty in making women 'fall'. As this 'Tale' showed, the loss of female sexual virginity does not equate with the loss of innocence, although the tender-hearted student withdrew his offer of marriage when the girl, in all innocence, was honest and told him how she had been misused by men. Discussion of virginity, its loss, and the consequent state of motherhood, all featured prominently in Mathilde's poetry and in her personal debate.

The poet in Mathilde appealed to Madox Brown's literary approach to making pictures, while his passionate belief in her professional career gave her a staff to lean upon. Mathilde's career became the object of Madox Brown's crusade. Having constantly tried to enlist Dante Gabriel Rossetti to her cause, his campaign intensified early in 1881. Rossetti already had one female poet competitor in his life – his sister Christina – and while family was one thing, a German immigrant apparently monopolising 'Bruno', his best friend, was someone to be avoided. His attitude to Mathilde had always been patronising, perhaps because she did not attract him, or because she was one woman who did not succumb to his personal spell. She, on the other hand, would have wholeheartedly welcomed his poetic patronage, if she could have achieved it.

Madox Brown became aware that he couldn't on his own make his dearest friend Gabriel help the woman he considered 'of transcendent intellect' and a great poet. In February 1881, he tried to wheedle his daughter Lucy, Gabriel's sister-in-law, into making an intervention. 'Have you ever spoken to Gabriel about her work or about his seeing her? You have I believe much influence on him & I think it looks strange his never seeing or speaking of her – & such a poetess as she is ought to be on good terms with him – but I know how queer he is.' Madox Brown suspected that Gabriel held an irrational bias against his protégée. 'It is too

absurd, seeing the terms on which we all are, & the pleasure she might be to him going to talk to him, that he should keep up this prejudice against her.' He believed that Gabriel had taken against the whole Blind family early on and was now too stubborn ever to alter his first impressions.

As Mathilde's self-appointed protector, Madox Brown identified with her deep-rooted sense of hurt, her fear of being slighted and disparaged. He frequently felt the same about his own lack of recognition in the art world. He understood how easily she lapsed into a 'terribly morbid state'. And he remembered the depression he had suffered in his thirties, the same age as Mathilde was now. He longed to be 'in some degree instrumental in pulling her through' but recognised that, 'like most poets' she was 'very wayward and hard to reason with.' Naturally Madox Brown's zeal in the cause of his 'affectionate friend' drove Dante Gabriel to take the opposite position. After Gabriel's breakdown in 1872, his mental health continued to be fragile throughout the next ten years until his death in 1882. He became ever more reclusive and self-protective. By the early 1880s, it was hard enough to receive calls from his most intimate friends, quite impossible for him to envisage tête-à-tête interviews with a formidable poetess.

On the evening of 21 March 1881, Madox Brown called on Gabriel, armed with a sonnet by Mathilde. When 'it elicited less of hearty panegyric than he had hoped for', he left 'in a huff', stumbled across a dark room and smashed into a screen decorated with aesthetic peacock feathers. His only recourse was grovelling apology. 'My dear Gabriel,' he wrote, 'I am very sorry indeed for having broken your beautiful screen last evening, & more so for the small set-to between us that led to it.' He blustered an excuse to Gabriel: he was under extreme work pressure. But the real reason was his obsessive identification with Mathilde. Frequent underlinings in his letter of so-called apology indicated how strenuously he refused to compromise on Mathilde. 'I do not wish to recede, & will not an inch . . . You yourself declared you had no wish to <u>injure</u> the writer concerned <u>materially</u> in any way. I should wish − <u>on the understanding that the whole thing is to be forgotten</u> − to remain on the old terms of affection with you.'

Gabriel replied by return. He was not entirely mollified by Madox Brown's 'bristling' apology, as he told Theodore Watts-Dunton, the 'solicitor-poet', who had witnessed the screen incident. But he was anxious to shore up a deep, old friendship. If Madox Brown insisted Mathilde was a genius, then he would concede genius, 'ever affectionately'. But meet her and discuss her work, he would not. So it was Madox Brown who discussed Mathilde's poetry with her line by line,

and William Michael Rossetti who corrected her proofs. Dante Gabriel
Rossetti remained aloof. Madox Brown's belief in her poetry, his
recognition and promotion of her talents was the surest way to Mathilde's
heart. Sharing intellectual discussion of his paintings was the route to his.
Madox Brown had no choice but to accept Gabriel's intention to ignore
Mathilde. It was all too reminiscent of how Ruskin had sidelined his own
most lyrical pictures, especially *An English Autumn Afternoon* of 1852–3,
which seemed to celebrate a modern equality and rapport between the
sexes, a state neither Ruskin nor Rossetti could ever claim to have wanted
or achieved.

Detail from *An English Autumn Afternoon*, 1852.

Madox Brown empathised with Mathilde as she tried, repeatedly and
unsuccessfully in 1881, to place her novel *Tarantella* with a reputable
publisher. 'There is a chance of her novel being taken in 2 quarters now',
he told Lucy in August 1881, 'but such ill luck has hitherto attended it'
that he simply dreaded a negative outcome and its effect on her depressed
state of mind. Her cycle of depression and bronchitis only reinforced his
role as her protector. He could not get her or her problems out of his
head. 'Poor Mathilde! I feel as if I should never see her in sound health

again', he wrote again to Lucy, 'indeed as if I never should see her much again – & there seems a fate in it & that all we have all done to bring her out as what she is, one of our first authors, is futile & wasted.'

However, just over three years later, in January 1885, *Tarantella* was published on both sides of the Atlantic, by T. Fisher Unwin in London and Roberts Brothers in Boston, and attracted many flattering reviews. The subject had been in Mathilde's mind since 1872.

Tarantella was Mathilde's only novel. The British Museum, probably through Garnett's connection with the author, received its advance copy in December 1884, a month ahead of publication. Mathilde's signature was boldly blocked on the magenta covers of each of its two volumes. She now had a visible literary career. She had published her sensational, anti-religious poem, 'The Prophecy of St Oran' in 1881, as well as the first biography of George Eliot in 1883. Now she showed her versatility by turning to fiction. Although written in prose, it was a prose lushly inflected with poetic imagination. The story was built on extreme contrasts, between Mina, an innocent girl and Antonella, a deranged countess; between a painter and a musical virtuoso; between the dance of the tarantella and the fateful bite of a tarantula spider. The Continental setting, from folkloric Germany to operatic Capri, the original subject matter and narrative methods were welcomed enthusiastically from London to Boston, from Dublin to Melbourne.

All the critics responded to the contrasts in the book. Some congratulated Miss Blind and prophesied that the book was bound to make its mark. They praised it for its powerful emotions, the strength and delicacy of its poetry, its brilliant scenic effects, its revealing analysis of the creative temperament, its charm and its 'strange originality'. But they also criticised the ornamentation of its prose. On the one hand Mathilde's poetic language was her greatest strength; on the other hand it was her greatest weakness. However, positive remarks outweighed the negative. She was the 'complete mistress of the art of dramatic cause and effect', and never allowed 'the interest to flag for a single moment.' Several papers noted approvingly her wit and humour 'with which the book is freely sprinkled'. The critics found *Tarantella* 'extremely clever', likely to give Miss Blind 'a high rank as a novelist'. The novel showed an 'extraordinary knowledge of the human heart – extraordinary alike for its depth and its range.'

In *Tarantella* Mathilde found a way of expressing the many aspects of her sexuality. Using a coded language available to Victorian novelists,

heightened with poetic effects, she could explore subversive, even explosive themes. Dangerous sexual material could be both camouflaged and exploited by poetic diction and devices. The romance was built on a dramatic contrast between a heroine and an anti-heroine who symbolised respectively innocence and experience. Mina and Antonella provided the fictional opportunity for Mathilde to examine the contradictory nature of her own sexuality.

The novel opens in a sleepy South German town in 1846, recalling Mathilde's own childhood in Mannheim. Mina is the epitome of virginal innocence, courted by the much older protagonist, Emanuel Sturm, a virtuoso violinist probably based on Niccolò Paganini. His name alone was enough to link him to *Sturm und Drang*, the German literary movement active between the Enlightenment and Weimar Classicism. 'Storm and stress' were undoubtedly Mathilde's themes, although '*Drang*' also translates as longing, passion, energy, urge or impulse, all of which drive the hero and the novel.

Mathilde began in a high register which she sustained through two volumes of eroticism and suspense. Her reverence for the creative life of practising artists, whether in music, dance, painting or literature, ran deeper even than her conviction about feminism. At the core of her relationship with Madox Brown lay her passion for 'genius'; it was one of the key reasons why he replaced Garnett in Mathilde's life. Madox Brown's studio was strewn with eclectic objects to put into paintings, like properties for a stage production. Mathilde described the fine disorder of Antonella's studio with pictures and portfolios everywhere. It could have been Madox Brown's which she knew so well. 'Costly old laces and richly embroidered scarfs were mixed up with brushes and coloured chalks, while Indian cashemeres [*sic*] and other Eastern fabrics were flung over sofas, or even on the floor, like common rugs.'

The hero, Sturm, is a musical genius whose violin plays 'an allegory of love'. He woos Mina during a thunderstorm when they shelter together in an old summer house. He takes her on a tour through its faded rooms where 'they only met themselves at every turn in the magnificent mirrors – which brought them face to face with their doubles, like the lovers in the legend.' The doppelgänger myth and the mirror images portend a fateful end for the lovers. For a secret from Sturm's past threatens the outcome of the courtship. Long ago, he had been caught in another storm and in another erotic experience, on the island of Capri. Antonella, a young Caprese, had been bitten by a tarantula which pitched her into a cycle of manic dancing, a syndrome that could be broken only by Sturm playing the tarantella. Violinist and dancer both fell into 'death-like'

swoons. When Sturm woke he followed Antonella in a wild chase over the rocks of Capri but she managed to slip from his grasp and vanished as if into the elements.

Retreating to Naples, Sturm launched himself as an international maestro, possessed by the compulsive rhythms of the tarantella. Through 'magnetic affinities' he tracked Antonella to Rome where he secretly married her. But he felt unable to acknowledge her publicly as his wife. In view of her feminist position, Mathilde's neutrality at this point seems surprising. Perhaps her silence about Sturm's behaviour reflected her feelings about her own covert relationship with Madox Brown. Did Mathilde believe that he deserved a partner of intellectual parity like herself, a cerebral partnership that Emma could not provide? And if so, did Mathilde realise the irony? For Antonella's position as a simple girl who needed to be educated for a superior husband was an exact replica of Emma Hill's in the early 1850s. However, unlike Emma, Antonella decided to become an artist herself. Then, suddenly fearing that she had been tricked into a 'mock-marriage', she secretly left Rome.

Fame followed Sturm in the concert halls of Europe. Antonella, now the Countess Ogotshki, appeared at one of his performances in Paris and burst into convulsive sobs when he played the tarantella. Dramatically she fell into another death-like trance and was carried out of the concert hall. Sturm took her back to his apartment and as she regained consciousness, he found himself falling in love with his wife all over again. She still danced her menacing tarantella, 'slowly swaying herself to and fro, the undulating curves of her beautiful body being instinct with a dreamy voluptuousness'. With 'all the sorceries of love', like a 'sweet narcotic', she seduced her husband again before he escaped from her spell.

After this flashback to Sturm's past, the narrative returns to Germany, where Sturm proposes to Mina, stifling an impulse to tell her about his guilty past. He tells himself that his first wedding with Antonella had no legality and that he is free to remarry. His wedding with Mina is set for the end of December. Suddenly Countess Antonella appears in Mina's room, to disclose the truth about Sturm's past. Antonella pulls out a dagger, threatening suicide if Mina will not cancel her imminent wedding. Antonella is a true tarantula. Blackmailed and distraught, Mina promises to be gone. A snow-bride made by local children is melting outside her window. Mina steals back to the old pavilion in the woods where she overhears Sturm playing a tumultuous work of his own composition. Mistakenly, she believes his music is inspired by love for Antonella, and not for herself. Outside, looking in, Mina falls asleep in the snow, as the bells ring on what should have been her wedding morning.

Meanwhile, Antonella speeds to the pavilion where she finds Sturm 'twined and clinging' round the frozen dead form of Mina, imprinting 'her lips with burning kisses'.

Eventually, Sturm transmutes his sexual longing for Mina into composing for the violin. Mina's eternity is in Sturm's music. But he falls dangerously ill, and in his delirium he imagines himself as fly-fodder for an emasculating spider. As his two loves merge in his mind, Sturm confuses Mina not just with the snow-bride, but with a horrifying tarantula, Antonella. 'She stood by his bedside without a head . . . and he could see the heart in her bosom like a clock, and hear it ticking, ticking, through the ghostly silence . . . Suddenly it stopped for the spring broke, and the head and face and eyes of Antonella laughed at him with insolent triumph from Mina's figure . . . then he himself was metamorphosed into a fly, struggling in the web that enmeshed him in a living death.' Mathilde's tarantula was a powerful image for her investigation of erotic desires, extreme states of consciousness, and hallucinatory experiences.

Antonella's fixation and tarantella mania fitted some of the wide range of symptoms Victorian doctors commonly ascribed to 'hysteria' which they considered an almost exclusively female malady, characterised by demonic possession, ecstatic states, fainting spells, excessive seductiveness and female assertiveness. Freud's *Hysteria* (1895) and *The Interpretation of Dreams* (1899), even in their original German versions, appeared ten years after *Tarantella*. Therefore, although not 'Freudian', the sexual subject matter of *Tarantella* suggests that Mathilde either imagined more than she had actually experienced, or had experienced more than seems apparent.

Mathilde's friends and readers were as enthusiastic as the critics about *Tarantella*. Lily Wolfsohn wrote breathlessly from Naples, just ahead of official publication. By addressing Mathilde as 'My dearest Maud!' (Mathilde had regularly signed herself 'Maud' in her early letters to Garnett, enjoying the romantic association with Tennyson) Lily knew she would please the novelist:

> Brava, bravissima! Your romance is splendid. It is poetical, fresh, vivid, the
> dialogue natural, the little touches charming. I am altogether delighted . . .
> You must be very happy & content dearest Maud. I have always a sort of
> wondering admiration for anyone who can write a decent novel, & when
> it is a <u>good</u> one, I wonder still more how they did it. What a pleasure the
> writing of your romance must have been to you. Did it come by fits of
> inspiration? I suppose for many things you have drawn from the life.

MANCHESTER FRESCOES AND REVOLUTIONARY HEROINES

IN ORDER TO WORK FULL-TIME ON THE Manchester Town Hall commission Madox Brown and Emma had had to move north, at least on a semi-permanent basis, and this they did in 1880, flitting first between a variety of lodging houses. In a new setting, Emma made a new resolution – total abstinence. She tried to keep to it 'in a rather peculiar way . . . Emma walks into the Town Hall with me every morning & back each eve, & <u>stays with me</u>, & is very good-tempered, but how things are to go on for the future I hardly know,' Madox Brown wrote to Lucy in August. When they finally settled in Manchester a year later, Mathilde joined Madox Brown and Emma, although the northern triangle was no more tenable than it had been in London. From time to time Mathilde moved out to nearby lodgings. This was a pattern they would repeat later.

Manchester was a teeming and polluted industrial city. Its toiling workers made Manchester the capitalist 'icon of a new age: industrial, urban and ferociously modern. Its steam engines, cotton mills and train tracks; its warehouses, shops and villa suburbs; its slums, immigrants and radical politics – this assembly of the future was there for all to see amidst Manchester's stinking streets.' It was also a cosmopolitan city and Mathilde was well aware of its thriving German community of industrialists, political thinkers, writers, artists and musicians. Friedrich Engels had worked for the Manchester branch of his father's textile firm, Ermen and Engels, from 1842 to 1869. What he saw in Manchester led directly to his most influential book, *The Condition of the Working Class in*

England, first published in German in 1845, not translated into English until 1887. German musician Charles Hallé settled in Manchester in the late 1840s, where he began the Hallé Concerts, and in 1858 founded the great Hallé orchestra. Sir Jacob Behrens, a German Jewish merchant and philanthropist, ran an important textile business in the north of England; Madox Brown was on 'affectionate terms' with the Behrens family in Manchester throughout the 1880s.

The train service from London, Euston, to Manchester, London Road, was fast and frequent, with eleven trains a day from six in the morning until nine at night. The journey, by London & North Western Railways, usually took five hours although faster trains could deliver passengers in four and a quarter hours. The railway made living in Manchester a viable proposition for Madox Brown, who hated to feel out of touch with London. In August 1881 he signed a lease on Calais Cottage, 33 Cleveland Road, in what was then the new suburb of Crumpsall, an airy hill above Manchester's smoggy streets. 'Calais Cottage' may have been the original name of the house, or chosen by Madox Brown who had been born in the northern French port sixty years before. The fortuitous name reminded him of his Continental roots, as did the whole Manchester exercise. Investigating methods of fresco painting, applying paint direct on to walls, as practised by Belgian artists, took him back twice in the 1870s to Rubens' city, Antwerp, where he had been an art student and had fallen in love with his first wife, Elisabeth Bromley.

As an epic of sustained history painting, the twelve murals in Manchester Town Hall were Shakespearian in their breadth and scope. Madox Brown treated the whole of society from royalty to labourers, from King Edwin of Northumbria to Nubians slaving for the colonising Romans. The murals focused on Manchester but invoked a wider European world, from Rome to Flanders, whose ascendancy built on its textile industry prefigured the rise of Victorian Manchester. Madox Brown's approach was to treat key scenes from the history of Manchester in a way that combined tragedy and comedy. In one almost filmic scene of crowd violence, *The Expulsion of the Danes from Manchester, AD 910*, an injured Dane is hauled diagonally across the composition as the invaders flee the city, while just beneath his stretcher runs a grinning piglet, tripping up the feet of the retreating army. In moments of humour or insight, Madox Brown focused on contrasts between the scale of things to show how great historical events are inevitably entwined with smaller personal dramas.

On the walls of Manchester Town Hall, Madox Brown could explore the social, religious and political issues that exercised him all his life. They

called to mind the connections and concerns he had shared with Elisabeth Bromley, Emma Hill, Marie Spartali and now Mathilde Blind, women whose lives had impacted on his own for more than forty years. So although the Manchester murals were, on the face of it, a public, visual history for the people of Manchester to read, a vibrant modern equivalent to the Bayeux Tapestry, they also allowed the artist to access personal memories and incorporate his ideals.

One of the subjects, *The Establishment of the Flemish Weavers in Manchester, AD 1363*, (see Plates) painted on the wall using the Gambier Parry method, had been in his mind for 'near 30 years', as he told Frederic Stephens in about September 1881. This encounter between Belgians and British, royalty and artisans, bathed 'in early summer sunlight' projected an optimism he had scarcely felt or expressed since his earliest days with 'dearest Lizz'. The Flemish subject implicitly recalled his own springtime and his first romance with Elisabeth in Antwerp. The figure of Queen Philippa 'in early summer sunlight . . . with her maids of honour, all on horses', carrying 'branches of may in their hands, as though out on a May pilgrimage' filled him with joy. The queen, with one glove off, is 'feeling the textures of a long piece of cloth of Lincoln green', the colour that gives the mural its liveliness, wit and hope. It made him think of Chaucer's opening lines of *The Canterbury Tales* about spring, 'Thanne longen folk to goon on pilgrimages', a literary connection he knew Mathilde would recognise. Poet and painter were able to offer each other professional two-way support, in a mental conversation to which Emma could not contribute.

Things past and things present, frescoes, poetry, Belgium, Elisabeth, and now Mathilde and Manchester were curiously intertwined in Madox Brown's thoughts, and in the project. Emma had never been able to replace the natural affinity he had known between his mind and Elisabeth's, although by the 1880s Emma was far from the uneducated girl she had been when they first met. She had a sweet singing voice and read modern, literary novels: George Eliot's *Middlemarch* and Tolstoy's *War and Peace*. But she never provided what Elisabeth had offered in the past, nor the rich challenge that Mathilde could offer in the present: a meeting of minds.

Not surprisingly, however, as the Madox Browns and Mathilde tried to acclimatise to the 'cold & boisterous' north of England, teetering on the tightrope of their awkward threesome, the tension often snapped. Mathilde and Madox Brown were both recovering from overwork and ill health, and Emma too was repeatedly 'unwell'. The death on 9 April 1882 of his old friend, Dante Gabriel Rossetti, far away at Birchington, hit

Madox Brown hard. The news reached him at Manchester Town Hall at 10.30 the next morning, by telegraph from Lucy, and 'sent a terrible pang' to his heart. 'I had known him, without even a break since [18]48 I believe. It is like part of one's life torn away . . . All day the memories of events 10, 20, or 30 years past away have been "crowding up" . . . in my memory & however he is to be replaced for me or others I can't think – My wife has known [him] almost as long as I & feels bitterly the loss,' he told their mutual friend, Theodore Watts-Dunton. As a last tribute to the friend he considered a genius, Madox Brown designed his tomb at Birchington and a memorial fountain-bust which stands opposite Rossetti's London home by the Thames.

There was nothing for it but to continue his punishing hours at Manchester Town Hall, '10 a.m. to 10 p.m. & 7 days per week – consequently no dinner, or little trips to friends.' Every day he winched up his gouty body in a special screw chair to paint several feet above ground. Emma often accompanied him and sometimes Mathilde brought her piles of books into the town hall. She was reading pioneering freethinkers, Shelley and Darwin, and researching for her forthcoming biographies of transgressive female role models, George Eliot and Madame Roland.

Four months after Rossetti's death, in August 1882 they all escaped from dirty, industrial Manchester to the pretty cobbled town of Chapel-en-le-Frith, set high up on a ridge in Derbyshire's Peak District. Here Mathilde and Madox Brown had a dramatic falling out. They walked out on each other in turn, although William Michael Rossetti tried to play it down as a 'little tiff'.

By the time the holiday began, Madox Brown and Mathilde were exhausted. She had just finished writing her life of George Eliot and felt that at last she could lay down her pen, 'go out and actually stay out as long as ever I liked'. Perhaps her famously independent walks over the hills caused the 'tiff'. The recent task had proved a strain. Her subject was not the problem. Indeed if she had not been commissioned to write the biography for the 'Eminent Women' series, Mathilde might well have chosen to write a literary study of George Eliot. But her creativity could not fly within the genre of biography. Sleuthing for facts involved a huge effort of willpower. It was hard labour for her to assemble them in 'luminous arrangement'. Deep in the task, she presented a wild, if epic image, 'a striking figure as she sat like a Sibyl amid the disarray of her scattered scrolls, snowed down at random upon carpet and furniture, all astray from their right places, and all interlined with correction and scored with obliteration'.

While Mathilde had been working on *George Eliot* during 1882, Madox

Brown was immersed in equally scholarly research, both biographical and astronomical, for his mural, *Crabtree and the Transit of Venus*, now well underway, although not completed until the following year. Encouragement may have come from Mathilde's mother Friederike who took a passionate interest in astronomy. But during this year, Madox Brown had been infuriated with the Manchester councillors who were still prevaricating about who was to paint the final six murals. In addition, the publication of four engravings of his work in *L'Art*, promised by French art critic Ernest Chesneau, was unaccountably held up. On holiday in Derbyshire, Mathilde and Madox Brown were both in fractious states of mind.

When Madox Brown and Emma returned to Calais Cottage in September, the breach was still not repaired. Madox Brown tried to heal Mathilde's 'soreness' by letter, but if this apology was anything like the non-apology he had crafted to Dante Gabriel Rossetti after he'd smashed his screen in 1881, it was little wonder Mathilde remained implacable. 'Stiff and unyielding', she seemed 'to regard their intimate friendship as at an end.' Doubting that Madox Brown had given 'substantial offence', William Michael Rossetti found the stand-off 'certainly very ungrateful and foolish on Mathilde's part, as Brown has for some years past made her practically a member of his family, housing and supporting her.'

What sort of family role did William, or other observers, consider Mathilde played in relation to Madox Brown? Just a couple of years senior to his eldest child, was she an 'adopted' extra daughter, naturally resented by Lucy and Cathy? Or, twenty years junior to the artist, was she a live-in competitor to Emma, a mistress in the head if not in the bed? Probably she slipped between both these roles at different times. The intensity of the row between Mathilde and Madox Brown betrayed the complexity of their emotional relationship.

Mathilde herself grasped the opportunity to mend the quarrel when Madox Brown had a severe attack of gout early in 1883. Both his hands were completely disabled, and by 6 January this 'long, painful, and exhausting illness' gave rise to 'very serious apprehensions'. Lucy rushed up by train to see her father who, believing he was on his deathbed, had summoned a solicitor to make his will. But it was Lucy's baby Michael who was really dying, suddenly, of convulsions and meningitis. Lucy was called back to London and Mathilde swiftly replaced her at Madox Brown's side. As he had so often ministered to her ill health, she would now minister to his. But this time she stayed outside Calais Cottage.

Three weeks later, the patient could stand unaided for a few moments and was allowed to sit in a chair for an hour a day. He told Lucy that

Emma and Mathilde 'keep well on the whole'. They had established a domestic truce and a diurnal rhythm. 'Mathilde works in her lodgings all the early part of the day and walks here usually by 4 or 5 and then reads us what she may have done – or else poetry of some kind and we chat.' In London, Michael Ford Madox Rossetti, aged twenty-one months, was buried in the same grave at Highgate as his grandmother, Elisabeth Bromley, who had been laid there in her youth almost four decades before.

In February 1883, still in severe pain, Madox Brown moved south to Hampstead where he stayed, mostly in bed, at Caroline House in The Mount, the street location of his key painting, *Work*, first begun over thirty years before. In that year 1852, he had been separated from Emma, alone and in mental crisis. This time, Mathilde was at his side, living in the same lodgings for a month. Lucy and Cathy were distinctly uneasy about this proximity, and about Emma, who did not appear to be with him. Perhaps she had taken refuge with Cathy. His daughters planned he should visit their own London homes, staying first with the Hueffers in West Kensington and then with the Rossettis in Bloomsbury. As soon as he arrived at the Hueffers, he was struck by pain worse even than his gout. His digestive system had been compromised by weeks in bed. On examination, his physician John Marshall diagnosed 'an internal fistula' and proposed an operation. A few days later the 'fistula' had become an 'abscess' and Marshall's diagnosis, only 'a sort of inflammation' which could be dispersed by frequent fomentations. At the end of March, Dr Marshall issued a two-part prescription of stunning insensitivity to Emma: convalescence at a seaside resort; and he should take Mathilde as his companion.

Lucy and Cathy were outraged, either on Emma's behalf, or because they felt slighted as daughters. They ostracised Mathilde as they felt sure she had plotted with the doctor. Madox Brown swiftly retaliated. Forgetting his own recent falling out with Mathilde, he was more belligerent than ever in her cause. Lucy was his 'clever' daughter, the one who reminded him of her mother, Elisabeth Bromley. Cathy, on the other hand, was like her mother Emma, dazzlingly blonde and pretty, but in her father's view 'so childish as to be really of no account' – by which he meant easily led by Lucy, at least in matters relating to Mathilde. So he made Lucy the target of his attack.

He was indignant to find her away from home when he called round. He had wanted to have it out with Lucy, face to face, before returning to Manchester on 5 April. Her absence forced him to write. 'You will understand no doubt that I refer to the unfortunate difference with

Mathilde Blind. "Unfortunate" I must call it, from every point of view, as long as it lasts, for it cannot fail to attract attention.' How had Dr Marshall offended Lucy and Cathy? Even if, unwittingly, he had done so, 'why of all people' should Mathilde 'have been made to pay for it?' Lear-like and slighted, Madox Brown raged at the supposed hypocrisy of his daughters, 'who for years have been outwardly the most sincere friends of our friend Mathilde', and he admitted, 'the most devoted daughters to me.' The whole thing was simply 'too outrageous'. Surely Lucy did not 'expect Mathilde to take the first steps in a reconciliation – I am really now taking the first step.' His real theme, as it had been in his quarrel with Rossetti two years before, was Mathilde and her 'genius'. Lucy would resent that implied comparison. 'It is from a house of yours where I was lying sick at the time', he accused her, that Mathilde 'was practically driven – She certainly never can return to undergo the like again – Unless some slight token of apology is held out – you should call on Mathilde at Hampstead.'

Moreover, he defended his doctor for suggesting the intimate seaside escapade in the first place. Marshall 'knows that for years Mathilde had been the inmate of our house – what more natural than that he should think her, with her splendid powers of conversation, a fitting companion of my convalescence by the sea side?' Lucy must make the first move to mend the stand-off with Mathilde. The quarrel had affected Emma badly, said Madox Brown. It had 'made us miserable enough already and driven us off home just as I was getting well enough to enjoy my stay in London.' He added in self-pity – 'if I am ever well enough again to enjoy anything.'

Lucy was not disposed 'to make it up at once with Mathilde Blind'. She was as intransigent as her father. The most distressing aspect of the affair, thought William, who wanted only conciliation, was that Madox Brown was more on Mathilde's side than he was on Lucy's and Cathy's, and hence 'not in the most cordial of moods'. Madox Brown cut short his London convalescence and scuttled back to Manchester. After the train journey north, he cooled down in northern spring weather. In London, Lucy invited Mathilde to a dinner party with Theodore Watts-Dunton, Lucy Clifford, John Ingram, and Cathy and Frank Hueffer, thus avoiding the risk of a private tête-à-tête or the requirement of an outright apology.

However, this was not the etiquette, nor the climbdown, that her father had demanded. 'All right about asking Mathilde to dinner – I would strongly urge however the desirability of you and William calling there first as he proposed. If you do a gracious thing it is better not to do it by halves, and the sooner such a quarrel is healed the better for all parties

concerned.' Lucy was nearly forty years old. She did not call on Mathilde before the dinner engagement. The tension round the table at 5 Endsleigh Gardens on that April evening in 1883 was palpable but 'all passed off satisfactorily', in William's cryptic opinion.

Lucy remained highly suspicious of Mathilde's influence over her father. He continued to rumble – 'You are quite mistaken however in supposing MB's influence caused my way of thinking or acting – For 9 days, during which I received two notes from her I knew nothing about any thing.' Mathilde had not come running to him about the row. The first he'd heard of it was 'from something Emma told me.' Emma's daughter and stepdaughter were voicing their misgivings about Mathilde on their mother's behalf, in a way that Emma could not. More than a decade ago she had seen off Marie Spartali. Experience suggested she could hold the balance with her husband without open confrontation. Perhaps she tolerated Mathilde in their marriage as a trade-off for Madox Brown's patience with her alcohol addiction. In any case, throughout the 1880s, her health was too fragile for sustained conflict.

Once back in Manchester, Madox Brown and Emma moved in May 1883 from Calais Cottage to 3 Addison Terrace, a handsome house in Victoria Park, a more prosperous area of the city. With his increased fees for the murals, Madox Brown could afford the annual rent of £55. Set in a black and white Gothic terrace on Daisy Bank, the house in Addison Terrace had arched ecclesiastical windows and a back garden. It had been the home of the great conductor, Charles Hallé, thirty-five years before. In 1887 his orchestra would play at the Manchester Jubilee Exhibition for which Madox Brown painted eight huge figures twelve feet high, 'all in oil & gold . . . And there will be eight others of angels, spirits of Energy.' Madox Brown loved music almost as much as he loved art and theatre. He and Emma would have enjoyed the musical association of their new home.

Mathilde wrote warily to Madox Brown about the prospect of running into Lucy and Cathy in the new elegance of Addison Terrace. 'I hope it will be all right meeting all together at your house, and sincerely trust for my part that we may meet as if that unpleasant episode had never been.' He forwarded this as a warning to Lucy but in 1883 his daughters did not make their usual summer visit to Manchester.

By October 1883, the old order of working and domestic life was re-established in the north. While Madox Brown was forging ahead with his sixth mural, *The Proclamation regarding Weights and Measures*, Mathilde was

Emma sidelined at Manchester Town Hall, observed by John Hipkins,
1 August 1883.

awaiting publication of *George Eliot* and 'again staying with the Browns in
their new house'. A sustained cultural and political exchange between
Mathilde's words and Madox Brown's images during the Manchester
years, may indicate the preoccupations of their lost conversations.

For her first biography, Mathilde chose a literary heroine she felt had
relevance to her own unconventional relationship with Madox Brown.
Although George Eliot wrote with profound moral purpose, she lived
openly in an irregular union with a married man. In 1883, Mathilde's was
the first biography of the great novelist to be published, even ahead of
Eliot's husband, John Cross, whose three-volume *Life* appeared in
1885–6. Mathilde used up-to-date biographical methods, cited primary
sources, trod in the 'footsteps' of George Eliot by interviewing her
brother Isaac Evans, her schoolfellows, and her oldest friends, Mr and Mrs
Charles Bray.

She had hoped for a further commission in John Ingram's 'Eminent
Women' series, to which Lucy Madox Brown Rossetti contributed a life
of Mary Shelley and Vernon Lee wrote *The Countess of Albany*. She
wanted to write the life of George Sand, the most outrageous icon of
female sexuality of the age. Like George Eliot, Mathilde admired the
women of France for having 'the courage of their sex', and making a vital
contribution to French literature. But the commission went to novelist

Bertha Thomas, who may have secured it through her friend, Vernon Lee. Instead, Mathilde chose *Madame Roland*, not to be published until 1886. It enabled her to identify with a tragic heroine of the French Revolution, another woman who found comfort in a forbidden lover. Ernest Chesneau reviewed *Madame Roland* warmly in the Paris journal, *Le Livre*. Mathilde's book was 'more than a biography of Madame Roland'; it was an excellent history of the Revolution which he preferred even to Carlyle's account. Madox Brown was especially pleased with the French critic's final remark – 'This English book has moreover the merit of making the reader love France.'

During summer 1884, while Emma was away from home, accompanied by Charlotte Kirby, the trusted family servant, Mathilde chose another Madox Brown summer holiday. Emma had been 'very good, & appears happy, though on slender grounds' in the early part of the year. Her husband decided to reward her, or placate her, with a present of gold rings, chosen by Lucy in London, with £15 he sent for the purpose. One held a diamond solitaire, the other was set with little rubies. 'Mathilde is going to Arran & is to get a room for Emma & me at the Corrie hotel there.' He longed for 'the bracing air of Scotland', he told Lucy defiantly. Once arrived on the rugged, green Isle of Arran, Emma and Mathilde set out walking together, in curious accord, while Madox Brown wrote letters in the hotel.

It was more of a research trip than a holiday for Mathilde. She was fired by the history of Highland crofters, ruthlessly expelled from their homes at the beginning of the century, 'to make way for sporting grounds rented by merchant princes and American millionaires.' Mathilde crusaded against injustice, irrespective of national boundaries. 'She was full of fire in all causes of freedom, whether Italian or in regard to the cruelties of Crofter evictions,' approved Charles Rowley. *The Heather on Fire* finally appeared two years later in 1886, priced 10*d*. The work 'was produced almost entirely in our house here in Manchester. It goes deeply into the matter, & a terrible matter it is when one considers it – We went with Miss Blind to Scotland when she was in quest of the materials for the story,' Madox Brown told Spielmann, editor of the *Magazine of Art*, just before publication.

Mathilde's poem highlighted a social tragedy by focusing on the plight of individuals. It was a fiery polemic on behalf of the 'brave, moral and industrious peasantry' told through the hard lives of Mary, a Highland Madonna, and her faithful herring-fisher husband, Michael, whose home

and family were brutally torched during the Clearances. Hours spent in
Madox Brown's studio and at the town hall fed into her imagery in *The
Heather on Fire*, full of colour effects and shapes:

> The ground
> Looked like patch-work counterpane with edges
> Of currant bushes and frayed blackberry hedges.

Although Mathilde was 'morbidly suggestible' about the reception of *The
Heather on Fire*, the *Athenæum* found it 'one of the most noticeable and
moving poems' of recent years and congratulated Mathilde 'upon her
boldness in choosing a subject of our own time'. The *Manchester Examiner
and Times* likened her to Elizabeth Barrett Browning: 'Miss Blind does not
possess her theme; she is possessed by it, as was Mrs Browning when she
wrote *Aurora Leigh*.'

Social and political injustices like these united the threesome of Madox
Brown, Mathilde and Emma. They took different routes, painting, poetry
or practical interventions, but they held the same principles. In 1884,
Madox Brown was completing his mural, *The Proclamation regarding
Weights and Measures*, which illustrated the operation of a new edict in
1556. The beggar girl with her baby, bowl and spoon in the conspicuous
left foreground could equally be seen every day on the streets of Victorian
Manchester. In her poetry Mathilde, too, observed the factories and fumes
of industrial Manchester and saw an infernal vision of a modern city,
reminiscent of Blake's 'London':

> O'er this huge town, rife with intestine wars,
> Whence as from monstrous sacrificial shrines
> Pillars of smoke climb heavenward, Night inclines
> Black brows majestical with glimmering stars.

She contrasted the grandeur of nature with the petty tyranny of
mechanised labour, and deplored what people do to one another in the
competition to survive. Manchester illustrated all too clearly Darwin's
hypothesis of the survival of the fittest:

> Now toiling multitudes that hustling crush
> Each other in the fateful strife for breath,
> And, hounded on by divers hungers, rush

Across the prostrate ones that groan beneath,
Are swathed within the universal hush,
As life exchanges semblances with death.

Emma and her husband also took a more hands-on but no less impassioned role. Madox Brown was forever managing subscription funds for friends and artists who had fallen on hard times. In London, during winter 1866, when many men were unemployed and their families starving, Emma had 'turned her drawing room into a soup kitchen and made soup for them and fed them. She was quite poor then, and had to go without all sorts of things herself to get the money.' Twenty years later, in Manchester, during one of its periods of cyclical unemployment between 1885 and 1887, she supported Madox Brown as he set up labour exchanges for starving workmen. He publicised these 'labour bureaux' as he called them, in the newspapers, through his connection with one of his buyers, C. P. Scott, the liberal editor of the *Manchester Guardian*. At the grass-roots level, Madox Brown employed Joseph Waddington, a carpenter out of work for the past two years, who became a leader of public meetings, and headed marches of starving Manchester men. Recalling the popular medieval Italian leader in Rome, Madox Brown called Waddington, 'the Rienzi of the Manchester Unemployed'.

For Madox Brown 'the question of labour & the unemployed' was the single most important contemporary issue, more important even than affairs in Ireland. 'On its solution depends the future of the world.' On 14 April 1886, he attended a mass meeting of unemployed workers in Manchester's Pomona Gardens, '6,000 or 7,000 poor, wretched-looking ragged fellows. I had to speechify them, for, did I tell you?' he asked artist Frederic Shields, 'I and some others have started a "labour bureau" to register all who want employment . . . The workers have come in numbers, but not 5 per cent of those numbers as employers. In fact, I believe the manufacturer looks upon a good broad margin of starving workmen as the necessary accompaniment of cheap labour – I shall get a nice name, I expect.' In June, the prime minister, William Gladstone, visited Manchester and made a point of seeing the murals. He 'shook hands & spoke a few words with me in the Town Hall today,' Madox Brown noted. Gladstone's Home Rule bill for Ireland had been defeated in the House of Commons two weeks earlier, by the narrowest of margins.

If Manchester employers were wary of Madox Brown, his fame was spreading among workers everywhere. In London, the Rossettis' plumber told Lucy that the name of Madox Brown 'that good man' was 'now constantly spoken in Workmen's Clubs. He is regarded as one of the

genuine friends of the working classes.' Thinking of turning Communist, as he told Lucy, Madox Brown voted for the Liberals in the November 1885 election in Manchester. 'But it is of little use, they will be overwhelmed, I fear, by Tories & Parnellists.' The painter had been actively supporting the rights of the working class since before the electoral Reform Act of 1867.

Madox Brown, by now a confirmed agnostic, if not an atheist, nevertheless recognised the power of religious subjects in art. During his first marriage, he had respected the importance of Elisabeth's Christian faith and her spirituality, and he depicted that faith with both reverence and drama in two of his murals, *The Baptism of Edwin* (1878–80) and *The Trial of Wycliffe* (1885–6). He showed faith strengthened by trial and challenge, as Jesus was tested, and Elisabeth was surely tested by the loss of her son and by tuberculosis. Into the bustling courtroom scene of *The Trial of Wycliffe*, Madox Brown smuggled his own self-portrait as Simon Sudbury, Archbishop of Canterbury. Elisabeth had been witty enough to appreciate a joke like this. The mural depicted Wycliffe on trial in 1377 for his challenge to established Catholic authority. His books and his translation of the Bible into English pointed the way forward to Elisabeth's faith, Protestantism and the Church of England.

The Trial of Wycliffe did more than remind him of Elisabeth's loyalty to the church. The reforming figure of Wycliffe sorted well with the post-Darwinian, secular philosophy Madox Brown shared with Mathilde. Her poem 'The Prophecy of St Oran' in 1881 had been so shocking in its challenge to conventional Christianity that the publisher, Newman and Co., took fright and withdrew it because of its 'atheistic character'. 'None of the Booksellers here [in Manchester] can get her poems for people. Answer to-day from the chief shop that the <u>Publishers cannot find this book</u> – This has been going on for 3 weeks,' raged Madox Brown.

The hero of Mathilde's poem was Oran, one of Columba's most devoted monks, but 'his pulses thrilled' with love for Mona, a beautiful pagan. He tries to convert her to Christianity but she simply cannot understand 'his joy-killing creed', nor fathom 'of what she should repent'. Oran fights to keep faith with chastity until neither he nor Mona can restrain their love:

> What boots it thus to struggle with his sin,
> So much more sweet than all his virtues were?
> Like a great flood let all her love roll in

> And his soul stifle mid her golden hair!
> And so he barters his eternal bliss
> For the divine delirium of her kiss!

As they labour to build God's holy house on Iona, Columba's monks are thwarted by violent storms, while the local people revert to their pagan gods. Suspecting a curse on their work, Columba asks 'what man among you all/Living in deadly sin, yet wears the mask/Of sanctity?' Oran denies his sin but is flushed out by the arrival of Mona, like the ghost of a Druid princess, wildly searching for her lover. Columba sentences Oran to be buried alive. Three days later, Oran's bloodless face breaks out of the clay and speaks:

> Lo, I come back from the grave, -
> Behold, there is no God to smite or save.

There is no devil, no heaven, no hell, he reports. Instead, he tells them, 'Ye can have Eden here! . . . Cast down the crucifix, take up the plough!' There is indeed a God. But 'that God is Love', the 'tender human tie' that Oran knows with Mona. Although Columba orders his instant reburial, Oran's voice is stronger and reverberates after the grave is shut and the poem ended.

Mathilde's poem could be read as a blasphemous reworking of the Resurrection or as an expression of nineteenth-century humanism. Madox Brown's Wycliffe and Mathilde Blind's Oran were both modernising voices. Their bodies could be buried alive or burnt, as Wycliffe's was after his death, but they could not be silenced. When *The Trial of Wycliffe* was finally completed in June 1886, it coincided almost to the month with publication of Mathilde's *Madame Roland* with its stirring account of the persecution and trial of the French revolutionary heroine. Heroism on trial was a theme which engrossed both writer and artist in their parallel projects.

In the Manchester murals, Madox Brown illustrated his and Mathilde's shared views on politics and education. The mural *Chetham's Life Dream* was a sympathetic treatment of Henry Chetham's dream to provide education for poor boys by endowing a school in Manchester by a term of his will of 1656. A passion for educating hitherto disadvantaged students, specifically women at Newnham College, Cambridge, was the most important term of Mathilde's final will and testament. To this day,

the Mathilde Blind Scholarship funds women to study English, foreign or classical literature, in any combination. All these literatures had sustained Mathilde's intellectual life but the opportunity to study them at university was not available to women when she had been of student age. Madox Brown's mural that showed Mancunians rising against invading Danes in the tenth century was a graphic cipher for European upheavals in the nineteenth century, such as the 1848 revolution in Germany which had first brought Mathilde to England. She never ceased to identify with the oppressed, Italians against Austrians, Scottish crofters against Highland landlords, and to support revolution wherever she felt it justified. Both Mathilde and Madox Brown unswervingly promoted their democratic values.

Madox Brown's long identification with Oliver Cromwell was still apparent in the last mural he painted for Manchester. *Bradshaw's Defence of Manchester* showed an episode during England's Civil War, when Parliamentarian John Bradshaw defeated a superior force of Royalist troops besieging Manchester. Madox Brown suffered a stroke in 1892 which affected his right side so that he had to complete the mural with his left, non-painting hand. Nevertheless, he managed to render the Roundheads' assault on Lord Montague, the unhorsed Royalist leader at the focal point of the composition, with remarkable vigour. It was a heroic subject, heroically undertaken in spite of disability, in honour of his Cromwellian principles.

The mural that actually completed the series on the town hall walls, although not the last that Madox Brown painted, was *Dalton Collecting Marsh-Fire Gas* (1887). In the mid-1880s, it was the most modern subject the council would allow him. He had wanted to illustrate the Peterloo Massacre of 1819 but that was thought still too hot to handle by Manchester's conservative councillors. Instead of demands for democracy, he had to make do with advances in scientific thought. John Dalton's experiments with gases at the beginning of the century were the basis for atomic theory. Mathilde meanwhile was busy reading the science of Darwin who had presented the Victorian public with an equally innovative theory, of evolution, natural selection and the 'survival of the fittest'. On 10 November 1886, Mathilde read her paper, 'Shelley's view of Nature contrasted with Darwin's', to the Shelley Society in London. William Michael Rossetti was in the chair and Richard Garnett was in the audience: her safe older men. Two days earlier she had rehearsed it to Lucy Rossetti. The women found it easier to relate on intellectual matters rather than at a personal level. Nevertheless, the rehearsal showed rapprochement since the row three years before. The lecture combined

two of Mathilde's deepest interests, entirely in tune with those of both Lucy and Madox Brown: Shelley the atheist and Darwin who had become an agnostic.

THE END
OF THE AFFAIR

DURING THE LATER DAYS IN MANCHESTER, Emma's craving for alcohol escalated. In January 1886 she even persuaded Mrs Pyne, wife of the town hall organist, to smuggle drink into the house. Subterfuges like these became embarrassing. Madox Brown discovered the bottle of rum which Emma handed over meekly. But how was he to deal with his friend, Kendrick Pyne? The artist was afraid the musician would fly into a fury, his wife would have hysterics, and the story would be all over Manchester in no time. He decided to tell Mrs Pyne that 'Mrs B has a kind of suicidal mania nothing to do with dipsomania – but worse. I think I can frighten her, or threaten to tell Pyne . . .' By March 1886, Emma began to imagine she could help other members of the family in difficulty. She would go to the Isle of Wight and nurse Lucy who was recovering from bronchial pneumonia in Ventnor. She meant only kindness, but Madox Brown warned Lucy, 'it would more add to your bothers than help them.'

The long connection with Manchester was gradually broken as the Madox Browns moved back to London at the end of 1887, to take a new home at 1 St Edmund's Terrace, Regent's Park. The monumental task of the Manchester murals had made the artist feel unappreciated, not least because at one time the Corporation threatened 'to paint out his frescoes and use the wall-spaces for advertising the products of the city.' As ever, Madox Brown, Emma and Mathilde all continued in poor health, but Madox Brown and Mathilde maintained their unremitting work schedules. He was working long-distance on the final murals during 1888,

FMB and Emma in 1887 by their daughter Cathy.

as well as a family group portrait commissioned by his Manchester patron, brewer Thomas Boddington. A year later, Mathilde agreed to have her portrait painted, under Madox Brown's supervision, by his student, Harold Rathbone.

In 1889 Mathilde was forty-eight years old and projecting her most aesthetic image, while Harold Rathbone was less than thirty and in awe of his subject. Harold had trained first at the Slade, later in Paris, then privately with Madox Brown in Manchester. His father, Philip Rathbone, was an alderman who chaired the influential Arts and Exhibitions subcommittee of Liverpool's Walker Art Gallery. In the late 1880s, Harold was a neurotic and excitable personality. In 1894 he would become well known as co-founder of the famous Della Robbia Pottery at Birkenhead, Liverpool. But these sessions painting Mathilde's portrait nearly destroyed him.

Harold was undone by his own apprehension of Mathilde's special status as a poet, perhaps because he too aspired to write poetry. On questions of belief, they were chasms apart. Harold's overwrought religiosity was no match for Mathilde's unyielding agnosticism. Long and lanky, in owlish spectacles, with tufts of facial hair and a high-pitched reedy voice, he looked the classic boffin, although Holman Hunt saw him as a youthful dandy, a sensitive dreamer rather than a figure of fun.

For this, her only full-length portrait, Mathilde chose a loose Pre-Raphaelite costume: black velvet overdress, with an Ophelia-like

Mathilde Blind by Harold Rathbone, 1889.

underskirt scattered with flowery motifs, echoed in the bouquet of poppies in her hand. Her hair was no longer loose, as it had been in earlier portraits by Lucy and Madox Brown, but was carefully swept up, leaving a few curls over her forehead. She looked delicate but the sittings were far from peaceful. Mathilde and Harold argued vociferously. 'She said he made her face look like a piece of gingerbread, and that the poppies were like dabs of scarlet flannel, and he said he had never been spoken to like that in his life before. They talked so loudly, and were so rude to one another', that Madox Brown had to climb down from his painting chair to try and make peace. Harold simply collapsed on his shoulder and burst into tears. '"Be a man now, Harold, and control yourself,"' Madox Brown said, 'and was most kind and patient and tried to make them friends.' But Mathilde would not be reconciled. 'She cast a furious look at him, and swept out of the room and collided with Aunt Lucy [Lucy Madox Brown Rossetti], who was coming up the stairs.'

The drama of the painting sessions was suppressed in the cool, accomplished, finished portrait, although the tilt of Mathilde's head, the

jut of her jaw, suggests her command over the trembling artist. He placed her in front of a 'greenery-yallery, Grosvenor Gallery' background with plain, geometric interior mouldings. A single flower head has dropped from her bunch of poppies, held downwards, as Europeans but not the English, carry their flowers to this day. In the Victorian language of flowers, the meaning of poppies ranged from wealth and success to the more poetic attributes of consolation, imagination, eternal sleep and oblivion. Harold may have seen Mathilde as successful in her literary life but she was in no way wealthy. Mathilde herself may have chosen the poppies for their connection with her creative nature and her rich imagination. On the other hand she would have been aware of their apt association with her need for consolation, her recurrent depression and romantic temptation towards oblivion. Or she may just have liked the vividness of their blooms against her own dark colouring.

In conscious response to Darwin's second book on evolution, *The Descent of Man* (1871) Mathilde named her epic poem on Darwinian theory, *The Ascent of Man*. It came out in 1889, the same year her portrait had been painted by Harold Rathbone. Reviewers praised Miss Blind for being the 'first to seriously render Charles Darwin and Herbert Spencer into verse.' They found the poem brilliant and original, and likened it to Lucretius and Tennyson. Integrating the latest scientific thought, Mathilde traced 'The Ascent of Man' through his successive stages of evolution. 'From Chaos to Kosmos she hurries her reader along, breathless and perspiring perhaps, but never anxious to stop. We have known her book to be read on the Underground Railway, and the reader to be so absorbed . . . as to be carried unawares several stations past his destination.'

Mathilde described creation in terms that were geological, biological and electrical. From the primeval slime, sea animals developed until 'a new strange creature' was born, 'wild – stammering – nameless – shameless – nude', who learned to make tools – and fire. In turn, he created 'irresponsible, capricious gods' whom he tried to placate with altars and human sacrifice. After paganism, 'the Son of Man, the Man of Sorrow' brought initial hope with his moral teaching. However, following his crucifixion, priests and creeds transformed his message of peace into a flaming sword, the burning of heretics and the Inquisition. Massacres and revolutions prompted the narrator to ask, 'what help is there without, what hope within/Of rescue from the immemorial strife?' The answer lay in Nature or pantheism, a more feminine society, and the search for 'Love', in Mathilde's view the only god worth seeking.

The Ascent of Man had just arrived in the bookshops when, on 31 May 1889, Mathilde attended a 'Literary Ladies' Dinner' at the gorgeous marble and mosaic Criterion Restaurant on Piccadilly Circus. Because male authors were excluded, the event caused a stir in the press. The authoresses assembled, mostly strangers to each other, determined to establish 'a sisterhood of letters'. They studied the menu:

Hors d'oeuvres

———

Consommé Sarah Bernhardt
Creme Fontage

———

Darne de Saumon, Sauce Mousseline
Pommes Nouvelles, Concombres, Whitebait

———

Fricassée de Volaille à l'ancienne
Filet de Boeuf, à la Portugaise
Pommes Rissoles

———

Caneton Roti, Petits Pois
Salades de Romaines

———

Bavarois de Fraises
Biscuits et Petits Fours

———

Bombe Criterion

———

Dessert

Mona Caird, the feminist writer, sat at the head of the table, 'in a gown of white and gold brocade' with rosebuds in her hair. Among the thirty guests were poets Mathilde Blind, Kate Freiligrath Kroeker, Alice Meynell and Katharine Tynan, novelist Amy Levy and the political writer, Clementina Black. As coffee and cigarettes went round after the meal, Mathilde Blind made 'a noble and eloquent speech on the dreams, needs, hopes, and aspirations of woman.' When the writers disbanded into the night, they hoped 'the day when woman may work side by side with man without having for ever to assume a quasi-apologetic attitude, was coming very soon. We saw the dawn, and one of its brightest rays last night shone from the gabled roof of the Criterion.'

A few months later, in November 1889, the *Pall Mall Gazette*

announced: 'Miss Mathilde Blind is now engaged on a translation of the journal of Marie Bashkirtseff. Miss Blind was the first in England to write about Marie Bashkirtseff.' Mathilde first heard about Marie Bashkirtseff when, because of her chronic bronchitis, she wintered on the French Riviera in 1887. At the Pension Villa Garin in Cimiez, above Nice, she met a young Russian tourist, Aleksandr Bashmakoff, who took her on drives along the coast. He was related to Marie Bashkirtseff, the Ukrainian artist who had lived in Nice in the early 1870s, and died of tuberculosis in 1884, aged only twenty-six. Her brilliant French *'journal intime'* had been published that year in Paris. The *Journal*'s revelations of a young girl's innermost thoughts, combined with her artistic brilliance and tragic early death, caused a sensation.

Mathilde called Bashkirtseff's *Journal* 'a book in the nude'. Its themes – the importance of a young woman's inner experience, the drive of the creative personality, the immense power of unconsummated love, religious unbelief, and the fight for female emancipation – spoke directly to her deepest interests. 'Continually thwarted by the impediments and restrictions' of her sex, Bashkirtseff demanded rights, great and small, for women. She had the 'ambition of a Caesar'. She longed to be a great dancer, a fine singer, 'the most accomplished harp player in existence'. She dreamed of marrying the tsar but settled for art as her true vocation. At the private Académie Julian in Paris which allowed women artists to study from the nude model, Marie won the top prize for her 'phenomenal' life drawing. Like Zola in his novels, Bashkirtseff's aim was 'to catch hold of the life of to-day, the common life of the streets, vagabonds, gamins, working people, strollers, convicts' in a style that was super-naturalistic and, in Mathilde's view, ultra-modern.

In *Woman's World* edited by Oscar Wilde, Mathilde had introduced Marie Bashkirtseff to the Anglo-Saxon public in 1888, and to Gladstone, who responded with his own appreciation of the artist. Mathilde then brought out the first English translation of Bashkirtseff's *Journal* which has not been superseded to this day. When the *Journal* was published in London in spring 1890, some critics found it 'too intensely modern for repose'. Unlike Gladstone, they were suspicious about the sincerity of Marie Bashkirtseff's confessions. Swinburne referred to her as 'the Muscovite minx' when writing to Karl Blind. Reviewers disliked Bashkirtseff's 'absorbing egotism' but they conceded that the *Journal* was 'unique, probably, in the history of literature produced by women.' The translation 'by so eminent and poetic writer as Miss Mathilde Blind . . . leaves nothing to be desired'.

The Meeting by Marie Bashkirtseff, 1884.

★

Emma's health had been failing intermittently during the final years in Manchester. She made a simple will in Manchester in 1886, and remade it in London in 1888, in an age when it was unusual for women to make wills at all. Both documents contained the same single term: she left all 'property, money, furniture, pictures, laces, clothes and jewellery' to her daughter, Cathy. As she aged, Emma retained her perennial gift of seeming young, even to Juliet, her granddaughter. 'She wasn't old and bent at all, but tall and straight, and her voice was so soft that sometimes you'd hardly know that she was speaking.' Juliet used to follow Emma into the kitchen storeroom hoping for chocolate. 'When she moved from

one shelf to another her dress made the nice sighing sound and smelt countrified even among all the cookery things.' At this stage of her life, Emma's presence had a soothing effect. 'She was so gentle that whenever she came into a room where people were quarrelling they stopped and behaved properly.' She had found a way of living at peace with her husband that accommodated Mathilde Blind, on her terms. 'She was always taking care of my grandfather and trying to make people pleased and give them what they wanted . . . Nothing ever made her angry. When my grandfather flew into a rage she used to smile and say, "Ford, Ford," and he was quiet at once, and began smiling.' The dramatic conflicts of their earlier days together had been resolved. Understanding and indulgence were now the keynotes of a new domestic harmony.

It was the time of Madox Brown's life when his grandson, young Ford Hueffer (later Ford Madox Ford), knew him best, when in spite of everything, his personality was 'picturesque and buoyant', his appearance full of vitality. 'His thick hair was a bright silver; his cheeks were pink, his eyes luminous; he spoke always with a profusion of gesture.' Like Emma, 'he had preserved an inestimable gift of youth'. His enthusiasms were warm, his cultural and political interests wide. 'He admired Maclise and Ingres; J. M. W. Turner and the Pre-Raphaelites were "geniuses", so were Mr Whistler, the French Impressionists, and the young men who drew for the *Daily Graphic*. He would speak with reverence of Gluck and of Rossini, of Offenbach and of Wagner; Byron, Rossetti as poet, Mazzini, Mr Parnell, Carlyle and the Duke of Wellington.'

Early in 1890, Emma's life contracted to the bedroom. By May, she had had seven 'fits'. She was effectively paralysed. 'When she was ill she was sorry for giving people trouble and for making them run up and down the stairs. She used to say to [Juliet], "Thank you, little granddaughter, and you must forgive me, for, you see, I'm ill. I shan't be able to get up any more and go down to the storeroom with you as I used to do."' This slow death was caused by 'paraplegia 7 months' and 'mollitis 1 month' – perhaps a slip of the registrar's pen for 'mellitus'. Emma may have suffered from 'diabetes mellitus' for much longer than her death certificate suggested. During September 1890, Madox Brown told friends, 'we go on hoping still', but Emma had already been delirious for ten days. 'Once in the night, just before she died, when she'd forgotten all about the world already, she began to sing a song, but very gently, and my grandfather said her voice was just as sweet as when she was a girl and they used to sing it together.'

Madox Brown sat beside Emma on her deathbed. Her sleeping face recalled an earlier Emma he had drawn pallid and *Convalescent* after a

serious illness in 1872. In that picture, her abundant chestnut hair spilled across the pillows, while in her thin hand she held a posy of pansies, for thought.

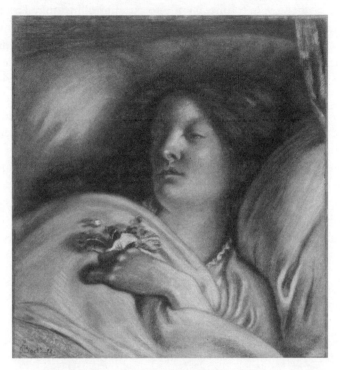

Emma *Convalescent* in 1872.

Now he drew Emma for the last time, on 10 October, the day before she died, her still chestnut hair pinned back in a neat chignon. Emma was buried in the same grave at St Pancras Cemetery in which her son, baby Arthur, had rested since 1857, and her 'golden boy' Oliver had been laid in 1874. Inside her elm coffin was a 'soft superfine Cambric Tufted wool Mattress – pillows – ruffles & fullworked soft cambric sheets [on a] Chemically prepared bed.' The 'Funeral Furnisher' James Parsons charged £36 2s. 6d., to include 'Attendants with truncheons . . . 6 Best Broughams & pairs, Coachman in livery, Gloves & Bands, 7 Pairs Dents best Gloves, 3½ doz Memorial Books, 1 Attendant Extra, Gratuities to Attendants, Coachmen, Gravediggers, Telegrams, Railway & omnibus Fares.' The old fiction about Emma's age which she had kept up since she first modelled for Madox Brown in 1848 was perpetuated on her gravestone and her death certificate. For those purposes, she was not her true age of sixty-one, but only fifty-five, part of Emma's myth of agelessness.

After the funeral, Madox Brown sat for hours alone in his studio without lifting a brush. 'In the evening he used to wander up and down and in and out from room to room, as if he were looking everywhere to try and find my grandmother.' When Juliet went into the studio, he looked at her 'with an odd far-away expression' as if he didn't see her. She ran up to him in surprise and asked 'Grandpapa, have you lost something?' He smiled and said, 'Oh, it's little pigeon. Yes, my little pigeon, yes I have.'

After his wife's death, Madox Brown curiously conflated Emma in his mind with Mathilde. When Mathilde's collection *Dramas in Miniature*

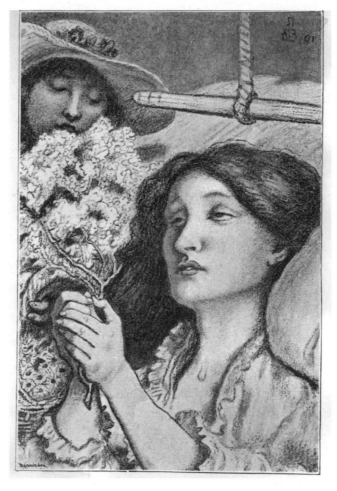

Emma lives on in FMB's frontispiece for Mathilde Blind's
Dramas in Miniature, 1891.

came out in 1891, he designed its frontispiece to illustrate one of her poems, 'The Message'. It was unmistakably based on his earlier portrait of Emma, *Convalescent*.

'The Message' dramatised the deathbed of a prostitute, Nellie Dean, whose name recalled Emily Brontë's narrator in *Wuthering Heights*. Mathilde's Nellie was a 'ruined maid' from the countryside, like Hardy's *Tess of the d'Urbervilles* published in the same year, or like Emma herself when she first came to pose for Madox Brown in 1848. Perhaps we see Emma's face twice in this picture, as the young girl she was and as the woman she became. In Mathilde's poem an innocent young girl brings 'green boughs of milk-white thorn [hawthorn]' to Nellie's hospital bedside which the dying woman grips in redemption. 'The perfume of the breath of May/Had passed into her soul' were the exact lines Madox Brown chose to illustrate. Was he also alluding to some sort of absolution that Emma had given him, or that he wished she had given him?

After Emma's death, Mathilde continued to live close to Madox Brown, sometimes within his home. They made excursions away together. Contemporary speculation murmured that the two planned to marry – or had already married. Even as a widower, Madox Brown remained defensive about Mathilde. 'One point upon which Madox Brown was excessively touchy,' said his granddaughter, Helen, who was fourteen at the time, 'was Miss Mathilde Blind'. In Helen's memory Mathilde was only ten years junior to Madox Brown, when in fact the difference was twenty years. Mathilde had a great many friends and admirers, Helen admitted, but 'the most devoted and distinguished of them all was Madox Brown.' Helen's patronising and perhaps racist view was that 'towards the close of his life' her grandfather's feelings had overstepped 'mere friendship'. He had become soppily 'romantic' about 'the handsome Jewess', with the 'disagreeable voice'. By the time Emma died, Madox Brown was nearly seventy and in poor health; Mathilde herself nearly fifty and suffering from increasing depression and bronchial problems. Helen believed strongly that it was her mother, Lucy, who had stopped Madox Brown from marrying Mathilde in his final years.

Most significant of all, however, was the fact that marriage was not, and probably never had been in her maturity, part of Mathilde's life plan. Her career came first. She made a modern choice. But it was also a choice made in the shadow of the marriage modelled for her since childhood, between her bright, clever mother, Friederike, and her overbearing stepfather, Karl Blind. Choosing to avoid marriage made Mathilde the most progressive of the four women Madox Brown loved. It also made her the most difficult, most complex, most hurt – or as he called her, the

most 'wayward'. Although she depended on a variety of intellectual male helpmeets throughout her life, she always retained her absolute core of mental independence.

In 1892, Madox Brown's thoughts came back to Shakespeare once more, when Henry Irving commissioned him to design three sets for his production of *King Lear*. Irving had always admired Madox Brown's treatment of the play, and in homage hung a print of *Cordelia's Portion* in his dressing room. He used to employ artists as set designers, including Alma-Tadema and Burne-Jones, and for *King Lear* he naturally turned to Madox Brown – who now cultivated a Lear-like personal image. Critics noted a certain simplification, even a grotesquerie in Irving's stage gestures. Perhaps his acting style attracted him to Madox Brown's dramatic *King Lear* pictures.

Madox Brown's designs for Lear's palace, and Gloucester's and Albany's castles reflected his lifelong vision of Lear's world – a world of grandeur contrasted with desolate open spaces. Irving's Lear and Ellen Terry's Cordelia wore the same combination of 'Roman-pagan-British' costumes Madox Brown had chosen in his earlier *Lear* pictures. For 10s. 6d. in the stalls or 1s. in the gods, theatregoers at Irving's Lyceum experienced a *King Lear* that grew in stature as the run continued. Although critics sniped that King Lear could have done with a haircut,

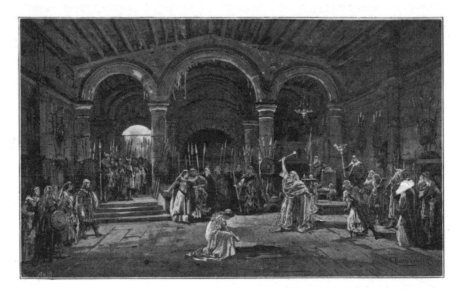

FMB's design for Lear's palace in Henry Irving's production, 1892.

they recognised Irving's genius and praised the settings which were 'gorgeous throughout', giving 'the eye something to feast on'. When Mathilde saw Irving's *King Lear* she wrote to tell him how 'extraordinarily moved' she had been.

Between the covers of a dummy copy of *The Ascent of Man* lies Mathilde's unpublished commonplace book. Inside are private thoughts, poetic drafts, aphorisms, travel jottings and an intimate diary of a holiday taken in September 1893 with novelist Mona Caird. They lodged at Chestnut Cottage on the main High Street of Wendover, a rural village in Buckinghamshire. A committed advocate of women's rights, Mona Caird vigorously defended her fellow suffragists from Mrs Lynn Linton's provocative accusation that they were 'wild women' of a 'shrieking sisterhood'. In powerful novels, such as *A Romance of the Moors* (1891) and *The Daughters of Danaus* (1894), she promoted the new 'status and destiny of women', arguing passionately for personal independence within marriage, equality between the sexes, and an end to male dominance in the home and in politics. However, unlike Mathilde, Mona sustained a long marriage, variously described as unhappy and happy – to James Caird – and bore him one son.

 Although Mathilde, now fifty-two, didn't feel 'as well as she would have wished' during September 1893, she was rejuvenated by Wendover with its thatched cottages and country walks through the Chilterns. It was an English autumn idyll. She and Mona, considerably younger at thirty-nine, established a daily discipline of writing in the morning and walking in the afternoon. 'At a certain distance meadows, lanes and trees run into one another till they melt away in a confusion of universal blueness,' noted Mathilde. From the blue vision she reduced her focus to the smallest flower. From a love of nature, she turned to a human love which 'stole upon' her 'unaware':

> 'Ere the first daisy lifts its white lashed eye
> To the blue splendours of the sun-thrilled sky
> I think of thee.

This human love would outlast the brief daisy. 'All life must taste of thee for evermore.' The poet was hungry for permanence, to challenge ill health. For the narrator was a 'withering flower' whose bloom had dwindled like 'the last gleam of daylight'. Richard Garnett described Mrs Caird as 'an attached friend' whose company Mathilde found 'especially

exhilarating'. Only the magical energy of human rapport, perhaps with Mona, might rouse the poet from physical decline:

> So doth your brightness touch my failing days.
> From your bright eyes my saddened heart hath caught
> The sweet infection of joy's living glow . . .
>
> Seen with your eyes the world becomes once more
> The fairy land my childhood knew of yore.

Who was the object of the poet's love? Man or woman, past or present, alive or dead, real or imagined? Five years before, on the French Riviera when she first read Marie Bashkirtseff's *Journal*, Mathilde wrote love poems in a narrative voice either fictional – or her own:

> You may perchance, I never shall forget
> When, between twofold glory of land and sea,
> We leant together o'er the old parapet,
> And saw the sun go down. For, oh, to me,
> The beauty of that beautiful strange place
> Was its reflection beaming from your face.
>
> *Cagnes. On the Riviera.*

Among the Wendover notes, was a moment retrieved from Mathilde's past: '*Une route solitaire qui se perd dans le lointain* [A lonely road lost in the distance]. – Vence – Cagnes Bashmakoff.' It was the name of the young Russian who had taken her to the French medieval hilltop towns of Vence and Cagnes. Mathilde's experiences of love had been repeatedly lonely and unspeakable, unsatisfactory on many levels. But there is no doubting the intensity of her loves that could not be admitted in public, or loves that could never be consummated, whether for unavailable married men or for other women. 'We would rather be made wretched by the person we love than be made happy by one we don't,' she wrote bleakly in her commonplace book.

During evenings at Chestnut Cottage, the two writers read their work in progress to one another. Mona read Mathilde an article she was writing called 'Man and his Enemy'. Did Mathilde read aloud her sensuous description of Mona leaning against an old white horse on one of their Wendover walks? 'Mona with very soft little touches began patting it & driving the flies away. I shall long remember the picture. I wish it could be painted. She was sitting tilted on the gate, the brim of her large black

straw hat shading her eyes. She wore a blue serge gown with a skirt dotted with little blue & red spots. The delicate lines of her skin & form were on the green background & caressing the somewhat asinine-looking horse & she reminded me of Titania when she begs Bottom to be still "While I thy amiable cheeks do coy."'

The image of Mona as the amorous Fairy Queen caused Mathilde to feel a wave of love, initially for the world in all its vastness. 'And then I thought of Edmond. Of the life we might have had together here on earth. The growth of knowledge, of spiritual insight, of sympathy & the sense of loss, of something irrevocably missed has come with a sorrow beyond expression. Yes, I believe, I still believe, that it might have been.' What might have been and who was 'Edmond'? Could he, or a disguised she, have been an individual, or a composite member of the Mond family who became friendly with Mathilde in the last decade of her life? She stayed regularly at their country estate, Winnington, in Cheshire. Ludwig Mond (1839–1909), was a German Jewish immigrant who founded Britain's modern chemical industry and became a discerning art collector. In August 1893, Mathilde and Alfred Mond, Ludwig's younger son, had read poetry together in Winnington's lush gardens, only a few weeks before her holiday with Mona. 'The majestic sunflowers meet the sun barefaced, which makes one a little afraid of them. It seems over bold. Intoxicated peacocks eyes stay in the laps of carnations & sweet peas, too drowsy for flight. There's a spittle of blood red poppy leaves on the earth & the leaves of the Vines are blistered & burnt with heat.' Maybe 'Edmond' was the young Russian who had taken Mathilde on romantic tours along the Riviera? Or was 'Edmond' a cipher for Madox Brown whose wife Emma had died too late for Mathilde to embark on married life? 'Edmond' could have been an idealised amalgam of all the men and women Mathilde had loved.

It was as if love was trapped inside her complicated heart. 'The passion which Charlotte Brontë infused into Jane Eyre', she noted, 'acted as a fire escape of the soul.' Poetry was Mathilde's fire escape – and she knew just how combustible was the fire within her. She withdrew from the flames soberly, noting a prosaic remark made by Robina Findlater, her landlady at Chestnut Cottage: 'When I was young I was like other girls & wished to be married but now I am very thankful that God ordered it otherwise.' While out walking on 26 September, the two writers 'were struck by the singular outline of a hornbeam with the trunk & branches half thrown back curiously resembling a woman's body. It might have been some female struggling passionately to escape pursuit – yea, Daphne herself changing into a shrub.' The tree was an image of Mathilde. She had spent

a life struggling to escape everything that heterosexual passion might have brought with it, and ultimately never choosing to put her career second to any man.

THE DEAD
ARE WITH US STILL

WHILE MATHILDE WAS IN WENDOVER, responding to Mona and lamenting 'Edmond' in her private notebook, Madox Brown was in London, unbeknown to him entering the last phase of his life. Just before his final illness he called on his granddaughter, thirteen-year-old Helen Rossetti. 'Oh Nellie . . . I'm going for a little walk in the Park. Come with me.' So off they stepped together, Madox Brown in his Inverness cape and top hat, down Ormonde Terrace, across the Albert Road, over the bridge across the Regent's canal, straight into the setting sun. 'Never shall I forget that sun nor the vision of Grandpapa walking as it seemed straight into it – opaque and glowing and unnaturally big. I had the vision that Grandpapa could not stop, bound to walk on for ever into the setting sun.'

During the last week of September 1893 he kept regular working hours at home, where 'the fine airs and fresh breezes of Hampstead blew directly into the front windows of St Edmund's Terrace'. The house and its studio held a musty glamour. The writer and old family friend, Ella Hepworth Dixon, observed the melancholy of its interior decoration. 'Walls and wood-work were painted a pensive olive-green; there was a long, low couch covered in some dull tapestry . . . the painter of *The Last of England* was always surrounded by canvases which he intended to retouch or repaint.' In a frame by themselves hung fourteen exquisite pencil drawings of Emma, ten by her husband of nearly forty years, and four by his friend Rossetti. For the grandchildren, the studio was a place of fascination as well as decay. 'There was a row of dusty casts on the mantelpiece, a

Hercules raising a club, fighting horses intertwined and biting; a con-torted, flayed figure . . . an ancient lay figure with a papier mâché head that was brown with age . . . a large oak table covered with odds and ends, little coils of string, rusty screws, the knobs from ends of curtain poles.' Madox Brown never noticed his curtains were transparent with age, 'until one day when he wanted to paint the sun shining through a sail. Then he found that he could use them.'

As always, the work meant everything. But on Sunday 1 October, after working for an hour or two on his replica of *Wycliffe on Trial*, he climbed goutily down the ladder from the screw-chair in which he painted. He felt inexplicably tired. As Cathy Hueffer, his widowed younger daughter, helped him upstairs to bed, he said to her, 'Well, my dear, my work's done now.'

On Monday he stayed in bed, at his home hung with golden wallpaper, next to Primrose Hill. According to Cathy's son, nineteen-year-old Ford, his grandfather was able to talk with much of his 'usual vivacity' while sitting up in bed, and even managed to dictate an account of his early life. This formed the basis of the first chapters of Ford's biography of his grandfather, published three years later in 1896. Then Lucy Rossetti visited for a painful farewell – wasted by tuberculosis, she was leaving the next day to winter in Italy.

At this point, either Cathy or Ford decided to summon Mathilde back from her writing holiday at Wendover with Mona Caird. Lucy was implacably opposed to Mathilde's liaison with her father and no one would have wanted to take the risk of the two women colliding on the stairs. However, Cathy was less intransigent than her half-sister on the subject of Mathilde. Although Ford's talent was for fiction rather than fact, he later maintained that his grandfather's 'last quite coherent words' were spoken either to Lucy on the eve of her departure, or to Mathilde 'whilst advising some alterations' to her work in progress. Madox Brown's partisanship of Mathilde's literary work had always fuelled their relation-ship. 'I found him more vivacious and alert than for some months past', thought Mathilde. 'He listened with his usual vivid sympathy to some poems I had lately written', probably the drafts she had made on holiday with Mona Caird. Mathilde's love poems were partly imagined, partly written out of experience; they fused all her tumultuous feelings. She could read them safely to Madox Brown who was both critic and recipient of her lines.

No one wanted to believe Madox Brown was on his deathbed: they were planning for the future. 'At his express wish,' Mathilde 'went to Tunbridge Wells', one of her favourite health retreats, 'to look for

rooms for himself, Mrs Hueffer, and her daughter [Juliet]. The idea of going there seemed to please him greatly.' However, on Tuesday, Madox Brown suffered an attack of apoplexy (a stroke or cerebral event) and remained comatose for three days. Cathy called in Dr Gill of Russell Square and Dr Roberts of Harley Street. On the morning of Friday 6 October, the seventy-two-year-old artist regained consciousness briefly, had breakfast, relapsed into a coma and died at 4.30 p.m.

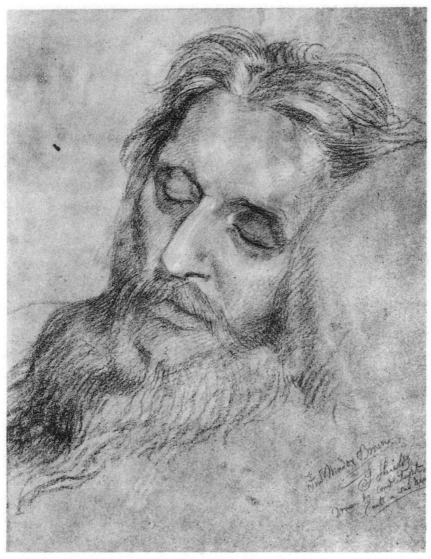

'Drawn by candle-light with an aching heart', *FMB on his deathbed* by Frederic Shields.

Young Ford was present at his bedside, probably with Cathy, but not it would seem with Mathilde, who was in Tunbridge Wells. Dr Gill gave the cause of death as 'podagra [gout], diarrhoea, apoplexia' when Ford registered his grandfather's death. Mathilde went into mourning, alone, in Tunbridge Wells, one of the dozens of lodgings she used throughout her adult life.

'My grandfather was dead', recorded Juliet. 'Next day when I went out I saw the placards, "Death of FMB", and I stood and stared at them. I didn't cry because I couldn't believe that the dead man was really my dear grand-papa, who had always been there in the studio winding himself up and down in the screw-chair, and calling me "little pigeon", and loving me.'

The funeral took place in the unconsecrated section of St Pancras Cemetery at East Finchley at 12.30 on Wednesday 11 October, five days later. The coffin of polished elm with brass fittings was covered with wreaths and inscribed simply, 'Ford Madox Brown. Born in Calais, 16th April 1821. Died in London, 6th Oct., 1893.' The cortège consisted of an open car drawn by two horses, followed by sixteen carriages. There was no religious ceremony as the coffin was lowered into the grave, which already held the bodies of Madox Brown's wife Emma and their two sons. It was three years to the day since Emma's death.

Many members of the family, friends, and representatives from Manchester Corporation convened at the graveside. Associates from the old Pre-Raphaelite days were led by William Michael Rossetti, Holman Hunt, Arthur Hughes and Georgie Burne-Jones. Other writers and artists included Mathilde Blind, Richard Garnett, Lawrence Alma-Tadema and Walter Crane. The *Glasgow Herald* reported that even Christina Rossetti attended, from a distance in a closed carriage. The *Daily Graphic* noted the unusual procedure: 'As soon as the mourners had gathered round under the shadow of a fine sycamore, of which the leaves have just faded into a beautiful golden brown, the coffin was lowered'. Then Moncure Conway, the American freethinker in whose honour Conway Hall in London was later named, delivered a moving and entirely secular address. Many newspapers described Mathilde Blind's beautiful foliage wreath with a 'line from Blake woven in gold on a ribbon of black silk: "Death is the mercy of eternity."' In fact, Mathilde had deliberately revised Blake's gnomic words from *Milton*, 'Time is the mercy of eternity.' Neither Mathilde nor Madox Brown envisaged an afterlife. In a curious slip, several newspapers reported Mathilde's name incorrectly and called her 'Mathilde Brown'.

Newspaper reports of Madox Brown's death were copied nationally and internationally from London to Edinburgh, from Dublin to Cardiff, from Paris to New York. Obituaries and the world's assessment followed. Some saw him as other-worldly. 'He painted, not for money, or even for fame, but for art's sake.' Others saw him as a modern man, 'A Captain of the Advance'.

Mathilde's own summation of her nomadic life lies in her commonplace book. 'I have been an exile in this world. Without a God, without a country, without a family.' This was the force that impelled her passionate attachments. Her friendship, liaison, *amitié amoureuse* with Madox Brown had been the most meaningful, sustained relationship of her life. She had lost a friend but not a friendship. 'The death of a friend is a grievous affliction but the death of a friendship "works like madness in the brain" ', she felt. She clung to a line from one of her own sonnets, suggesting that in a deep, evolutionary sense the dead 'are with us still'. 'Dear Mathilde,' wrote Richard Garnett, 'I can very well enter into the sorrow you so touchingly express in your letter, knowing what an incomparable friend you have lost in Madox Brown, and how much you have mutually been to each other.' When he published his *Memoir* of Mathilde in 1900, Garnett tactfully categorised Mr *and* Mrs Ford Madox Brown 'above all' in a list of her intimate friends. But in careful code he gestured towards the relationship between Mathilde and the painter as 'singularly beautiful'.

After retreating to Tunbridge Wells, the only person with whom Mathilde could share her loss was Cathy, because it had 'touched us both so grievously'. In spring 1894 Mathilde set out for the more exotic health resort of Egypt. She was no longer worried about every penny. She was beginning to get used to the fact that her half-brother, Max Cohen, had left her his estate in 1892, making her a woman 'of independent means.' The money gave her freedom to travel beyond Europe where a new face in a new setting inspired a new poem:

To Blanche, Marchioness of Waterford, Luxor, March 1894

All harmonious things that be
Verse & twin born harmony
Must be drawn as grace to grace
By the magic of your face.

What we paint & carve & sing
Is but Beauty on the wing!
With no further wish to roam
She has made your heart her home.

In the shadow of the Pyramids, Mathilde scoured Blanche's face in an effort to heal her recent loss. Blanche may have recalled her ardent rapport with 'Blanche Hellifield', the schoolfriend summarily removed from Mathilde's dangerous influence over forty years before. 'Perhaps the sunshine and brightness of Egypt were the best antidote to the grief caused me by Madox Brown's death,' Mathilde wrote to her old friend Lily Wolfsohn. 'But, perhaps owing to mental as well as physical causes, Egypt has not quite realised my expectations.'

When Madox Brown died in London, Marie Spartali Stillman was living in Rome. Writing to Cathy, she now regretted her lifelong practice of destroying all her incoming post. She was grieved 'to say I have no letters of your dear Father'. Perhaps his death recalled life in his studio twenty-five years earlier, when she had been the object of his tormented love sonnets. As she painted her latest picture of a young woman reading an illuminated book of verse, she called it *Love Sonnets*. In her hand was a spray of deep orange calendula which in the Victorian language of flowers

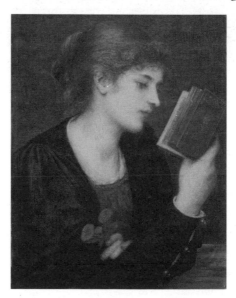

Love Sonnets by Marie Spartali Stillman, 1894.

denotes sorrow and sympathy, a motif repeated on the binding of the book.

Mathilde Blind died from cancer of the uterus on 26 November 1896. The *Illustrated London News* obituary of 5 December carried an engraving, based on a studio picture by London photographers, Elliott and Fry of Baker Street. The medium may be crude but the newspaper's mass-circulation figures were indicative of Mathilde's public profile by the time of her death. Although nearly full face, Mathilde's gaze, characteristically, does not meet ours. Unlike the loose, Pre-Raphaelite dress of Lucy's

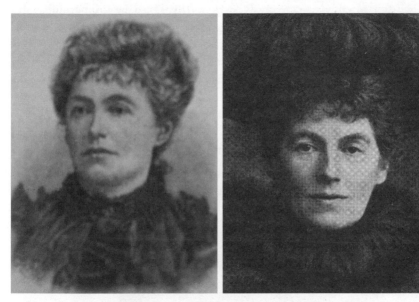

Two late views of Mathilde Blind: (left) engraving from the *Illustrated London News*, 5 December 1896, and (right) photograph from the *Literary Yearbook* 1897

portrait, the intimate suggestion of déshabillé in Madox Brown's scrutiny, the high aestheticism of Harold Rathbone's study, or the extreme elegance of Elliott and Fry's earlier *carte de visite* shot, Mathilde is now in conventional, late Victorian dress. This may be the least feminine of her self-presentations, closest to the stereotype of a mannish suffrage campaigner, but Mathilde looks handsome and powerful.

By contrast, a photograph of Mathilde from the 1897 *Literary Yearbook* – also published posthumously – is quite different from the strong image in the *Illustrated London News*. Although furred and hatted, in the persona of a graceful society lady, Mathilde looks ill and wan. Not only the cancer

that killed her but years of depression and chronic 'bronchitis' are uncompromisingly reflected in her thin face. She still cared about elegant presentation, self-expressive clothes and a calm arrangement of her features. It is the only one of the portraits in which she looks directly at us. Her gaze is unflinching, and subtly reversed, as if instead of submitting to the photographer's inspection, she is looking death in the face.

From adolescence onwards, Mathilde challenged accepted codes of behaviour for women in the second half of the Victorian age, perhaps because her mixed-up identity allowed her to straddle several different sectors of society. She was German, but had acquired British roots. When she visited Shelley's grave in Rome in the last year of her life, 'she expressed the hope that her last resting place would be in England, which had become her home by every form of adoption, and which she loved so well.' She was Jewish, but a freethinker who was interested in comparative religions. She was an insider within the cosmopolitan world of political revolutionaries; an outsider in middle-class English life. She was a woman whose nature, if not her practice, was bisexual. Born in the nineteenth century, she reached out to the future, believing that women should have careers as fulfilling as men's.

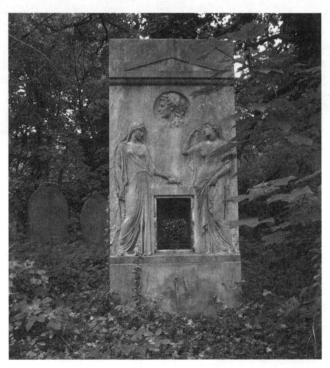

Mathilde's monument by Edouard Lanteri at St Pancras Cemetery.

Time has eroded the original lettering on Elisabeth Bromley's grave in Highgate. The inscription on the Madox Brown headstone two miles north-west is still discernible, although the grave is hidden from view in a remote section of St Pancras Cemetery at East Finchley. It is distorted by an ash tree which has pushed the headstone forward at a rakish angle. The grave itself is almost sunk in the earth and the foot-stone is skewed and half buried in the ground. A few steps away, in a more accessible position, stands Mathilde Blind's imposing monument in Carrara marble, erected by her friends the Monds in 1898. Cut beneath her name is the same line she had chosen for Madox Brown's wreath: DEATH IS THE MERCY OF ETERNITY.

Two years after her death, the French sculptor Edouard Lanteri made a bronze medallion portrait of Mathilde. He was one of the best sculpture teachers in his adopted country, England, where he became professor at the National Art Training School in Kensington, now the Royal College of Art. Lanteri was noted for his ideal figures and his bronze is certainly the most idealised image of Mathilde. Borrowing the format of a classical medal, reminiscent of Marie Zambaco's portrait medallion of Marie Spartali, Lanteri shows Mathilde's face in profile like a Roman emperor. The pale, wasted face in her final photograph is replaced with a clear-eyed, purposeful young woman. A luxuriant mane of hair tumbles across and outside the lower edge of the medallion. Its Pre-Raphaelite glamour is a foil for Mathilde's fine head with its aquiline features. After death, Mathilde was restored to strength and youth.

Mathilde Blind portrait bronze plaque by Edouard Lanteri, 1898.

Although made posthumously, Lanteri's bronze is in no way a death mask. Curiously perhaps, it was in the rigid material of bronze, harder and heavier than any paint, that Lanteri captured, but did not petrify the essence of Mathilde. Her final image in unyielding metal is the most surprising, substantial and pleasing to touch. In its permanence, Mathilde's vitality shines bright, a visual testament to Kate Freiligrath's account of Mathilde in her youth. Kate was one of the speakers on the day Mathilde's memorial was unveiled. 'It is to me a pleasure to remember Mathilde Blind as she was then, nor do I recollect ever having seen more dazzling and vivid beauty than was hers.' Mathilde may have perished, her fire set in stone, but inscribed in Kate's memory she was in no way extinguished.

It was the image her friends wanted to remember. It was the permanence Mathilde wanted to project, as she said in her sonnet 'The Dead':

> The dead abide with us! Though stark and cold
> Earth seems to grip them, they are with us still . . .

Lanteri made his portrait plaque the central focus of the monument, setting it above two classical goddesses of Philosophy and Poetry, the muses most appropriate to Mathilde. Subject, sculptor and patron were all exiles from their own countries. Their stormy Continental origins coalesced at Mathilde's memorial, a still point in St Pancras Cemetery, a sprawling city of the dead in the London suburb of East Finchley.

In 1896 George Bernard Shaw recalled seeing Marie Spartali Stillman at the opening of *The Tables Turned*, a socialist play by William Morris. She was still 'a tall and beautiful figure, rising like a delicate spire above a skyline of city chimney pots.' Widowed on 6 July 1901, Marie lived on until 6 March 1927 when she was nearly eighty-three. 'I do feel that living on so long seems an indiscretion,' she remarked in the disarming, conversational language of her will. In harmony with her warm personality, Marie left countless small individual bequests. But in contrast with the Spartali wealth of her youth, her estate amounted to just £155 1s. 2d.

Madox Brown had made a will in Manchester in 1886, and remade it in London in 1888. The terms were unchanged, appointing his daughters Lucy and Cathy joint executrixes to administer the whole of his property 'for my dear wife Emma during her life and for her sole use should she marry again'. There was no mention of Mathilde, no embarrassment and no separate bequest, even though in 1888 she was

still poor. His ultimate concern was for Emma. In spite of disparity and shared loss, alcohol and illness, he underlined the enduring power of their long love.

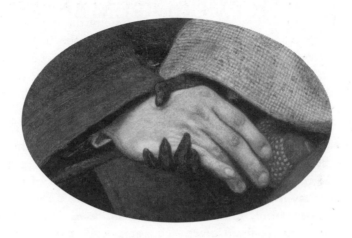

ACKNOWLEDGEMENTS

In his heyday Ford Madox Brown gave the most wonderful parties. The many people who have contributed to this book in dozens of different ways would constitute a party after his own heart. Top of the list of invitations to my Madox Brown party of the mind are today's members of his extended family in Italy and England who have unfailingly encouraged me and offered practical input as well as private insights: Edward Dennis and Helen Guglielmini, Turley and Nell O'Conor, Susan Plowden, Nick Rossetti, Charles and Angela Rossetti, Mary Rossetti Rutterford, Professors David Soskice and Niki Lacey, the Hon. Oliver Soskice and Dr Janet Soskice, and Josephine Weston.

Other guests at my latter-day Madox Brown party to whom my thanks are due for a variety of kindnesses include many Pre-Raphaelite scholars, collectors and friends: Glenys and James Andrews, Mary Bennett, Sue Bradbury, Judith Bronkhurst, Jane Cowan, Colin Cruise, Marion Davies, Jim Diedrick, David Elliott, Beth Emanuel, Valerie Wadsworth Falchi, Valerie Fehlbaum, Betty Fredeman, Paul Goldman, Lavinia Greacen, Laurie Harwood, Phyllis Hetzel, Carola Hicks, Ulrike Hill, Dennis Lanigan, Jane Liddell-King, Rupert Maas, Laura MacCulloch, Jan Marsh, Tim McGee (who first mocked up the jacket design for me), Gail Marshall, Monique Meager, Lucasta Miller, Teresa Newman, Patricia O'Connor, Suzanne O'Farrell, Professor Leonée and Richard Ormond, Richard Owen, Patricia Potts, Christine Pullen, Len Roberts, Tracey S. Rosenberg, Professor Max Saunders, Carol Seigel, Frank Sharp, Gloria Simmons, Virginia Surtees, Guilland Sutherland, Julian Treuherz, Stephen Wildman, Paul Willatts, Helen and Tony Wyand.

For thoughtful specialist advice on nineteenth-century medical diagnoses I thank Dr Elspeth Macdonald.

Of the many libraries and public collections which have shown me

continued courtesy and professional knowledge, I would like to thank Jef van Gool of the Koninklijke Academie voor Schone Kunsten in Antwerp; Monique Morbé at the Stad Antwerpen Stadsarchief; Colin Harrison of the Department of Western Art at the Ashmolean Museum, Oxford; Dr Isaac Gewirtz, Curator at the Berg Collection at the New York Public Library; Tessa Sidey at Birmingham Museums & Art Gallery; Colin Harris, Superintendent, Department of Special Collections and Western Manuscripts at the Bodleian Library, Oxford; Bonhams in Edinburgh; George Brandak and staff at the University of British Columbia Library, Rare Books and Special Collections; the British Library, especially the department of manuscripts; Philip Attwood at the Department of Coins and Medals at the British Museum; the Department of Prints and Drawings at the British Museum; the British Library Newspaper Library at Colindale; the Department of Manuscripts at Cambridge University Library; Lucy Burgess at Rare and Manuscript Collections at Cornell University; the Witt Library at the Courtauld Institute of Art; Trinity College Library, Dublin; Special Collections at Durham University Library; Dr Iain G. Brown, Principal Curator at the Manuscripts Division of the National Library of Scotland, Edinburgh; Exeter Library Special Collections; Department of Manuscripts and Printed Books at the Fitzwilliam Museum, Cambridge; the Getty Research Institute; Kate Perry, Archivist at Girton College, Cambridge; Stephen Freeth, Keeper of Manuscripts, Guildhall Library; Jean Pateman, Chairman of the Friends of Highgate Cemetery; the House of Lords Record Office; the Huntington Library, San Marino; Special Collections at the Library of the University of Kent; Richard High at Special Collections, Leeds University Library; Alison Sproston at the London Library; the London Metropolitan Archives; the Women's Library, London Metropolitan University; Manchester Archives Service; John Hodgson, Keeper of Manuscripts and Archives at the John Rylands Library, University of Manchester; Manchester Town Hall; Charles Nugent at the Whitworth Art Gallery, University of Manchester; Karen Strobel at Mannheim City Archives; Philip Mould Historical Portraits; Anne Thomson, Archivist at Newnham College, Cambridge; the Pforzheimer Library at the New York Public Library; Christine Nelson at the Pierpont Morgan Library; Margaret Sherry Rich at Rare Books and Special Collections, Princeton University Library; Reading University Library; Orlando Fowler at St Pancras Cemetery, East Finchley; the Schaffer Library, Union College, Schenectady; Pauline Adams, Librarian and Archivist at Somerville College, Oxford; Special Collections at Stanford University; Alison Smith, Curator at Tate Britain; the Walker Art Gallery, National

Museums Liverpool for the George Rae papers and Ford Madox Brown's Housekeeping Ledger; the Yale Center for British Art, and the National Art Library at the Victoria and Albert Museum. If I have inadvertently omitted to mention individuals or collections, I hope they will forgive me.

Jenny Uglow at Chatto & Windus has been a superb editor. My agent Felicity Bryan believed in the project from the start.

I want to thank my family who have lived with Ford Madox Brown and his four loves over the last five years. To John, Zoë and Adam Thirlwell goes my love and gratitude for their constant support and advice.

ABBREVIATIONS AND SOURCES

FMB: Ford Madox Brown
EBB: Elisabeth Bromley Brown
EMB: Emma Madox Brown, née Hill
Marie: Marie Spartali, later Stillman
WJS: William James Stillman
Mathilde: Mathilde Blind
WMR: William Michael Rossetti
DGR: Dante Gabriel Rossetti
Lucy: Lucy Madox Brown Rossetti

Archives and Sources

Agresti: Olivia Rossetti Agresti, *The Anecdotage of an Interpreter*, Columbia University, Rare Books and Manuscript Library, 98–2115–3, unpublished typescripts, 1958.

BL: British Library, London.

Cornell: Division of Rare and Manuscript Collections, Carl A. Kroch Library, Cornell University.

FMB Sonnets: Exercise book containing FMB's unpublished sonnets at the House of Lords Record Office, Stow Hill Papers STH/BH/2/3–6.

Princeton: Manuscripts Division, Department of Rare Books and Special Collections, Princeton University Library.

WMR Diary: William Michael Rossetti MS Diary, various years 1865–1913, at the Angeli-Dennis Collection, University of British Columbia Library, Rare Books and Special Collections, and on microfilm at Bodleian Library, University of Oxford, Modern Papers.

Schenectady: William James Stillman Collection, Schaffer Library, Union College, Schenectady, NY.

UBC: Angeli-Dennis Collection at University of British Columbia, Rare

Books and Special Collections.

V&A: National Art Library, Victoria and Albert Museum, London: Ford
Madox Brown Papers, Boxes 1–42.

Abbreviations for Published Sources

Ancient Lights: Ford Madox Hueffer, *Ancient Lights and Certain New
Reflections* (London: Chapman and Hall, 1911).

Bendiner: Kenneth Bendiner, *The Art of Ford Madox Brown* (University
Park, Pa; Pennsylvania State University Press, 1998).

Blind: Mathilde Blind, *The Poetical Works of Mathilde Blind*, ed. Arthur
Symons with a memoir by Richard Garnett (London: T. Fisher Unwin,
1900).

Bornand: Odette Bornand (ed.), *The Diary of W. M. Rossetti 1870–1873*
(Oxford: Oxford University Press, 1977).

Diary: Virginia Surtees (ed.), *The Diary of Ford Madox Brown* (New Haven
and London: Yale University Press, 1981).

DGRFLM: William Michael Rossetti, *Dante Gabriel Rossetti: His Family
Letters with a Memoir*, 2 vols. (London: Ellis and Elvey, 1895).

Exhibition: Ford Madox Brown, *The Exhibition of WORK, and other
Paintings* (London: privately printed, 1865) and reproduced in Bendiner,
op. cit., Appendix 3, pp. 131–56.

Fredeman: *The Correspondence of Dante Gabriel Rossetti* ed. William E.
Fredeman et al., 10 vols. (Cambridge: D. S. Brewer with The Modern
Humanities Research Association, 2002—).

HRA: Helen Rossetti Angeli, *Dante Gabriel Rossetti: His Friends and
Enemies* (London: Hamish Hamilton, 1949).

Hueffer: Ford M. Hueffer, *Ford Madox Brown: A record of his life and work*
(London: Longmans, Green, 1896).

N&W: Teresa Newman and Ray Watkinson, *Ford Madox Brown and the
Pre-Raphaelite Circle* (London: Chatto & Windus, 1991).

Paden: W. D. Paden, 'The ancestry and families of Ford Madox Brown',
Bulletin of the John Rylands Library, 50 (1967), pp. 124–35.

Præraphaelite Diaries and Letters: William Michael Rossetti (ed.),
Præraphaelite Diaries and Letters (London: Hurst and Blackett, 1900).

WMR *SR*: William Michael Rossetti, *Some Reminiscences*, 2 vols.
(London: Brown, Langham, 1906).

Soskice: Juliet Soskice, *Chapters from Childhood* (London: Selwyn &
Blount, 1921).

NOTES

Chapter 1 – Your husband loves you as the first day

page no.

7 'Your husband loves you as the first day': FMB to 'My Blessed Lizzy', ? December 1844, from *Præraphaelite Diaries and Letters*, p. 52.

7 'Where is the bridegroom?': Hueffer, p. 27.

8 'How bewildered I felt': FMB to Theodore Watts-Dunton, 29 January 1881, typescript of ALS at Special Collections, Brotherton Library, Leeds University.

8 'Madox Brown sought out his sister's grave': FMB, EMB, WMR and Lucy visited Antwerp together in 1875. FMB was researching techniques for painting frescoes in connection with his commission for Manchester Town Hall. WMR *SR*, II, p. 432.

8 'I found that the stone over my sister's grave': FMB to DGR from Antwerp, 4 July 1875, UBC, A-D 2–4.

9 'His last appointment': FMB to Henry Boddington, 25 March 1889, UBC, 5–10.

9 'someone to grumble at': Hueffer, p. 20.

10 'he settled a liberal £900 on her': information from Paden.

10 'annual private income amounted to about £250': Hueffer, p. 27. Later FMB allotted part of his share in the Ravensbourne Wharf to his daughter Lucy.

10 'old Kentish family': Lucy Madox Rossetti, 'Ford Madox Brown', the *Magazine of Art*, XIII (1890), pp. 289–96, p. 290.

10 'I was dressed': FMB's earliest memories as related to Henry Boddington, 25 March 1889, UBC, A-D 5–10.

11 'Caroline herself joined a local drawing class': the *World*, in its 'Celebrities at Home' series, 11 October 1893. FMB had been interviewed for this just before his final illness.

11 'engaged the best drawing masters': Lucy Madox Rossetti, 'Ford
 Madox Brown', the *Magazine of Art*, XIII (1890), pp. 289–96,
 p. 290.

11 'Because my mother had sewn it': childhood memories from
 FMB's letter to Henry Boddington, 25 March 1889, UBC, A-
 D 5–10.

12 'One of the two prizes': I am grateful to Jef van Gool of the
 Koninklijke Academie voor Schone Kunsten for showing me
 the List of Prizes published on 7 April 1839 by the then
 Académie Royale des Beaux Arts d'Anvers. The number of
 students in these classes ranged from thirty-one to forty-six.

12 'one of the greatest painters living anywhere': DGR to Louisa,
 Lady Ashburton, 8 June 1871, Fredeman, V.71.66.1.

12 Jan van Eyck's statue outside the Bruges Academy: FMB would
 have seen the 1820 statue of Jan van Eyck, not the grander statue
 to be seen today which was erected in 1878.

13 *Cromwell on his Farm* is at the Lady Lever Art Gallery, Port
 Sunlight.

13 *The Expulsion of the Danes from Manchester* is one of the murals at
 Manchester Town Hall.

13 Hôtel du Pot d'Etain/Hotel de Tinnen Pot is today a café called
 Spaghetti World.

13 FMB's student lodgings in Antwerp in 1838: for help with
 identifying all FMB's addresses in Antwerp and understanding
 how the street names and numbers have changed, I am grateful
 to Monique Morbé at the Stad Antwerpen Stadsarchief.

13 'very pretty small feet': Hueffer, pp. 16–17. The drawing of
 Daniel Casey is at Birmingham Museums & Art Gallery.

14 'he said he did not care': Eliza Coffin Brown (Lyly) to FMB, 16
 December 1839, Cornell, Ford Madox Ford Collection #4605,
 Box 49 Folder 107.

14 *Rubens' Ride*: he 'had in view a picture to be called *Rubens' Ride*
 (Rubens and some friends riding out for pleasure), for which he
 wished to study the polders and other details of Flemish scenery;
 the picture, after all, was not painted.' WMR *SR*, II, p. 432.

Chapter 2 – Elisabeth's notebook and *King Lear*

18 EBB's notebook is in the Angeli-Dennis Collection, 12–10,
 Rare Books and Special Collections, University of British
 Columbia Library.

22 'sufficiently handsome and accomplished': Hueffer, p. 27.

23 'arranged his burial': 22 November 1842, Paden.

24 'the only perfect picture': reviewer John Forster in the *Examiner*, 4 February 1838.

24 'only person present': Harriet Martineau, *Harriet Martineau's Autobiography*, 3 vols. (London, Smith, Elder, 1877), reprinted in 2 vols. (London, Virago, 1983) II, 119–20.

24 FMB's *King Lear* drawings made in Paris *c*.1844: most of these are at the Whitworth Art Gallery, Manchester, although some are at Birmingham Museums and Art Gallery.

25 'In this first one Cordelia is asked': *Exhibition*, p. 20; Bendiner, p. 147.

26 'Unhappy that I am': *King Lear*, I, i, 91–3.

26 'is biting his nails': *Exhibition*, p. 20; Bendiner, p. 147.

27 *Cordelia's Portion*, 1866–72, watercolour, 75 x 107.3 cm. National Museums Liverpool, Lady Lever Art Gallery. A later version in oils, 1875, is at Southampton Art Gallery.

27 'when honesty stiffened in pride': *Exhibition*, p. 6; Bendiner, p. 134.

28 'Found wildly running about': *Exhibition*, pp. 5–6; Bendiner, p. 134.

28 *Cordelia at the bedside of Lear*: *King Lear*, IV, vii.

28 'the fresco competition for the new Palace of Westminster': FMB entered designs of *Adam and Eve* and *The Body of Harold brought before William the Conqueror*.

28 'Everything in Madox Brown': Henry James, *The Painter's Eye* (Wisconsin: University of Wisconsin Press, 1989), pp. 249–50, 'Lord Leighton and Ford Madox Brown', 1897.

28 'Throughout all its phases': Hueffer, pp. 416–17.

29 'interwoven with Lear': the *Examiner*, 4 February 1838.

Chapter 3 – Out of town

33 'I have showed my coloured sketch': FMB to 'My Blessed Lizzy', ? December 1844, from Præraphaelite Diaries and Letters, p. 52.

33 'My dearest Lizz':, FMB to EBB, ? February 1845, from Præraphaelite Diaries and Letters, pp. 53–4. FMB's picture *The Banks and Braes of Bonny Doune* is currently unlocated.

34 'My blessed Wife': FMB to EBB, 6 May 1845, from Præraphaelite Diaries and Letters, pp. 55–7.

34 'he fell asleep at 11 p.m.': FMB to EBB, May ? 1845, from
 Præraphaelite Diaries and Letters, pp. 57–8.

34 'My own dear Lizzy, I am now in peace and quiet': FMB to
 EBB, 18? May 1845, from Præraphaelite Diaries and Letters, pp.
 59–60.

35 'really did initiate modern art': Ford Madox Hueffer (later
 Ford), *The Pre-Raphaelite Brotherhood* (London: Duckworth,
 1907), p. 21.

35 'Never can I forget': *Diary*, pp. 2–3, 4 September 1847.

Chapter 4 – Alas! My poor wife

37 'My Mother['s] loss was often felt by me': Lucy to WMR, 8
 April 1886, UBC, A-D 9–5.

38 Tuberculosis in the 1840s: for information about the disease in
 the nineteenth century, I am grateful for specialist advice from
 Dr Elspeth Macdonald.

38 'My heart for English faces sigh'd': all quotations from EBB's
 notebook, UBC, A-D 12 –10.

38 'by sea to Marseilles': memories of their last journey north from
 Rome to Paris were recorded by FMB in a letter to Henry
 Boddington, 25 March 1889, UBC, A-D 5–10.

38 'in Madox Brown's arms': Lucy Madox Rossetti, 'Ford Madox
 Brown', the *Magazine of Art*, XIII (1890), pp. 289–96, p. 291.

38 'the expensive outlay of transporting the coffin across the
 Channel': *Diary*, pp. 153–4, 15 September 1855.

39 'a private grave': EBB's monument in Highgate Cemetery still
 stands, next to the Rossetti family grave which was erected a
 few years later when Gabriele Rossetti died. It is only possible
 to visit these graves by special appointment.

40 'It is today 18 months since the death': *Diary*, p. 18, 5 December
 1847.

40 'He rescued the fuchsia': ibid., p. 22, 5 January 1848.

40 'O! dear, her [address] has been for upwards of 19 months': ibid.,
 p. 28, 1 February 1848.

41 'muddled and worked and muddled': ibid., p. 18, 9 December
 1847.

41 *Wycliffe reading his translation of the Bible to John of Gaunt*, 1847–8.
 The picture is now at Bradford Art Gallery.

Chapter 5 – A girl as loves me

45 'a girl as loves me': *Diary*, p. 58, 10 February 1849.

45 'Her exact birthday': WMR Diary, 16 May 1890.

47 Birth of EMB's daughter Cathy: details about the ancestry of the Hill and Madox Brown families from Paden.

47 'pink complexion, regular features': WMR *SR* I, p. 137.

49 'his friend on the spot': *DGRFLM*, I, p. 118.

50 'stamen by stamen': Robin Ironside and John Gere, *Pre-Raphaelite Painters* (London: Phaidon Press, 1948), p. 13.

50 'What they saw, that they would paint': William Michael Rossetti, *Fine Art, Chiefly Contemporary* (London: Macmillan, 1867), p. 171.

50 'no proper function in modern art': Theodore Watts-Dunton, *Old Familiar Faces* (London: Herbert Jenkins, 1916), p. 73.

50 'Holman Hunt vetoed the idea': Holman Hunt, *Pre-Raphaelitism and the Pre-Raphaelite Brotherhood*, 2 vols. (London: Macmillan, 1905), I, pp. 226–8.

50 'contributed to the *Germ*: FMB's etching of *Cordelia parting from her sisters* was placed at the opening of the *Germ*, Issue 3, March 1850; his essay 'On the Mechanism of a Historical Picture' appeared in Issue 2, February 1850; his sonnet 'The Love of Beauty' was in Issue 1, January 1850.

51 'rather old to play the fool': FMB to Holman Hunt, n.d., printed in Hunt, I, pp. 246–7.

51 'its end was marked': *DGRFLM*, I, p. 137.

Chapter 6 – Emma in the foreground

53 'to bring him to his knees': Hueffer, p. 61.

55 'painting room being on a level with the garden': *Diary*, p. 76, retrospective entry 16 August 1854, referring to summer 1851.

55 'in five months of Hard Labour': ibid., p. 74.

55 'discussion was very rife': *Exhibition*, p. 7, Bendiner, p. 135.

56 'almost entirely in sunlight': ibid., p. 76.

56 'divulged to him by Millais': the story about Millais divulging the secrets of Pre-Raphaelite technique to FMB is from Hunt, I, p. 278.

56 'This picture was painted out in the sunlight': *Exhibition*, p. 7, Bendiner, p. 135.

56 'Few people I trust will seek for any meaning': ibid.

57 'Woolner was cheered on from the quayside': Amy Woolner, *Thomas Woolner, RA Sculptor and Poet: His Life in Letters* (New York: E. P. Dutton & Company, 1917), p. 14. The voyage took just over three months. The digging was extremely arduous and Woolner returned to England a year later with not much gold but having had plenty of experience in Melbourne and Sydney in what was to become his speciality, portrait medallions.

57 'remained one year & nine months': *Diary*, p. 78, retrospective entry 16 August 1854, referring to summer 1853.

59 'chiefly out of doors when the snow was lieing [*sic*] on the ground': ibid., p. 80, retrospective entry 16 August 1854, referring to early 1853.

59 'To insure the peculiar look': *Exhibition, The Last of England* entry, p. 9; Bendiner, p. 137.

59 'the first painter in England': *Ancient Lights*, p. 2.

59 'This picture is in the strictest sense historical': *Exhibition, The Last of England* entry, p. 8; Bendiner, p. 136.

59 'from self in the looking glass': FMB is known to have used this method when working on *The Prisoner of Chillon* in 1856, *Diary*, p. 167, 16 and 18 March 1856.

60 'he visited Florence': FMB and EBB travelled to Rome via Florence in 1845, Hueffer, p. 40.

61 'The flying ribbons of Emma's bonnet': *Diary*, pp. 78–80, retrospective entry 16 August 1854.

61 'Absolutely without regard to the art of any period or country': *Exhibition, The Last of England* entry, p. 9; Bendiner, p. 137.

61 '*The Last of England*, as far as its rendering of the dramatic motive': Hueffer, p. 414.

61 £150 in 1855 is worth approximately £14,600 today, using the GDP deflator from www.measuringworth.com.

61 'command the highest prices in the art market': *Diary*, p. 153, 5 September 1855.

64 'a quiet Tuesday morning affair': until the Marriages (Hours of Solemnization) Act of 1886, weddings had to take place before noon.

64 DGR's *Study for Delia*: Virginia Surtees comments in her catalogue raisonné of *The Paintings and Drawings of Dante Gabriel Rossetti* (Oxford: The Clarendon Press, 1971) p. 24: 'According to Fairfax Murray the model was Mrs Ford Madox Brown, but there is little resemblance between this head and No. 272 [DGR's portrait of EMB, dated 1 May 1853].' However, as

discussed, there is a resemblance to the first of the two portraits of EMB by FMB on her wedding day, the one dated 5 April 1853.

67 'not like scent bought at shops': Soskice, p. 42.

67 'architect John Gandy': information from Paden.

67 'ceremony performed by the rector, Edward Auriol': from the Parish Register of St Dunstan-in-the-West (GL Ms 10354/8) with thanks to Stephen Freeth, Keeper of Manuscripts, Guildhall Library.

Chapter 7 – Special relationships: Emma, Madox Brown, Rossetti and Lizzie

69 'greenish-blue unsparkling eyes': *DGRFLM*, I, p. 171.

71 'All this while Rossetti was staying': *Diary*, p. 78, retrospective entry 16 August 1854.

71 1 Grove Villas, Church End, Finchley: this house no longer stands.

71 'wasted 2 weeks through Nervous dissorder [*sic*]': *Diary*, p. 80, retrospective entry 16 August 1854, referring to 1851–3.

71 'was I right? Custom says yes': ibid., pp. 86–7, 26 August 1854.

71 'After about 5 P.M.': ibid., p. 87, 30 August 1854.

71 'a mere brooklet running in most dainty sinuosity': ibid., p. 88, 1 September 1854.

72 'I ought to go & take Lucy a pounds worth': ibid., p. 91, 12 September 1854.

72 'not an aristocratic proceeding': ibid., p. 92, 17 September 1854.

72 'Emma strongly advised lazyness [*sic*]': ibid., pp. 96–7, 3 October 1854.

73 'fearful Idleness self abasement & disgust': ibid., p. 102, 14 October 1854.

73 'not seeming to notice any hints': ibid., p. 110, 17 December 1854.

73 'Emma found in her drawer 2 shillings': ibid., pp. 111–12, 24 December 1854.

73 Fourpenny pieces: a groat, also known as a Joey, was a silver fourpenny piece, struck in the early years of Victoria's reign. It also happened to be the standard fare for a short Hackney carriage ride in London.

73 'Have been casting up my accounts': *Diary*, p. 115, 10 January 1855.

74 'was certainly the closest of Lizzie's intimacies': HRA, p. 188.

74 'Sensing Rossetti's antipathy she would sideline him': *Diary*, p. 144, 15 July 1855.

74 'she is a silly pus [*sic*]': ibid., pp. 145–6, 21 and 27 July 1855.

74 'Lizzie and Emma Brown were both drunkards': from Helen Rossetti Angeli's unpublished typescript, 'Brief Account of Lizzie Siddal Rossetti', 1964–5, Fredeman Family Collection.

74 'all day about her extravagance': *Diary*, p. 139, 25 May 1855.

74 'raving & did not know me': ibid., p. 159, 22 December 1855.

75 'E.D.': e.g. ibid., pp. 207 and 214, 14 October 1865 and 15 March 1866.

75 'Emma went into town with Miss Siddal': ibid., p. 149, 16 August 1855.

75 13 Fortess Terrace: the house has been renamed 56 Fortess Road. A blue plaque commemorates FMB's period at the house.

75 'that there is in shame and degradation': *Diary*, p. 83, 18 August 1854.

75 'How little done Oh Lord': ibid., p. 133, 16 April 1855.

75 '*I* feel Haydonish': ibid., p. 136, 6 May 1855.

75 'determined to give her a dose of it': ibid., p. 142, 5 July 1855.

76 'When we got there he had forgotten': ibid., p. 154, 15 September 1855.

77 'He was anxious to keep Lucy out of the house': ibid., p. 162, Note 4 to entry for 27 January 1856. Private information cited by Virginia Surtees.

77 'Lucy's resentful adolescent presence': ibid., pp. 161 and 164, 3 January and 14 February 1856.

77 'that Emma sets Miss S. against him': ibid., p. 173, 15? May 1856.

77 'in a terrible rage with Emma': ibid., p. 175, 25 May 1856.

78 'Madox Brown was forced to rescue her by train': ibid., pp. 175–6, 22 June 1856.

78 'On coming home whom should we find': ibid., pp. 177–8, 10 July 1856.

78 'He is mad past care': ibid, pp. 182–3, 16 July 1856.

79 'Madox Brown began to draw Arthur Gabriel': ibid., pp. 187–8, 13–19 September 1856.

80 'went & laid out a lot of money for Emma & chicks': ibid., pp. 190–1, 27 and 30 September 1856.

80 'was due exactly £5 12s.1d.': ibid., p. 191, 9 October 1856.

80 '*Take Your Son, Sir!* which he never satisfactorily finished': ibid., p. 194, 16 March 1857.

80 'Jan van Eyck's famous picture': I am grateful to Carola Hicks for information about *The Arnolfini Marriage* in Britain.

80 'She is a stunner': *Diary*, p. 126, 10 March 1855.

81 'Miss Siddall has been here for 3 days': ibid., pp. 195–6, 16 March 1857.

81 'I also would excell!': FMB's Hogarth sonnets, General Manuscripts Bound, CO199, number 155, Princeton.

82 'very different from what could be seen in the ordinary picture-shows': *DGRFLM*, I, p. 200.

82 'poor little Arthur': *Diary*, pp. 198–9, retrospective entry 17 January 1858.

83 'brilliant and forcible': Frederic Shields' lecture quoted by Hueffer, pp. 145–7.

83 'Kid having appeared': William Morris to FMB, quoted by Fiona MacCarthy, *William Morris: A Life for our time* (London: Faber, 1994), p. 185.

83 'Lizzie left a suicide note': HRA, p. 197.

Chapter 8 – Dearest Emma as a mother

84 Catherine Emily Brown: more usually known as Cathy Madox Brown until she took the name Hueffer on her marriage in 1872 to Francis/Frank Hueffer (Franz Hüffer), German-born music critic of *The Times*.

84 'hot roll as she arrived with the hot rolls': details about EMB and FMB as parents, and Cathy's childhood are from two unpublished documents written by Cathy Madox Brown Hueffer for her grandson Frank Soskice, 'Jottings with a shaky pen', dated August 1922, private collection and 'A Retrospect' undated, House of Lords Record Office, Stow Hill Papers: STH/BH/2/3–6.

86 'that when she was a baby': Soskice, p. 42.

86 'Blow, blow thou winter wind': from FMB's list of favourite things, 2 October 1866, Pierpont Morgan Library, MA 4500.

87 'how proud and pleased I was at the confidence': Georgiana Burne-Jones, *Memorials of Edward Burne-Jones*, 2 vols. (London: Macmillan and Co. Ltd., 1904), I, pp. 179–80. Reprinted 1993, London: Lund Humphries.

Chapter 9 – Heydays

94 'From 10 March until 10 June 1865, he would stage an exhibition at Hamerton's Gallery at 191 Piccadilly': Philip Gilbert Hamerton to FMB, 15 December 1864. Hamerton asked for a whole year's rent for the gallery, coming to a total of £168, although it is possible that FMB negotiated a better price. This letter was offered for sale on the internet in 2008.

95 'I now reside [in Hampstead]': FMB to Lowes Dickinson from High Street, Hampstead, 17 October 1852, Lowes Cato Dickinson Correspondence CO152, Box 1 Folder 2, Princeton.

96 'the most ethereal and extatic [sic] state possible': *Diary*, p. 113, 3 January 1855.

96 'in a state of great despondency': ibid., p. 119, 28 January 1855.

96 'All day at the design of "Work"': ibid., p. 135, 29 April 1855.

96 'whose only business in life': *Exhibition*, p. 29; Bendiner, p. 153.

96 'by his manners and modesty': FMB described Gladstone's visit to George Rae, 18 March 1865, George Rae Papers, Coll. Lady Lever Art Gallery, loan to the Walker Art Gallery, National Museums Liverpool.

97 'The critics found it almost unprecedented': from *Fraser's Magazine*, LXXI (May 1865), pp. 598–607, reprinted in WMR's *Fine Art, Chiefly Contemporary* (London: Macmillan, 1867) pp. 178–202.

97 '£126 9s. 0d.': from FMB's housekeeping ledger book at the Walker Art Gallery, National Museums Liverpool, Inventory No. 10514.

97 'Entries in a housekeeping ledger book': ibid.

97 'By October 1866, he and the family moved': FMB played the parlour game of 'Favourite Things' on 2 October 1866 at Fitzroy Square, F. M. Brown papers, Pierpont Morgan Library, MA 4500; FMB to F. G. Stephens, 23 November 1866, sent from his new address 37 Fitzroy Square. Bodleian, Ms Don e.61.

98 'common gas burners': the interior of 37 Fitzroy Square as seen by diarist Jeannette Marshall, daughter of John Marshall, surgeon and friend of FMB, in Zuzanna Shonfield, *The Precariously Privileged: A Professional Family in Victorian London* (Oxford: Oxford University Press, 1987), p. 86.

98 'He had a burst of prosperity': Ford Madox Hueffer, 'Nice People', *Temple Bar*, November 1903, p. 573.

98 'the most wonderful people': *The Whistler Journal*, eds. E. R. and
 J. Pennell (Philadelphia: Lipincott, 1921), p. 170.

100 'Those were bright gatherings': Justin McCarthy, *Reminiscences*,
 2 vols. (London: Chatto & Windus, 1899), I, pp. 314–18.

100 'Jules Andrieu . . . probably introduced': Bornand, p. 195,
 WMR *Diary* entry 4 May 1872, and Bornand's note referring to
 the probable connection made by his French and Latin tutor,
 Jules Andrieu, between Oliver Madox Brown and the French
 poets Rimbaud and Verlaine in 1872. See also discussion in
 V. P. Underwood's *Verlaine et l'Angleterre* (Paris: Librairie Nizet,
 1956), p. 84.

100 'He hated all Academicians': Hueffer, 'Nice People', p. 572.

100 'much sought-after among the élite': McCarthy, I, pp. 314–18.

Chapter 10 – Greek goddess

106 'Aglaia's mother gave a Burne-Jones nude picture': Marie only
 sold the nude study with great regret when she was hard up in
 old age.

107 'Give me your tired, your poor': in 1903, a bronze plaque
 bearing Emma Lazarus' sonnet was placed on the inner wall of
 the Statue of Liberty's pedestal.

107 'over-worked, & over-dined': Emma Lazarus to Helena deKay
 Gilder, London, 30 May 1886, Bette Roth Young, *Emma
 Lazarus in her world: Life and Letters* (Philadelphia and Jerusalem:
 The Jewish Publication Society, 5755, 1995), pp. 151–2.

107 'works had converted her': Henry James to Alice James, July
 1882, quoted by R. W. B. Lewis, *The Jameses: A Family Narrative*
 (London: Andre Deutsch, 1991), pp. 341–2.

107 'I quite agree with you': Emma Lazarus to Helena deKay Gilder,
 London, 21 June 1886, Bette Roth Young, p. 149.

107 'depositing them at the feet of the Misses Spartali': W. Graham
 Robertson, *Time Was* (London: Hamish Hamilton, 1931)
 pp. 12–13, 95.

108 'was probably the most gifted intellectually': HRA, pp. 169–70.

109 'most intimate and the most beloved of all Lucy's female
 friends': WMR *SR*, II, p. 492.

109 'most cherished friends': ibid., p. 342.

109 'like entering a vault': Mario Praz, *The House of Life*, transl.
 Angus Davidson (London: Methuen, 1964), pp 232–3.

110 'Lord Ranelagh, who "was madly in love with her"': Diana

Holman-Hunt, *My Grandfather, His Wives and Loves* (London: Hamish Hamilton, 1969), pp. 271–2.

Chapter 11 – Art student

111 'My dear Brown': DGR to FMB, 29 April 1864, Fredeman, 64.58.

112 'the numbers for several years': FMB to Harry Quilter, 1 July 1886, Tate, 7027.3.

112 'I teach with the object of developing': FMB to the Principal of the Working Men's College, from 13 Fortess Terrace, n.d., Durham University Library with MSS in the Rare Books Department.

112 'We consider it is owing to you': letter from twenty-one students to FMB, 31 May 1853, Cornell, Violet Hunt Papers, 4607, Box 5 Folder 26.

113 'His aspiring soul chafed sorely': *DGRFLM*, I, p. 119.

114 Lucy Madox Brown, *The Dancing Faun*, signed in monogram and dated 'LMB 2/12/[18]69'. Black chalk on grey-green paper, 585 x 333 mm, private collection.

114 'any attempt to discard the living model': FMB to M. H. Spielmann, 8 October 1885, Manchester John Rylands Library, English MS 1290.

114 'At eight every morning': Cathy Madox Brown Hueffer, 'Mrs Francis Hueffer', *The Times*, 6 June 1927, p. 15. Peter Paul Marshall was one of the seven founder members of Morris, Marshall, Faulkner & Co., otherwise known as 'The Firm' run on William Morris' principles of domestic interior design. The other members were FMB, DGR, Burne-Jones, Charles Faulkner and Philip Webb.

Chapter 12 – Eros in the studio

117 'A Sonnet is a coin: its face reveals/The soul': from DGR's introductory sonnet to *The House of Life*.

118 'Hopeless Love – Sonnets by Ford Madox Brown': the exercise book containing FMB's sonnets to Marie is in the House of Lords Record Office, Stow Hill Papers STH/BH/2/3–6. Some of the poems, in the same or slightly alternative versions, are in General MS Bound, CO199 number 155, Princeton.

118 'Amor Incendiaris': FMB Sonnets, Sonnet 22 in the sequence but numbered 10.

119 'Be mine no doubtful theme': ibid., Sonnet 2, 'Late Love'.

119 'Voiceless Love': ibid., Sonnet 18 in the sequence but numbered 5. Princeton gives alternative title of 'Hopeless Love'.

119 'for my honour': ibid., Sonnet 21 in the sequence but numbered 9, 'Pleading Contraries'.

120 'that she my loved one sees my love I see': ibid.

120 'We met! no word disclosed what either thought': ibid., Sonnet 4, 'An Understanding' entitled 'Hopeless Love' in an alternative version in General MS Bound, CO199 number 155, Princeton.

121 'Of all the torments known beneath the sun': ibid., Sonnet 19 in the sequence but numbered 7, 'Cruelly Kind'.

121 'passionate glare': Sonnet 7, 'On a painting by Marie Spartali representing herself amid fields, sitting with a treatise of mathematics in her lap, & a laurel-crown on it'.

121 'glances fall': Sonnet 5, 'For a drawing by Marie Spartali/Love's Problem', dated 'Nov. 69', also reworked in Sonnet 6.

122 'Dear Swinburne': FMB to A. C. Swinburne, 12 January 1867, BL, Ashley B 1860 ff. 89–90b.

122 'a New England family of Seventh Day Baptists': I am grateful to David B. Elliott for details about the Spartali and Stillman family backgrounds in his book *A Pre-Raphaelite Marriage: The Lives and Works of Marie Spartali Stillman & William James Stillman* (Woodbridge: Antique Collectors' Club, 2006).

124 'just over five feet seven inches': Hueffer, p. 39 cites details from FMB's passport, issued at the Belgian Legation in London, when he was twenty-four, '*taille*, 1 m. 71 cm.'

125 ' "death's foot-fall" on his "hopeless love!" ': Sonnet 15, signed and dated 'FMB Sept – 69'.

125 'On a painting by Marie Spartali': three versions of the same sonnet on Marie's probable self-portrait, November 1869, are alternatively titled 'Love's Problem', 'For a Drawing by Marie Spartali: Love's Problem' and 'On a painting by Marie Spartali representing herself amid fields, sitting with a treatise of mathematics in her lap, & a laurel-crown on it'.

125 'grecian-like': FMB Sonnets, Sonnet 24 in the sequence but numbered 11, 'Mute Worship', December 1869.

125 'Sweet love of twenty years': ibid., Sonnet 8, 'To Emma', 7 December 1869.

126 'You either have no love for me at all': ibid., Sonnet 25 in the
 sequence but numbered 12, 'Idle Groans', 3 January 1870.
126 'My friend at midnight brought me word': ibid., Sonnet 9, 'To
 D.G.R. An end'.
126 'who only sees in me her truest friend': ibid., Sonnet 21 in the
 sequence but numbered 9, 'Pleading Contraries'.

Chapter 13 – The engagement

127 'An heiress with all London at her feet': Agresti, p. 41.
127 'Dear soul': WJS to Marie, March/April ? 1870, from Scalands,
 WJS 391, Schenectady.
128 'Your drawings': WJS to Marie, WJS 386, Schenectady.
129 '*The Romaunt*': WJS to Marie, WJS 386, Schenectady.
129 'Miss Spartali has a fine power': from 'Arthur Hughes – Windus
 – Miss Spartali – the younger Madox Browns' by WMR, in J. B.
 Atkinson, *English Painters* (London: Seeley, Jackson, 1871), p. 48.
129 'something very exquisite': Henry James, *The Painter's Eye*, ed.
 John L. Sweeney (Wisconsin: University of Wisconsin Press,
 1989), p. 92, first published in the *Galaxy*, July 1875.
129 'You want severe schooling': WJS to Marie, late 1869/early
 1870?, WJS 386, Schenectady.
131 'I am so broken hearted': Michael Spartali to FMB, 7 March
 1870, V&A, Box 21 MSL 1995/14/105/69.
131 'I regret the unwholesome adulation': Michael Spartali to FMB,
 12 March 1870, V&A, Box 21 MSL 1995/14/105/70.
132 'After you left I again thought the matter over': Euphrosyne
 Spartali to FMB, ? March 1870, V&A, Box 21 MSL
 1995/14/105/72.
132 'walks with me, talks with me': DGR to Barbara Leigh Smith
 Bodichon, 15 March 1870, Fredeman, 70.53.
132 'has actually come in for *the* Slice of luck': DGR to Charles Eliot
 Norton, 11 April 1870, Fredeman, 70.88.
133 'I cannot refrain from thanking you': WJS to FMB, 15 March
 1870, V&A, Box 21 MSL 1995/14/105/64.
133 'to violate her duty': WJS to FMB, 28 March 1870, V&A, Box
 21 MSL 1995/14/105/65.
134 'querulous account of Stillman's disappointed hopes': WJS to
 FMB, March? 1870, V&A, Box 21 MSL 1995/14/105/66.
134 'The whole affair "is very wearing on me"': WJS to FMB,
 March? 1870, V&A, Box 21 MSL 1995/14/105/67.

134 'Now that they have contrived': WJS to FMB, 12? March 1870, V&A, Box 21 MSL 1995/14/105/68.

135 'infinite thanks for your sympathy & help': Marie to FMB, postmarked MR 18 1870, V&A, Box 21 MSL 1995/14/105/1.

135 'dinner at the Madox Browns': Marie to FMB, postmarked 24 May 1870, V&A, Box 21 MSL 1995/14/105/2.

135 'I feel there is absolutely nothing to be done': Marie to FMB, spring 1870, V&A, Box 21 MSL 1995/14/105/5.

135 'If I don't come at 6 tomorrow': WJS to Marie, May/June? 1870, WJS 388, Schenectady.

136 'What a darling you were today': WJS to Marie, June? 1870, WJS 393, Schenectady.

137 'To feel good cause to shun you': FMB Sonnets, Sonnet 14, 'Change in Constancy', 4 July 1870.

137 'Could I have known': ibid., Sonnet 12 in the sequence but numbered 16, 'Angela Damnifera', signed and dated 'FMB August 1870'.

138 'You must not expect to see much': Marie to FMB, postmarked SP 15 1870, V&A, Box 21 MSL 1995/14/105/3.

139 'I too felt more sad than glad': Marie to Lucy, ? August 1870, UBC, A-D 7–5.

141 'We only heard last night that she was so much worse': Marie to FMB, ? 1870, V&A, Box 21 MSL 1995/14/105/6.

141 'My mistress this dark hour is on the sea': FMB labels this sonnet 'Poem 6' even though it appears towards the end of his exercise book. The Princeton version, Janet Camp Troxell Collection, CO189, Box 10 Folder 29 has this poem with some slight differences of punctuation. It seems to be in FMB's hand but is initialled 'FMB?' General MS Bound, CO199, number 155, Princeton, has this sonnet in the hand of FMB but initialled by DGR so maybe he edited it or advised on it. There are five drafts of this sonnet in this volume.

141 'Your remarks & letter': Marie's ambitious outline for a picture of Brunhild and Gunther does not appear to have been painted. I am grateful to David Elliott for his advice on Marie's design. Marie to FMB from Paris, Sunday, V&A, MSL 1995/14/105/7.

142 'a favourite Paris restaurant, Robinson's': this curious restaurant was well known in Paris. 'No one really knows the Parisians until he sees them in happy summer mood . . . lunching in one of the tree-top restaurants at Robinson.' E. V. Lucas, *A Wanderer in Paris* (London: Methuen, 1909), p. 317.

142 'I dare say you know the place well': Marie to FMB, ? 1870,
 V&A FMB Papers, Box 21 MSL 1995/14/105/7.
143 'the dreaded event': Michael Spartali to DGR, 22 February
 1871, UBC, A–D 4–1.

Chapter 14 – The impenetrable mystery

144 'The young bride went forth': Agresti, p. 41.
144 'he did not possess genius': WMR *SR*, 1, p. 267.
144 'one of the greatest painters now living anywhere': DGR to
 Louisa, Lady Ashburton, 8 June 1871, Fredeman 71.66.1. An
 early watercolour version of FMB's *Romeo and Juliet* (1867) is at
 the Whitworth Art Gallery, University of Manchester. DGR
 was referring to 'the passionate rapture & the anguish of
 separation' in both the watercolour and the recently finished oil
 version of 1870, now at the Delaware Art Museum.
145 'very excellent . . . like a tenderer kind of Hogarth': DGR to
 FMB, 1 October 1871, D&W 1175, Fredeman 71.158.
145 'No word – no tear – no wild embrace': FMB Sonnets, Sonnet
 14, unfinished 'Stanzas'.
145 'his soul's filaments would inexplicably extend towards Marie
 "through eternities"': ibid., Sonnet 21 in the sequence but
 numbered 9, 'Pleading Contraries'.
146 'O only kind in dreams! O lost lost love!': ibid., Sonnet 11 in
 the sequence but numbered 15, 'Dreams Alms', 16 April 1871.
146 'We got here all right some the worse': WJS to FMB,
 Christchurch, 11 April 1871, V&A, Box 21 MSL 1995/14/
 105/61.
146 'statue of the drowned Shelley': by Henry Weekes.
146 'I gave Marie a lecture': WJS to FMB, Christchurch, 11 April
 1871, V&A, Box 21 MSL 1995/14/105/61.
147 'Marie improves astonishingly': WJS and Marie to FMB, Isle of
 Wight, 19 April 1871, V&A, Box 21 MSL 1995/14/105/62.
148 'I wish you were coming in now': Edward Burne-Jones to
 Marie, *c.*1890, WJS 54 and WJS 53, Schenectady.
148 'to see the last (probably)': Bornand, p. 66.
149 'Her clustering hair': Byron, *Don Juan*, Canto II, stanzas 116–17.
149 'tall, but faint and pale, sinking back into the shades': Ford
 Madox Ford, *No More Parades*, 1925. This edition Penguin
 Books, 1948, p. 30.
150 'Russie's condition may have been caused by rheumatic heart

disease': I am very grateful to Dr Elspeth Macdonald for her speculative diagnosis.

150 'prove curable as far as the affection': Bornand, p. 113, 29 August 1871.

151 'The life here is not what it used to be': WJS to FMB, V&A, Box 21 MSL 1995/14/105/63.

151 'gave no sign of recognition': Bornand, p. 113, 29 August 1871.

151 'William Michael Rossetti also forecast a complete rift': ibid., p. 115, 15 October 1871.

152 'Awaiting the birth of her baby': ibid., p. 122, 2 November 1871.

152 'This all weighed heavily "upon poor Marie"': ibid., p. 138, 14 December 1871.

152 'relented so far as to have two interviews': ibid., p. 153, 24 January 1872.

152 'now looking well again, and cheerful': Bornand, 10 March 1872, p. 176.

152 'dropsy': The medical term 'dropsy' is now obsolete. The diagnosis referred to an abnormal collection of fluid in the chest, abdomen or skull. Untreated, it would be fatal.

153 'most exquisite artistic papers': Shonfield, *The Precariously Privileged*, p. 86.

153 'became so intolerably insolent': Marie to EMB, ? August 1872, V&A, Box 21 MSL 1995/14/105/8.

153 'very weak and ailing': Bornand, 27 January 1873, p. 233.

153 'the crayon portraits Dante Gabriel Rossetti had made': numbers 518 and 519, p. 197. Virginia Surtees, *The Paintings and Drawings of Dante Gabriel Rossetti, A Catalogue Raisonné* (Oxford: Clarendon Press, 1971).

153 'very good portrait': Bornand, p. 233, WMR Diary, Monday 27 January 1873. This is possibly the picture Marie exhibited at the Dudley Gallery, *Portrait of a Child*, dated 1872.

153 'I have never in any way or to any person disparaged Marie's art': WJS to FMB, postmarked 3 May 1870, V&A, Box 21 MSL 1995/14/105/60.

154 'he published it anonymously': 'An English Art Reformer: Ford Madox Brown', unsigned article by WJS, *Scribners Monthly*, Vol. 4, Issue 2, June 1872, pp. 157–61.

154 'I need scarcely tell you': FMB to Marie, 5 August 1873, WJS 36, Schenectady.

155 'be careful <u>not to get excited</u>': WJS to Marie, n.d., WJS 407, Schenectady.

155 'so anxious all the summer about Russie': Marie to FMB, 7 August 1873?, V&A, Box 21 MSL 1995/14/105/39.

156 'May I come on Thursday?' Marie to FMB, 1873?, V&A, Box 21 MSL 1995/14/105/25.

156 'Dear Mr Brown': Marie to FMB, 26 March 1873?, V&A, Box 21 MSL 1995/14/105/26.

156 'I rejoice in your happiness with all my heart': Marie to Lucy, 27 July 1873, UBC, A-D 7–5.

156 'because Emma got in one of her tantrums': FMB to Lucy, 28 May 1873, UBC, A-D 8–12.

156 'I am a mere baby': Oliver Madox Brown to Philip Bourke Marston, n.d. (1874?) but describing his final illness, Cornell, Ford Madox Ford Collection #4605, Box 50 Folder 46.

157 'Oliver's "imaginative nature was entirely against his recovery"': FMB reported Sir William Jenner's opinion to George Rae, 16 November 1874, George Rae Papers, Coll. Lady Lever Art Gallery, loan to Walker Art Gallery, National Museums Liverpool.

157 'pyæmia (blood poisoning with fever and abscesses)': WMR SR, II, p. 424.

157 'When they were going to bury his boy': Soskice, pp. 71–2.

158 'Yesterday we had an allarming [sic] day': FMB to DGR, 23 November 1874, UBC, A-D 2–4.

158 'always made her "very restless"': FMB to Lucy, 22 January 1885, UBC, A-D 5–6.

158 'What seemed likely to turn out the crowning reward': FMB to George Rae, 16 November 1874, George Rae Papers, Coll. Lady Lever Art Gallery, loan to Walker Art Gallery, National Museums Liverpool.

159 'I send you two photos': Marie to FMB, 27 May 1875 or 1876?, V&A, Box 21 MSL 1995/14/105/11.

159 'I see that perhaps she might be inclined': Marie to FMB, September 1875?, V&A, Box 21 MSL 1995/14/105/18.

159 'I have written to Miss Clayton': Marie to FMB, 25 September 1875, V&A, Box 21 MSL 1995/14/105/44.

160 'I can never remember whether it is the 10th or 11th March': WJS to Marie, 10 March 1876, WJS 402, Schenectady.

161 'Time only will tell': WJS to Marie, 9 August 1877, WJS 451, Schenectady.

161 'If at any time you should care to make a tracing': FMB to Marie, n.d., WJS 35, Schenectady.

161 'I should be glad to send you a tracing': Marie to FMB, 27 October 1878? V&A, Box 21 MSL 1995/14/105/36.

161 'so full of beauty and light': Marie to FMB, 5 August 1878?, V&A, Box 21 MSL 1995/14/105/34.

162 'he lectured there in December 1874': *Manchester Evening News*, 13 December 1874.

162 'the entire history': Alfred Waterhouse to FMB, 12 June 1877, quoted by Julian Treuherz – see below.

162 'at the centre of the modern, industrial world': for discussion of the murals see Julian Treuherz, 'Ford Madox Brown and the Manchester murals', Chapter 7 in *Art and Architecture in Victorian Manchester* (Manchester: Manchester University Press, 1985).

162 '"Manchester beginners" and "nobodies"': FMB to Frederic Shields, 19 December 1877, *Life and Letters of Frederic Shields*, ed. Ernestine Mills (London: Longmans, Green, 1912), p. 222.

162 'not pitched in a key popular enough for most of us': Charles Rowley to F. G. Stephens, 27 April 1877, Bodleian: Ms.Don.e.61.

163 'the intention was that the murals should be painted direct on to the walls': the first seven murals were indeed painted direct on to the walls using the method invented by Thomas Gambier Parry. As FMB aged, he preferred to work in his studio, in oil on canvas. The last five murals were painted in this way and subsequently glued into place on the panels in Manchester Town Hall.

163 'Secondly, the fee agreed, at £275': WMR Diary, 12 January 1883.

163 'The one I have begun by': [but second in the series], *The Baptism of Edwin*, 1878–80, mural at Manchester Town Hall.

163 'As I have gas of my own': FMB to Marie, 30 April 1879, WJS 37, Schenectady.

163 'A housekeeping ledger book': is at the Walker Art Gallery, National Museums Liverpool, Inventory No. 10514.

164 'Old Charlotte': description of her character drawn from 'Old Charlotte', unpublished notes on Charlotte Kirby, servant, cook and general domestic help in the Madox Brown household for over thirty years, by Helen Rossetti Angeli, from the Fredeman Family Collection.

164 'to dispose of them': FMB to Lucy, 7 January 1878, UBC, A–D 8–12.

164 'I have now had two attacks of gout': FMB to Marie, 30 April 1879, WJS 37, Schenectady.

164 'It has always been my custom to destroy <u>all</u> letters': Marie to Cathy Madox Brown Hueffer, 15 January 1895, V&A, Box 21 MSL 1995/14/105/10.

164 'I am very sorry to have you a victim': WJS to Marie, 27 June 1878?, WJS 486, Schenectady.

165 'distracting neuralgia': Marie to FMB, 17 October 1884, V&A, Box 21 MSL 1995/14/105/23.

165 'The Official Receiver said': summary statement of Spartali's affairs, reported in *The Times*, 18 February 1885.

165 'so changed and frail looking': Marie to FMB, 8 December 1884, V&A, Box 21 MSL 1995/14/105/24.

165 'Did you hear': FMB to Frederic Shields, 8 December 1884, UBC, A-D 5–2.

165 £600,000 in 1884 would be worth over £60 million today, using the GDP deflator from www.measuringworth.com.

165 'by your thinking so kindly of us when you heard of my father's failure': Marie to FMB, 8 December 1884, V&A, Box 21 MSL 1995/14/105/24.

Chapter 15 – A radical education

169 'I shouldn't choose her if I sinned!': in DGR's letter to FMB, 29 June 1871, Fredeman, 71.79

169 'her first book of poetry': Mathilde Blind, *Poems by Claude Lake* (London: Alfred W. Bennett, 1867).

170 'possessed the beauty': details from Garnett's *Memoir*, Blind, p. 2.

170 Details about the Cohen family from the Cohen *Familienbogen* in Mannheim City Archives.

170 '*partikulier*': I am grateful to Karen Strobel of the Mannheim City Archives for interpreting this information for me; 'a retired banker of independent means': Garnett's *Memoir*, Blind, p. 2.

171 'Karl Blind, a Protestant working-class radical': the Blind family were Mannheim Protestants. Karl was their second son, their first born in wedlock, on 4 September 1826. Johann Blind, his father, was then an unskilled labourer, who later described himself as a merchant; Karl's mother, Magdalena Nicolaus, had been a domestic servant before marriage. Details about Karl Blind's religious and social background from the Blind *Familienbogen* in Mannheim City Archives.

171 'Jacob Cohen's money': information from *Revolution im Südwesten* (Karlsruhe: INFO Verl.-Ges., 1997).

171 'A hot sun shone': Karl Blind, 'In Years of Storm and Stress', *Cornhill Magazine*, New Series V (September 1898), p. 341.

171 'Their purpose was to disseminate': details of Karl Blind's revolutionary career in Germany can be found in his 'In Years of Storm and Stress', *Cornhill Magazine*, New Series V (September 1898), pp. 340–2 and '1848–1849', VIII (June 1900), pp. 788–813.

171 'a revolutionary spirit was already vaguely abroad': ibid., p. 351.

172 'the Blinds' two children': information about the births of Rudolf and Ottilie Blind, later Ottilie Hancock, from the England Census returns for 1861, 1881 and 1891.

172 'visited the Great Exhibition': the Blinds' visit to the Great Exhibition noted by Karl Marx to Friedrich Engels, 13 October 1851, Marx-Engels Correspondence, *MECW*, Vol. 38, p. 472.

172 'Marx persisted in calling Friederike "Madame Cohen"': ibid.

172 'I still remember sitting on the window sill': from Mathilde's typescript of autobiographical fragments, BL: Add. 61930, ff. 1–35.

172 'an ambitious four-page poem': handwritten document by Mathilde, 'Birthday Verses. To my dear mother on her birthday', Ghistelles, 15 August 1852, BL: Add. 40124, f. 14.

173 Ibid. I am grateful to Ulrike Hill for translation and comments on Mathilde's poem.

173 'After leaving the Brussels boarding school': In 1842–3 Charlotte Brontë taught English at Constantin Heger's school in Brussels. If Charlotte had arrived in Brussels ten years later, it's tempting to imagine she could have taught Mathilde.

173 'wide reading and deep thinking': Garnett's *Memoir*, Blind, pp. 3–4.

173 'so-called Educational Establishment for Young Ladies': Mathilde writing from FMB's house, 1 St Edmund's Terrace, to the editor of a dictionary of English literature in response to a request for personal information, 2 January 1890, BL: Add. 61930, ff. 95–6.

173 'Hebrew, harmony and the use of the Globes': Mathilde's typescript of her fictionalised autobiography, BL: Add. 61930, ff. 1–35. All details of her school life in England and her Alpine journey in 1860 are from this document.

173 *The Light of the World:* Judith Bronkhurst, *William Holman Hunt: A Catalogue Raisonné*, 2 vols. (New Haven and London: Yale University Press, 2006), I, pp. 150–4.

174 'Alma': Lord Raglan's decisive allied victory at Alma, the first battle of the Crimean War on 20 September 1854, made the name instantly fashionable in Britain.

174 'the persons introduced are undoubtedly real': Garnett's *Memoir*, Blind, p. 3.

174 ' "fell violently in love" with "Amy Carlton"': ibid. p. 4.

176 'Professor Kuno Fischer': Mathilde's obituary in *The Times*, 28 November 1896, names her teacher in Zurich as Professor Schweitzer.

177 'one summer dawn': this date corroborated by a list Mathilde made of her annual holidays 1860–83. BL: Add. 61930, f. 90.

179 'exquisite day, hedges all gold rubies and emeralds': *Diary*, p. 102, 13 October 1854.

179 'attempt at out-door effect of light': *Exhibition*, p. 18, Bendiner, p. 145.

181 'in exile in England': information from Karl Blind's obituary in *The Times*, 1 June 1907, p. 14.

181 ' "Political & Scientific Publisher" or "Author General Literature" ': from the England Census returns for 1871 and 1881.

181 'assiduous ant-like industriousness': Karl Marx to the editor of the Stuttgart *Beobachter*, a daily newspaper, written 28 November 1864, first published in the *Nordstern*, number 287, 10 December 1864.

182 'as many little dodges up his sleeve': Karl Marx to Friedrich Engels, 1 July 1861, Marx-Engels Correspondence, *MECW*, Vol. 41, p. 300.

182 'Isn't that "naice"?': Karl Marx to Friedrich Engels, 9 April 1863, Marx-Engels Correspondence, *MECW*, Vol. 41, p. 466.

182 'fabricating letters, circulars': Karl Marx to the editor of the Stuttgart *Beobachter*, written 28 November 1864, first published in the *Nordstern*, number 287, 10 December 1864.

182 '2, later 3 Winchester Road': this area of London, now known as Swiss Cottage, between Hampstead and St John's Wood, takes its name from a pub built in 1840 on the Finchley Road, next to a tollgate.

182 'their host nation "where freedom of thought" was paramount': Louis Blanc, *Letters on England*, 2 vols. (London: Sampson Low & Co., 1866), I, p. 53.

182 'Karl Blind never took British nationality': Karl Blind describes himself as a 'German subject' in the 1901 Census.

182 'Mathilde possessed beauty': Moncure Daniel Conway, *Autobiography*, 2 vols. (London: Cassell, 1904), II, p. 62.

182 'if only she had been able to write in her first language': ibid.

183 'serving on the Schiller centenary committee in 1859 and on the *Athenæum*'s Shakespeare committee': Rosemary Ashton, *Little Germany: Exile and Asylum in Victorian England* (Oxford: Oxford University Press, 1986), p. 171.

183 'extreme beauty and fire': *Ancient Lights*, p. 51.

183 'Mathilde as a rule talked and I listened': all details from Kate's account of Mathilde from 'My Recollections of Mathilde Blind', a handwritten document by Kate Freiligrath Kroeker, dated September 1899, BL: Add. 61930.

183 'as a bright and particular star': 'One bright particular star', from Shakespeare, *All's Well that Ends Well*.

183 'German *Liederkranz*': I am grateful to Marion Davies for glossing *Liederkranz* for me.

184 'a jolly little red republican': William Bell Scott to Alice Boyd, n.d., 1869, UBC, N&W, p. 147.

184 'As Ferdinand wandered through the blooming fields of Germany': Ferdinand Cohen Blind to a friend in Germany, 1866, translated by Moncure Daniel Conway in his *Autobiography*, 2 vols. (London: Cassell, 1904), II, p. 61.

184 'Moncure Conway . . . at Mathilde's [funeral]': BL: Ashley. B4140, f. 47.

184 'young Blind had sacrificed himself': ibid.

184 'combined beauty, dignity, and sorrow': Garnett's *Memoir*, Blind, pp. 22–3.

185 'I love your letters and I think of you a lot': Friederike Blind to Mathilde, 29 October 1866, BL: Add. 69127.

185 Mazzini: most details about Mathilde's intellectual relationship with Mazzini are from her 'Recollections of Mazzini', *Fortnightly Review* (ed. Frank Harris), XLIX, 1 January–1 June 1891 (London: Chapman and Hall; New York: Leonard Scott Publication Company, 1891), pp. 704–12.

185 'The delight of Mazzini in her society': Conway, *Autobiography*, II, p. 62.

186 'with the same greediness with which a flower drinks in the rain': Garnett's *Memoir*, Blind, pp. 15–17.

186 'she was disposed to devote her life': Charles Rowley, *Fifty Years of Work without Wages* (London: Hodder and Stoughton, 2nd edition, n.d. but *c.*1912), pp. 108–9.

186 'distinguished guests at Madox Brown's glittering parties': Hueffer, p. 241.

Chapter 16 – We are not in Arcadia

188 'Admit both ladies 18 May 1859': BL: Add. 48340, ff. 223–4.

188 'Mathilde was then living on modest funds': from a German bank statement, showing the account balanced satisfactorily, still in the name of Fraulein Mathilde Cohen, 31 December 1862, BL: Add. 61930, ff. 86–7.

188 'This is all I have to say in the capacity of Devil's Advocate': Richard Garnett to Mathilde, 18 May 1869, BL: Add. 69127, ff. 28–30.

188 'marvellous psychological insight': 'Maud Blind' to Richard Garnett, 15 May 1869, BL: Add. 69127, f. 25.

188 'My only real intense life': 'Maud Blind' to Richard Garnett, 2 July 1869, BL: Add. 69127, ff. 34–5.

188 'They discussed De Quincey': notes by Richard Garnett, 1869–70?, BL: Add. 69127, ff. 40–1.

189 'Can man be free if woman be a slave?': Mathilde Blind, *Shelley. A Lecture* (London: Taylor & Co., 1870), p. 8.

189 'a thousand times better': Richard Garnett to Mathilde, quoting letter from Lady Jane Shelley, 29 January 1870, BL: Add. 69127, ff. 47–8.

189 'just as if somebody accosted me': Mathilde to Richard Garnett, postmarked 10 February 1870, BL: Add. 69127, ff. 49–50.

189 'Your genius and perseverance shall triumph': Richard Garnett to Mathilde, 21 February 1870, BL: Add. 69127, ff. 55–6.

189 'my regard for you is not in the least dependent': Richard Garnett to Mathilde, 18 April 1870, BL: Add. 69127, ff. 70–1.

189 'burning to hear all about it': Mathilde to Richard Garnett, 2 May 1870, BL: Add: 69127, ff. 72–3.

189 'Adieu, dear Mathilde': Richard Garnett to Mathilde, 1870?, BL: Add. 69127, ff. 77–8.

190 'He appealed to Mathilde': Richard Garnett to Mathilde, 13 June 1870, BL: Add. 69127, ff. 82–3.

190 'the war would "weld Germany into a nation"': Richard Garnett to Mathilde, 19 July 1870, BL: Add. 69127, ff. 85–6.

190 'I am also writing to my friends at Berlin': Richard Garnett to Mathilde, 23 July 1870, BL: Add. 69127, ff. 87–91.

190 'just criticised rather severely in the *Westminster Review*':
 Mathilde Blind, 'Shelley', *Westminster Review*, New Series
 LXXV (July 1870), pp. 75–97.

190 'favourite Miss Blind': DGR in a comment to his mother,
 Frances Mary Lavinia Rossetti, 11 August 1871, D&W1149,
 Fredeman 71.120.

190 'I had another delightful letter from Mr Rossetti': Mathilde to
 Richard Garnett, 26 July 1870, BL: Add. 69127, ff. 92–5.

191 'matters at home': ibid.

191 'For what with the troubles here': ibid.

191 'You may be sure, dear Mathilde': Richard Garnett to Mathilde,
 3 August 1870, BL: Add. 69127, ff. 97–100.

192 'We have proved, I believe, what some doubt': Richard Garnett
 to Mathilde, 5 September 1870, BL: Add. 69127, ff. 104–5.

192 'You shall want for nothing': ibid.

192 '[William] Morris was there and quite *en famille*': Mathilde to
 Richard Garnett, 2 September 1870, BL: Add. 69127, ff. 101–2.

192 'lamenting that everyone was somewhere else': FMB to
 Frederic Shields, 26 July 1871, Hueffer, p. 267.

193 'Shelley, "whose radiant light beckons"': Mathilde Blind,
 'Shelley', p. 97.

193 'My dear friend, I hasten to let you know': Mathilde to Richard
 Garnett, 22 July 1871, BL: Add. 69127, ff. 124–6.

193 'I am going to draw [Mary Blackmore]': FMB to Frederic
 Shields, 26 July 1871, Hueffer, p. 267.

193 'Mathilde thought he had "half promised"': Mathilde to
 Richard Garnett, 22 July 1871, BL: Add. 69127, ff. 121–3.

194 'the most momentous of all our modern ideas': Mathilde Blind,
 'Shelley', p. 88.

195 'Dear Mathilde, I have been dreaming about you': Richard
 Garnett to Mathilde, 22 July 1871, BL: Add. 69127, ff. 121–3.

195 'I have myself a little Spring song': Richard Garnett to Mathilde,
 28 February 1872, BL: Add. 69127, ff. 146–7.

195 'You are doing what George Eliot commenced': Richard
 Garnett to Mathilde, 21 January 1873, BL: Add. 69127, ff.
 173–4.

195 'fine, animated, speaking countenance': WMR *SR*, II, p. 388.

195 Lucy's portrait of Mathilde hangs today at Newnham College,
 Cambridge, devoted to women's education, the cause
 championed by both Mathilde and Lucy.

197 'consuming hot meals and hot potions': HRA, p. 50.

197 'spasmodic bronchitis or incipient asthma': WMR Diary, 13
 April 1877.

198 'the intimacy of Mathilde Blind in Brown's house': ibid., 15
 January 1891.

198 'Mathilde confessed that as a child': ibid., 25 January 1880.

Chapter 17 – The lost somnambulist of love

199 'the shoulders rather narrow': WMR Diary, 10 December 1876.
 Did he mean that Mathilde's shoulders were indeed broader
 than they appear in her slightly vulnerable pose? Or did he mean
 that the artist had got them out of proportion with the rest of
 the figure?

200 'inability naturally to command our idiom': Charles Rowley,
 Fifty Years of Work without Wages, p. 108.

200 'Do you know that sweet Willi, Miss Blind?': DGR to FMB, 29
 June 1871, Fredeman, 71.79.

201 'The Song of the Willi': The 'Willi' were legendary sprites who
 became part of popular culture after the première of the ballet
 Giselle in Paris in 1841, followed by performances across Europe
 and America. In Scandinavian and Eastern European folklore,
 the Willi were spirits of young girls who died of a broken heart
 before their wedding day. They broke out of their graves to
 revenge themselves on men, by luring them to death through
 compulsive dancing.

201 'All her yearnings were for more light': Rowley's comment
 probably refers to Goethe's famous last words, '*Mehr Licht.*'

201 'blighted by a Teutonic pessimism': Rowley, *Fifty Years of Work
 without Wages*, pp. 108–9.

201 'You ought to come some day': Mathilde to Richard Garnett,
 14 February 1877, BL: Add. 61928, ff. 90–1.

201 'Madame Roland': Mathilde Blind, *Madame Roland* (London:
 W. H. Allen, 1886).

202 'the most masked of all the portraits of Mathilde': although the
 photograph was published opposite the title page of Arthur
 Symons' posthumous *Selection* of Mathilde's poems in 1897, it
 obviously dates from Mathilde's mid to late thirties.

202 'I dare not call thee lover': 'Love in Exile' VII, Blind, p. 301.

202 'Winding all my life about about thee': 'Love in Exile' II, Blind,
 p. 296.

202 'filtered second-hand, via Mathilde': WMR Diary, 12 June 1877.

202	'self-assertive, high-minded, and altogether formidable': HRA, p. 49.
202	'more romantic than those of mere friendship': ibid., pp. 49–50.
203	'was practically her home': FMB to F. G. Stephens, 29 July 1878, Bodleian: Ms.Don e. 61.
203	'There was also an inquest here': FMB to Hipkins, 4 August 1878, private collection.
204	'she was careful to stay at a boarding house': WMR to Lucy, 4 August 1878, UBC, A-D 7–8.
204	'as I can't summon up energy': Mathilde to Richard Garnett, 6 August 1878, BL: Add. 61928, ff. 111–12.
204	'might also soothe Madox Brown's aching gout': WMR Diary, 11 August 1878, 'B. again somewhat troubled with gout. As Mathilde will on W. be going to Matlock Bath for health's sake, & the Hueffers propose to accompany her, B. & Emma also mean to do down; they wd. return by themselves at the end of a week.'
204	'"old" Matlock Bath': today 'new' Matlock Bath down below the old resort is a centre for motorbikers, quite separate from the gentility of 'old' Matlock Bath where Mathilde and the Madox Browns stayed.
204	'Mathilde much improved in health': WMR Diary, 11 September 1878.
204	'Oscar Clayton . . . said to have cured the Prince of Wales' gout': ibid., 15 September 1878.
204	'Reflect how very much better': Richard Garnett to Mathilde at 43 York Road, Tunbridge Wells, n.d., but postmarked SP 22 78, BL: Add. 61928, ff. 119–20.
205	'the stoneless man': Diary, 13 July 1855, p. 144.
205	'lazy as to sightseeing': FMB to DGR, 6 May 1874, UBC, A-D 2–4.
205	'William "has such very unconventional notions"': FMB to Lucy, 16 January 1881, UBC, A-D 8–12.
206	'of transcendent intellect': ibid.
206	'Have you ever spoken to Gabriel about her work?' FMB to Lucy, 21 February 1881, UBC, A-D 8–12.
207	'a terribly morbid state': FMB to Lucy, 28 February 1881, UBC, A-D 8–12.
207	'By the early 1880s, it was hard enough to receive calls': WMR's note explaining his brother's stand on Mathilde, appended to letter above.

207 'it elicited less of hearty panegyric': WMR's note on the correspondence between FMB and DGR about the screen incident.

207 'My dear Gabriel': FMB to DGR, 21 March 1881, UBC A–D 2–4.

207 'He was not entirely mollified by Madox Brown's "bristling" apology': DGR to Theodore Watts-Dunton, 21 March 1881, D&W 2438, Fredeman, 81.128.

208 'There is a chance of her novel being taken': FMB to Lucy, 12 August 1881, UBC, A–D 8–12.

208 'Poor Mathilde! I feel as if I should never see her in sound health again': FMB to Lucy, 13 September 1881, UBC, A–D 8–12.

209 'The subject had been in Mathilde's mind since 1872': Bornand, 15 December 1872, p. 219.

209 'prophesied that the book was bound to make its mark': *Pall Mall Gazette*, 5 February 1885 and *Whitehall Review*, 11 December 1884.

209 'They praised it for its powerful emotions': the *Athenæum*, 17 January 1885, p. 84 & other reviews from the *Bookseller*, the *Echo*, *Life*, *British Quarterly*, *London Figaro*, *Dublin Mail*, *Melbourne Argus*, *Scottish News* and the *Western Daily Press*.

210 'Mina is the epitome of virginal innocence': Mathilde Blind, *Tarantella*, 2 vols. (London: T. Fisher Unwin, 1885), I, p. 147.

210 'Costly old laces and richly embroidered scarfs': ibid., I, p. 38.

210 'an allegory of love': ibid., I, p. 81.

210 'they only met themselves': ibid., I, p. 148.

210 'Violinist and dancer both fell into "death-like" swoons': ibid., I, p. 172.

211 'vanished as if into the elements': ibid., I, p. 196.

211 'she secretly left Rome': ibid., II, p. 28.

211 'slowly swaying herself to and fro': ibid., I, p. 32.

211 'all the sorceries of love': ibid., II, p. 48.

212 'twined and clinging': ibid., II, p. 215.

212 'She stood by his bedside without a head': ibid., II, p. 229.

212 'Brava, bravissima! Your romance is splendid': Lily Wolfsohn to Mathilde, 11 December 1884, BL: Add. 61928, ff. 189–90.

Chapter 18 – Manchester frescoes and revolutionary heroines

213 'a variety of lodging houses': their Manchester lodgings included addresses in Grafton Street, Marshall Place, Cheetham Hill.

213 'She tried to keep to it "in a rather peculiar way"': FMB to Lucy from 29 Marshall Place, Cheetham Hill, Manchester, 24 August 1880, UBC, A–D 8–12.

213 'Mathilde moved out to nearby lodgings': Mathilde's addresses in Manchester included York Place, 147 York Row and/or 147 York Street, Cheetham Hill. None of these houses still stand.

213 'Manchester the capitalist "icon of a new age"': Tristram Hunt, 'Manufacturing Culture: The 1857 Art Treasures Exhibition in Historical Context' in *Art Treasures in Manchester: 150 years on* by Tristram Hunt and Victoria Whitfield (Manchester Art Gallery/Philip Wilson Publishers, 2007), p. 41.

214 Sir Jacob Behrens: curiously, his wife was Dorothea Hohenemser, the same name as the Mannheim bankers from whom Mathilde's father, Jacob Cohen, rented his apartment in the Kaufhaus in 1838. So the connection to the Behrens family in Manchester may have been made by Mathilde.

214 'on "affectionate terms" with the Behrens family': FMB to Frederic Shields, 22 May 1887, Getty: Accession 870093–2 ID 87–AA5, Ford Madox Brown Letters 1886–1891.

214 'Calais Cottage, 33 Cleveland Road': Calais Cottage no longer stands.

215 'the Gambier Parry method': rejecting the waterglass method of Belgian fresco painting he had seen on his recent visit to Antwerp, FMB eventually chose a method perfected by Thomas Gambier Parry for Highnam Church, just outside Gloucester. Mixing the pigments with copal varnish, wax and gum elemi, he achieved the shine-free finish he wanted. It was resistant to Manchester damp and had the advantage of being retouchable like oils. The first seven murals were all painted by this method but it was so labour-intensive that FMB abandoned it and painted the last five in oils on canvases which were then fixed to the walls.

215 'had been in his mind for "near 30 years"': FMB to F. G. Stephens, from Calais Cottage, Crumpsall, Monday, n.d., but *c.* September 1881, Bodleian, Ms. Don.e.61.

216 'It made him think of Chaucer's opening lines': ibid.

216 '[Emma read] George Eliot's *Middlemarch* and Tolstoy's *War and Peace*': FMB to Lucy, 23 November 1888, UBC, A–D 5–7.

216 ' "cold & boisterous" north of England': FMB to F. G. Stephens, 31 January 1882, Bodleian, Ms. Don.e.61.

216 'I had known him, without even a break': FMB to Theodore
 Watts-Dunton, 10? April 1882, BL: Add. 70627, ff. 17–22.

216 '10 a.m. to 10 p.m. & 7 days per week': FMB to F. G. Stephens,
 1 June 1879, Bodleian, Ms. Don.e.61.

217 'little tiff': WMR Diary, 12 September 1882.

217 'a striking figure as she sat like a Sibyl': Garnett's *Memoir*, Blind,
 p. 32.

217 *Crabtree and the Transit of Venus*: William Crabtree was a
 seventeenth-century astronomer who, on 24 November 1639,
 jointly with Jeremiah Horrocks, was the first to observe and
 describe the rare phenomenon of the transit of Venus across the
 face of the Sun.

217 'the breach was still not repaired': WMR Diary, 12 September
 1882.

217 'Stiff and unyielding': ibid., 5 October 1882.

218 'long, painful, and exhausting illness': ibid., 6 January 1883.

218 'Mathilde works in her lodgings': FMB to Lucy, 1 February
 1883, UBC, A-D 8–13.

218 'buried in the same grave at Highgate': information about the
 grave from WMR Diary, 15 April 1883.

218 'mostly in bed, at Caroline House': FMB to Theodore Watts-
 Dunton, 19 February 1883 from Caroline House, Hampstead.
 Brotherton Library, Leeds University.

218 'This time, Mathilde was at his side': this domestic arrangement
 at The Mount lasted from 21 February to 17 March 1883,
 according to WMR Diary.

219 'an internal fistula': WMR Diary, 20 March 1883.

219 'You will understand no doubt that I refer to the unfortunate
 difference': FMB to Lucy, 4 April 1883, UBC, A-D 8–13 and
 WMR Diary, 6 April 1883.

220 'not in the most cordial of moods': WMR Diary, 6 April 1883.

220 'All right about asking Mathilde to dinner': FMB to Lucy, 12
 April 1883, UBC, A-D 8–13.

220 'all passed off satisfactorily': WMR Diary, 18 April 1883.

220 'You are quite mistaken': FMB to Lucy, 15 April 1883, UBC,
 A-D 8–13.

221 'the house in Addison Terrace': now Addison Terrace Flats,
 102 Daisy Bank Road, with a garden at the rear, the third
 house from the left, opposite Daisy Bank Hall of Residence,
 Manchester University. There is a blue plaque on the house
 which reads: 'Charles Hallé 1819–1895 Musician and

Conductor/ Ford Madox Brown 1821–1893 Pre-Raphaelite Artist lived here.'

221 'It had been the home of the great conductor': Charles Rigby, *Sir Charles Hallé* (Manchester: The Dolphin Press, 1952), pp. 72–3 and *The Life and Letters of Sir Charles Hallé*, eds. Charles Emile Hallé and Marie Hallé (London: Smith, Elder & Co., 1896).

221 'eight huge figures twelve feet high, "all in oil & gold"': FMB to M. H. Spielmann, 12 February 1887, John Rylands Library, Manchester, English MS 1290.

221 'I hope it will be all right meeting all together': FMB to Lucy, summer? 1883, UBC, A-D 8–13.

221 'again staying with the Browns in their new house': WMR Diary, 13 October 1883.

222 'Mathilde's was the first biography of the great novelist': Mathilde Blind, *George Eliot* (London: W. H. Allen, 1883), Prefatory Note.

222 'the courage of their sex': ibid., p. 1.

222 'Bertha Thomas, who may have secured it through her friend, Vernon Lee': WMR Diary, 17 March 1882.

222 'more than a biography of Madame Roland': 'Le Livre', 10 August 1886, quoted by FMB to M. H. Spielmann 18 August 1886, John Rylands Library, Manchester, English MS 1290.

222 'a present of gold rings': FMB to Lucy, 2 February 1884, UBC, A-D 8–14.

222 'Mathilde is going to Arran': FMB to Lucy, 6 August 1884, UBC, A-D 8–14.

223 'to make way for sporting grounds rented by merchant princes': Blind, p. 91.

223 'She was full of fire in all causes of freedom': Rowley, *Fifty Years of Work without Wages*, p. 108.

223 'The work "was produced almost entirely in our house"': FMB to M. H. Spielmann, 13 April 1886, John Rylands Library, Manchester, English MS 1290.

223 'morbidly suggestible': FMB to M. H. Spielmann, 22 April 1886, John Rylands Library, Manchester, English MS 1290.

223 'one of the most noticeable and moving poems': *Athenæum*, 17 July 1886.

223 'Miss Blind does not possess her theme': *Manchester Examiner and Times*, 1 September 1886.

224 'O'er this huge town, rife with intestine wars': from Mathilde's sonnet 'Manchester by Night'.

224 'turned her drawing room into a soup kitchen': Soskice, p. 43.

224 'in the newspapers': C. P. Scott refers to FMB's name being inadvertently omitted from his letter to the (*Manchester Weekly?*) *Times* or the (*Manchester Examiner and?*) *Times* on 14 February 1887. V&A, Box 19 MSL 1995/14/96/17. C. P. Scott commissioned FMB to paint a portrait of his daughter, Madeline Scott, on a tricycle in 1883. Manchester City Art Galleries.

224 Rienzi: he was made famous in the nineteenth century, first by Bulwer Lytton's novel, *Rienzi, The Last of the Tribunes* (1835), then by the Pre-Raphaelites who included his name in their 'List of Immortals' in 1848, and by Holman Hunt, one of their founders, who painted *Rienzi Vowing to obtain Justice* (1848–9).

224 'the Rienzi of the Manchester Unemployed': FMB to M. H. Spielmann, 9 May 1886, private note about Joseph Waddington at end of letter, John Rylands Library, Manchester, English MS 1290.

224 'the question of labour & the unemployed': ibid., 13 May 1886.

225 Manchester's Pomona Gardens: later the site of Pomona Docks on the Manchester Ship Canal.

225 '6,000 or 7,000 poor, wretched-looking ragged fellows': FMB to Frederic Shields, 16 April 1886, Hueffer, p. 376.

225 'he "shook hands & spoke a few words with me"': FMB to Lucy, 26 June 1886, UBC, A-D 8–15.

225 'the name of Madox Brown "that good man"': WMR Diary, 8 November 1886.

225 'But it is of little use, they will be overwhelmed, I fear': FMB to WMR, 15 November 1885, UBC, A-D 4–15 and FMB to Lucy, 25 November 1885, UBC, A-D 5–6.

225 'The painter had been actively supporting the rights of the working class': WMR Diary, 27 August 1867.

226 'atheistic character': WMR to FMB, 24 September 1881, *Selected Letters of William Michael Rossetti*, ed. Roger W. Peattie (University Park, Pa: The Pennsylvania State University Press, 1990), p. 400.

226 'None of the booksellers here': FMB to Lucy, 21 September 1881, UBC, A-D 8–12.

227 The Mathilde Blind Scholarship at Newnham College, Cambridge: thirty years later, Mathilde's half-sister, Ottilie Hancock, née Blind, made similar provisions at Girton College, Cambridge.

228 'Mathilde read her paper, "Shelley's view of Nature contrasted with Darwin's"': WMR Diary, 10 November 1886.

Chapter 19 – The end of the affair

229 'Mrs B has a kind of suicidal mania': FMB to Lucy, 14 January 1886, UBC, 8–15.

229 'it would more add to your bothers than help them': FMB to Lucy, 29 March 1886?, UBC, A-D 8–15.

229 'the Corporation threatened "to paint out his frescoes"': Hueffer, 'Nice People', p. 573.

230 'Holman Hunt saw him as a youthful dandy': Holman Hunt's portrait of Harold Rathbone, *c.* 1893, is at the Walker Art Gallery, National Museums Liverpool.

231 'She said he made her face look like a piece of gingerbread': Soskice, pp. 40–1.

232 'first to seriously render Charles Darwin and Herbert Spencer into verse': *Wit and Wisdom*, 3 August 1889.

232 'From Chaos to Kosmos': *Athenæum*, 20 July 1889.

233 'Literary Ladies' Dinner': all details about the dinner from 'Women Who Write/The Literary Ladies' Dinner/ [By Our Lady Representative]', *Pall Mall Gazette*, 1 June 1889, p. 6.

234 'Miss Mathilde Blind is now engaged on a translation of the journal of Marie Bashkirtseff': 'Literary Notes, News and Echoes', *Pall Mall Gazette*, 2 November 1889.

234 'Pension Villa Garin': today the Villa Garin is the home of the Musée Matisse at Nice.

234 'Her brilliant French "*journal intime*"': Mathilde to Richard Garnett, from Nice, 26 November 1887, BL: Add. 61929, ff. 23–6.

234 'Bashkirtseff's aim was "to catch hold of the life of to-day"': Mathilde's Introduction to *The Journal of Marie Bashkirtseff* (London: Cassell, 1890). Marie Bashkirtseff's *œuvre*, though small, was distinguished, with paintings and sculpture, such as *The Meeting* and *Nausicaa's Pain*, now held in the Musée d'Orsay, Paris, and in public galleries across Europe.

234 'In *Woman's World*': *Woman's World*, I, pp. 351–6 and 454–7, June and August 1888.

234 'Gladstone, who responded with his own appreciation': 'Journal de Marie Bashkirtseff' by W. E. Gladstone, *The Nineteenth Century*, 1889, 126, pp. 602–7.

234 'Mathilde then brought out the first English translation': Mathilde to W. E. Gladstone, 15 October 1889 (writing from 1 St Edmund's Terrace, showing Mathilde was once again staying

with the Madox Browns). Gladstone Papers, BL: Add. 44508, ff. 66–7.

234 'too intensely modern for repose': Mathilde's Introduction to *The Journal of Marie Bashkirtseff*.

234 'the Muscovite Minx': A. C. Swinburne to Karl Blind, 11 February 1892, BL: Add. 40126, Vol. 4, ff. 11–12.

234 'absorbing egotism . . . unique, probably, in the history of literature produced by women': the *Globe*, 29 April 1890.

234 'by so eminent and poetic writer as Miss Mathilde Blind': *Manchester Examiner*, 3 May 1890.

235 'she left all "property, money, furniture" ': from EMB's letter of wishes, or will, 20 April 1888, Cornell, Ford Madox Ford Collection #4605, Box 49 Folder 108.

235 'She wasn't old and bent at all': Soskice, pp. 42–3.

236 'his personality was "picturesque and buoyant" ': Hueffer, 'Nice People', p. 573.

236 'By May, she had had seven "fits"': FMB to Lucy, three letters, 16 April 1890, 13 May 1890 and ? May 1890, UBC, A-D 5–7.

236 'When she was ill': Soskice, p. 43.

236 'This slow death was caused': death certificate of EMB, dated 13 October 1890.

236 'we go on hoping still': FMB to Theodore Watts-Dunton, 23 September 1890, Brotherton Library, Leeds University.

236 'Once in the night, just before she died': Soskice, pp. 43–4.

237 'Now he drew Emma for the last time': this drawing is in a private collection.

237 'Emma was buried in the same grave at St Pancras Cemetery': confusingly, St Pancras Cemetery is at East Finchley.

237 'The "Funeral Furnisher" James Parsons': account for EMB's funeral on 16 October 1890, Cornell, Violet Hunt Collection # 4607, Box 5 Folder 35.

238 'In the evening he used to wander up and down': Soskice, p. 44.

239 'Contemporary speculation murmured that the two planned to marry': HRA, p. 50.

239 'One point upon which Madox Brown was excessively touchy': ibid., pp. 49–50.

239 'Helen believed strongly that it was her mother, Lucy': private information.

240 'Madox Brown's designs for Lear's palace': information from FMB to Henry Irving, 24 June 1892, Henry Irving Correspondence at the V&A Theatre Museum Archives,

THM/37/7/18 number 477, and from the Souvenir programme of the play which opened 10 November 1892 at the Lyceum Theatre.

241 'the settings which were "gorgeous throughout"': *Pick-Me-Up*, 17 December 1892.

241 'extraordinarily moved': Mathilde to Henry Irving, 6 December 1892, Henry Irving Correspondence at the V&A Theatre Museum Archives, THM/37/7/17 number 366.

241 'Mathilde's unpublished commonplace book': Bodleian: Ms Walpole e 1.

241 'Chestnut Cottage': I am grateful to Cathy Soughton, genealogist in Wendover, for locating the position of Chestnut Cottage in 1893.

241 'At a certain distance meadows, lanes and trees': Mathilde Blind's commonplace book, Bodleian: Ms Walpole e 1, p. 7.

241 'Richard Garnett described Mrs Caird': Garnett's *Memoir*, Blind, p. 41.

242 'So doth your brightness touch my failing days': Mathilde Blind's commonplace book, Bodleian: Ms Walpole e 1, p. 8.

242 'We would rather be made wretched': ibid.

242 'Mona with very soft little touches': ibid., p. 15.

243 'And then I thought of Edmond': ibid., note dated 23 September 1893.

243 'Ludwig Mond . . . became a discerning art collector': Ludwig Mond's bequest, mainly of Italian Old Masters, to the National Gallery, London, was one of the largest endowments the gallery has ever received.

243 'The majestic sunflowers meet the sun barefaced': Mathilde Blind's commonplace book: Bodleian: Ms Walpole e 1, p. 25b and p. 27, both dated August 1893.

243 'The passion which Charlotte Brontë infused into Jane Eyre': ibid., pp. 17b and 17c.

243 'When I was young I was like other girls': ibid., p. 22.

243 'were struck by the singular outline of a hornbeam': ibid., pp. 24 and 24b.

Epilogue – The dead are with us still

245 'Oh Nellie . . . I'm going for a little walk': unpublished notes by Helen Rossetti Angeli on FMB from the Fredeman Family Collection.

245 'the fine airs and fresh breezes of Hampstead': the *World*,
 London, 11 October 1893.

245 'Walls and wood-work were painted a pensive olive-green':
 Ella Hepworth Dixon, 'Pensées de Femme', *Lady's Pictorial*, 6
 February 1897.

245 'In a frame by themselves': the *World*, London, 11 October 1893.

245 'There was a row of dusty casts on the mantelpiece': Hueffer,
 'Nice People', p. 572.

246 'his replica of *Wycliffe on Trial*': a commission intended for
 presentation to the nation. Hueffer, pp. 395–6 and 444.
 Probably based on *The Trial of Wycliffe AD 1377*, one of the
 twelve murals FMB painted for Manchester Town Hall.

246 'he later maintained that his grandfather's "last quite coherent
 words"': Hueffer, pp. 396–8.

248 'My grandfather was dead': Soskice, account of FMB's death
 from pp. 68 to 73.

248 'The funeral took place in the unconsecrated section': details
 from the *Birmingham Daily Gazette*, 12 October 1893.

248 'The *Glasgow Herald* reported that even Christina Rossetti
 attended': 12 October 1893. This may not be true.

248 'As soon as the mourners had gathered round': the *Daily
 Graphic*, 12 October 1893.

248 'Neither Mathilde nor Madox Brown envisaged an afterlife':
 Holman Hunt to WMR, 15 April 1894, UBC, A-D 22–2.

248 'Mathilde Brown': *Birmingham Daily Post*, 12 October 1893, the
 Globe, 12 October 1893, the *Morning Post*, 12 October 1893, the
 Citizen, 14 October 1893.

249 'He painted, not for money': *The Times*, 7 October 1893.

249 'A Captain of the Advance': *Pall Mall Budget*, 19 October 1893,
 also carried by the *Galignani Messenger*, Paris, 15 October 1893.

249 'I have been an exile in this world': Mathilde Blind's common-
 place book, Bodleian: Ms Walpole e 1, p. 22b.

249 'The death of a friend is a grievous affliction': ibid., pp. 36b and
 37, note dated 25 December 1895.

249 'Dear Mathilde': Richard Garnett to Mathilde, 17 October
 1893, BL: Add. 61929, ff. 100–1.

249 'singularly beautiful': Garnett's *Memoir*, Blind, p. 26.

249 'touched us both so grievously': Mathilde to Cathy Hueffer,
 n.d., V&A, Box 21 MSL 1995/14/135/6.

249 'To Blanche': Mathilde Blind's commonplace book, Bodleian:
 Ms Walpole e 1, p. 23.

250 'Perhaps the sunshine and brightness of Egypt': quoted in Garnett's *Memoir*, Blind, p. 38.

250 'I have no letters of your dear Father': Marie to Cathy Hueffer, 15 January 1895, V&A, Box 21 MSL 1995/14/105/10.

250 'deep orange calendula': *Calendula officinalis* or pot marigold.

251 'cancer of the uterus': death certificate gives cause of death as 'uterine cancer 10 months'.

252 'she expressed the hope': Mathilde's words to Mrs Ludwig Mond, quoted by her son, Alfred Mond, at the unveiling of the monument to Mathilde at St Pancras Cemetery, East Finchley, in 1898, BL: Add. 61930, f. 114.

253 'Edouard Lanteri made a bronze medallion portrait': photographs of Lanteri's medallion were reproduced twice, once in the 1899 edition of Mathilde Blind's *The Ascent of Man*, and a year later in *The Poetical Works of Mathilde Blind*, ed. Arthur Symons with a memoir by Richard Garnett (London: T. Fisher Unwin, 1900).

254 'Lanteri's bronze is in no way a death mask': it's not known whether Mathilde had given Lanteri any sittings during her lifetime or whether he worked from photographs after her death.

254 'It is to me a pleasure to remember Mathilde Blind': Freiligrath Kroeker, 'My Recollections of Mathilde Blind', BL: Add. 61930 ff. 56–62.

254 '*The Tables Turned*, a socialist play by William Morris': *The Tables Turned* opened on 15 October 1887. I am grateful to Frank Sharp for information about Shaw's impressions of seeing Marie in the audience at a performance of this play.

254 'a tall and beautiful figure, rising like a delicate spire': G. B. Shaw, 'William Morris as actor and dramatist', reprinted in *Our Theatre in the Nineties*, 2 vols. (London: Constable, 1932), II, p. 213.

BIBLIOGRAPHY

There has been surprisingly little biographical work on Ford Madox Brown. With his approval, his daughter, Lucy Madox Brown Rossetti, wrote a summary of his life and career to date for *The Magazine of Art* in 1890, three years before his death. His grandson, Ford Madox Hueffer, published the first biography *Ford Madox Brown: A Record of his Life and Works* in 1896. Hueffer had the benefit of living mostly in his grandfather's house from 1889 to 1893 and interviewed Madox Brown on his deathbed. However, he had an imaginative approach to biography. His Rossetti cousins considered him a dreadful liar.

The richest resource for any biographer of Madox Brown is Virginia Surtees' scrupulous edition of his *Diary* (1981). It was nearly a century after Hueffer's that the only other biographical work appeared, *Ford Madox Brown and the Pre-Raphaelite Circle* (1991) by Teresa Newman and Ray Watkinson, which rightly located Madox Brown within the art context of his times. Kenneth Bendiner's *The Art of Ford Madox Brown* in 1998 has been the only study to date to assemble and interpret his works in a wide variety of media. John A. Walker examined a single painting *Work: Ford Madox Brown's Painting and Victorian Life* in 2006. Tessa Sidey edited and Laura MacCulloch catalogued *Ford Madox Brown: The Unofficial Pre-Raphaelite* at Birmingham Museums and Art Gallery in 2008. Mary Bennett's comprehensive and long-anticipated Catalogue Raisonné is due out in 2010. A major exhibition devoted to Ford Madox Brown, to be held in Manchester and other venues, is scheduled for 2011.

The four loves of Ford Madox Brown have attracted even less biographical attention. Elisabeth Bromley is a ghostly presence because she died so young. Jan Marsh included Emma Hill briefly in her *Pre-Raphaelite Sisterhood* in 1985. Marie Spartali was the joint subject of David B. Elliott's *A Pre-Raphaelite Marriage: The Lives and Works of Marie Spartali Stillman & William James Stillman* in 2006. Mathilde Blind's poetry is gradually capturing the attention of academics, notably in a series of

articles by James Diedrick in the USA. *Into the Frame* provides the first biographical work on Elisabeth, Emma and Mathilde.

What follows is a selective guide to some of the sources I have found most useful. Other references are in the endnotes.

Angeli, Helen Rossetti, *Dante Gabriel Rossetti: His Friends and Enemies* (London: Hamish Hamilton, 1949).

Ashton, Rosemary, *Little Germany: Exile and Asylum in Victorian England* (Oxford: Oxford University Press, 1986).

Avery, Simon, ' "Tantalising Glimpses": The Intersecting Lives of Eleanor Marx and Mathilde Blind' in *Eleanor Marx (1858–1898) Life, Work, Contacts* ed. by John Stokes (Aldershott: Ashgate, 2000).

Barringer, Tim, *Men at Work: Art and Labour in Victorian Britain* (London: Paul Mellon Centre, 2005).

Bendiner, Kenneth, *The Art of Ford Madox Brown* (University Park, Pa: Pennsylvania State University Press, 1998).

Bennett, Mary, *Ford Madox Brown 1821–1893*, exhibition catalogue (Liverpool: Walker Art Gallery, 1964).

—, *Artists of the Pre-Raphaelite Circle, The First Generation* (London: Lund Humphries, for the National Museums and Galleries on Merseyside, 1988).

Blind, Mathilde, *Poems by Claude Lake* (London: Alfred. W. Bennett), 1867.

—, trans., *The Old Faith and The New*, by David Strauss (London: Asher & Co., 1873).

—, 'Mary Wollstonecraft', *The New Quarterly Magazine*, July 1878, 390–412.

—, *The Prophecy of St. Oran* (London: Newman and Co., 1881).

—, *George Eliot* (London: W. H. Allen, 1883).

—, *Tarantella* (London: T. Fisher Unwin, 1884).

—, *Madame Roland* (Boston, Mass: Roberts Brothers, 1886).

—, *The Heather on Fire* (London: Walter Scott, 1886).

—, ed., *Letters of Lord Byron* (London: Walter Scott, 1887).

—, 'Marie Bashkirtseff, the Russian Painter', *The Woman's World* I, 1888, 351–56, 454–57.

—, *The Ascent of Man* (London: Chatto & Windus, 1889).

—, trans., *The Journal of Marie Bashkirtseff* (London: Cassell, 1891) and reprinted (London: Virago, 1985).

—, *Dramas in Miniature* (London: Chatto & Windus, 1891).

—, 'A Study of Marie Bashkirtseff' in *Jules Bastien-Lepage and his art* with

a memoir by André Theuriet (London: T. Fisher Unwin, 1892), 145–90.

—, *Songs and Sonnets* (London: Chatto & Windus, 1893).

—, *Birds of Passage* (London: Chatto & Windus, 1895).

—, *Poetical Works*, ed. Arthur Symons, with a Memoir by Richard Garnett (London: T. Fisher Unwin, 1900).

Bornand, Odette, ed., *The Diary of W. M. Rossetti 1870–1873* (Oxford: Clarendon Press, 1977).

Borowitz, Helen, 'King Lear in the art of Ford Madox Brown', *Victorian Studies*, Spring 1978, 309–34.

Bronkhurst, Judith, *William Holman Hunt: A Catalogue Raisonné*, 2 vols. (New Haven and London: Yale University Press, 2006).

Burne-Jones, Georgiana, *Memorials of Edward Burne-Jones*, 2 vols. (London: Lund Humphries, 1993) (first published 1904).

Casteras, Susan P., and Linda H. Peterson, *A Struggle for Fame: Victorian Women Artists and Authors* (New Haven: Yale Center for British Art, 1994).

Casteras, Susan, and Colleen Denney, *The Grosvenor Gallery – A Palace of Art in Victorian England* (New Haven: Yale University Press, 1996).

Champneys, Basil, *Memoirs and Correspondence of Coventry Patmore*, 2 vols. (London: George Bell, 1900).

Chapman, Alison, and Jane Stabler (eds.), *Unfolding the South: Nineteenth century British women writers and artists in Italy* (Manchester: Manchester University Press, 2003).

Cherry, Deborah, *An Annotated edition of the Diary and selected Letters of Ford Madox Brown 1850–1870*, unpublished PhD, University of London, 1977.

—, *Painting Women: Victorian Women Artists* (Rochdale: Rochdale Art Gallery, 1987).

Clayton, Ellen, *English Female Artists*, 2 vols. (London: Tinsley Brothers, 1876).

Conway, Moncure Daniel, *Travels in South Kensington* (New York: Harper & Brothers, 1882).

Conway, Moncure Daniel, *Autobiography*, 2 vols. (London: Cassell, 1904).

Cosnier, Colette, *Marie Bashkirtseff: Un portrait sans retouches* (Paris: Pierre Horay, 1985).

Diedrick, James, ' "My love is a force that will force you to care": subversive sexuality in Mathilde Blind's dramatic monologues', *Victorian Poetry* 40.4, 2002, 359–86.

—, 'A Pioneering Female Aesthete: Mathilde Blind in *The Dark Blue*', *Victorian Periodicals Review* 36:3, Fall 2003, 210–41, University of

Toronto Press.

—, '"The hectic beauty of decay": positivist decadence in Mathilde Blind's late poetry', *Victorian Literature and Culture*, 34, 2006, 631–48, Cambridge University Press.

Donaldson, R. J., and L. J. Donaldson, *Essential Public Health Medicine* (Dordrecht and London: Kluwer, 1993).

Dormandy, Thomas, *The White Death: A History of Tuberculosis* (London: Hambledon, 1999).

Doughty, Oswald, *A Victorian Romantic* (Oxford: Oxford University Press, 1968, reprint of the 2nd edn., 1960, first published 1949).

Doughty, Oswald, and J. R. Wahl, eds., *Letters of Dante Gabriel Rossetti*, 4 vols. (Oxford: Oxford University Press, 1967).

Elliott, David B., *A Pre-Raphaelite Marriage: the lives and works of Marie Spartali Stillman & William James Stillman* (Woodbridge: Antique Collectors Club, 2006).

Flanders, Judith, *A Circle of Sisters* (London: Viking, 2001).

—, *The Victorian House* (London: HarperCollins, 2003).

Fredeman, William E., *Pre-Raphaelitism: A Bibliocritical Study* (Cambridge, Mass: Harvard University Press, 1965).

—, *Prelude to the Last Decade: Dante Gabriel Rossetti in the Summer of 1872* (Bulletin of the John Rylands Library, Manchester, Vol. 53, Nos 1 & 2, 1970 and 1971).

—, ed., *The PRB Journal. William Michael Rossetti's Diary of the Pre-Raphaelite Brotherhood 1849–1853* (Oxford: Clarendon Press, 1975).

—, et al, eds., *The Correspondence of Dante Gabriel Rossetti*, 10 vols. (Cambridge: D.S. Brewer with The Modern Humanities Research Association, 2002—).

Freeman, Michael, *Railways and the Victorian Imagination* (New Haven and London: Yale University Press, 1999).

Friswell, Laura Hain, *In the Sixties and Seventies: Impressions of Literary People and Others* (London: Hutchinson, 1905).

Garnett, R. S., *Letters about Shelley* (London: Hodder and Stoughton, 1917).

Gere, J. A., *Pre-Raphaelite Drawings in the British Museum* (London: British Museum Press, 1994).

Goldman, Paul, *Victorian Illustration* (Aldershot: Scolar, 1996).

Harding, Ellen, ed., *Re-framing the Pre-Raphaelites* (Aldershot: Scolar, 1996).

Hares-Stryker, Carolyn, *An Anthology of Pre-Raphaelite Writings* (Sheffield: Sheffield Academic Press, 1997).

Hawksley, Lucinda, *Lizzie Siddal: The Tragedy of a Pre-Raphaelite Supermodel* (London: André Deutsch, 2004).

Heilbrun, Carolyn G., *The Garnett Family* (London: George Allen & Unwin, 1961).

Henderson, Philip, *Swinburne: Portrait of a Poet* (New York: Macmillan, 1974).

Hewison, Robert, Ian Warrell and Stephen Wildman, *Ruskin, Turner and the Pre-Raphaelites* (London: Tate Gallery, 2000).

Hill, Ulrike, *The Poetry of Mathilde Blind and the Victorian Woman Question*, unpublished MA thesis, Open University, 1989.

Hilton, Tim, *John Ruskin: The Early Years* (New Haven and London: Yale University Press, 1985).

—, *John Ruskin: The Later Years* (New Haven and London: Yale University Press, 2000).

Holman-Hunt, Diana, *My Grandfather, His Wives and Loves* (London: Hamish Hamilton, 1969).

Holroyd, Michael, *A Strange Eventful History* (London: Chatto & Windus, 2008).

Hueffer, Catherine Madox Brown, *A Retrospect* (House of Lords Record Office, Stow Hill Papers, STH/BH/2/3–6, unpublished, undated MS).

—, *Jottings* (Private collection, unpublished MS, August 1922).

Hueffer, Ford Madox, *Ford Madox Brown* (London: Longmans, Green, 1896).

—, 'The Younger Madox Browns: Lucy, Catherine, Oliver', *The Artist*, 19 (February 1897).

—, 'Nice People', Temple Bar 128, November 1903.

—, *Ancient Lights and Certain New Reflections* (London: Chapman and Hall, 1911).

Hunt, Tristram, *Building Jerusalem: The Rise and Fall of the Victorian City* (London: Weidenfeld & Nicolson, 2004).

Hunt, Tristram, *The Frock-Coated Communist: The Revolutionary Life of Friedrich Engels* (London: Allen Lane, 2009).

Hunt, W. Holman, *Pre-Raphaelitism and the Pre-Raphaelite Brotherhood*, 2 vols. (London: Macmillan, 1905).

Ingram, John H., *Oliver Madox Brown* (London: Elliot Stock, 1883).

Ionides, Luke, *Memories* (Ludlow: Dog Rose Press, 1996, facsimile reprint).

Ironside, Robin and John Gere, *Pre-Raphaelite Painters* (London: Phaidon, 1948).

Jalland, Pat, *Women, Marriage and Politics 1860–1914* (Oxford: Clarendon Press, 1986).

James, Henry, *The Painter's Eye*, ed. by John L. Sweeney (Wisconsin: University of Wisconsin Press, 1989).

Johnson, Barry C., ed., *Tea and Anarchy! The Bloomsbury Diary of Olive*

Garnett 1890–1893 (London: Bartletts, 1989).

—, ed., *Olive & Stepniak: The Bloomsbury Diary of Olive Garnett 1893–1895* (Birmingham: Bartletts, 1993).

Judd, Alan, *Ford Madox Ford* (Cambridge, Mass: Harvard University Press, 1991).

Kennedy, Ian, and Julian Treuherz, *The Railway: art in the age of steam* (New Haven and London: Yale University Press, 2008).

Lambourne, Lionel, *The Aesthetic Movement* (London: Phaidon, 1996).

Maas, Jeremy, *Victorian Painters* (London: Barrie & Jenkins, 1970).

—, *Gambart* (London: Barrie & Jenkins, 1975).

MacCarthy, Fiona, *William Morris: a life for our time* (Faber and Faber, 1994).

MacKenzie, John M., *The Victorian Vision* (London: V&A Publications, 2001).

Macleod, Dianne Sachko, *Art and the Victorian Middle-Class – Money and the making of cultural identity* (Cambridge: Cambridge University Press, 1996).

Marsden, Gordon, ed., *Victorian Values*, 2nd edn. (London: Longman, 1998).

Marsh, Jan, *Pre-Raphaelite Sisterhood* (London: Quartet, 1992).

—, *Christina Rossetti* (London: Jonathan Cape, 1994).

—, *Dante Gabriel Rossetti: Painter and Poet* (London: Weidenfeld & Nicholson, 1999).

Marsh, Jan and Pamela Gerrish Nunn, *Women Artists and the Pre-Raphaelite Movement* (London: Virago, 1989).

—, *Pre-Raphaelite Women Artists* (London: Thames and Hudson, 1998).

Mason, Michael, *The Making of Victorian Sexuality* (Oxford: Oxford University Press, 1994).

Maynard, Mary and June Purvis, eds., *Researching Women's Lives from a Feminist Perspective* (London: Taylor & Francis, 1994).

McCarthy, Justin, *Reminiscences*, 2 vols. (London: Chatto & Windus, 1899).

Millais, J. G., *The Life and Letters of Sir John Everett Millais*, 2 vols. (London: Methuen, 1899).

Mills, Ernestine, *The Life and Letters of Frederic Shields* (London: Longmans, Green, 1912).

Nead, Lynda, *Victorian Babylon* (New Haven: Yale University Press, 2000).

Newman, Teresa and Ray Watkinson, *Ford Madox Brown and the Pre-Raphaelite Circle* (London: Chatto & Windus, 1991).

Nunn, Pamela Gerrish, *Victorian Women Artists* (London: The Women's Press, 1987).

Oppenheim, Janet, *"Shattered Nerves": Doctors, Patients and Depression in Victorian England* (New York, Oxford: Oxford University Press, 1991).

Ormond, Richard, 'A Pre-Raphaelite Beauty', *Country Life* (30 December 1965), 1780–81.

Orr, Clarissa Campbell, ed., *Women in the Victorian Art World* (Manchester: Manchester University Press, 1995).

Osborne, Charles Churchill, *Philip Bourke Marston* (London: Times Book Club, 1926).

Pagel, Walter and others, *Pulmonary Tuberculosis*, 4th edn. (London: Oxford University Press, 1964).

Parris, Leslie, ed., *Pre-Raphaelite Papers* (London: Tate Gallery, 1984).

—, ed., *The Pre-Raphaelites* (London: Tate Gallery, 1984).

Peattie, Roger W., ed., *Selected Letters of William Michael Rossetti* (University Park, Pa: The Pennsylvania State University Press, 1990).

Pointon, Marcia, ed., *Pre-Raphaelites re-viewed* (Manchester: Manchester University Press, 1989).

Rabin, Lucy, *Ford Madox Brown and the Pre-Raphaelite History Picture* (New York and London: Garland, 1978).

Reid, Forrest, *Illustrators of the Sixties* (London: Faber & Gwyer, 1928).

Richards, Jeffrey, *Sir Henry Irving* (Hambledon and London: Hambledon Continuum, 2005).

Robertson, W. Graham, *Time Was* (London: Hamish Hamilton, 1931).

Rose, Andrea, *Pre-Raphaelite Portraits* (Yeovil: Oxford Illustrated Press, 1981).

Rossetti, Lucy Madox, 'Ford Madox Brown', *The Magazine of Art*, 13, 1890, 289–96.

Rossetti, William Michael, *Fine Art, Chiefly Contemporary* (London: Macmillan, 1867).

—, 'Mr. Madox Brown's frescoes in Manchester', *Art Journal*, 43, September 1881, 262–3.

—, 'Ford Madox Brown: Characteristics', *The Century Guild Hobby Horse*, April 1886, 48–54.

—, ed., *Dante Gabriel Rossetti: His Family Letters with a Memoir*, 2 vols. (London: Ellis and Elvey, 1895).

—, ed., *Præraphaelite Diaries and Letters* (London: Hurst and Blackett, 1900).

—, ed., *The Germ . . . Being a Facsimile Reprint of the Literary Organ of the Pre-Raphaelite Brotherhood, Published in 1850: With an Introduction* (London: Stock, 1901).

—, ed., *Rossetti Papers 1862–1870* (London: Sands, 1903).

—, 'Dante Rossetti and Elizabeth Siddal', *The Burlington Magazine*, I (May

1903), 273–95.

—, *Some Reminiscences*, 2 vols. (London: Brown, Langham, 1906).

Rowley, Charles, *Fifty Years of Work without Wages* (London: Hodder & Stoughton, 1912).

Rubinstein, David, *Before the Suffragettes: Women's Emancipation in the 1890s* (Brighton: Harvester, 1986).

Saunders, Max, *Ford Madox Ford: A Dual Life*, 2 vols. (Oxford: Oxford University Press, 1996).

Scott, William Bell, *Autobiographical Notes*, ed. by W. Minto, 2 vols. (London: Osgood, McIlvaine, 1892).

Shonfield, Zuzanna, *The Precariously Privileged – A Professional Family in Victorian London* (Oxford: Oxford University Press, 1987).

Sidey, Tessa, ed., *Ford Madox Brown: The Unofficial Pre-Raphaelite* (London: Giles, 2008).

Simmons, Jack, *The Victorian Railway* (London: Thames and Hudson, 1991).

Smith, Alison, ed., *Exposed: The Victorian Nude* (London: Tate Publishing, 2001).

Sontag, Susan, *Illness as Metaphor* (Harmondsworth: Penguin, 1983).

Soskice, Juliet M., *Chapters from Childhood* (London: Selwyn & Blount, 1921).

Staley, Allen, *The Pre-Raphaelite Landscape* (New Haven: Yale University Press, 2001).

Stillman, W. J., *Autobiography of a Journalist* (London: Grant Richards, 1901).

Surtees, Virginia, *The Paintings and Drawings of Dante Gabriel Rossetti (1828–1882) A Catalogue Raisonné* (Oxford: Clarendon Press, 1971).

—, ed., *Diary of Ford Madox Brown* (New Haven and London: Yale University Press for The Paul Mellon Centre for Studies in British Art, 1981).

—, *Rossetti's Portraits of Elizabeth Siddal* (Oxford: Ashmolean Museum, University of Oxford, 1991).

Taylor, Ina, *Victorian Sisters* (London: Weidenfeld and Nicolson, 1987).

Thirlwell, Angela, ed., *The Pre-Raphaelites and their World* (London: The Folio Society, 1995).

Thirlwell, Angela, *William and Lucy: The Other Rossettis* (New Haven & London: Yale University Press, 2003).

—, 'Tender human tie: the unconventional intimacy of Ford Madox Brown and Mathilde Blind' in *The Times Literary Supplement*, 10 October 2008, pp. 14–15.

Treuherz, Julian, 'Ford Madox Brown and the Manchester Murals', in *Art*

and Architecture in Victorian Manchester (Manchester: Manchester University Press, 1985).

—, *Pre-Raphaelite Paintings from Manchester City Art Galleries* (Manchester: Manchester City Art Gallery, 1993).

—, *Victorian Painting* (London: Thames and Hudson, 1993).

—, *Dante Gabriel Rossetti* (London: Thames and Hudson, 2003).

Trevelyan, Raleigh, *A Pre-Raphaelite Circle* (London: Chatto & Windus, 1978).

Vadillo, Ana Parejo, *Women Poets and Urban Aestheticism* (Basingstoke and New York: Palgrave, 2005).

Vrettos, Athena, *Somatic Fictions: Imagining Illness in Victorian Culture* (Stanford: Stanford University Press, 1995).

Walker, John A., *Work: Ford Madox Brown's Painting and Victorian Life* (London: Francis Boutle, 2006).

Warner, Malcolm, *The Victorians: British Painting 1837–1901* (Washington: National Gallery of Art, 1997).

Watkinson, Raymond, *Pre-Raphaelite Art and Design* (London: Trefoil, 1970).

Watts-Dunton, Theodore, *Old Familiar Faces* (London: Herbert Jenkins, 1916).

Wildman, Stephen, *Visions of Love and Life* (Alexandria, VA: Art Services International, 1995).

Willis, I. C., ed., *The Letters of Vernon Lee* (Privately printed, 1937).

Wilson, A. N., *The Victorians* (London: Hutchinson, 2002).

Wilton, Andrew and Robert Upstone, *The Age of Rossetti, Burne-Jones and Watts* (London: Tate Gallery, 1997).

Woolner, Amy, *Thomas Woolner, R. A., Sculptor and Poet His Life in Letters* (New York: E. P. Dutton, 1917).

Yeldham, Charlotte, *Women Artists in the Nineteenth Century* (New York: Garland, 1984).

LIST OF ILLUSTRATIONS

All paintings, drawings, sketches, engravings and designs listed below are by Ford Madox Brown unless otherwise specified.

Plates Section

1. *The Bromley Family*, oil on canvas, 117.4 x 81.1 cm, signed and dated, F. M. Brown/1844. Bridgeman / © Manchester Art Gallery, UK.
2. *Cordelia's Portion*, watercolour, 75 x 107.3 cm, 1865–6, © National Museums Liverpool, Lady Lever Art Galley.
3. *Cordelia at the bedside of Lear*, oil on canvas, 71.1 x 99.1 cm, 1849–54. © Tate, London, 2010.
4. *Out of Town*, oil on canvas, 23.2 x 14.4 cm, begun 1843–4, completed 1858. Bridgeman/ © Manchester Art Gallery, UK.
5. *The Pretty Baa-Lambs*, oil on panel, 61 x 76.2 cm, 1851, re-touched 1851–53, 1859. Bridgeman/ Birmingham Museums & Art Gallery.
6. *The Last of England*, oil on panel, oval 82.5 x 75 cm, 1852–55. Bridgeman/ Birmingham Museums & Art Gallery.
7. *The Brent at Hendon*, oil on millboard, oval, 21 x 26.7 cm, 1854–55. © Tate, London, 2010.
8. *Waiting: An English Fireside in the Winter of 1854–55*, oil on panel, 30.5 x 20 cm, 1851–55. © National Museums Liverpool, Walker Art Gallery.
9. *Take Your Son, Sir!*, oil on paper, mounted on canvas, 70.4 x 38.1 cm, 1851–52, re-worked 1856–57 and later. © Tate, London, 2010.
10. *Walton-on-the-Naze*, oil on canvas, 31.7 x 41.9 cm, 1859–60. Birmingham Museums & Art Gallery.
11. *Mrs. Madox Brown*, black and coloured chalks, 75.5 x 54 cm Inscribed 'Ford Madox Brown Jan. 69'. Bolton Museum and Art Gallery.
12. *La Rose de l'infante (Child with a Rose) Effie Stillman*, oil on canvas, 46 x 35.9 cm, 1876. Harvard Art Museum, Fogg Art Museum, Bequest

of Grenville L. Winthrop, 1943. 186. Photo: Katya Kallsen © President and Fellows of Harvard College.

13. *Consider the Lilies* by Marie Spartali Stillman, watercolour and bodycolour heightened with gum arabic, 47 x 36.8 cm, exhibited Royal Academy 1876. Private collection.

14. *The Establishment of the Flemish Weavers in Manchester, A.D. 1363.* Mural no. 4, one of seven of the twelve subjects painted using the Gambier Parry method, 146 x 318 cm, 1881–82. Bridgeman/© Manchester Art Gallery, UK.

15. *Marie at her easel*, coloured chalks, 76 x 55.5 cm, 1869. Private collection.

16. *Ford Madox Brown at his easel* by Cathy Madox Brown, watercolour on paper, 53.5 x 48.2 cm, 1870. Private collection.

Illustrations in the Text

I Elisabeth

page

5 Part-title: Detail from *The Bromley Family*, 1844, Oil on canvas, 117.4 x 81.1 cm, signed and dated, F. M. Brown/1844. Bridgeman Art Library, London/ © Manchester City Art Gallery.

7 Parish register entry, 3 April 1841, Meopham Parish Church, Kent.

11 Detail from *Dalton collecting Marsh Fire Gas*, 1886–87, oil on canvas, 146 x 318 cm, one of twelve murals for Manchester Town Hall, 1879–1893. Bridgeman/© Manchester Town Hall, Manchester, UK.

15 Study for head of swooning attendant for *Mary Queen of Scots*, c. 1841, oil on paper laid on canvas, 39 x 44 cm, Ashmolean Museum, University of Oxford.

16 *The Execution of Mary Queen of Scots*, 1840, oil on canvas, 779 x 691 mm, © Whitworth Art Gallery, The University of Manchester, UK/Bridgeman.

21 *Elisabeth Madox Brown née Bromley*, 1843, pencil, 175 x 106 mm, later annotated by his son-in-law William Michael Rossetti: 'Seems to be by Brown – From an acc[oun]t book of his wife ending Nov./43'. Private collection.

25 *Lear questions Cordelia*, inscribed lower left 'Ford M Brown' and lower right 'Paris/44', pencil, pen and brown ink on paper, 210 x 288 mm. The Whitworth Art Gallery, The University of Manchester.

II Emma

64 *Study for Delia* by Dante Gabriel Rossetti, pencil on cream-toned paper, 263 x 135 mm, November 1851. Birmingham Museums & Art Gallery.

65 *Emma on her wedding day*, (left), graphite on grey-white paper, 129 x 107 mm, inscribed and dated 'FMB 5 April 53' lower right. Private collection.

65 *The artist's wife Emma on her wedding day*, (right), red, white and black chalks on blue paper, 40 x 34.6 cm, 1853. Yale Center for British Art, Paul Mellon Fund.

66 Parish register entry, 5 April 1853, St Dunstan-in-the-West, London.

68 *Mrs. Ford Madox Brown* by Dante Gabriel Rossetti, pen and brown ink on buff paper, 126 x 100 mm, signed in monogram and inscribed 'GR 1st May/53'. Birmingham Museums & Art Gallery.

70 *Self-portrait*, aged 29–32, black chalk on light brown paper, 25 x 23 cm, September 1850, re-touched October 1853. © National Museums Liverpool, Walker Art Gallery.

78 *Mrs Ford Madox Brown* [Emma], by Dante Gabriel Rossetti, pen and brown ink on buff paper, 124 x 99 mm. Monogram and date, '10 Sept 1856'. Birmingham Museums & Art Gallery.

82 *Arthur Gabriel Madox Brown*, watercolour, 114 x 89 mm. 1857. Inscribed 'From memory'. Private collection.

89 *Oliver Madox Brown* aged 4, pencil, circular, 31 cm diameter. Inscribed 'FMB May 16–59'. Private collection.

91 *Catherine Madox Brown* aged 13, pencil, oval 39.5 x 32 cm Inscribed 'FMB-63'. Private collection.

94 *Work*, oil on canvas, 137 x 197.3 cm 1852–65. Bridgeman/© Manchester Art Gallery, UK.

95 *The painting wagon in Hampstead*, pen and ink sketch in letter to Lowes Dickinson, 17 October 1852. Princeton University Library, Department of Rare Books & Special Collections, Lowes Cato Dickinson Correspondence CO152, Box 1, Folder 2.

99 *List of Favourite Things*, courtesy of the Morgan Library, New York.

101 *Byron's Dream* designed by Ford Madox Brown and engraved for the title page of Moxon's edition of Byron's *Poems*, 1870.

III Marie

IV Mathilde

167 Part-title: Mathilde Blind, studio photograph, undated. Frontis-piece to *Selection of the Poems of Mathilde Blind*, ed. Arthur Symons, 1897.

178 *Manfred on the Jungfrau*, oil on canvas, 141 x 115.5 cm, first painted 1840, re-touched often and returned to in 1861. Bridgeman/ © Manchester Art Gallery, UK.

180 *Ottilie Blind*, aged 18, by John Brett, oil on canvas, 60 x 49 cm, July 1869. The Mistress and Fellows, Girton College, Cambridge.

191 Karl Blind, photograph courtesy of Stadtarchiv Mannheim.

194 *Mary Blackmore*, pencil, 199 x 130 mm, monogram in ink, FMB-71. The Ashmolean Museum, University of Oxford.

196 *Mathilde Blind* by Lucy Madox Brown, black, red and white chalks on grey paper, 770 x 550 mm., signed in monogram and dated 'LMB – 72'. By kind permission of the Principal and Fellows of Newnham College, Cambridge.

199 (Left) *Portrait of Mathilde Blind*, 1876 [currently declared lost by the Royal Shakespeare Theatre Collection, Stratford-upon-Avon], from Charles Rowley, *Fifty Years of Work without Wages*, 1912.

199 (Right) Emma Hill 1852, detail from *The Last of England*. Bridgeman/ Birmingham Museums & Art Gallery.

203 FMB's letter about the death of Cicely Marston, 4 August 1878. Private collection.

208 *An English Autumn Afternoon*, 1852–53, 1855, oil on canvas, 71.7 x 134.6 cm, detail. Bridgeman/ Birmingham Museums & Art Gallery.

221 Caricature by John Hipkins, pencil, 111 x 175 mm, 1 August 1883. Royal Library of Scotland, Edinburgh.

230 Portraits of *Ford Madox Brown* and *Emma Madox Brown* by Cathy Madox Brown, red chalks, each 33 x 26 cm, 1887. Private collection.

231 *Mathilde Blind* by Harold Rathbone, pastel, 182.2 x 83.8 cm, 1889. © Philip Mould Ltd.

235 *The Meeting* by Marie Bashkirtseff, oil on canvas, 193 x 177 cm, 1884. Reproduced in André Theuriet, *Jules Bastien-Lepage and his art*, 1892.

237 *Convalescent: Portrait of Emma Madox Brown*, pastel on paper, 475 x 435 mm, 1872. Bridgeman/ Birmingham Museums & Art Gallery.

INDEX